AESTHETICS OF REPAIR

INDIGENOUS ART AND THE FORM OF RECONCILIATION

Aesthetics of Repair analyses how the belongings called "art" are mobilized by Indigenous artists and cultural activists in British Columbia, Canada. Drawing on contemporary imaginaries of repair, the book asks how diverse forms of collective reckoning with settler-colonial harm resonate with urgent conversations about aesthetics of care in art. The discussion moves across urban and remote spaces of display for Northwest Coast–style Indigenous art, including galleries and museums, pipeline protests, digital exhibitions, an Indigenous-run art school, and a totem pole repatriation site.

The book focuses on the practices around art and artworks as forms of critical Indigenous philosophy, arguing that art's efficacies in this moment draw on Indigenous protocols for enacting justice between persons, things, and territories. Featuring examples of belongings that embody these social relations – a bentwood box made to house material memories, a totem pole whose return replenishes fish stocks, and a copper broken on the steps of the federal capital – each chapter shows how art is *made* to matter. Ultimately, *Aesthetics of Repair* illuminates the collision of contemporary art with extractive economies and contested practices of "resetting" settler-Indigenous relations.

EUGENIA KISIN is an associate professor of art and society at the Gallatin School of Individualized Study at New York University.

AESTHETICS OF REPAIR

INDIGENOUS ART AND THE FORM OF RECONCILIATION

EUGENIA KISIN

UNIVERSITY OF TORONTO PRESS
Toronto Buffalo London

© University of Toronto Press 2024
Toronto Buffalo London
utorontopress.com

Printed and bound by CPI Group (UK) Ltd, Croydon, CR0 4YY

ISBN 978-1-4875-0342-0 (cloth) ISBN 978-1-4875-1791-5 (EPUB)
ISBN 978-1-4875-2266-7 (paper) ISBN 978-1-4875-1790-8 (PDF)

Library and Archives Canada Cataloguing in Publication

Title: Aesthetics of repair : Indigenous art and the form of reconciliation / Eugenia Kisin.
Names: Kisin, Eugenia, author.
Description: Includes bibliographical references and index.
Identifiers: Canadiana (print) 20240347412 | Canadiana (ebook) 20240347439 | ISBN 9781487522667 (paper) | ISBN 9781487503420 (cloth) | ISBN 9781487517915 (EPUB) | ISBN 9781487517908 (PDF)
Subjects: LCSH: Reconciliation – British Columbia. | CSH: First Nations art – Social aspects – British Columbia. | CSH: First Nations art – Political aspects – British Columbia. | CSH: First Nations artists – British Columbia.
Classification: LCC N6549.5.A54 K57 2024 | DDC 704.03/97071 – dc23

Cover design: Louise OFarrell
Cover image: Luke Parnell, *Fall of Man*, 2012, 18 x 12, wood

We wish to acknowledge the land on which the University of Toronto Press operates. This land is the traditional territory of the Wendat, the Anishnaabeg, the Haudenosaunee, the Métis, and the Mississaugas of the Credit First Nation.

University of Toronto Press acknowledges the financial support of the Government of Canada, the Canada Council for the Arts, and the Ontario Arts Council, an agency of the Government of Ontario, for its publishing activities.

Contents

List of Figures vii

Introduction: Remediating Loss and Repair 3

1 Re-enchanting Repair: Teaching from the "Dark Age" of Northwest Coast Art 19

2 Finding Repair: Contemporary Complicities and the Art of Collaboration 47

3 Across the *Beat Nation* 69

4 Cultural Resources and the Art/Work of Repair at the Freda Diesing School 95

5 Copper and the Conduit of Shame: Beau Dick's Performance/Art 125

6 Transitional Properties of Art and Repair 147

7 Afterword: There Is (Still) Truth Here 165

Acknowledgments 171

Notes 175

Bibliography 201

Index 227

Figures

0.1 Luke Parnell, *Remediation*, 2018 4

0.2 Promotional poster for *Beyond Eden*, 2010 8

1.1 Cover of Gil Cardinal's film *Totem: The Return of the G'psgolox Pole*, 2003 20

1.2 Frederick Alexcee, *Txaldzap'am nagyeda laxa,* c. 1886 25

1.3 Surrealist map of the world, *Variétés*, 1929 30

1.4 Emily Carr (Klee Wyck), catalogue cover for the *Exhibition of Canadian West Coast Art: Native and Modern*, 1927 33

1.5 Reverend George H. Raley's collection displayed at Coqualeetza Residential School, Sardis, BC, 1934 36

1.6 Reverend George H. Raley in 1946 37

1.7 Picture frame from the Raley Collection 43

2.1 Luke Parnell, *Phantom Limbs*, 2010 48

2.2 Luke Parnell, *A Brief History of Northwest Coast Design*, 2007 56

3.1 Raymond Boisjoly, *an other cosmos*, 2012 73

3.2 Skeena Reece, *Raven: On the Colonial Fleet*, 2010 75

3.3 Raymond Boisjoly, *an other cosmos: disaggregation*, 2012 91

4.1 *Arts of the North*, year-end exhibition at the Freda Diesing School of Northwest Coast Art, Terrace, BC, April 2013 100

4.2 Freda Diesing finishing a mask at 'Ksan, 1972 102

4.3 Angelo Cavagnaro, *Gitmidiik Wildman*, 2013 118

4.4 Stan Bevan, contemporary poles at Kitselas Canyon, BC 124

5.1 Beau Dick in Victoria on *Awalaskenis I*, 2013 128

5.2 Poster for *Awalaskenis* 130

5.3 Marianne Nicolson, *Oilspill: The Inevitability of Enbridge*, 2011 137

5.4 Michael Nicoll Yahgulanaas, *Stolen But Recovered*, 2007 138

5.5 Cathy Busby, *WE ARE SORRY 2013*, 2013 142
5.6 Cathy Busby, *WE ARE SORRY 2013*, detail with fragment, 2013 143
6.1 Video still from Skeena Reece, *Touch Me*, 2013 160
6.2 Luke Marston, *The Medicine Box*, 2009 161

AESTHETICS OF REPAIR

INTRODUCTION

Remediating Loss and Repair

At the end of his residency at a contemporary art gallery near Montreal, Quebec, the artist Luke Parnell took a chainsaw to the pole he had spent the past six weeks carving.[1] Incised with an eagle and a beaver – Parnell's family crest and sub-crest, respectively, on his father's side – the seven-foot pole was propped up on mounts in front of an audience. Like a magician sawing a body in half, Parnell separated the two animals along a horizontal cut line carved between them. Attaching the eagle to his back, he boarded a train for Vancouver.

This work, *One Line Creates Two Spaces* (2016), is at once a sculpture and a durational performance, a creation that honours the artist's dual Haida and Nisga'a lineages while carrying their weighty obligations. This piece also sets the stage and provides material for another work, Parnell's film *Remediation* (2018), which follows the artist's long journey from Montreal to Vancouver, carrying the eagle on his back. *Remediation* is Parnell's interrogation of a 1959 documentary film by the famed Haida artist Bill Reid about a museum-led mission to salvage deteriorating totem poles on the island of SGang Gwaay – or, in Reid's narration, "the remains of a deserted village."[2] Parnell's journey with the half-pole on his back recreates many of the conditions of this earlier film: a journey across art worlds to the Pacific Northwest, an intervention into the life cycle of these monumental wooden sculptures, and, perhaps, the actions of an ambivalent protagonist of mixed Indigenous heritage.

Indeed, during his lifetime, Reid's "half-breed" Haida status was simultaneously lionized for the mobility it conferred upon him as a public figure and attacked as somehow diluting his Indigeneity – the latter, certainly, when it came to his complicity in removing totem poles from their ancestral villages and depositing them in urban museums. In the 1959 film, Reid describes this salvage work in poetic, mournful terms: "The old cedar was wonderfully sound," he narrates, solemn and clear over a shot of chainsaws cutting into cedar. "The saws had to cut deep before the tall column began to yield. And even then it seemed to struggle to remain upright. But finally, slowly, and carefully, and I think with the same dignity it always had, it began its final descent."[3]

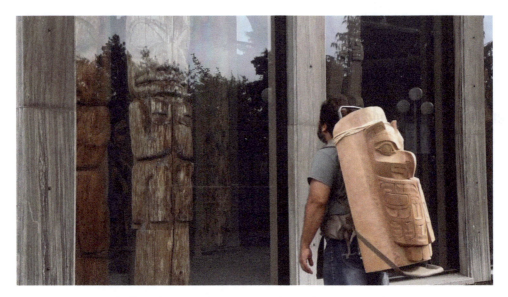

Figure 0.1. Luke Parnell, *Remediation* (2018). Still by Sean Arden, the film's cinematographer. Courtesy of the artist.

Unlike Reid's film, Parnell's *Remediation* is not a premature elegy to a dying culture or a denial of the tangled roots of intercultural belonging. It does not romanticize wilderness or the rugged terrain of masculine exploration that animates Reid's 1959 narration – the pleasure of the felling against the "struggle" of the pole, for example. Instead, through long shots of landscape from the window of the VIA Rail train and an absence of narration, Parnell carries his crest across the country from the gallery in Montreal to the rail terminus in Vancouver. He walks us through the urban infrastructure of the port city – condominium construction, bridges, viaducts, an anthropology museum – and boards a ferry to Vancouver Island, voyaging across the Strait of Georgia. In Victoria, he walks past the museum where Reid's salvaged poles stand, protected in a climate-controlled hall (Figure 0.1). We witness him carrying the eagle through a clear-cut forest and towards a trail that leads down to a rock beach. It is raining lightly, and the droplets of water speckle the eagle's carved face. Parnell builds a fire, its logs popping and crackling under the rain. He places the eagle on top of the pyre.

Once we reach this final cathartic shot, Parnell's film has set up its question of what remediation means for a thing that isn't inert and shows the endurance required to bear the weight of history on one's back. This severing and burning are not a death. "This isn't a museum piece," Parnell explains. "Mine is still alive."[4]

How is remediation made possible in contemporary art worlds, and how is justice enacted between persons and things in a settler state dependent on extractive relations? Writing from the particular aesthetic spaces and formalisms of the Northwest Coast art world, this book considers how the belongings called art acquire value and forms of attention, often called care, through complex processes and networks of intercultural exchange – the daily

rituals of an art school, for instance, or the performative force of an anti-pipeline protest. Museums and galleries, like the ones where Reid's poles were deposited, the locations of Parnell's pilgrimage, or the contemporary gallery hosting his residency, are themselves sites of remediation. In curator Clementine Deliss's coining, "remediation" in museological contexts refers to healing a sick institution, returning animacy to what remains in storage or in a vitrine through remedial acts of curating; "cure" and "care" are both etymologies frequently emphasized in the recent treatment of museum pieces.[5]

This healing is also particularly resonant for cultural institutions in the wake of Canada's Truth and Reconciliation Commission (TRC) on the violence perpetrated against generations of Indigenous children in church- and state-run residential schools. The TRC ran from 2008 until 2015, when its findings were released in a six-volume final report; this report, which lays bare the assimilative and genocidal violence of these church- and state-run schools, and their impact on generations of Indigenous people, also imagines a future of reconciliation, a reshaping of Indigenous-settler relations in which "virtually all aspects of Canadian society may need to be considered."[6] This imagined reshaping extends to art and educational institutions. Significantly, the Canadian TRC was the first of its kind to include an open call for visual art as testimony alongside survivors' words, the more traditional substance for remediating the body politic through transitional justice. In this way, this book is an account of art's efficacy in what might be called the age of reconciliation, a contested moment of figuring out what remediation – and even repair – looks like in a settler state forced to come to terms with its genocidal structures and the Indigenous presence, protest, and resilience that threaten its legitimacy.[7]

Watching Luke Parnell bear the weight of the severed eagle, his own remediation for salvage work done during the postwar renaissance of Northwest Coast art, I feel my lower back twinge with a sense memory. It is the summer of 2012, and I am sweating, pushing a palette on wheels – one of those sturdy wooden art-handling apparatuses, heavier than it looks – up the hill under the Granville Street Bridge in Vancouver, towards the rise of commercial galleries. As I push, Luke directs me and Adam, another friend of his, to watch out for cracks in the pavement as we haul his work up from his studio to a new gallery in the wealthiest part of town. Once or twice, Adam and I lose control in our dance with the art-on-wheels, and it threatens to fall off the curb into the street. But we catch it in in time and set it back on its ascent like an off-kilter shopping cart. "Good thing you both have day jobs," Luke jokes.

To remediate is to arrest damage or deterioration, to stop or reduce harm in its tracks: cleaning up a river after an oil spill, for example, or drawing heavy metals out of contaminated earth. To repair is a close and related concept but also presumes a restoration – fixing the leak in the pipe, containing the lead paint that is flaking into the soil – though not necessarily to a prior state of non-damage. Writing now, more than a decade after I nearly sent that palette careening down a hill, I still don't have easy answers about the reparative role of anthropologists working after the salvage paradigm, a mode of cultural preservation that calls for the removal of belongings to museums to arrest what is understood as inevitable in situ decay; one of the many paradoxes of this mode is that collecting to preserve enacts further cultural loss, doing more harm than good.

As an ethnography of art and a form of art writing, this book is also an account of my work and relations in contemporary Indigenous art worlds and an enquiry into the kinds of research and collaboration that are possible between artists and anthropologists. This, too, is part of what I am calling the aesthetics of repair: an attentiveness to which kinds of labour can be shared and which cannot. As the critic and poet Maggie Nelson points out in her recent account of the kinds of freedom and care involved in reparative projects of art-making, the limits of this care are important, partly because we all have finite capacities for reckoning with damage and harm.[8] But equally, Nelson reminds us that refusing repair, and the notion that art and its attendant labours are separate from other kinds of care work, can be an important gesture, one that brings us back to a kind of protective formalism[9] – or, in more familiar anthropological terms, to the aesthetics that artists are elaborating as they grapple with the material conditions of our present moment.

Over the last century, Indigenous artists and activists have made Vancouver, British Columbia, a vital centre of artistic and cultural activity – a location tied to a politics of cultural rights claims and a lucrative market for Northwest Coast–style work in which "art" is a contested commodity. Since the 1980s, this market has expanded, fueled by local projects of cultural renewal and global interests in postcolonial art and cultural resources. Indigenous cultural activists have intervened into Canadian politics of recognition, enacting sovereign rights that diverge from official provisions of multiculturalism policies. Taking up the fluid categories of "contemporary art" – its potential for participatory practice, political intervention, and play – artists are challenging modernist models of art's efficacies, imagining different ways that aesthetics and politics can comingle in the broader contexts of Indigenous practice and sovereignty.

Attending to these emergent forms of care, this book stays close to these material practices – art-making, collecting, preservation, revolution, and returns – and how they imagine and activate human and non-human relations on this contemporary resource frontier.[10] It is a regionally situated analysis of contemporary imaginaries of repair and how they are lived and resisted in a particular art world, and how these modes of collective imagining resonate with other movements and conversations about aesthetics of care in art. In these ways, it is not a book about reparations, though I hope that some of its material knowledge might add to conversations about how forms of political redress and their discursive mediation work together. I do not claim to offer recommendations for how to repair anything. Rather, this book provides an account of an aesthetics of repair that has taken shape in a particular regional art world through the practices, experiences, and interventions of artists; these strategies meet my ethnography as a kind of reparative writing that feeds back into these projects in unexpected and intertextual ways.

Returning to an earlier scene of encounter, Parnell's work references the kinds of repair that Bill Reid and his collaborator, the anthropologist Wilson Duff, were engaged in during their journey to salvage old poles for future generations of researchers and museum publics. As with most projects of salvage anthropology, alongside the easy metaphors and justifications of a "dying culture," there were much more complex display relations involved in the mid-century revival of many traditional Northwest Coast art forms. Indeed, Reid

and Duff's collaboration set the stage for the post-1967 moment known as the Northwest Coast art "renaissance," which anticipates and sets the ground for Parnell's work as a contemporary carver – and, crucially, for his own critical reflexivity about the conditions and movements of this art world and how it incorporates and understands its histories.[11] That this kind of critical reflexivity is involved in the work of repair is a major argument of this book.

Indeed, *Remediation* is not the first time this story of collaborative salvage has been dramatized. In 2010, as part of the Cultural Olympiad for the 2010 Vancouver Olympics, a musical called *Beyond Eden*, based on the story of the 1950s anthropological expedition, was performed.[12] *Beyond Eden*'s protagonist is called Lewis Wilson, a pseudonym for anthropologist Duff – a man whose obsession with getting "behind the mask" of Northwest Coast art wholly consumed him, eventually leading him to commit suicide in his office in 1976. *Beyond Eden* memorialized Duff's obsession as tragedy. Throughout, Lewis Wilson is haunted by Haida ghosts as he and "Max Tomson" – a fictionalized Bill Reid – cut down the monumental poles. Lewis and Max are driven by a shared passion to uncover, know, and preserve the past in order to ensure a Haida future. Throughout, both are haunted by the figure of the Haida Watchman, played by Métis actor Tom Jackson, and spirits, including Haida singer Raven Ann Potschka, who appear throughout the production to challenge the protagonists with riddles, warnings, and a story of twin masks – one with its eyes open and the other with its eyes shut – named "Appetite" and "Insight." The promotional poster for *Beyond Eden* advertised the conflict of these multiple desires, as Lewis is shown looking, wild-eyed, over his shoulder, his skin literally inscribed with Haida motifs, while silhouetted figures wielding chainsaws hack at a blood-spurting totem pole (Figure 0.2). This violent tableau resonated strongly with images of protests against resource extraction in Indigenous territories on the coast during the Winter Olympics, its meaning and haunted figure dependent on analogies between different kinds of forced removals.

This tragedy is made most palpable in the show's climax, where the Watchman finally reveals to Lewis "what lies behind the mask" of his "Eden," as the robes of the spirits on stage – made from infamously contaminated Hudson's Bay Company blankets – erupt in grotesque and bubbling light-simulated smallpox. In this scene, the audience is offered no way out of recognizing that their identification as consumers of "Haida culture" is irrevocably bound up with conquest and suffering. In the Watchman's words, these acts of consumption "open the wounds of our memories."

Yet this public spectacle was also one of redemption for both its players and its audience. Witnessing the painful story of salvage, we are asked to move "beyond Eden" and into a future that is reconciled with the conflicts of the past. The musical ends with a song called "We Go On": *How did we live, how did we die, what memories lie behind our eyes?* This future is also a shared one that moves "beyond" a troubled past into a new world of balancing "insight" and "appetite" in moments of encounter. Haunting moments in the performance are recuperated as guilt *from which we must go on*. The Watchman and the spirits disappear just before the poles come down, while Lewis poses for Max to take a final photograph. "Take a photo before this all changes ... We'll want to know

Figure 0.2. *Beyond Eden* (2010), promotional poster showing the actor John Mann playing Lewis Wilson (Wilson Duff). Image courtesy of David Cooper Photography.

what it looks like before everything changes," Lewis says, mouthing "I'm sorry" as Max captures the image. Change, redemption, apology, and going on: these are the musical's resolutions.

What I am trying to suggest through this opening juxtaposition is that the work of remediation – itself a response to always intertextual conditions of knowledge production – is different from that of redemption. More than a decade later, *Beyond Eden*'s extractive wounds persist, and so do its motifs: the desire to know and access, the balance of care with accountability, and the tragedy of unintended consequences of consumption. In drawing attention to aesthetics of repair as an important aspect of some contemporary art and cultural production in this resource frontier,[13] I do not mean for "repair" to become redemptive, a message of seamless fixing or "going on." As I write these words, land and water defenders in Wet'suwet'en territory in the northern part of British Columbia are still in the midst of bitter struggles against the Coastal GasLink pipeline and denial of the Indigenous rights and title by the settler government in the process of reaching an agreement.[14] These activists have declared: "Reconciliation Is Dead. Revolution Is Alive";[15] and I agree with them. As Eve Tuck and K. Wayne Yang have powerfully argued in their canonical text "Decolonization Is Not a Metaphor,"[16] claims of reconciliation that don't foreground questions of land and water are simply words. Yet I also want to suggest that there is something in this moment *before* the discourse of reconciliation's failure that is perhaps worth returning to: specifically, the nascent formalisms that the artists in this book propose, which unsettle what repair looks and feels like.

How to do justice to these assemblages across time and space is also a representational problem, relevant to writing about the cultural and epochal formation that some theorists call "the contemporary" or "contemporaneity."[17] As a time conceived as a series of "posts" and "beyonds" – after aesthetic postmodernism, after postcolonial anger, and even "after the end of art"[18] – the contemporary moment raises issues of representation that extend anthropology's long crisis of representation[19] and also identifies new problems that

are distinct from it. How can one write an ethnography of present conditions when the present is self-consciously tethered to the past and simultaneously straining towards the future? What are the problems and possibilities of art writing amidst ethics and aesthetics in which interpretation – the right to know and the ability to extract and recirculate grounded knowledge – can enact epistemological violence?[20]

My thinking about and participation in this art world started in 2002 when I moved to Vancouver from Toronto as an undergraduate student. At the University of British Columbia, I learned how to conserve basket fragments, woven cedar-bark blankets, stone carvings, and other belongings and took art history classes in which Northwest Coast artists were regular participants in the conversation, coming in from far-flung territories to critique the museum. This recounting is not to imply a utopian pedagogy but to signal the distinctive political horizon of this city at the end of the twentieth century: a strong contemporary presence of Indigenous people, belongings, and social movements demanding the fraught decolonization of a place where settlers came to stay somewhat later than to other unceded territories. For graduate school, I moved to New York City to be closer to one of the collections most revered by artists and anthropologists at the American Museum of Natural History, while maintaining a post in the Canadian art world as an editorial intern and assistant editor at *C Magazine*, an art criticism publication based in Toronto. My fieldwork – initially on the histories and lived realities of the commercial market for Northwest Coast art – brought me back to British Columbia, where I spent two years based in Vancouver, working with artists, curators, and scholars. In addition to the standard seasonal gallery openings and collections-based research, I looked for unexpected locations for art-making and theorizing: the gathering of a Native Ministries Consortium at the Vancouver School of Theology, for instance, or the opening of a downtown healing lodge, or an anti-pipeline protest at a theatre. After meeting Parnell and working on a project with him to record video interviews with prominent gallerists who had been involved in the formation of the post-1960s scene, I relocated to Terrace, a city in the northern part of the province, to co-teach Northwest Coast art history with him at the Indigenous-run Freda Diesing School of Northwest Coast Art.

As a multi-sited ethnography of an art world, this book's mobilities and interdisciplinary narrative reflect and depend on this shuttling between places – movement that often mirrored the grounded cosmopolitanisms of many of the artists whose work I write about. Over time, my thinking about what it means to write from a settler position has shifted, and the chapters in this book reflect on what it means to be unsettled, to describe art as a sovereign act without demanding a redemptive conclusion. I do not present this book, however, as a decolonial text. My work is not community-initiated, and its research questions about the role of art in contemporary cultural politics are addressed to the discipline of anthropology. As a hybrid of ethnography and art criticism, this book contributes to the discourse and discursive value around specific art practices and works, and *their* interrogations of what decolonization looks and feels like.

Yet as a form of "speaking nearby"[21] such decolonial projects, this discourse is also meant to contribute to thinking in anthropology about how artists' critical intellectual

work is entangled with "our" theories of practice. Indeed, I also begin with Parnell's film because – like the multimedia artist Gerhard Richter for Paul Rabinow, or the painter Kweyetwemp Petyarre for Jennifer Biddle, or the fashion designer Virgil Ortiz for Jessica Metcalfe[22] – Luke Parnell is an artist to whom my thinking about contemporary art is greatly indebted. The second chapter of this book expands on this influence and its implications for collaboration in the anthropology of art, particularly in the small but influential world of Northwest Coast art.

To clarify how I am thinking about these practices, "Northwest Coast art" is a stylistic, cultural, and ideological category of aesthetics and value that refers to the cultural productions of Indigenous artists working on the Northwest Coast of North America. Formally, Northwest Coast art follows a vocabulary of formlines, ovoids, U-forms, and other recognizable visual elements codified during the mid-twentieth century by the non-Indigenous art historian Bill Holm, who drew on anthropologist Franz Boas's work on "primitive art."[23] In practice, this formalist story, which is still very much alive in connoisseurship, belies a great deal of fluidity, friction, and influence. Northwest Coast art has been extraordinarily generative both within and beyond anthropology as both an idea and an area of research.[24] Considering this category of art as a site of cultural production, I suggest how it comes to be both meaningful for and contested by contemporary Indigenous artists and inspires a great deal of cultural activity beyond the space of the gallery or museum. Tracing these connections and spaces, this book is an ethnographically informed description of a regional art world at a particular moment in history – post-Olympics, mid-reconciliation, pre–Enbridge Northern Gateway pipeline protest, and amidst other political and economic contexts that matter to how this art world feels and works.

Theoretically, this book most directly addresses the anthropology of art and its emphasis on what art *does* in expanded social worlds and across cosmopolitics. In the tradition of this subdiscipline, understanding contemporary art worlds, which might be labelled variously as "regional," "Indigenous," or even "peripheral," aesthetics must be related to politics across different social realms: legal, economic, cultural, and religious. This expanded focus, too, is an artifact of a particular research optic and historiography since the anthropology of art's emphasis on relations and insistence on holism is profoundly influenced by "other" ontologies of art as a category of action, as opposed to a Kantian aesthetic of distancing from the social.[25] For example, in many Indigenous cultures of display on the Northwest Coast, a mask, for instance, may also be a legal document, showing a claim to particular names or territories that are solidified and witnessed when the mask is danced at a feast or ceremony. This aesthetic is also articulated precisely in Charlotte Townsend-Gault's name for these relations: "art claims," a term whose meaning depends on local analogies between land claims and the work of art amidst unsettled treaty conditions. Indeed, the fact that almost no historic treaties were signed between Indigenous nations and settlers in British Columbia is frequently asserted by artists and theorists as a mark of this region's difference and dissidence.[26] I suggest that various conditions of repair across art worlds and resource regimes have constituted such "art claims" as thinkable regional imaginings of art's efficacy – in other words, they have become real. Working across this expanded space of the contemporary art

world, this book also traces multiple forms of human and non-human agency that cohere in Indigenous cultural politics and produce relations of repair. Why does it matter, for example, that a repatriation might bring back depleted fish stocks or how, paradoxically, a narrative of art's decay and decline could serve as a resource for contemporary art-making?

Transactions between different regimes of value in the art world also inform significant shifts in how "we" – and by this I mean academic anthropologists – apprehend the human in the midst of the imaginary of climate change, disaster, and toxic landscapes. This post-apocalyptic imaginary, as Métis anthropologist Zoe Todd points out, is not new for Indigenous peoples whose lives, lands, and bodies are disproportionately affected by the ongoing crisis of colonialism.[27] Tracing how art-led forms of protest insist on these connections and draw on other understandings of culture and nature, the chapters in this book also speak to a particular liveliness of things deeply informed by long histories of intercultural exchange and how they come to animate *and* upend what Elizabeth Povinelli has called "geontology." A form of power in late capitalism (or "late liberalism" in Povinelli's schema), geontology depends on the distinction between life and non-life amidst "competing claims of precarious natures and entangled existences."[28]

It is also no coincidence that Povinelli's theorizing of geontology's replacement of biopower comes out of her work with Karrabing, an experimental artist and film collective in Australia. Working with artists, whose self-consciousness about their practice and its material relations differentiates them from other kinds of analysts of the present, allows a particular collaborative framework for theorizing what Povinelli calls the "cramped space" of late liberal governance.[29]

Stemming from my own collaborative work with artists who are differently positioned but similarly committed to seeing the contradictions inherent in Canada's reliance on oil and petrochemicals, this book theorizes the aesthetics of repair, not as a space of redemption but as a generative frame that emerges from the art world for reorganizing political relations in the settler state, often working between the human and the non-human. Showing how artists consciously draw on recursive networks between art and anthropology, I emphasize how Indigenous regimes of value – bound up in gift economies of the potlatch, for instance – have had effects on institutional reciprocities far beyond the Northwest Coast, including Indigenous solidarities in China, notions of intellectual and cultural property, and corporate social responsibility programs in extractive industries. Tracing these slippages between different spaces of cultural production also joins recent challenges to contemporary art's presumed baseline secularism through the "re-enchantments" allowed by a particular optic of ecological crisis and what is often called the "new materialism" – the sense that things called "art" have never been purified of their ties to ritual efficacy and power.[30] Indeed, transcendence, traffic with Indigenous religiosity, and Protestant doctrines of work are but a few of Western art's connecting lineages to the Northwest Coast that I witnessed during my research. I elaborate upon these connections in the chapters that follow, adding some detail to a growing conversation about how religion and religious institutions still matter concretely to Northwest Coast art's circulation and meaning.[31]

This book speaks to the efficacies and "agency" of art, contributing to the theoretical discussion of how art is related to social action in a contemporary art world imbued with the local politics of Indigeneity and of the aesthetic terms of contemporary global art, including its networks, institutions, and markets. Building on anthropological approaches that see "art" as a social and material practice of signification[32] – indeed, as a meaning-making, relational category rather than as a self-evident classification for certain kinds of objects – I focus on how Northwest Coast art comes to mean things to people through the social relations of art worlds. Meaning emerges, takes shape and place, as particular structures of feeling – faith in art's power to do political things – become institutionalized through markets, art schools, and contexts of display.

For art historians, the terms of reference have been fundamentally and variously altered by what some critics writing in the first decade of the twenty-first century rendered as a "crisis."[33] One solution to the crisis in aesthetics has been to particularize through a turn to globalization and visual culture.[34] Such approaches displace the imperialist chronologies implied by "history" and instead, like cultural anthropology, take "culture" as their object, focusing on its visual and material traces, often in places and among artists previously excluded by art history's master narratives. To cite one example among many, art historian Chika Okeke-Agulu has written about "postcolonial modernism" in Nigeria since the 1960s as a parallel and self-conscious counter-movement to imperialist art histories and aesthetics.[35]

As a term like "postcolonial modernism" critically suggests, such global approaches generate new epochal terms and categories for describing aesthetic engagements with "alternative modernities."[36] Terms for describing the shift associated with global art may also be spatial, like the term "cosmopolitanism" when applied to Indigenous arts, or new renderings of the "marginal" or "peripheral" that recognize the existence of multiple art world centres beyond Paris and New York. These worlds are vividly captured in visual anthropologist Jennifer Biddle's concept of the "remote avant-garde," which emphasizes the disruptive, haptic Aboriginal aesthetics that are marginal to the art world's typical value currents and urban centres in Australia and beyond.[37] For Biddle, these bodily and performative practices – the foraging for recycled tin in traditional territories, the rendering of breast milk through shimmering fat applied to canvas – unsettle categories of the ceremonial and the theatrical, while signalling the settler state of emergency shaping the conditions of a desert aesthetic that thrives in the impossible conditions of humanitarian imperialist occupation. Crucially, these modes of working are neither representational nor abstract but offer "primary affective ontologies: ways of doing and being and sensing in Indigenous-specific, practice-based modalities of collaborative process and collective assemblage."[38] Seeing them in this way, as embodying a reciprocally produced remote avant-garde that exceeds demands for "high traditionalism" of the Dreaming-based acrylic paintings favoured by the art market, allows Biddle to trouble these taxonomies, arguing ultimately that "tradition is *revealed* through experimental practice" (emphasis mine).[39]

Similarly, as Jessica L. Horton has argued, a generation of Indigenous artists involved with the American Indian Movement articulate through their cosmopolitan movements an

"art for an undivided earth," troubling the presumed boundaries between the human and the non-human while remaining resolutely intercultural. This approach provides a much needed corrective to only valuing Indigenous art and its environments in primitivist ways as uncontaminated by modernity's many currents.[40] These terms of analysis for Indigenous contemporary art are, above all, attempts to shift the balance of power away from hegemonic art historical (and anthropological) discourses of singular aesthetic criteria and the subsequent writing of art history as a series of movements and stories of mastery that ostensibly held sway before the end of art.[41] Indeed, as Elizabeth Harney and Ruth Phillips argue, it is important not to lose sight of a critical approach to what categories of "global art" continue to occlude about the different, uneven, and fragmented ways that modernisms and modernities are taken up.[42]

An analogous and fragmented "remote avant-garde" and its revelatory affective catalysts are visible in the work of Indigenous artists that I analyse here. As I will argue, however, circulation is shaped by the particular practices of reciprocity on the Northwest Coast and by artists' distinct engagements with extractive modes of a neoliberal settler state and its logics of reconciliation. I hope to show that these logics and modes of objectification are both alienating and generative, and that their particular efficacy is inseparable from their mutually informed entanglements and complicities with this contemporary moment.

Thinking about art movements anthropologically, it is striking how epochal and spatial terms of art – modernism, postcolonial, decolonial, even "art" itself – are so easily displaced in moves that contend with non-Western art worlds and the epistemological violence of art history. As I shall expand throughout this book, the categories of "art," "modernism," and "the contemporary" are extremely meaningful to the Indigenous artists who live and work in what is now called British Columbia. It feels significant that art history's recognition of "global art" is concurrent and implicitly synonymous with its "crisis" and that, for art historians like Terry Smith, "the contemporary" is intimately tied to "Indigeneity." Such analogies suggest that there is much work to be done in unpacking *how* these discursive histories have been reconfigured as placeless critiques of crises but also how what happens in a particular place may, in fact, have effects on "art" far beyond the marginal locations of a regional art world. As Smith argues, contemporary art itself encompasses a contradictory array of aesthetic movements including relational aesthetics, nostalgic forms of modernism, and, of interest to me here, the alternative and decolonial modernities represented by Indigenous art – specifically, for Smith, by Aboriginal Australian painting.[43] Smith has articulated contemporary art's defining feature as being an "art to come," a worldly consciousness that is immanent in a sense of this work's potency to engage in a transcultural way.[44] This concept is an important anticipatory rendering of art's potential that resonates with many reflexively interwoven art and social movements on the Northwest Coast.

In attending closely to these complicities, I argue that much might be gained from seeing in this new moment of becoming global – or, more accurately, planetary[45] – a reparative move, continuous with contemporary criticism informed by literary theorist Eve Kosofsky Sedgwick's influential concept of reparative reading.[46] For Sedgwick, reparative reading produces different results from the (equally generative) paranoid reading favoured by

deconstructive theorists or readings that overwhelmingly account for the multiple entrapments of oppressive social structures. We might read Sedgwick's call for reparative reading as analogous to Eve Tuck's calls to suspend "damage-centered" approaches to research with Indigenous communities,[47] which risk over-inscribing injury rather than enacting resilience.

Expanding Sedgwick's textual reading to a broader account of art and ethics of care, Nelson astutely points out that the irreducibility of the artwork is what allows for this reading in the first place. "The whole point of reparative reading," she writes, "is that people derive sustenance in mysterious, creative, and unforeseeable ways from work not necessarily designed to give it, and that the transmission is non-transferable and ungovernable."[48] This intervention allows us to see what is at stake and made possible by a particular vision of art's autonomy, as well as the complexity of the reparative mode. As I will elaborate, this autonomy and *ungovernability*, threaded through by centuries of traffic between the Indigenous and the modern, is what Indigenous aesthetics and particular formalist commitments to repair – its strategies and mediums – enact on the Northwest Coast.

In other words, in proposing aesthetics of repair as a concept, I am not suggesting that contemporary Indigenous art is somehow a salve to the ruptures of modernity; though, as I shall argue, a re-primitivizing desire for redemption through Indigeneity often animates criticism and the wish for relations to be restored through transitional justice and other reparative means. Instead, my notion of an aesthetics of repair is meant to hold in tension trauma, resilience, crises, critiques, and new locations of the contemporary avant-garde *without* turning to ontological incommensurability – the argument that Indigenous aesthetics are untranslatable or separable from cosmopolitanism and intercultural exchange. Indeed, one of the main claims of this book is that these forms of repair are often profoundly intercultural, enacting relations of repair differently depending on their publics.

Repair, as a metaphor for mending that implies accountability, is meant to capture these current conditions and their various contradictions and multiplicities: the revealed inadequacies of Western ways of knowing, the displacement of colonial knowledge by decolonizing and decolonial art practices, the anxiety and unease with which art history attempts to accommodate other reckonings of ends and beginnings of art. At the same time, repair also indexes the specific location of British Columbia and its ongoing treaty process and anti-pipeline protests, the recent Truth and Reconciliation Commission, and other political modes of reckoning with the past as forms of "un-settling" and perhaps, more cynically, "re-settling" what was uprooted in the violence of settler colonial conquest and, equally, what is unceded.

In thinking about repair, I am interested in the ways that aesthetic judgment is applied to beings and belongings – the phrasing that Musqueam curator and scholar Jordan Wilson has proposed for the things variously called objects, artifacts, and Indigenous cultural properties[49] – that are recontextualized as artwork.[50] I largely follow this usage of beings and belongings but make some exceptions when I believe it matters to signal the categories of "art," "artifact," and "collections" to talk about how these categories themselves may also be lively, intercultural, and change over time.

In attending to reparative aesthetics, I am also reflecting on how terms of art criticism have shifted towards what Dylan Robinson calls "functional ontologies"[51] – a sense of art's efficacy that draws on Indigenous idioms of careful contextualized use and purpose rather than the aestheticizing and decontextualizing language of art. Although this book does not focus overtly on the intertwined histories of slavery, imperialism, and settler colonialism, anthropologist Deborah Thomas's political theory of "repair," which is grounded in plantation-structured violence, is important as a related conceptualization.[52] Focusing on the affective dimensions of sovereignty and bringing the body back in to an analysis of political process in the Caribbean, Thomas argues that repair marks a shift from reparations to insist on bodily practice. "But where reparation seeks justice through the naming of names, the exposure of public secrets, and the articulation of chains of causality, repair looks for something else," she writes. "It demands an active listening, a mutual recognizing, an acknowledging of complicity at all levels – behavioral evidence of profound transformations that are ongoing."[53] Likewise, the aesthetics of repair that I document run alongside reconciliation as a state process of reckoning with these causal chains, but it cannot be reduced to these forms.

What is so striking about the works and lives that I represent in this book is the ways in which artists and other cultural producers *knowingly* entangle their practices with multiple regimes of value and aesthetics.[54] This approach is visible, for instance, in the practice of young artists embracing a connoisseurship narrative of artistic decline and a judgment of "badness" as a way of articulating cultural loss and maintaining a boundary of what becomes legible as art (see chapter two). Part of the work of anthropological analysis, then, is to understand how things *become* art situationally and what this category admits and excludes in its traffic between different regimes of value. Anthropologist Fred Myers's ethnographic study of Pintupi Aboriginal painting and its art worlds articulates both an argument and a paradigm for navigating these different forms of agency.[55] Showing how value is created for Pintupi painting amidst its local histories and cultural protocols as well as those of the international art world in Sydney and New York, Myers approaches art as a material, social, and signifying practice.[56] Assessing multiple contexts and meanings of circulation, Myers attends to what people do and say to *make* objects play as art, revealing how agency, political and otherwise, is emergent in this process.

Working from Indigenous imaginaries of art also productively disrupts the strict "methodological philistinism" that anthropologist Alfred Gell insisted upon for understanding art's enchantments as social relations.[57] Many anthropologists working after this theory have noted Gell's anti-aesthetic stance and its failure to define, let alone account for, the ontological dimensions of *either* art or agency.[58] It is perhaps ironic, then, that Gell's theory continues to be influential in discussions of distributed agency in the kinds of social art practice that have emerged in the past two decades.[59] Indeed, his provocative definition of contemporary art as "traps" – animate entities that forcefully engage or capture the viewer – anticipates and prefigures many of the new materialisms in thinking about art that also attend to distributed forms of agency and environmental knowledge.[60] I do wonder, though, how this prefiguring goes beyond mere intellectual history. Gell's heuristic may in fact undo

itself, allowing us to apprehend the kinds of ontological efficacy that Tim Ingold has proposed for an "anthropology *with* art"[61] that attends closely to art's status as living work in the process of becoming.[62]

Building on this attention to ontologies of art "after relations,"[63] I suggest that attending to the slippages between religious, political, and legal worlds in art's definitions and practices allows us to question the secular modernities bound up with Northwest Coast art and to get at how multiple forms of agency *become* possible.[64] I elaborate on such agencies of art, broadly construed, to map artists' understandings of themselves and their work, the efficacies of objects as they circulate under particular political-economic conditions, and the broader political, religious, and cultural stakes of this circulation.

The chapters of this book are arranged chronologically to follow my process of research and thinking, moving from the archive into galleries, studios, and art schools, and the particular aesthetics of repair that are visible from these different locations. Weaving between more traditional ethnographic vignettes and the kind of close-to-the-work analysis offered by conventions of art criticism, each chapter articulates a different strategy and medium for repair: re-enchantment, collaboration, exhibition, pedagogy, performance, and preservation. Together, they present a composite image of this regional art world and the continued relevance of its histories in contemporary practice.

The first two chapters provide two different contextual framings for the idea of Northwest Coast art and how it has shaped art and social practice. "Re-enchanting Repair" opens with a particular case of art's efficacy: the return of the oolichan – small oily fish also known as "candlefish" – to the Skeena River following the repatriation of the G'psgolox totem pole to the Haisla Nation in Kitimat, British Columbia, from a museum in Stockholm. Against the particular histories of this return and its efficacies in relation to museum protocols, this chapter also provides historical background on the Northwest Coast art market as a regional phenomenon that has been shaped by Native social welfare programs and property regimes governed by church and state, particularly through the efforts of the Methodist missionary George Raley. It tracks the discursive history of framing art as a resource for the present and the future, and considers overlap between art and other renewable and non-renewable resources since the 1920s, as well as the political stakes for anthropologists, art historians, and artists to regard this period of Northwest Coast art as a "Dark Age."

The second chapter, "Finding Repair," is a methodological reflection on collaborative practice between art and anthropology, stemming from an engagement with Luke Parnell's work and its reckoning with Northwest Coast art history. Considering Parnell's concept of "bilateralism" – a formalist metaphor of secrecy and revelation – this chapter provides a grounding for the terms and debates of Northwest Coast contemporary art as social practice. I focus on how anxieties are articulated around participatory and reparative turns, considering how activism and social practice overlap with anthropological debates around ethics of care in fieldwork.

The book's middle chapters are more ethnographically grounded accounts of two different art world locations: a long-running popular exhibition of contemporary Indigenous art and an art school, the Freda Diesing School of Northwest Coast Art. Chapter three, "Across the

Beat Nation," analyses the exhibition *Beat Nation: Art, Hip Hop, and Aboriginal Culture*, a show that uses the frame of hip hop to explore a contemporary pan-Indigenous artistic practice and urban culture in Canada. Since its first grassroots iteration in 2009 at an artist-run centre in Vancouver, *Beat Nation* has travelled via a web-based project and two major exhibitions in Vancouver and Toronto, serving as a locus for major gatherings of Indigenous intellectuals in both cities, including exhibition-based programming. As a breakthrough moment in contemporary Indigenous curatorial practice, *Beat Nation* activated transnational Indigenous networks around art. This chapter considers the ways in which "methodologies of visiting" – artist and scholar Dylan Miner's term for a decolonizing research practice – are shared between anthropology and contemporary Indigenous art.

Chapter four, "Cultural Resources and the Art/Work of Repair at the Freda Diesing School," travels to the Freda Diesing School of Northwest Coast Art in Terrace, British Columbia, which is a hub for artists as well as for those involved in mining and pipeline projects in the region. The Native-run carving school trains its students – a mix of high school graduates and Elders – in painting, carving, and design, with the goal of appealing to the Vancouver-based market "down South" while contributing to community-building projects and political activism in the North. The school's faculty and founders were trained at 'Ksan, the first Native-run art school in the province, and like 'Ksan, Freda Diesing is not without controversy: three adjacent First Nations that have relationships with the school's location have long histories of intermarriage and intense competition. Moreover, the Northern style taught at 'Ksan has been regarded by some collectors and art historians as suspect for its eclectic mix of design motifs, concerns that inform choices about style at Freda Diesing. This chapter addresses controversies around "Northern style," as well as an emergent traditionalism in the region, as related to other anxieties about extraction and change in the North/South art and resource nexus. Drawing on students' concerns about belonging and community obligations, this chapter explores how the art world's expectations of stylistic purity are mediated in remote places, amidst long histories of cultural and material exchange.

The book's final two chapters return to art-as-resource to take up the ends and afterlives of the Truth and Reconciliation Commission and its ongoing reverberations across art worlds. Chapter five, "Copper and the Conduit of Shame," chronicles a performance and powerful shaming ritual carried out by the Kwakwaka'wakw artist Beau Dick in the summer of 2014, in which Dick broke an old copper – a ceremonial and legal object of value – on Parliament Hill in Ottawa. The copper, which had been acquired from the Haida Nation, was called *Taaw*, meaning "oil," and this chapter argues that Dick's performance animated both long-standing intercultural networks and contemporary resource economies while participating in the broader Idle No More social movement. At the same time, I consider what the frame of "art" does in materializing shame that other concurrent and spectacular mobilizations of public shame – specifically, the Truth and Reconciliation Commission on the state- and church-led violence perpetrated against students in Indian residential schools – do not. This chapter also considers how some political art draws upon artists' understandings of the magical capacities of objects to build potlatch-like moral economies.

The concluding chapter, "Transitional Properties of Art and Repair," considers the implications of including visual art as a form of survivor testimony in the TRC, expanding on intersections between cultural and legal regimes of value as art is transformed into testimony. Drawing on the TRC's open call, two public exhibitions of survivor art, and the TRC's material archive, this chapter asks how different kinds of testimony are made commensurable as proof of cultural loss and what the consequences of doing so may be. I also return to the concept of repair to ask how these properties of objects disrupt a category of assemblages often considered to be stable: the collection of a museum. How does an emphasis on repair shift the meanings of objects on display? In the wake of the TRC, this chapter concludes by signalling ongoing social and political change in British Columbia to assert how these contexts for art and culture continue to shape the possibilities – and limits – of repair.

CHAPTER ONE

Re-enchanting Repair: Teaching from the "Dark Age" of Northwest Coast Art

I begin with the case of the 2006 repatriation of a 145-year-old mortuary pole, known as the G'psgolox pole, to the Haisla people in Kitimat, British Columbia. In a great deal of museological and cultural property literature, this repatriation from an ethnographic museum in Stockholm, Sweden, is regarded as a successful one. Indeed, it was one of the first voluntary repatriations from a European museum to a North American Indigenous community.

The story goes like this: In 1872, a nine-metre pole was commissioned[1] by Chief G'psgolox to mark an encounter that he had with the spirit Tsooda (who is at the top of the pole) after he had lost his wife and child in a smallpox epidemic. The pole was raised at Misk'usa, which was a seasonally occupied site for the Haisla. In 1929, at a moment when the Haisla were not at Misk'usa, it was cut down by the British Columbian Swedish Consul, Olaf Hansson, and sent to Sweden as a gift to the Museum of Ethnography. The pole was greatly missed, but no one knew where it was until the 1980s. In 1991, a delegation of Haisla travelled to the museum to begin repatriation talks that acknowledged the theft but also raised difficult questions about preservation and what would happen to the pole when it returned home. In 2000, Haisla artists, including Henry Robertson, a descendant of one of the original carvers of the G'psgolox, carved two replica poles, one of which was sent to the museum in Sweden and the other designated to be raised at the original site. In 2006, the original G'psgolox pole was returned to the Haisla and installed at the City Centre Mall in Kitimat to await the building of a cultural centre to permanently house it.[2]

This repatriation is also significant for the prominent role visual media played in facilitating returns. The late Métis filmmaker Gil Cardinal's *Totem: The Return of the G'psgolox Pole* (2003; Figure 1.1) eloquently represented the multiplicity of Haisla and museum professional perspectives on preservation. Indeed, one of the reasons that this repatriation case has been so central to the literature on cultural property is that it drew attention to the multiple and often conflicting understandings of objects and their agency, and to the

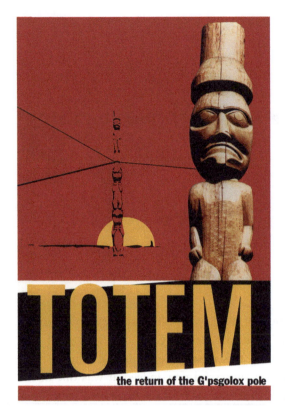

Figure 1.1. Cover for the film *Totem: The Return of the G'psgolox Pole* (2003), directed by Gil Cardinal. Image courtesy of the National Film Board of Canada.

relationships between the past and the future in a single community, with many Haisla articulating their belief that the repatriated totem pole should be left outside to return to the earth and others wanting to preserve it for future generations in a climate-controlled cultural centre. Cardinal's film catalysed a great deal of media coverage and public outrage about the pole as stolen cultural property that arguably contributed to the willingness of Ecotrust and other Canadian organizations to finance the return and the carving of two replica poles, one for the museum and one to stay outside at Misk'usa, the pole's original site.

As an undergraduate student in museum anthropology, I was moved by this story of loss and repair, and it deeply influenced my thinking about the material practices of museums. Working in the conservation lab at the museum, I and my fellow students had watched Cardinal's film with a sense of moral outrage, first at the pole's removal and then at the delays in its repatriation. In seminar discussions, we carefully considered the conflicts within the community, too, between those who wanted the totem pole to decay outside and those who wanted it to be preserved in a museum for future generations; but both possibilities, it seemed to me, depended on the pole's return to Haisla territory.[3]

Later, watching the news footage of the pole's belated homecoming, I felt a sense of justice: through painstaking collaboration between Haisla activists and the good museum professionals, a righteous critical museology had triumphed over the backward

transubstantiations of missionaries, museum looters, and colonial officials, who had tried to disfigure this animate entity – properly, an ancestor – into a mere ethnographic object that could just be cut down and removed to Europe.[4]

This story is, of course, more complicated, both in its moment and its afterlife. While doing research on objects made in residential schools, I was surprised, for example, to find archival documents that suggested that some of the moral support and pressure for repatriation had come from what seemed to me an unlikely source: the United Church of Canada. In response to pressure by First Nations members of different local congregations on church officials to make tangible reparations, the church had made its official apology to Indigenous peoples in 1986. The church's support for this repatriation suggests that the apology was taken seriously: in accordance with both ethical practice and traditional protocol, such words needed to be solidified by things.[5] The church followed through during the repatriation process, voicing its support for the repatriation as a matter of policy.[6] Clearly, the ceremonial frames of references for the transfer of objects were multiple and stemmed from unlikely sources beyond Kitimat and beyond the museum.

Through these transactions involved in the pole's return, the recurrent imagery of loss and repair is striking. For example, on the occasion of the return, Gerald Amos, former chief councillor of the Haisla Nation, remembered being part of the original delegation who went to visit the pole at the museum and noted that "the symbolism we saw in the steel yoke around the neck of the totem pole … was heart-wrenching." He went on to say: "And now that yoke is off. That symbolism shouldn't be lost on anyone. What this shows is that we can reconstruct this relationship that got off to such a bad start."[7]

In this narration of return, the removal of this yoke marks a transition in G'psgolox's museological life. And it is here that the story shifts. In 2013, I was accompanying students at the Freda Diesing School of Northwest Coast Art on a fieldtrip to Kitimat when the G'psgolox inserted itself once again into a story of renewal. We were eating in the City Centre Mall food court, the temporary climate-controlled site for the G'psgolox as well as the future site of a "Friendship Pole" carved from a log donated by a logging company, when one of the teachers revealed a postscript to the story: since the pole's return to the community, the oolichan – small oily fish – had *also* returned to their spawning grounds near Kitimat, bringing back an important natural and cultural resource to the waters. It seems that both a being and a belonging in its "afterlife," post-repatriation, the G'psgolox had come into relationship with another source of the Haisla's cultural wealth, the species of smelt known as "oolichan" or "candlefish," which are important to and endangered in several ecosystems in the Pacific Northwest.

What to make of this parallel return and its ecological stakes? And how to understand such object lessons as part of a much longer horizon of museological repair that works beyond the museum and across different frames of enchantment and ceremonial life? This chapter introduces object transformations, returns, and the relations between missionaries and museums to suggest some deeper resonances between these forms of repair. Like many beings and belongings, oolichan are very significant as forms of sustenance for the Haisla and for First Nations up and down the coast. The seasonal return of the oolichan to spawn

in rivers marks the end of a long, difficult winter, so much so that they are also called *saak* ("saviour fish" or "salvation fish") in the Nisga'a language. This abundance is also strikingly intercultural. The reason the oolichan are also called candlefish is that they are so oily that you can dry them, insert a wick, and burn them as you would a candle. The trade routes from the interior to the coast are also known colloquially as "grease trails," referring to the importance of oolichan grease in intercultural exchange. Meriwether Lewis and William Clark, those would-be "discoverers" of the already-inhabited Columbia River, documented oolichan as "lussious [sic] fish,"[8] remarking on their oiliness and robust nutrition. Even the scientific name for these fish, *Thaleichthys pacificus*, comes from the Greek word *Thaleia*, meaning richness or abundance. In these ways, like other entities that return, oolichan are an important form of wealth and not only in the cultural registers of the Haisla.

Scientists, too, are struck by the "saviour" qualities of the fish, referring reverently to the migration patterns of these small beings as "mysterious."[9] Until very recently, non-commercially relevant fish were not studied in the same way as species such as salmon and halibut, partly because their more-than-human relations return other forms of value, beyond and between the commercial.[10] Attending to these forms of value shifts us helpfully from causal relationships – return of pole equals return of fish – to less "settled" ones that exist between objects that exert agency alongside one another. It is such relationships that are invoked in the statement that the return of the pole enabled the return of the fish – a story of risk and resilience.

These connections between pole and oolichan are an example of what Zoe Todd has named "fish pluralities"[11] in Indigenous contexts. They provide a space for thinking about the political in more-than-human assemblages that reckon with fish as kin, including the extended timescales of repatriation. My argument here is that attending to the afterlives of repatriated belongings allows us to see the "theft-return-renewal" narrative as really a rather short disruption of much longer histories of being and belonging, disrupting the centrality of the museum as a site of cultural remediation.

In placing the G'psgolox pole in conversation with our current ways of talking about environmental change and extraction, I also mean to unsettle the repatriation stories in which an object's "social life" – and the process of repair itself – ends with return. As Cara Krmpotich has argued in relation to the return of Haida ancestors, the kin-making function of repatriation as an ongoing process is central to its meanings in communities and museums.[12] This idea is also the spirit in which I use the term "afterlife" – to extend the life story told by the cultural property case study.[13] More precisely, I am suggesting that we hear in these stories of resources and returns an imaginary of repair and, perhaps, a form of reconciliation that is more than human. By bringing the pole into the same space of meaning as the fish, with all of its frictions and failures, the Haisla are also giving voice to an important cultural loss in a way that recognizes wealth and resilience in the *longue durée*, which is, as for scientists, more than a bit mysterious. "My first experience actually seeing traditional carving in situ was fishing eulachon," the Haisla artist Lyle Wilson writes. "I saw graveyard memorials (ah-aluuch-tin): grey, weather-beaten and somewhat moss-covered, but very impressive in their natural state and site. Although I didn't know it at the time, it was part of the beginning of my life-long interest in Haisla culture."[14]

These returns also raise materialist questions in the political-economic sense. There are striking parallels between the forms of settler forgetfulness in the moment of G'psgolox's theft – specifically, the Department of Indian Affairs granting permission to the Swedish ethnographer for the pole's removal based on the premise that the site could not be inhabited by a "dying race" and therefore its cultural properties were free for the taking. Far from being over, the afterlife of the G'psgolox is bringing these narratives into public consciousness – fish, poles, and oil brought into the same space of visibility. Their return signals an ecological resilience as well as a cultural one, questions of routes that are far from settled even though the pole has returned home.

Tracing the economic frames of Northwest Coast art, I hope to first familiarize readers with some of the objects, theories, and histories that have informed the story of this art world; and second, to foreground some less familiar actors in these stories – missionaries and religious institutions – in order to re-enchant return. By arguing for return's re-enchantment, I do not mean to minimize the material stakes of repatriation but instead to broaden the scope of analysis for "object transformations" in which missionaries moved religious objects into museums, ostensibly to prevent their continued use in communities and also to contribute to burgeoning national heritage collecting. The well-documented paradox of this sort of collecting is that it simultaneously appears to neutralize the threat of the sacredness of these belongings – they are disenchanted or at least contained in museums – while also marking them as threatening, risky, and dangerous to new forms of social and economic order – specifically, market relations that are not based on ceremonialism – and Christian religious practice. Yet their power remains.

In taking seriously the multiple narratives of loss and return that are tied to these belongings, I question a stubborn commitment to "methodological philistinism"[15] in the anthropology of art that remains sceptical about the power of these relations. As I described in the introduction, the polemical concept of methodological philistinism is Alfred Gell's, and it describes a scepticism around the effects of art that denaturalizes aesthetic values in order to constitute the anthropology of art as critical project. Explicitly, Gell's call for philistinism is animated by the anthropology of religion's separation from theology – in other words, by its methodological suspension of questions of belief. More recently, the anthropology of religion has turned increasingly towards questions of materiality in assemblages of belief, practices, and things that reintroduce theological questions about the efficacy of objects as they circulate. As Pamela Klassen argues in her critical analysis of the life of British Columbia–based Anglican missionary Frederick du Vernet, telling more complex stories about missionaries and their intercultural forays between spiritual and material mediums can be offered in a spirit of reconciliation.[16] Importantly, Klassen's work on the missionary encounter suggests how enchanted readings can be reparative, attending to the complex and transcultural ways that art's agency is felt, exceeding the settler colonial logics of forced removal. In attending to these aspects of enchantment and faith – forms of world-making that are perhaps better apprehended through objects than texts – I make visible some under-examined aspects of the Northwest Coast art world while arguing that these forms of enchanted object transformation persist in contemporary cultural repertoires of resistance.

In doing so, I return to the period of Northwest Coast art before 1967, the date that is often agreed upon as the moment Indigenous belongings from this region become both "modern" and "art" rather than ethnographic curios.[17] I argue that this art world's existence – its institutional support, its cultural policy, and its ties to resource economies and revolution – is joined to syncretic forms and institutions of Christianity. In this way, this chapter addresses Northwest Coast art's discursive production since the early twentieth century in anthropological and art historical texts. This history is presented in conversation with the writings of Reverend George H. Raley, an early-twentieth-century social reformer who focused some of his efforts on the renewal of Northwest Coast art and Indigenous industry. Like that of most missionaries, Raley's reformist efforts, however sincere and complex, arguably participated in that cultural alchemy of transforming ethnographic curios and so-called heathen artifacts into objects of national patrimony that could promote Protestant industriousness and moral hygiene. Asking how Northwest Coast objects *became* contemporary as cultural resources – examining some of the Protestant logics that underwrote the revival of Northwest Coast art at mid-century – I reconsider the re-enchantment of contemporary art and its traffic with the spiritual realm. This chapter shows how the missionary encounter is residual in regional anthropology and art history, and how it has crystallized in debates around cultural patrimony that were important aspects of the Northwest Coast renaissance in the 1960s. I argue that these alternate routes of resources are of continued relevance in understanding cultural dynamics for present-day negotiations around art, injury, and repair. *How* we tell these stories continues to shape how artists working in their wake relate to them.

RESOURCES AND RETURNS

At the entrance to the visible storage in the Museum of Anthropology (MOA), a curious figure stands in a case (Figure 1.2). Carved in wood, it gazes to the heavens, holding a bowl in one hand and making a gesture of blessing with the other. Its facial features are smoothly rendered, as on a nineteenth-century Tsimshian portrait mask, and feathered wings stretch out from its back. But rather than suggesting transformation, the solid nature of the large-scale carving – unlike many such figures, there are no moving parts – expresses a finality of form. It looks unmistakably like an angel. And indeed it is, called *Txaldzap'am nagyeda laxa* (carved angel) in the Tsimshian language and attributed to the hand of the master Tsimshian carver Frederick Alexcee (c. 1886).[18]

Before its life as harbinger of object lessons, this angel was a baptismal font in a church at Lax Kw'alaams, a Hudson's Bay trading post known formerly as Fort Simpson (1834–80) and then Port Simpson. Following the arrival and departure of the Anglican missionary William Duncan in the 1850s, the Reverend Thomas Crosby introduced Methodism to the community in 1874, where it took hold, articulating with Indigenous spiritual practices and beliefs, often through Native evangelists' proselytizing.[19] Tsimshian people in the village strongly resisted colonial policies and practices, extending pre-existing forms of social

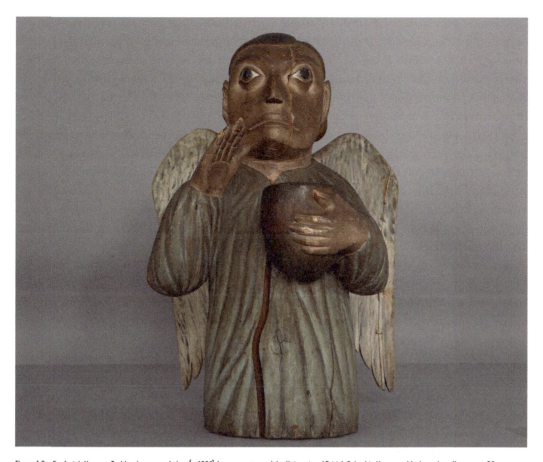

Figure 1.2. Frederick Alexcee, *Txaldzap'am nagyeda laxa* (c. 1886). Image courtesy of the University of British Columbia Museum of Anthropology, Vancouver, BC.

and legal organization into new Christianized institutions such as the Native Brotherhood of British Columbia, founded in 1931 to defend the rights of First Nations, particularly fishing rights, in the province.[20] As Susan Neylan documents in her history of Tsimshian Christianity, throughout the nineteenth and early twentieth century Indigenous Christians asserted their cultural practices amidst large-scale collecting programs carried out on behalf of church and state, both of which were intended to extinguish non-Christian Indigenous ceremonialism through the removal of its tangible referents.[21]

For these reasons, the community of Lax Kw'alaams figures prominently in the literature on Native Christianity on the coast and also in regional accounts of the kinds of transformations that occur when objects are collected by missionaries and removed to museums. Such accounts generally emphasize First Nations cultural continuity and agency amidst great devastation and loss wrought by the missionary encounter.[22] For instance, in her analysis of Duncan and Crosby's collecting activities at Metlakatla and Port Simpson, Joanne MacDonald suggests that both missionaries were able to acquire crest objects – distinguished from the other prestigious items by their public ceremonial and legal

functions – because some Tsimshian people regarded the exchange as a transfer of power that would attract wealth, as in the traditional case of a new chief giving away the possessions of a predecessor.[23] Likewise, the missionaries' decision to burn some so-called heathen objects may not have reduced such objects' power to access the supernatural world.[24] In these cases, a cultural inclination towards particular kinds of exchange that would testify to power shaped both Native peoples' interactions with missionaries and the collections of objects that were sent to museums. In her documentation of the Methodist missionary R.W. Large's collections made in Heiltsuk territory and bound for the Royal Ontario Museum in Toronto, art historian Martha Black observes that Large mostly collected tools, fishing equipment, and hunting gear as object lessons of Heiltsuk culture prior to technological advances brought by modernity and Christian conversion[25] – a collection that displayed evidence of conversion both through its pre-Christian contents and through the successful act of removal itself.

Yet according to missionary records, prior to its removal from Lax Kw'alaams by the Methodist missionary Reverend George Henry Raley – a key player in the story of revelation and revolution I tell in this chapter – Alexcee's baptismal font had been in storage in the community because its wide eyes and powerful stature scared the village children too much to be displayed in church. The angel is a syncretic object as its intended function was interrupted before its transformation into ethnological curio or specimen.[26] Its arresting depiction of Christian imagery with Tsimshian formal conventions is a reminder of these acts of exchange and of how local interpretations of objects – as frightening figure rather than reverent spirit, for instance – exceed spiritual and colonial meanings as evidence for conversion. In such situations, statements about syncretism or even cultural continuity, however much they articulate Indigenous agency and assert the ways in which traditional cultural practices defied colonialism, fall short of explaining the complexity of missionary collecting and do not address its central paradox, as articulated by Kwakwaka'wakw scholar Gloria Cranmer Webster more than twenty years ago: how did missionaries simultaneously devalue and revere heathen and syncretic objects such that they could be burned and collected?[27]

The social life of Alexcee's carving, and what art historian Kaitlin McCormick calls the artist's "entangled gaze" between Methodism and Tsimshian *naxnox* or ceremonial beings, hints at these complexities of motivation, interaction, and collection.[28] The meanings of this object also multiply if we consider the contemporary display of Alexcee's carved angel as an object of knowledge and power at a university-run anthropology museum via the Reverend Raley's activities at Lax Kw'alaams and, later, through his role as principal of the Coqualeetza Residential School. Raley's collection was purchased by the MOA in 1957, using funds provided by the forestry industrialist H.R. Macmillan to keep British Columbia's cultural patrimony inside the province. This history reveals an exchange of cultural and natural resources, and points to the slippages between both as preservation and capital intersect in the space of the museum.

I want to be very clear that, in tracing these connections, I am not making an argument about causality or origins. Instead, these relations and their cultural logics illuminate

how and why missionaries who set out to destroy traditional First Nations lifeways also contributed to the revival of art and culture as patrimony at mid-century and how they inflected Northwest Coast anthropology and art history along the way – a mode of writing between histories and cultural analysis that I am undertaking to re-enchant repair. Drawing on the Marxist tradition of cultural studies, anthropologist Renato Rosaldo has described his method of using history in the service of cultural analysis as a continual asking of "what was at stake?" in which "social life – viewed as a forward-looking struggle among alternative courses of action that certain structures both enable and limit – begins to emerge, not as the inevitable playing out of underlying principles, but rather as a complex interplay of political processes."[29] Cultural analysis, then, is about recognizing the possibilities and limits of a particular historical encounter and the ways in which such conditions continue to shape social life. This kind of cultural analysis is also different from ethnohistory, which is resolutely grounded in the local and the particular. Tracking between the two, as they are played out in colonial repositories, documents, and objects, allows us to see how a particular way of knowing – about the assemblage called "Northwest Coast art," for instance – comes to exert its influence on the world in tangible ways. This sort of history is also sensitive to the ways in which these discourses may become part of a cultural repertoire of resistance, creating the conditions and affinities from which social movements can emerge.[30]

COLLECTING THE COAST: 1880–1929

Culture area mappings of the late-nineteenth-century Northwest Coast have exerted considerable influence on anthropological theory. This legacy is visible in North American scholarship through the work of Franz Boas and fellow Americanists, including Edward Sapir and Ruth Benedict, and also in French *ethnologie* via Claude Lévi-Strauss's and Marcel Mauss's respective reinterpretations of Boas's data, with Mauss's *Essai sur le don* inspiring a range of work on the potlatch as a "total social fact."[31] To focus on the Americanist tradition, Boas's work for the Jesup North Pacific Expedition (1897–1902), sponsored by the American Museum of Natural History (AMNH), was crucial to the production of anthropological knowledge.[32] Indeed, this material legacy is one of the lasting effects of the period of anthropology known as the "Museum Age," roughly from 1880 until 1920 – a period that overlaps with the "Golden Age" of Northwest Coast collecting.[33] Historian Douglas Cole has described this era in competitive terms as a rough-and-tumble "scramble" for artifacts,[34] in which both professional and amateur anthropologists, enabled by the funding structures of the American "Gilded Age," vied to remove objects from Native communities on the coast to museums in New York, Chicago, and Washington, DC. In their new spaces, these objects would become tangible referents of anthropological knowledge. Although Cole has made the persuasive case that careful analysis at these institutions was outpaced by the thrill of accumulation, it is evident in the analytical legacy of the coast that artifacts – and later, "art" – were the matter out of which theories of cultural diffusion, exchange, and kinship were made.

Cole makes the provocative point that this "Golden Age" was also simultaneously a period of decline, not only for Native communities but also for collectors, as old objects became scarcer, and expedition funding was more difficult to secure during the First World War and economic depression. In a parallel narrative of decline, anthropologist Ira Jacknis has argued that Boas's progressive disillusionment with the museological method of anthropology and his eventual departure from the AMNH may be read as a kind of "swan song" for the centrality of objects in anthropological theory-making.[35]

Yet neither the claims of salvage anthropology, in which cultural belongings are transformed into museological specimens, nor the historical assessment of this period as one of frenetic energy followed by sharp decline quite capture the complexity of these transitions. As anthropologist Aaron Glass has argued, the late-nineteenth-century Northwest Coast, as the referent of salvage projects and the site of manic collecting, was not in fact a static repository of authentic Native culture but rather a space of extreme social upheaval, since an influx of wealth from trade with Euro-American settlers intensified the potlatch system, affecting both Indigenous social structures and decorative motifs in many communities.[36] Additionally, tracing the sharp decline of the "Museum Age" to 1920 makes more sense in relation to American institutions than to Canadian ones. As Cole points out, Canadian museums had come late to collecting on the coast, but a burgeoning patriotism and emphasis on the arts in the service of nationalism led to a secondary scramble to keep artifacts *inside* the country; this project had unexpected effects on the market north of the forty-ninth parallel, as "authentic" Golden Age objects and their ethnological reproductions, commissioned by Boas and others, were unobtainable. As a result, a parallel regime of collecting – adjacent to museum-based practices and carried out by artists, missionaries, and social reformers – becomes visible in this period if we focus our attention away from the "masterworks" of the late-nineteenth-century scramble. This focus also complicates narratives of "decline" and problematizes the equally reductive historiographies of the renaissance at mid-century by showing that other kinds of cultural production, including tourist objects and teaching items made in residential schools, were occurring in tandem with the so-called Museum Age.

Moreover, long before the maritime fur trade, object exchange in Northwest Coast societies had been based upon what Annette Weiner has called "keeping-while-giving,"[37] a mode of exchange by which truly inalienable things are preserved *through* circulation. This form of agency may be recognized in the kind of objects put on the market, whose formal ambiguity resisted full appropriation thus limiting knowledge production,[38] and in cultural production itself that balanced secrecy and revelation in resisting colonial impositions. For instance, the supposed "last Tlingit potlatch" in Alaska – a public and carefully orchestrated event that performed the abandonment of traditional cultural practices in light of the American potlatch ban – was actually highly subversive. As Megan Smetzer has argued, during this performance, objects such as the brilliantly beaded octopus bags – so-named for their tentacle-like hanging tabs – that circulated widely through Native trade networks, and which colonial officials and missionaries regarded as innocuous craft items, were danced alongside traditional regalia, enacting an equivalence between them that could

deflect colonial scrutiny.[39] Significantly, this potlatch was also deliberately memorialized in photographs, as Tlingit turned cultural protocols of amplifying status through inventories of their possessions to the task of asserting power in the face of colonial oppression.[40] In these ways, Native epistemologies of object agency are visible in these encounters, articulating how Indigenous mediators interacted in the "Golden Age" within and against the paradigm of salvage.[41]

SURREALIST IMAGINARIES

Following the period of anthropologically mediated "captured heritage,"[42] other Northwest Coast objects were exchanged during the first half of the twentieth century across networks of fine art. These market-based forms of exchange were also entangled with knowledge production, informing structuralist *ethnologie* and the critical imagination of the marvellous in the everyday proposed by the Surrealists. French anthropologist Claude Lévi-Strauss brought these two contexts of collecting together in his classic work *The Way of the Masks*, which moves from the author's encounter with the hall of Northwest Coast art at the AMNH in New York towards his theory of universal structural opposites. In his writing, Lévi-Strauss drew especially on Boas's analysis of the "split representation" that characterizes Northwest Coast design, a formal technique in which the figure is represented through a frontal view that joins two opposing profile views along a central axis, creating multidimensionality for even two-dimensional representations.[43]

Artists and would-be revolutionaries who identified as Surrealists, including André Breton, Max Ernst, and Kurt Seligmann, were also fascinated by this material world, in particular with the links they perceived between "primitive" art and the unconscious and the potentially revolutionary anti-colonialism embodied by all Indigenous arts. This transformative potential – the power of "primitive art" to reshape consciousness and social relations – is represented in the famous Surrealist map of the world (Figure 1.3), on which Tsimshian, Haida, and Tlingit territories in British Columbia and Alaska figure prominently as part of the map's inversion of colonial power and centre-periphery relations.[44]

During the Second World War, Lévi-Strauss lived in exile in New York, along with Breton and Ernst, a time that solidified the role of the Northwest Coast in their respective theories of modernism. In addition to the collection at the AMNH, Northwest Coast art was available at several commercial galleries in Manhattan and also via the collection of George Gustav Heye.[45] This alternative market, far from the coast, is thus another site of exchange that complicates the narrative of the art's "renaissance" in the 1960s, since the art traded on this market and in Paris was a mix of classic objects from the so-called Golden Age and more contemporary work. Indeed, although the majority of Breton's collection of Northwest Coast objects was assembled through the New York dealer Julius Carlebach, it also contained a Kwakwaka'wakw-made *yaxwiwe'* (headdress) confiscated by Canadian government officials in the aftermath of Chief Dan Cranmer's 1922 potlatch at Alert Bay. Anthropologist Marie Mauzé has traced the journey of this *yaxwiwe'*, made circa 1922, from its purchase in 1926

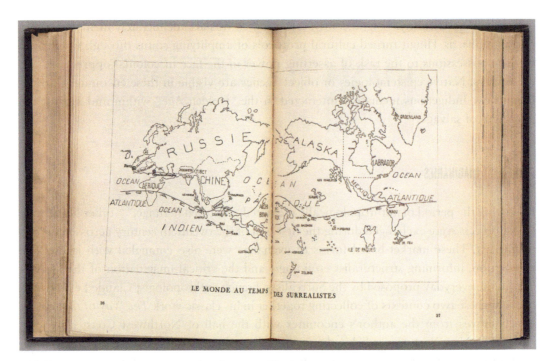

Figure 1.3. Surrealist map of the world, emphasizing Haida Gwaii ("Îles Charlottes") and Alaska. *Variétés*, 1929. Digital image © The Museum of Modern Art/Licensed by SCALA / Art Resource, NY. Photo courtesy of the author.

by Heye, who de-accessioned it to a Los Angeles gallery owner in 1957, who sold it to a Paris gallery, where it was displayed as a Haida mask.[46] Breton bought it in 1965 and displayed it prominently in his study. In 2003, his daughter, Aube Elléouët-Breton, repatriated the *yaxwiwe'* to the U'Mista Cultural Society, where it was welcomed home.

In 2011, while I was living in Vancouver, this *yaxwiwe'* was loaned to the Vancouver Art Gallery for Dawn Ades's major retrospective of Surrealism, *The Colour of My Dreams*. Situated in the opening room of the exhibition, it complicated presumed routes of repatriation, as its provenance indicated how a First Nations community had loaned it *back* to an urban museum. Both the story of its repatriation and U'Mista's ownership were prominently displayed on a didactic panel. Indeed, the rich social lives of Surrealist *objets* also point to the continued value of Northwest Coast art amidst its supposed decline in the early-to-mid twentieth century.

Just as the anthropological encounter with the Northwest Coast during the "Museum Age" was tied up with paradoxical notions of salvage, the Surrealists' experience of objects – for only Seligmann and Wolfgang Paalen actually ever visited First Nations people on the coast – was a complex mix of revolutionary romanticism and nostalgic bereavement. On the one hand, as Colin Browne has argued, non-Indigenous Surrealist artists were sympathetic to the plight of Indigenous peoples as survivors of Western rationalization, since the persistence of Native ceremonial practices amidst capitalism and colonialism fit with the

Surrealists' utopian quest for "re-enchantment of the world"[47] – a romantic notion that is analogous to the critique of capitalism implied in Mauss's contemporaneous analysis of gift economies. On the other hand, as in the narrative of salvage, the disappearance of this way of life *beyond* its material traces is figured as inevitable, since the Surrealists attempted to retain relics of primitive consciousness through their collecting in Paris and New York. Some contemporary artists also interpret the Surrealists' appreciation for Northwest Coast art as a misappropriation. In an interview with me, Tahltan/Tlingit artist Dempsey Bob explained how the Surrealists "stole the idea of freedom" from the Northwest Coast,[48] pointing out the seamless absorption of First Nations spiritual values into the broad frame of modernism – a borrowing without credit that is deeply offensive to Indigenous understandings of reciprocity and mutual obligation.

At the same time, the Surrealists' political and physical distance from the Northwest Coast allowed them to represent the oppressive presence of state and church in governing the spirit in a way that anthropologists and missionaries could not. For instance, in a 1939 article for *Minotaure* magazine entitled "Entretien avec un Tsimshian," Seligmann quotes (although does not name) Gitxsan Chief Donald Grey on the complex effects of colonialism on the material world after the "scramble" for artifacts and souls:

> "Recently," the Indian said, "they burnt [totem poles]. Currently, the state protects our relics, and the priests leave them alone. They think of them now like heraldic poles, stripped of all magic. For our young people they are outmoded objects and have lost their power. The magic of bicycles, cinemas, railways seems infinitely more attractive to them, and they speak with little respect of the older people who know and jealously guard the ancient secrets."[49]

It is of course possible that Seligmann projected his own notions of loss and change onto his interlocutor, either by altering the text or more subtly by directing the conversation. However, Grey's words also resonate strongly with my own experience of peoples' memories of this period and generational expressions of nostalgia for the good old days of Northwest Coast ceremonialism. Strikingly, however, Grey, at least via Seligmann, does not emphasize decline per se but a more complex co-existence of old and new ideas and practices. In this way, the Surrealist encounter represents a kind of spiritual bricolage in which forms of enchantment continue to exist alongside incursions of modernity, perhaps even altering modernity itself.

In all of these modes, Northwest Coast art was used as a particular kind of resource in anthropology and aesthetics in the first half of the twentieth century. This context of spiritual and theoretical bricolage is important because it is the backdrop for more overt slippages between religion, resources, and cultural policy that are exemplified in missionary collecting; indeed, the disjunctures between parallel contexts of collection and display are important because they challenge a narrative of Golden Age–decline–Renaissance. In effect, as a ground for anthropological theory-making and aesthetic inspiration, the ironies of the "Golden Age" designation and canonization are palpable in the midst of potlatch bans on both sides of the US-Canada border, smallpox epidemics, mass migrations, and Indigenous resistance to colonial policies.[50]

At the same time, it is important to note that many Indigenous people who had their livelihoods altered by wage economies based in emerging natural resource markets and who experienced profound cultural loss and violence through the residential school system share this narrative of decline. Memories can also be forms of mourning; many Indigenous people describe this period as a "dark time" in Northwest Coast history, emphasizing how much was lost in the "scramble" as culture was transformed into object lessons in museums, anthropological theory, and Surrealist understandings of the sacred. Yet there is also a parallel narrative arising from this time that belies the declines and swan songs, as a market emerged around Northwest Coast art in British Columbia that had less to do with salvage and more to do with social welfare and reform, which draw on, rather than break from, earlier enchantments. I turn now to these transformations.

BOOMING BRITISH COLUMBIA

The beginning of the twentieth century marked a period of transition for the young province of British Columbia as political instability and massive debt were offset by a booming market for natural resources. According to historian Jean Barman, its significant surplus – $10 million generated between 1905 and 1911[51] – meant that provincial officials were in a good position to negotiate with Canada's distant administrative and financial centres, Ontario and Quebec. As Barman argues, the main reason for intensification of the lumber industry in British Columbia was that American entrepreneurs had been forced by over-logging in other parts of the United States to move their operations to Washington state, transforming the Pacific Northwest into the key region in forest industries; meanwhile, the expanding fish canning industry also benefited from the deepening of the Fraser River to allow direct sea access.[52] The canning industry was the primary employer of Indigenous people in the province during this time – 41 per cent of the 27,720 Native people in the province by 1929 – and many men, including James Sewid, Harry Assu, and Gilbert Joe, owned their own fish boats, while women, including Florence Davidson, Hazel Stewart, and Rose Sparrow, many of whose descendants are prominent contemporary artists, worked in the canneries.[53]

Amidst these changes in labour, new markets opened up for art and leisure in the province, and a focus on "lifestyle" accompanied social reforms. Beginning in the 1920s, the local art world was consolidated by two new institutions: the Vancouver School of Decorative and Applied Arts (now the Emily Carr University of Art and Design) and the Vancouver Art Gallery.[54] Previously, the local art scene had consisted of a tourist market for late-nineteenth-century Northwest Coast Indigenous-made objects and painters like Emily Carr, who applied a European Fauvist style to depicting the province's wilderness and "disappearing" Indigenous people.[55] Artists and curators sought recognition externally from Toronto, Ottawa, Montreal, New York, and further abroad in Europe. Indeed, the 1927 exhibition *Canadian West Coast Art: Native and Modern* held at the National Gallery in Ottawa represented this requirement, bringing together Northwest Coast Indigenous cultural production with Carr's work into a dubious colonial narrative

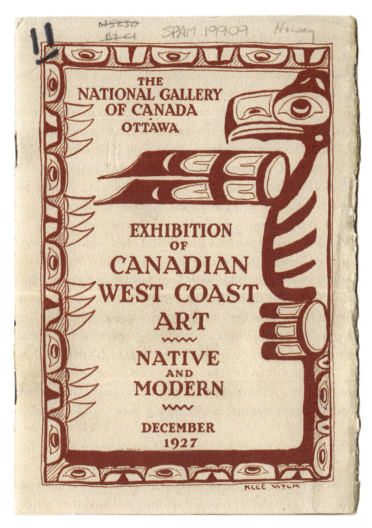

Figure 1.4. Catalogue cover for the *Exhibition of Canadian West Coast Art: Native and Modern* by Emily Carr (Klee Wyck), 1927. Courtesy of the University of British Columbia Library and Special Collections.

of the province's "Native" past alongside its present mode of non-Native "modern" painting (Figure 1.4).

In conjunction with this art-led search for external recognition, other quests for interior transcendence were also apparent in creative labour under the category of "lifestyle." Barman describes the province during this period as an ideal place for many groups seeking to separate themselves from mainstream society, including Doukhobors, Scandinavian idealists, Mennonites, and utopian cults. According to Barman's analysis, this search for "the perfect life style"[56] took place amidst a broader waning of the church's power to dictate how people should live their lives under changing labour regimes. These dynamics are especially apparent in relation to the "problem" of Indigenous labour as articulated by George

Raley, one of the period's social reformers who drew upon his earlier work as a missionary to connect art, labour, and social welfare in policy recommendations. Following the boom period outlined above, British Columbia sank into a period of economic depression more intense than experienced elsewhere in Canada, largely a result of its resource-based boosters' overconfidence and failures to offset the mounting provincial deficit, arrived at through overly optimistic projections or to ameliorate the widespread unemployment that attended the market crash and the decline of resource extraction and speculation.[57]

Looking to the United States for guidance, Raley called for a Rooseveltesque New Deal, the Keynesian state-managed economic policy credited with helping the United States out of the Depression. As historian Ronald W. Hawker documents, Raley's proposed "Indian New Deal" came out of his work as a missionary, and his experience of poverty on reserves as well as his interest in Northwest Coast objects as a collector led him to argue for state support of art and culture-based reforms that would echo what was already occurring in the American Southwest's establishment of a market for Native American art.[58]

Intriguingly, Raley's vision is at odds with both official *and* vernacular histories of this period of Northwest Coast art that view the early twentieth century as a "Dark Age" in Indigenous culture and art. Quoting one of Raley's contemporaries, Duncan Campbell Scott, a poet and then deputy superintendent of the Department of Indian Affairs (DIA), Hawker notes that the period was conceived as one in which "the race has waned and left but tales of ghosts."[59] Artists often gave me similar assessments of the period, accompanied by explanations of how their relatives had been both too busy with cannery work and too shamed by the assimilationist rhetoric of Aboriginal policy to devote any time to carving or painting.

Yet it is clear that this period *does* in fact have a history of cultural production, drawn as it may be from "tales of ghosts." Indeed, it would have been impossible for Raley to envision a market if the "Dark Age" had truly obscured the value of contemporary Native art. Here, I focus on the spirit of Raley's proposed reforms and how they articulated a complex analogy between art, extraction, and social welfare that continues to exist in the contemporary market for Northwest Coast art. Why did an "Indian New Deal" so compel him, and what are its contemporary legacies?

GEORGE RALEY AND THE INDIAN NEW DEAL IN CANADA

George Henry Raley was born in Yorkshire, England, in 1864 and moved to a farm in Ontario with his parents in 1882. Instead of working as a farmer, Raley was ordained as a Methodist minister and moved in 1893 with his wife Maude to the Haisla village of Kitimat to set up a new mission. Raley advanced to superintendent of the whole Port Simpson District – everything north of Alert Bay – in 1904. He moved to Port Simpson (Lax Kw'alaams) in 1906, where he lived and worked until 1914. During this time, Raley assembled the majority of his collection of northern Northwest Coast objects, a pursuit that historian Paige Raibmon traces to his interest in ethnology as it could be applied in the

service of Christian conversion[60] – an interest that perhaps accounts for his collection of Alexcee's baptismal font as a "conversion" object that would have been ignored by professional ethnologists operating under the ideology of salvage, which often could not accommodate hybrid or syncretic forms. Indeed, unlike many of his contemporaries at the DIA, Raley seems to have acknowledged the contemporaneity of Northwest Coast people and cultural production, an engagement that was epitomized in his publication of the periodical *Na-Na-Kwa; or, Dawn on the West Coast* in Kitimat. *Na-Na-Kwa* was an early expression of the textual "iron pulpit"[61] that reported on life in the community while providing heroic missionary testimony for the benefit of specific sponsors in Ontario with which Raley was connected. Each issue opens with a personal note from Raley, meant to strike an intimate tone with imagined recipients through reporting on the everyday activities of the mission while urging readers to help him increase the periodical's circulation.[62]

In addition to ensuring a system of settler governance via correspondence with sponsors in administrative and religious centres of eastern Canada, *Na-Na-Kwa* also featured Bible passages transcribed in the Haisla vernacular, which historians Alicia Fahey and Christine Horton connect to the widely documented Protestant zeal for exposing would-be converts to the "salvific potential of the written word."[63] Through both his material collecting and textual circulation, Raley articulated a vision of Indigenous and non-Indigenous coevalness[64] while tapping into Christian networks of support. In 1914, Raley moved to the Lower Mainland to become the principal of Coqualeetza Residential School in Sardis, a town about a hundred kilometres east of Vancouver, taking his collection of objects with him. He retired to Vancouver in 1934, where his collection was acquired by the University of British Columbia (UBC) to form the basis of the new Museum of Anthropology, purchased with money from H.R. Macmillan's logging dynasty.

During his tenure at Coqualeetza, Raley displayed parts of his collection in the residential school's main hall, including carved paddles, woven baskets, and Alexcee's baptismal font, as object lessons in traditional Native arts and handicraft that, he argued, should form the basis for the school's manual training (Figure 1.5). Raibmon connects Raley's enthusiasm for Native handicrafts to Victorian notions of childhood as a malleable period of development in which both moral and manual training were crucial to producing good Protestant citizens. Indeed, Raley differed from his contemporaries in his expansive view of manual training, connecting it to other economic outlets beyond the hard labour that was generally expected to be the bodily outcome of Aboriginal education programs, although what Raibmon calls a more "muscular Christianity" was also certainly encouraged by the school's extensive athletic programs.[65]

Raley's views on art as a form of social welfare in ameliorating the so-called Indian problem – and the key role of missionary education in inculcating these values – circulated in public through his extensive writing.[66] His pedagogy had implications for the United Church more broadly, which formally adopted a resolution in 1934 to encourage Indian arts in their educational programs.[67] Long after his retirement from Coqualeetza, Raley continued to lobby the DIA to institutionalize these connections between art and Indian welfare, and made the first attempt in the province to establish an Indian Arts and Crafts Board.[68] Raley

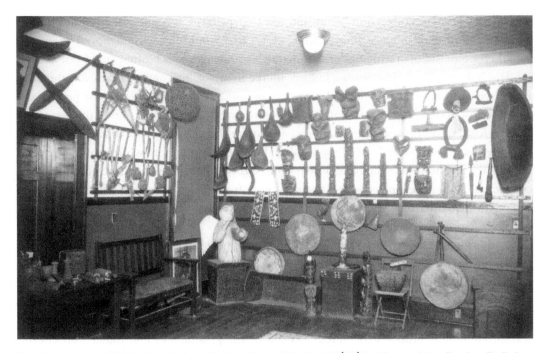

Figure 1.5. Reverend George H. Raley's collection displayed at Coqualeetza Residential School, Sardis, BC (1934). City of Vancouver Archives, Major James Skitt Matthews Collection.

also advocated an extension of these art-based forms of social action beyond institutions, arguing that students returning from residential schools could help their communities to develop and alleviate poverty on Indian reserves by spreading a gospel of art and welfare through the convenient structure of family lineages.[69] Moreover, he believed that, in displaying Northwest Coast art, the general Canadian public would develop greater sympathy towards Indigenous people and their plight, which was one motivation behind his sale of his collection to UBC. In these ways, the Raley Collection, and its presumed role as a pedagogical tool in stimulating art-based social welfare, was intended to have an impact on Indigenous peoples' lives beyond its communities of origin.[70]

Generally, historians have emphasized Raley's relatively sympathetic attitude towards Indigenous peoples and positive practices as an educator, especially when compared to other colonial officials and missionaries who committed horrendous crimes of emotional and physical abuse against their students. It seems that Raley's long tenure living in Indigenous communities and his valuing of ethnological knowledge did leave a mark on his thinking. Historian Sarah de Leeuw's literary analysis of his writings over the course of his career reveals a growing sympathy for Aboriginal issues and a deep personal conflict over the paradoxes of missionary education, which simultaneously sought to salvage Native culture while transforming its practitioners into Christian citizens.[71] De Leeuw also notes that former students of Coqualeetza frequently assert that it was one of the least violent residential schools in the province. Similarly, in her telling of Raley's life, Raibmon adopts a

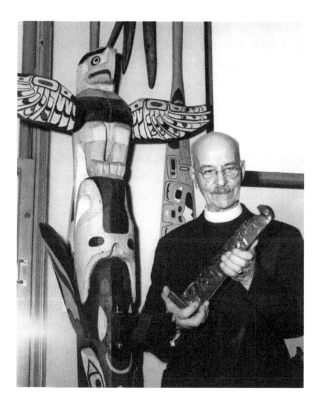

Figure 1.6. Reverend George H. Raley in 1946. City of Vancouver Archives, Major James Skitt Matthews Collection.

method of analysis that takes the structural violence of the Indian residential school system as a historical constant, against which Raley's interventions and sensitivity to Indigenous family systems may be assessed as a progressive viewpoint.[72] I am also struck by Raley's emphasis on teaching *between* an art school and dispersed communities of origin, a similar strategy to that of contemporary teachers and artists who attempt to bring back knowledge and skills to one's community (Figure 1.6).

In spite of these analogies, however, I am wary of analysing Raley's legacy as a social reformer on such terms, documenting the extent to which he transcended the residential school system or judging the extent to which his reforms were or were not "culturally appropriate" (incorporating, as they did, for instance, a respect for lineages). Writing from the age of reconciliation, my more pressing questions that might be asked of Raley's legacy are the following: How did this entangled logic of art and social welfare become thinkable? And how does it continue to be felt in interactions around art, both in establishing canonical forms of art and knowledge and in shaping our conceptions of Indigenous art's efficacies?

In presenting partial answers to these questions, I suggest that it is necessary to look more closely at Raley's moral philosophy in its historical and religious context and at its residues in art during the revival of Northwest Coast art at mid-century. Here, I turn to another source that animated his theories on the redemptive value of art and industry: the Arts and Crafts movement, which was based on reasserting a relationship between art and

labour through handmade objects in response to the perceived decorative decadence of the Industrial Age.[73] The movement spread to North America from Victorian England in the early twentieth century, inspiring a revaluing of handicraft as a moral and patriotic pursuit. This morality, and the regimes of value it generates, is analogous in many ways with Protestant ideals of simplicity and doctrines of work. As a movement centred on the value of "craft" – a word that expresses a longing, or nostalgia, for pre-industrial, non-alienated labour – the Arts and Crafts movement sits somewhat uneasily from a theoretical and critical standpoint with contemporaneous mediums of modernism, such as painting, which more easily fall under the category of "art." Indeed, revaluating Native "handicrafts" – largely objects – as "art" became the theoretical and political project of art historians and anthropologists in the 1960s.[74]

Writing in 1975, the art critic Robert W. Winter argued for an understanding of the movement as a kind of "religious revivalism" in the United States, which shared affinities with the branches of Progressivism that rejected the materialist focus of industrial labour *and* non-Protestant dogma – one reason, Winter argues, for the movement's "individualistic, self-help litany of Protestantism"[75] and a partial explanation for its failure to create a true revolution in art or labour. These connections between art, making, and masculinity seem firmly entrenched in a particular valuing of handicraft.

Moreover, Raley's writings to the DIA in British Columbia in the 1930s clearly show that he was aware of a central tension between "handicraft" and "industrial arts" that drove the Arts and Crafts movement. The following is an excerpt from Raley's letter to the DIA in response to their rejection of his funding application:

> I was unfortunate using the term "handicraft arts." The meaning would have been obvious if I had used the term "Indian industrial arts." However, the term "handicraft arts" generally expresses to me, when applied to the Indians of the Pacific Coast, the whole range of cultural activities and industries. In other words, the washing, carding, spinning, knitting, weaving, carving, and beadwork, with symbolic Indian designs are "Indian industrial arts."[76]

For Raley, then, whose work towards establishing an Indian Arts and Crafts Board in Canada echoed the reformist ideals of the larger movement around handmade objects, the phrasing "industrial" seems to have posed a problem, although he was willing to concede to its usage in his later writings in order to garner funding and to advocate for crafts as a form of industrial training in residential schools.[77] Moreover, given his missionary work, it is likely that the spiritual aspects of such an emphasis – an "individual, self-help litany" grounded in Protestantism – would have resonated strongly with Raley.

The presence of what might be seen as a crafting ethic in Raley's work and its entanglement with broader art and social movements is important because it complicates claims that are often made about this period's relentless abstracting or appropriation of Northwest Coast design from its cultural context[78] – an argument that closely resembles the secularization thesis in its emphasis on secular disenchantment via the networks of the art market. Counter to this narrative, if we take Protestant moral visions more seriously as a driving

force behind individual action and social movements of the time, we are able to perceive the ways in which Christian values suffuse Native ceremonial objects through their very circulation on the market – not an abstraction, per se, but a construction of a new regime of value for Protestant designs. This complexity is embodied in objects such as Alexcee's baptismal font and in the utilitarian objects produced by students in residential schools like Coqualeetza, whose meaning connects both to Indigenous cultural traditions and to new Protestant moralities around work. Indeed, these emergent notions of art, labour, and nation are resonant with Indigenous values of the well-made object and the lineage-based morality implicit in representing crests, names, and claims to territory through objects – one reason that Raley's programs may have been so successful in developing this syncretic complex of art, labour, and faith.

SECULAR ECONOMIES?

Theories of the secularization of Northwest Coast design are also complicated by Raley's ambivalent views on the potlatch. Like most missionaries writing in the early twentieth century, he denounced the practice as heathen in his newsletters, while collecting regalia as curios that would inspire future non-ceremonial work produced around the Protestant moralities of handicraft. By 1936, Raley had identified a suitable replacement for the potlatch economy that he believed would still allow ceremonial traditions to inspire and provide financial support for Indigenous publics: the tourist economy.[79] In an editorial in the *Province* newspaper, Raley succinctly outlined his vision for cultural commodification, focusing on the potential of marketing Northwest Coast art as a distinctly Canadian luxury good, the role of residential school education in arts training, and the importance of protecting designs by law to prevent imitation.[80] Throughout, Raley asserts the potential of Northwest Coast design *beyond* craft as well, perhaps spurred on by his interactions with the DIA to extol the potential of Native arts in industrial design via a broader market for Native-made commodities and, crucially, one that warrants legal protection.

In reality, however, this transition from ceremonial to secular economy was (and is) not so straightforward, and much of the recent literature on Northwest Coast art focuses on the ongoing negotiation between capitalism and ceremonial exchange. Based on her analysis of the market for utilitarian objects like tea-towels, mugs, and stationary emblazoned with Northwest Coast designs, for example, anthropologist Solen Roth has demonstrated that the mass-produced objects she refers to as "artware" often circulate *between* tourist and potlatch contexts and thus may have value as objects of identity across these different social spheres. For example, she explains how many Indigenous hosts of potlatches desire gifts or payments for witnessing that are "suitable for redistribution,"[81] meaning that they are ethically made by socially conscious corporations who respect the designs or are Indigenous-owned.[82] This interpenetration of economies was also expressed to me by several First Nations entrepreneurs, including Alano Edzerza (Tahltan) and Louis Gong (Nooksack), who both see the mass application of Northwest Coast motifs on textiles and

shoes, respectively, as part of the same effort to restore and make visible a sense of cultural pride and ownership[83] – a circulation of identity that is not that different from displaying a family crest in a ceremonial context.

In his 1936 editorial, Raley echoes this sense of pride as an explicit goal of commodification:

> There are valid reasons for an organized effort to revive and industrialize Indian handicrafts ... Because the Indian problem today is fundamentally economic and by placing Indian handicrafts on a commercial basis for the economic benefit of the Indians, we would restore cultural, congenial, hereditary occupation without competition and bring to a discouraged race a feeling of competence and self-support in the things they would be proud to do and do well.[84]

Crucially, Raley's policy suggests how forms of market-based self-determination were linked in cultural and religious policy before neoliberalism's particular conjoining of these modes of crafting the self. Although they are couched in a language of paternalistic responsibility, Raley's goals of cultural value-based pride help to generate a public that would be receptive to emergent forms of Indigenous political self-determination in the 1960s. In this earlier period, cultural *and* natural resources, as sources of economic uplift for a province shaken by the Depression, became entangled with conceptions of "art."

THE NISGA'A TREATY AND NON-SECULAR REPATRIATION

Amidst this liberation theology and economic futurism, the United Church became involved with debates around the Nisga'a Treaty in the late 1980s, the first modern-day treaty in British Columbia. Although its intercultural histories may be traced to an earlier era,[85] the treaty started officially in 1976 at the federal level, extended to negotiations with the BC government in 1990, and was finally passed in the form of a final agreement on 13 April 2000. This watershed settlement included a definition of the Nisga'a right to self-government and recognized Nisga'a ownership or treaty rights over 27,000 square kilometres of their territories in the Nass River Valley.[86] At the time, the Nisga'a Treaty generated a great deal of media hostility in the form of hand-wringing op-eds steeped in settler anxiety, which, among other accusations, considered the treaty in relation to Quebec's separatist threats – a recognition of constitutional uncertainty but also a familiar elision of Indigenous issues with other anxieties about Canadian sovereignty.[87]

Art also plays a role in social reform here, and one that is connected to both the Nisga'a Treaty and the politics of apology. Around the time of the impending Nisga'a deal, the United Church archive began collecting documents, not only on population, land rights, and liberation theology but also on material culture. For instance, filed alongside census documents is a small booklet called *Pitsaan* (1992), which photographically documents Jagam Txalp's (Alver Tait's) commemorative totem pole carving in Gitwinksihlkw (Canyon City) in Nisga'a territory. The booklet text is written in Txalp's words and describes his carving effort as an attempt to replicate a pole that was removed to France in the late

nineteenth century, with Txalp's explanation that "in the 1920s, Indians were not allowed to carve poles because the missionaries thought we worshipped them." In addition to resonating with the church's program of general moral atonement for a prior devaluing of Native spiritual practices as forms of fetishism, such documents also connect what Jennifer Kramer has called the "figurative repatriation" of objects – here, the replication of a stolen pole – to cultural renewal.[88]

In this way, the United Church was like other heritage institutions at the time in its documentation processes and recognition of repatriation as a tangible exchange tied to cultural redress.[89] The archive even includes various museum protocols for repatriation, demonstrating the ways in which the church drew on the example of museums for tangible restitution. This facilitating role was overtly patron-like and intended to produce a political and spiritual outcome via the return and exchange of objects. In the 1990s, the United Church became involved with repatriation projects of its own, stemming from its generalized support for the Nisga'a Treaty. It is instructive to consider the list of desired outcomes detailed in official church correspondence: the re-designation of key geographical features with Nisga'a names; the return of Nisga'a cultural artifacts; the provision for non-commercial harvest of halibut, oolichan, shellfish, and wildlife for cultural purposes; the endorsement of Nisga'a government and constitution and the Nisga'a ability to "make laws governing such things as culture and language, employment," and other matters of social and cultural world-making.[90]

This list is striking in its attention to materiality and its recognition of the connection between tangible objects, such as artifacts and natural resources, and intangible practices, like fishing and legal regimes. It is a slightly different imaginary from the one proposed in Raley's New Deal, as the spiritual properties of objects are rehabilitated alongside new forms of syncretism, and the signification of "art" is entirely absent. Yet the notion of efficacy itself is still clearly present: objects are meant to mediate social relations via a particular conception of autonomy that is very much tied to Protestant visions of social justice.

At this time, the United Church also became directly involved with projects that attempted to link repatriation with an apology in British Columbia. In addition to asking for support for the return of the G'psgolox pole, the Haisla Nation also petitioned the church to assist with the repatriation of objects from the Reverend Raley's collection, who, they argued, "would take [cultural belongings] to 'cleanse' a community of non-Christian articles, would take them in trade for services, and would pay much less than the true value of the articles to the community when he purchased them." These requests seem to have had tangible bureaucratic effects, including the drafting of a church policy on repatriation by Siebert, at that time the church's program officer for human rights and Aboriginal justice.[91] Through a bullet-point list, this document acknowledges that "a significant number of valuable artifacts, which carried the stories of the people, their history and their lineage, were forever lost to their communities though these encounters with Christian missionaries." Accordingly, Siebert recommends that "where these artifacts still exist, their return to their respective First Nations is important to the recovery of their peoples' spiritual and cultural life." To use this document's phrasing, "walking in light of the Apology" comes to mean

assisting with the return of cultural property, whose role in spiritual and political process is acknowledged. Here, we see the United Church playing the role of a different kind of "culture broker,"[92] using objects to mediate cultural loss. This moral role is strikingly at odds with more conservative museum mandates because of its non-museological obligations – for instance, the United Church has no need to preserve a collection or to consider the claims of multiple stakeholders.

As with all cultural policy, however, this repatriation protocol belies its contestation. Included in the archive alongside Siebert's drafts is a lengthy correspondence between Siebert and the Theology and Faith Committee, who disputed the use of the term "artifact" on theological grounds as an "objectification ... a making of what Native peoples held to be sacred, [as] 'objects.'" "Therefore," the committee writes, "any attempt at trying to distinguish between the 'legitimate' and 'non-legitimate' trade, or giving, of such sacred objects can be seen to be part of the continued abuse and exploitation of Native peoples and their relationship to the sacredness of creation." The committee then notes that "sacred objects cannot be 'possessed,'" citing as analogous the Christian practice of the church holding chalices in trust for the community and their necessary deconsecration before they can be bought or sold.

This theological debate about alienability articulates a re-enchantment of "artifacts" rather than their presumed secularization: essentially, it contends that Native objects were never, in fact, transformed into secular ethnographic curios but instead retained their sacred properties; therefore, *any* exchange, willing or not, may be exploitative. Curiously absent from this debate is any criteria for determining what is sacred, and therefore inalienable, although we might infer from the United Church's general attempt at "listening-in" that sacredness would be guided by Indigenous protocols and definitions rather than Western legal criteria of alienability.

In this local encounter of repatriation with Protestant modernity, apology initiates other forms of reciprocity and a commitment to intervening into networks of exchange that desacralize and objectify cultural property. Like Raley's social reforms, this particular iteration of the United Church's doctrine of work uses negotiations around cultural and natural resources as a form of social justice that is steeped in notions of religious atonement. They re-enchant objects and activate relations between persons and things, creating new hybrids between modernity and Indigeneity and between Christian faith and Indigenous cultural property.

Returning to Raley's activities at Coqualeetza, alongside its fine art objects, Raley's collection also included examples of student work, including picture frames engraved with Northwest Coast motifs (Figure 1.7). Given Raley's commitments as a social reformer, it is likely that these objects provided proof of students' industriousness and evidence of the potential value of First Nations cultural forms in emerging art and tourist markets, supporting his campaign of connecting art to a program of Native social uplift in the province.

But for survivors, these frames may have other meanings. Drawing on her interviews with survivors of Coqualeetza, De Leeuw emphasizes that many remember these works as creative outlets that allowed them to keep certain aspects of their culture intact.[93] Such

Figure 1.7. Picture frame from the Raley Collection. Courtesy of the UBC Museum of Anthropology, Vancouver, Canada.

remembrances resonate with Indigenous artists' arguments about the role of the Truth and Reconciliation Commission (TRC) in expressing cultural resilience and also with the uses of syncretism in enacting forms of covert resistance. Indeed, it is well known that, during the potlatch ban in Canada from the late nineteenth until the middle of the twentieth century, "craft" and "tourist" objects became important and undercover modes of displaying clan affiliations, hiding ceremonialism in plain, secular sight.[94] According to this interpretation, these objects, including the picture frames I described above, were not only signifiers of capitalist industry but also a way of preserving First Nations culture – even if of a pan-Indigenous, "Northwest Coast" type – amidst an oppressive system.

This interpretation is supported by handmade objects in the Raley's collection. Although crudely rendered, students' carvings of formlines and ovoids make use of their surfaces in ways that are consistent with traditional forms of decoration, expanding to fill the space available. In these ways, student works may function as "trade goods" in David Garneau's

sense,[95] their visual language going along with *and* against the grain of forced authority while preserving visual culture – a complex form of artistic resistance.

But this historical interpretation is also not quite the whole story, especially as it relates to the present. While co-teaching a class on pre-1950s Northwest Coast art histories at the Freda Diesing School of Northwest Coast Art, I was certain that the students, many of whom had experience with youth movements in their home communities, would be enthusiastic about this work because of its ties to covert Native resistance. Indeed, the very existence of these picture frames defies the oppressive implications of a "Dark Age" in Northwest Coast historiography, a period in which many Native people had abandoned artistic activities for necessary work in canneries.

I was completely wrong. Not only did students think the carvings on the frames were "bad" – which, admittedly, from a formalist perspective, they are – but they insisted that the Dark Age was "real." For students, this period was not an invention of historiography but a factual outcome of cannery work, economic depression, and forced separation of families through residential schools. By promoting a redemptive "art as resistance" narrative, I was in effect denying the ways in which students *felt* this historiography. These students urged me to acknowledge the sadness of these objects as signifiers of a former vitality and indexes of a painful time in their own families' lives and memories.

In this way, these frames, in their "badness," also materialized a kind of loss that the students found generative in establishing their own artistic identities. They were able to see their own generation of contemporary art, set against this Dark Age, as embodying opportunity and change. Their feelings of resilience were enabled by pity for such tokens of Northwest Coast design principles. One student noted how little these residential school students had to work with in the way of materials – cast-off wood, poorly made carving tools as evidenced by shaky formlines – compared to the Freda Diesing School's abundant resources. In recognizing and reframing the Dark Age through a narrative of loss, students were able to articulate their present in relation to the idea of a late-nineteenth-century Golden Age of Northwest Coast art rather than seeing themselves as victims of history. Moreover, their aesthetic judgment in an art school context displays a high level of discernment: their capacity to decide what is good and bad based on their knowledge of visual language and skill. Here, cultural loss may be a generative language of expression in relation to residential schools and art practice.[96]

~

It is springtime in Kitimat, and I am accompanying students from the Freda Diesing School on a fieldtrip to visit this neighbouring hub for Northern Indigenous art. We are all eating lunch together in the food court of the local mall when I remember that this mall is the site of a significant repatriation, the place where the famous G'psgolox totem pole was eventually returned in 2006 after years of Haisla negotiation and diplomacy with an ethnographic museum in Stockholm, Sweden. According to the repatriation protocol, the G'psgolox had to be housed indoors, and the mall was the most logical place for storage until a cultural

centre could be built to accommodate it. I turn to one of the teachers and ask where the pole is. He pauses before telling me that it has been moved outside into a wooded area near its original location. "Everyone thought it belonged there better," he explains. I am not surprised, I tell him, but wonder out loud if the Haisla Nation could get in trouble for not meeting the preservation requirements of the repatriation. He doesn't think so. "And besides," he adds, "since they moved it outside, the oolichan came back."

Can a repatriated pole bring back fish to a river? Does a narration of a "Dark Age" in Northwest Coast art craft reparative relations alongside a narrative of decline and rebirth? Regardless of the causality surrounding these animating stories of loss and repair, they reveal how cultural belongings are resources that exceed the frame of salvage, or the act of preserving that which is presumed to be already lost, in a resource frontier. In the next chapter, I turn towards contemporary art and action prefigured by these earlier enchantments and the kinds of collaboration made possible by shared discourses of Northwest Coast form.

CHAPTER TWO

Finding Repair: Contemporary Complicities and the Art of Collaboration

My first encounter with Luke Parnell's artwork took place on the floor of a white cube gallery.[1] Forty-eight carved figures encased in acrylic cases were arranged in regulated rows, their individual features – smiles, grimaces, teeth – visible at a crouching distance (Figure 2.1). The identical cases resembled vitrines, while the title of the work, *Phantom Limbs*, suggested boxes for human remains and the containment of something missing but not gone. Lines of connection were being drawn in the space of the gallery, and their points of origin were specific: forty-eight ancestors recently returned to Haida Gwaii from the American Museum of Natural History in New York. For Parnell, who belongs to the Wilp Laxgiik Nisga'a (House of Eagles) from Gingolx on his mother's side and Haida from Masset on his father's, these connections were visceral, evoking a history of stolen ancestors lodged in the body. *Phantom Limbs* was colonial theft re-membered, registered through the multiple channels of the Northwest Coast art market; the figures' features read as authentically of this regional style, signifying in the visual currency of connoisseurship, just as they evoked many routes and ethics of care.

As I witnessed this remembering, I was just beginning my research on contemporary Northwest Coast art, and I was struck by the force and complexity of Parnell's work and its capacity to contain all these narratives, networks, and archives in a way that my writing simply could not. *Phantom Limbs* evinced a startling reflexivity of the processes of knowledge production, a tussling with representation and the question of how the past can be made present through the aesthetic mode. Specifically, Parnell scrutinizes the location and imaginaries of the Northwest Coast, out of which many anthropological theories of exchange and "primitive art" and its materialization – belongings and human remains – have come. Indeed, the very ancestors that Parnell remembers were taken to the museum by unnamed collectors following the late nineteenth-century settler-borne smallpox epidemic that devastated Haida Gwaii, emptying whole villages and reducing the population to just 600 from 10,000.[2]

Figure 2.1. *Phantom Limbs* (2010) by Luke Parnell. Courtesy of the artist and the National Gallery of Canada.

In rendering these stolen and returned ancestors, Parnell's aesthetics recall both the highly elaborated formal visual markers of quality in connoisseurship – a language of formlines and ovoids – and the more intimate knowledge and meanings of place. These include, for instance, Parnell's whimsical and personal choice to represent the ancestors' faces in expressions that mimic those of the Kodama tree spirits from the 1997 Japanese anime film *Princess Mononoke*. The scale of the bodies relative to their heads also mirrors the doll-like animated appearance of these supernatural beings who protect forests, cursing those who cut down the trees where they reside.[3] Working in the wake of artists like Michael Nicoll Yahgulanaas (see chapter five), whose "Haida manga" also traces Pacific transcultural currents, Parnell's nod to Japanese anime calls up circulation and far-flung kin-making as it re-enchants through his own long-standing love of comic book aesthetics.

As I discussed in the previous chapter, this complexity of referents and resources for art is not new. Since the late nineteenth century, First Nations artists have deployed and performed the category of "Northwest Coast art" in ways that hold different meanings for different publics, including the formation of anthropological knowledge about art.[4] Art has served as a key site of intercultural social relations and negotiations, both in the market and beyond it. Based on local anthropological accounts of museum repatriation projects such as the one Parnell materializes, these deployments of the category and its formal properties might also be understood to enact an ethics of care through their reflexive and intertextual relations between persons and things, activating multiple contemporary ties as much as they draw upon the entanglements of the past.

In anthropologist George Marcus's terms, what could be regarded as my initial "scene of encounter"[5] – an artist's practice, grounded in a specific act of repatriation and its deep historical and cultural roots, mediated by an installation in a gallery space that brings a particular instance of mourning and return into experience – is typical of the contemporary moment in (and for) anthropology. In this scene of encounter, "reflexive subjects"[6] – humans – like Parnell are collaborators in the production of knowledge, as their insights and particular parsing of art's networks define the boundaries of research. Marcus describes this scene as a "found imaginary,"[7] deliberately invoking the aesthetic terms of the found object to evoke the contemporary affinities between art and anthropology present in these collaborative aesthetics.

What I want to suggest in this chapter is how this found imaginary and its intertextual properties give rise to a found *relation*: a notion of collaboration that is tied to contemporary ethical debates in politically charged fieldwork settings in which, in Marcus's words, "collaboration defines relations."[8] Considered in relation to long and painful histories of Indigenous struggle and ethnographic extraction, this link between advocacy and collaborative or complicit mise-en-scène may not seem to adequately capture the politics and tensions of such sited emergence like the decolonizing of research protocols for working with Indigenous communities and interlocutors. Such projects are, to borrow Aaron Glass's description of intertextual mediation among ethnographers and Kwakwaka'wakw people, "a set of contested but open-ended and valuable resources for reckoning cultural histories and futures."[9] Indeed, a metaphor of "finding" perhaps further disavows these actions and their historical and contested conditions of emergence through a narrative of chance discovery.

But there is, I suggest, an illuminating precision to Marcus's metaphor and use of the concept of the found object. As art historian Margaret Iverson argues, the found object for the Surrealists is not the same as a readymade, one of those Duchampian mass-produced things that disrupt the categories of art through their "desubjectifying strategy"[10] of recontextualized appearance in museums. Instead, Iverson draws a connection between the Surrealist found object and Lacan's *objet petit a* in psychoanalytic theory, which holds both traumatic experience and the failure to represent it: "the lost object which sets desire in motion and which, paradoxically, represents both a hole in the integrity of our world and the thing that comes to hide the hole."[11]

Forty-eight carved ancestors, making present a loss, its archiving, and its ambivalent repair through return: the found imaginary of collaborative relations in British Columbia is made visible through this remembering. Whether and how such collaborative found relations represent a "tentative rapprochement"[12] between anthropologists and Indigenous people – and, for my purposes here, between anthropologists and Indigenous artists as critical intellectuals – are important theoretical and practical questions in contemporary anthropology.[13] Collaboration is no longer an optional method or marginal practice. And, as long histories of Americanist and museum anthropology indicate, it never really was.[14]

Yet the value and urgency of such work has changed, as have the terms for describing and acknowledging it. There are multiple investments, stakes, and relations contained in

attempts to establish ethical research protocols, to document lineages of Indigenous agency in contributing to knowledge production, and to assert the value of community-initiated work as legitimate scholarship in an academy still wedded to settler colonial criteria of judgment, criteria that often fail to take seriously what Emma LaRocque describes as "Native resistance discourse" in academia.[15] This failure often takes a particular and curious form; many debates about the value of collaborative work turn on a tired rhetoric of "quality" and the qualities that differentiate (pure) anthropology from (contaminated) advocacy. The dynamics of settlement and unsettlement are crucial here; as Audra Simpson has argued, the reduction of collaboration to ethical "rapprochement" may itself serve as a denial of Indigenous sovereignty via a reduction of justice and care to liberal notions of inclusion, recognition, and accommodation, enabling a fundamental deferral of more uncomfortable questions and bodily presences[16] – the phantom limbs that continue to haunt the settler body politic even as their returns enact repair.

This chapter extends these reflections about the multiple values and effects of contemporary collaborative paradigms in art and anthropology, and their relations to reparative modes in both kinds of relational practice. Circling the perimeter of *Phantom Limbs*, I did not know that Parnell would later become my collaborator or, to use his even more implicating term for me, "co-conspirator," defining the boundaries of my own research imaginary found in fieldwork with contemporary artists and activists. Over the course of my research, Parnell and I would work together on several projects, none of which really quite count as anthropology: a series of filmed oral history interviews with non-Indigenous art dealers in the Vancouver area, archival research on artwork made pre-1951 for the tourist market, and most significantly, co-teaching at the Freda Diesing School of Northwest Coast Art (see chapter four). At the same time, Parnell's artwork became a significant primary source for my thinking. Our work together seriously complicated my understandings of the stakes of collaborative projects and of the kinds of co-produced knowledges that emerge out of anthropological engagement. In documenting my relation to Parnell's practice, this chapter is also an account of collaborative paradigms in British Columbia and an analysis of the contemporary affinities between art and anthropology in this place. It is a partial attempt to use the experimental space of fieldwork to think about theories of collaboration in both disciplines and the possibilities they offer as reparative practices.

Even as I deepen the conversations in which I situate my understanding of collaborative experiment across art and anthropology, I have chosen, in this revision of earlier thinking, to stay close to my initial interpretations. Indeed, fieldwork collaborations have indelibly altered how I theorize repair in this book. Since this time, the release of the Truth and Reconciliation Commission (TRC) final report and calls to action have done much to reorient how academic disciplines approach, value, and remunerate Indigenous contributions to knowledge and research. For instance, a performance art show in Vancouver called *Testify: A Project of the Indigenous Laws + the Arts Collective* paired artists with legal thinkers in responding to the TRC's calls to action. Such projects bring together multiple frames of art and culture into acts of witnessing, constituting a reparative mode grounded in collaboration and interdisciplinarity.[17]

These conversations were also latent in the particular scene of the 2010s. In this chapter, drawing upon my experience of working in this Indigenous art world generally and with Parnell more specifically, I reflect upon the processes of collaboration between artists and anthropologists, and the meanings of collaboration for both. I venture into debates about why and how such collaborations might be productive in both ethical and conceptual terms. And I consider what the broader "rapprochements" between art worlds and anthropologists look like in the contemporary moment in the context of recent social and participatory art practices that both do and do not resemble contemporary collaborative research paradigms in anthropology.[18] As Haidy Geismar has argued, the world of contemporary art, which is often valorized as a more neutral meeting ground or unproblematic site for remediating colonial relations through artistic intervention, also requires unpacking as culturally produced space.[19]

I am interested in the kinds of collaborative practice that follow reparative and dialogical expressive forms made for public use – art, for instance, that is meant to circulate and even intervene into social relations, initiating a conversation with ancestors, anthropologists, and other publics. Used in this way, collaboration moves closer to models of participatory practice in contemporary art worlds, as well as to what art historian and critic Hal Foster calls the "archival impulse" of projects that reckon with personal and collective pasts.[20] My expansion of the notion of collaboration is not meant to detract from its important associations with decolonizing forms of activism in the academy, including participatory action research.[21] Indeed, a crucial part of this activism, and part of the ethic of collaborative practice more generally, has been the foregrounding of Indigenous epistemologies and ontologies, and taking resistance seriously as a motive for scholarly practice. Like art historian Grant Kester, who has ironically characterized much reparative contemporary art as an "orthopedic aesthetic" that presumes a broken or deficient public in need of intervention or fixing by an implicitly more agential or able artist, I am interested in thinking through the complexity of collaborative practice and its potentially reparative effects at multiple levels of production and circulation.[22] Some of these involve, I argue, a kind of Indigenous formalism that might seem to be the very opposite of dialogical aesthetics, with its faith in art's function. My point is that, for some contemporary Indigenous artists working today, modes of practice also include paradigms of collaboration with and outside of anthropology – an entanglement with many sources for thinking about art's efficacies. I suggest that "crises" of critical judgment that attend unsettlements in the art world over recent elisions and revisions of the roles for artists, curators, critics, and audiences[23] are made intelligible by considering these points of intersection in collaborative practice. Specifically, considering these anxieties about collaborative practices helps us understand why co-production is both valued and threatening.

In doing so, I address the affinities between contemporary art and anthropology broadly through an analysis of how each discipline conceptualizes "uncertainty" and "process" as values and outcomes of collaborative projects. Next, I turn to anxieties around these projects from art historical and anthropological sources and contradictions in debates about efficacy and propriety whose resonances continue to be felt. Finally, I join recent ethnographic

attempts to reflect upon what it means for an art practice to address similar research problems as my anthropological one, seeing my work with Luke Parnell as one kind of contemporary collaboration that raises questions about accountability and care that draw on but also exceed the paradigm and ethics of protocol as having the potential to repair relations.

By reflecting analytically on these politics, aesthetics, and affinities of collaboration as a found imaginary, I do not mean to challenge the effectiveness of collaborative work; the outcomes are indeed real, material, and tangible, allowing for bridges to be made between institutions and publics. To cite just one recent example from the Northwest Coast, this careful and collaborative decolonizing work is apparent in anthropologist Aaron Glass and artist Corinne Hunt's full restoration of George Hunt as co-author of anthropologist Franz Boas's *Social Organization among the Kwakuitl*, with an accessible critical edition of the text produced in dialogue with Hunt's descendants in Alert Bay. In a dialogue about this collaboration, Glass and Hunt make this point profoundly material, noting that the photographs in the text are not only images but ancestors.[24] Indeed, it is precisely because this work attempts to mediate and broker among different ways of knowing that it is critical to explore its sources, theoretical limits, and possibilities.

What did it mean, for example, that Parnell's artistic and archival practice overlaps in obvious and significant ways with my anthropological one, and how might this overlap be productively activated as reciprocity, knowledge, and care? I am interested in how collaboration looked and felt unsettled at this moment, in this place, and why. As with the rest of this book, I suggest that much of the unsettlement – of art critics, of curators, of anthropologists, and of protocols for dealing with the material world – is the product of a change in consciousness that draws upon local Indigenous values and imaginaries.[25] But it also stems from contemporaneity and collaboration as they are rendered in non-Indigenous art theory, which, I argue, should also be recognized as a significant institutional context for Indigenous art, criticism, and curatorial practice. Turning to this context allows us to see how "collaboration" is already, and always was, impure in its networks and hybrids[26] – precisely in the connectivities made tangible by a work such as *Phantom Limbs*.

COLLABORATIVE AFFINITIES: ANTHROPOLOGISTS AND ART WORLDS

The practice of collaboration is one that scholars across disciplinary lines have embraced for shared political and ethical reasons.[27] Yet in spite of this shared ground of intervention, specific accounts of collaboration in ethnographic case studies rarely resonate with the theoretical treatment given to collaborative practice in art. The literature on collaboration between art worlds and anthropologists, most often presented as experimental case studies,[28] is also often curiously disjointed from more immediate and intimate accounts of the cultural politics of collaboration, especially in Indigenous contexts within settler states. In other words, there are two forms of rapprochement present in accounts of the found imaginary – between art and anthropology, and between anthropologists and Indigenous communities – and rarely are these two mutually implicated as an interdisciplinary conversation. In this

section, I situate the affinities and complicities between art and anthropology in these various accounts of collaborative practice. I suggest that these types of accounts and theoretical literatures help to illuminate how critical Indigeneities – as driving forces, moral projects, and paradigms behind collaborative research relations in British Columbia today – disrupt and contest settler colonial values. This critical practice has formed the basis for my shared ground with artists. How collaboration is marshalled discursively in specific work requires us to think critically about the roots of the aesthetics and ethics invoked in such projects.

As I am thinking through this concept – collaboration – with artists and art from a specific place, pursuing the lines of enquiry that emerge ethnographically from a particular constellation of people and objects, some grounding in local cultural politics is necessary. Living in Vancouver on land whose unceded character is articulated at every formal public gathering, collaborative ethics and notions of First Nations protocol constitute everyday life in the art world. As a local curator observed when I announced my intention to work with First Nations artists in British Columbia, I was in the wrong field: if I wanted to work with artists and cultural institutions, she counselled me, I would do better to get a law degree in cultural property than a PhD in the anthropology of art. Although the curator's comment was meant to signal the embattled state of museums in the repatriation era, it was also culturally astute and sensitive. Law and art are intertwined in First Nations practices of recognizing and reckoning kin, ancestry, and status, and particular connectivities and cultural analogies are well documented across many different nations. As art is used as a method of reckoning both the intimate and the political at potlatches and repatriation proceedings, it is related to processes of repair in both kinds of property regimes.

What this distinct situation of unsettlement means is that the things called belongings, artworks, or artifacts are a crucial site for reckoning loss and mediating the damages of continued settler occupation. As the examples in this book variously demonstrate, the tangible world forms a common language and currency of reconciliation through repatriation and other means. On a more symbolic level, a similar process might be seen to be at work in what Marcia Crosby has articulated as the discursive political reduction of all Indigenous rights to questions of property and land.[29] Crucially, in political and intimate spheres, this objectification happens in ways that draw upon both Indigenous practices and the machinations of the settler state, invoking the collaborative paradigms of *both* frames for reckoning. It is no coincidence, then, that many collaborative projects have emerged in this place around processes of objectification and in accordance with a distinct bureaucracy that is characteristic of audit cultures.[30] Museums and other institutions governing cultural representation have been crucial sites for reorganizing these subject-object relations,[31] working through what material culture scholar and ethnographic museum director Wayne Modest calls a "double bind": the presence of colonial residues and entanglements within the museum's important "belonging work"[32] in recognizing contemporary communities whose belongings are held in the museum. This ambivalence between belonging and critique also reiterates a tension in the concept of objectification between self-making Hegelian valences and alienating Marxist ones.[33] Both are present in collaborative process.

In these institutional settings, collaborative ethics are often formalized and given reparative form as "protocol" – in Western etymologies, a legal term used to refer to tangible agreements between states and later to refer to the standardization of practices. In many Indigenous knowledge traditions, protocol is used to approximate Indigenous legal and material practices as tangible and relational things with distinct epistemologies and ontologies, and most important, to enable *public* accountabilities around Indigenous knowledge.[34] Artist Maria Hupfield and theorist Leanne Betasamosake Simpson elaborated this meaning in a recent conversation at a residency in New York with the theme "As for Protocols."[35] As such, protocol has extended into broader art world conversations but remains connected with local notions of sovereignty, control, and access. It is also why an extensive literature and discussion of research ethics has already emerged in British Columbia, anticipating in many ways more recent dialogues.

AESTHETIC AFFECTS

This local context of objectification – of making culture and loss tangible – is made up of many networks. Like all social material practices, attempts at objectification produce an excess; it is impossible to stabilize completely the meanings of objects or protocols for different actors, and the fixing tendencies of governmental processes, including institutionalized collaboration, may have unexpected outcomes that reveal governmentality's limits.[36] In this way, rapprochement is not as simple as it appears, and understanding this kind of ethical action requires that we track these multiple routes and articulations of the found imaginary. Art worlds are one space in which this excess is particularly visible. Since the early days of anthropological collecting, art worlds have been a location that matters in both the valuing and circulating of Indigenous expressive culture in settler states. As I detailed in the previous chapter, on the Northwest Coast the networks and social relations that characterize First Nations art production and circulation have long formed the basis for anthropological thinking about exchange and value. Moreover, many of the collaborative relationships that have been formed in this history of encounter have involved the co-production of anthropological knowledge and federal Indian policy, drawing upon expressive forms in theorizing and law-making.[37]

Anthropological theorizing about the politics and poetics of co-production has often accompanied such work. For instance, the multiple and "unruly"[38] strands of visual anthropology have often been based upon working models of reciprocity, including Jean Rouch's concept of *anthropologie partagée*, a "shared anthropology" that draws upon the Maussian concept of the *contredon*, or counter-gift, both to give back to communities by sharing and showing research and to promote a critical reflexivity on the part of the anthropologist via this form of feedback.[39] Maureen Mahon has argued that the fit between expressive culture and anthropology may also be accounted for in cultural producers' high level of discursive consciousness, making them ideal collaborators in research and cultural activism.[40] Indeed, this shared theorizing is why the art-culture system is contested between realms of art

and anthropology.[41] The aesthetic realm, then, may be seen as a powerful and appropriate site for considering and developing disciplinary ethics and thinking about anthropological knowledge-making.

Such collaborations are also productive sites for critically mapping the multiple forms of agency that cohere around cultural production. As George Marcus and Fred Myers have argued, mutual entanglements between art worlds and anthropology turn upon their practitioners' shared identities, histories, and crises in relation to critical forms of modernism.[42] These entanglements form the often uneasy ground for contemporary rapprochements between art and anthropology in which there is often a shared recognition of political goals as well as an attempt to explore different ways of knowing that emerge from collaboration between artists and anthropologists.[43] The decolonizing implications of such collaborations are also made apparent in the literature, although "creative action"[44] often sits in uneasy relation to cultural policy, given the long histories of connection between Indigenous art worlds and the bureaucratic apparatuses of oppression. This uneasy relation is certainly the case in British Columbia, where the formation of "Northwest Coast art" as a stylistic category has had far-reaching political and economic implications. Indeed, as Crosby has argued, since at least the 1960s, the Vancouver art world has been a key expressive site for constituting the Aboriginal subject around notions of productivity and citizenship.[45] In this regional nexus, art, subjecthood, and territoriality are entangled.

There are multiple ways of thinking about these affinities, and this complexity is a characteristic of the collaborative imaginary that is part and parcel of the contested moment in art and anthropology.[46] The connections between aesthetics and ethics are woven into the fabric of anthropological thinking about art and cultural policy itself and must be accounted for. For contemporary First Nations artists working today, these connections and their traps create ongoing sites of struggle and possibility. Thus it may not be abundantly clear where the collaboration and various forms of complicity are located in the interstices between art and anthropology. Does a carving apprenticeship, in which multiple hands work on the same piece, count as collaboration? Is a gallery that supports an artist out of an ethical desire to challenge colonial conventions also a collaborator in the network of associations? And what about projects, such as my own research and the practices of many artists, that investigate and draw upon the co-produced and situated nature of art and knowledge itself?

In Parnell's work, this discursive history of Northwest Coast art serves as an important reference point and site of intervention. In *A Brief History of Northwest Coast Design* (2007; Figure 2.2), eleven painted planks document the narrative of Northwest Coast art history from pre-contact forms through the ban on ceremonial practices – a time that Parnell represents in his piece through the metaphor and material practice of whitewashing – until new technologies strip away layers of dirt and paint to reveal older designs on wood. This story of recovery references a specific collaboration at the Museum of Anthropology at the University of British Columbia in Vancouver, the Image Recovery Project, in which curators at the museum used infrared photography to uncover designs hidden under patinas and layers of newer paint on old Northwest Coast paintings.[47] Parnell's invocation of this

Figure 2.2. *A Brief History of Northwest Coast Design* (2007) by Luke Parnell. Courtesy of the artist and the National Gallery of Canada.

anthropological project of image recovery as a collaboration between artists and anthropologists is deliberate. His work's final two panels, in which contemporary practice draws upon older forms, reflect upon the meanings of the narrative of loss and recovery and constitute a symmetry that encompasses multiple ways of looking back.

In *A Brief History*, anthropological knowledge is both source and constraint, and is fitted together with formalism. Parnell refuses to unsettle the progressive narrative of art history – from the late-nineteenth-century Golden Age to wage economy–stimulated decline and present-day cultural recovery – in ways that might be read as uncritical or complicit. Among local art historians and anthropologists with whom I spoke, there was a general discomfort about the potential capacity of the Image Recovery Project and its progressive returns to create new orthodoxies and even resemble a project of salvage ethnography for contemporary artists. It might, in this way, be seen as a collaboration that is read anxiously as being *too* effective, producing new narratives of art history that are different in content but equally teleological in form.

From a critical standpoint, however, I would venture that this capacity is also precisely the point: Parnell's refusal reflexively implicates anthropology and art history to produce

what cultural theorist Walter Benjamin called a dialectical image – an allegorical representation that redeems the past, yet without a progressive teleology.[48] The material symmetry of Parnell's composition coheres into a unified piece composed of that which is faded, recovered, and collaboratively reassembled – also with the help of this anthropologist's hauling those cedar planks up a hill to the gallery that I recounted in the introduction. The work reveals the complicities and complexities of knowledge production on the Northwest Coast. Both the threat of whitewashing and the perils of adhering rigidly to a veneration of recovered form are presented – and unresolved. Indeed, the contemporary planks draw upon both in their completion of the design. Collaborations are represented as a legitimate source of practice in Parnell's contemporaneity. They produce symmetries, not mirrors.

Just as the collaborations referenced in *A Brief History* are specified – and bound up in a long history of co-production of knowledge tied to uneven and settler colonial relations of power that neutralize cultural production through logics of appropriation[49] – particular contexts have shaped this consciousness and how it is made tangible and effective, including relations with specific museums and academic departments.

Much collaborative research in anthropology shares these values and highlights the potential of and commitment to research to reconfigure and unsettle colonial relations of power, partially by privileging Indigenous knowledges as alternative and decolonizing epistemologies.[50] In one local example of such work and its reflexive theorization, Charles Menzies and Caroline Butler explain how their long-term community-based collaboration in British Columbia often involves abandoning liberal values of inclusion and access to knowledge that are necessities of conducting collaborative research with contemporary First Nations communities.[51] Producing knowledge out of these reconfigured relationships thus reverses or subtly shifts criteria of judgment for anthropological scholarship towards criteria that are affective as much as ethical, which Menzies and Butler render as "work that feels good in our hearts."[52] The affective value of such work, I suspect, is one of the reasons that its detractors misrecognize it as "social work"[53] – a position that both ignores its long histories and reduces a meaningful shift in consciousness to a sort of bleeding heart anti-scientism. My point here is the opposite: this shift in consciousness is significant because it constitutes a new aesthetic and ethic, the values of which are fundamentally different from earlier ones[54] and not merely a byproduct of institutional goodwill. Collaborative research feels a certain way because of long histories of Indigenous anti-colonial activism, entanglements between art and culture, and the institutionalization of this fieldwork aesthetic. It is also intended to do something, to intervene into colonial social relations by respecting and enacting Indigenous epistemologies of practice.

COLLABORATIVE FEELING

The camera is rolling, and I am behind it. Luke is in its field of vision, chiselling the rough line cuts of figures on the totem pole that is laid out in front of us. The pole is composed of two eagles, one right-side up and the other upside-down, holding three stacked identical human figures. "Aboriginal students," Luke explains, smoothing an edge.

This occasion is our second interview together and the first time we are meeting in Luke's studio space in the new Aboriginal Gathering Place (AGP) at Emily Carr University. When Luke arrived as a master's student in sculpture, he was already experienced in carving from a bachelor's degree totem pole project and apprenticeship with the Tsimshian artist Henry Green. As he works, Luke tells me about his teacher, who is from the northern village of Lax Kw'alaams, close to Luke's own hometown of Prince Rupert. Green studied under Haida carver Freda Diesing – Luke tells me that a school where he plans to teach is named after her – and later earned a degree from Emily Carr, where Luke is pursuing his graduate work.

Listening to the rhythm of Luke's voice over the slow, fine work of carving, I am struck by the symmetries of this genealogy and how perfectly it aligns with Luke's project. As I found out later, the AGP had commissioned this pole for their new space, stipulating only that it speak to themes of education. Luke had enacted this theme in ways both explicit and implicit, through the pole itself and through his work with the younger students at the AGP, several of whom come over to greet him while we are filming. The carving is mesmerizing, and I am still hesitant to ask too many questions – it is only our second meeting – but the silence between us feels unstrained, mirroring his ease with the students and the quiet of the space.

Luke looks up and directly at me. "Do you want to try?"

I startle. Clearly, I had become too comfortable behind the camera. I shift up from the digital screen and clear my throat. "Um. Are you sure?" *Why?* I think. *Oh god. I'm an anthropologist, not an artist. What if I really mess this up?*

"Yeah. I'll show you," Luke says. Panic sets in.

Dutifully, I move into the camera's frame, and Luke passes me the chisel. "You're left-handed!" he exclaims.

"Is that bad?"

"No, it just means you'll be working a different angle." He points to a side of the pole that needs smoothing. "Go for it."

He assumes that I've been paying close enough attention to his hands and not only his words. Tentatively, I mimic a scooping motion at a slight angle to the grain of the wood. Nothing happens. "You have to press," Luke says, arms folded in front of him.

I press harder. The chisel slips.

"Like *this.*" Luke pulls the tool from my hand. Slowly, he shows me the motion again. "Now you."

I try again. This time, I manage to smooth out a small section of wood, but it still doesn't look the same as Luke's cut. I look up. "Keep trying."

I press on. But I'm sweating, which is making the chisel harder to hold. And even though I'm barely making any progress, my forearms are starting to shake. Later, when I watch the footage, I notice that my tongue is pressed into my upper lip, a totally mortifying sign of my intense concentration.

Perhaps noticing my discomfort, Luke is ready to acknowledge that we aren't getting anywhere. "I'll take over," he says. *Thank God.* I hand back the chisel and resume my place as interviewer.

The title of Luke's pole? *Epistemological Conundrum.*

I think often of this early moment in our collaboration. At the time, I was stunned by Luke's generosity in treating me like another one of his students, casually stopping by to chat and learn. At the same time, I was uncomfortable at what it meant for my hand to have touched his work and to have done so poorly. Part of this discomfort surely stemmed from a lingering sense that anthropologists shouldn't intervene too much in the processes they are studying. But reflecting on this experience now, I think it was also a deeper disquiet at being made accountable for this work, and vulnerable to it, feeling the surface of this shared work on chisel's edge. Several years later, when this pole was loaned for an exhibition at an art gallery on the North Shore, I felt a thrill knowing that I had left a mark on its surface and that this mark was invited.

The finished work itself tells an ambivalent story about the role of Euro-North American education in Indigenous lives, as well as its discursive mediation. The upside-down eagle on the bottom signals that this piece is a shame pole, while the three stacked figures represent Indigenous students, wrapping their arms around themselves protectively as they are caught between ways of knowing. In this way, the pole's figures witness the violence of a genocidal education system; yet like Parnell's other archivally inflected work, the pole resists the revelations and redemptions of a trauma narrative, choosing instead to implicate viewers – primarily Indigenous students at the AGP – as witnesses to this history.

Doubling and inverting the eagle, Parnell plays with expectations of "reading" a pole hierarchically and de-monumentalizes the form through its relatively small scale at nine feet tall. This scale also enables witnessing: like *Phantom Limbs*, the ability to regard the work at eye level positions its polarities of shame and pride in relation to our own embodiment of this conundrum. It witnesses the shame caused by this system and, in the context of an art school, stands as a reminder of education's capacity to do so. In my own witnessing as participant-observer to Luke's practice, it was equally important to mark that I was there.

As Parnell's work connects a contemporary and reflexive critical Indigeneity to both settler and Native regimes of value,[55] collaborative work with artists who are knowledgeable about Western art theory draws upon debates in the art world around collaborative practice: notions of intervention that emerge out of a similar found imaginary. It is worth considering these ways of thinking about collaboration, especially if contemporary anthropology is to acknowledge fully its shared lineages with Western art worlds and seek to activate these connections. These debates parallel and reveal shared and divergent assumptions about the effects of collaborative practice and help to clarify what some of these values are and why.

ART EFFICACIES

In art history and art criticism there are multiple registers and notions of art doing things. Much like the various strands of collaboration in anthropology that attempt to enable ethical action and approaches of engagement, the networks of artworks and art-making have become a crucial site for recent practices in art history, criticism, and curatorial practice.

There is widespread recognition among many practitioners of similar desires to (1) engage and intervene in colonial relations of power; (2) contest and overturn the limits of modernist disciplinary relations; and (3) realize the potential of artwork and exhibitions to intervene into neoliberalist regimes of value and utility. Art historian and critic Claire Bishop glosses these multiple social practices and modes of exhibition as a participatory art "in which people constitute the central artistic medium and material,"[56] and she argues that its recent institutionalization in projects that engage so-called relational aesthetics have histories that must be acknowledged and situated in other lineages of critical modernism.[57] The range of these projects is great, and their often polemic theorizing cuts to the heart of questions about how collaboration may be marshalled to enable art as emancipatory project.

There is much overlap with critical anthropologies in how these relations have been theorized as collaborative and politically effective. Much of Marcus's writing on the found imaginary of networked, collaborative fieldwork relations draws upon participatory art practices, giving the sense that the art world has been equally transformed by this shift in mis-en-scène. Indeed, Bishop also confesses that her ambivalence and suspicion about social practice as not really constituting art was transformed through her experiences of working with artists and conducting research on the lineages of participatory art,[58] which reveal her own gradual complicity. This shift suggests that something perceptible has also changed for the mediators of art and culture, rendering collaboration a possible strategy for disciplinary transformation and emancipation, as well as for the production of new knowledges and recognitions of alternative experiences and practices of modernity.[59] These are the same hopes and desires of which collaborative anthropologies speak.

This space and hope are also crucial for art schools, where the techniques of evaluation are taught and practised. As a graduate of the master's program in applied arts at Emily Carr University, Parnell knows that his work is legible within these frames as well as within Indigenous histories. Aspects of social practice and political resonance, invoking audiences and networks not present in public critique or in the classroom, are part of its contemporaneity as much as they also form a critical Indigenous knowledge, such as its distinctly Haida and Nisga'a registers of art and the objects' capacities to do things. His work circulates through these parallel regimes of value, and like many successful Indigenous artists, he is able to negotiate and manage stereotypes deftly and engage both market and community-based connections between ethics and aesthetics.[60] The terms of collaboration, then, may not be set only by anthropology's distinctive histories or only in community-based protocols; there may be other networks and affinities that are present and meaningful, and it is worth examining these shared values of collaborative practice in and between art and anthropology in more detail.

PROCESS AND UNCERTAINTY

Based upon the literature on the intersection between art and anthropology, and on my conversations with curators who work across these fields, the value of process – often opposed to product or formal concerns – emerges as a salient idea. In their recent work exploring

the productivity of artist-anthropologist collaborations, for instance, Arnd Schneider and Christopher Wright emphasize "open research design processes"[61] as a useful import from artistic studio methods. Recent frameworks of anthropological "experimentation,"[62] which are often based on notions of assemblage drawn from science and technology studies and Latourian actor-network theory, are similarly process oriented.[63] In such approaches, the means by which knowledge is produced and assembled – a process that may include non-human actors – are foregrounded, as is the instability of the research object. Anna Tsing connects this flexible strategy to the necessary value of the shifting and contingency in fieldwork as a means of destabilizing research questions and expectations.[64]

Similarly, in participatory art, it is often the ephemerality of the art practice that critics and artists value as a non-commodity form and a means of transforming consciousness, if only for the duration of the performance or practice. In his analysis of collaborative art practice, Grant Kester identifies three effects of this shift for art world practitioners: first, the value of process over form raises questions about what constitutes art; second, destabilization becomes desirable as part of an ethic of collaboration; and third, meaning is located in the process itself rather than in a stable object, all of which require social scientific methodologies that focus on process for their elucidation.[65] Notably, Kester connects the value of process to contemporary political uncertainty, keenly felt by artists and critical intellectuals, which gives rise to a dual "sense of possibility, and imminent threat"[66] – an aesthetic of uncertainty and non-closure that Marcus also identifies as being central to collaborative and anthropological art practices.[67] Indeed, these aspects of uncertainty might just as aptly describe the crisis of representation in anthropology. These shared grounds of the contemporary and its destabilizing of representation are precisely why there is talk of rapprochement. Likewise, in the world of contemporary art, we might see an analogy with the ongoing blurring of the roles of artist, audience, curator, and critic – a structural change that is often perceived as a central aspect of this crisis as well as an opportunity for revising both institutional practices and power relations inherent in representation.[68]

There is a subject-making aspect to process and uncertainty in collaboration that warrants emphasis. In their analysis of collaborative projects in northern British Columbia, Menzies and Butler argue that disorientation and disappointment – both effects of privileging community protocols over Western academic notions of freedom – are productive rather than limiting. Specifically, in their words, such an approach "has the potential to facilitate the scholarly growth of more engaged and considerate students";[69] this collaborative subjectivity is necessary for future research and decolonizing transformation, even and especially as this kind of engaged research may be at odds with broader disciplinary theories or interests. Indeed, such work asserts the primacy of process and the rigorous, albeit locally inflected, forms of knowledge that emerge from a collaboration. In my own fieldwork, I witnessed many public events in which anthropologists and art historians defended and marked the ethics and rigours of such research, acknowledging their accountability to particular communities and attempts to conform to Indigenous protocol. As Paulette Regan has argued, this conscious discomfort is tied to what she calls "critical hope," adapted from the anti-oppression work of Paolo Freire.[70] As an aspect of unsettling settler privilege

through research, critical hope is a coming to terms with settler identities that uses feelings of unsettlement and helplessness, anthropological and otherwise, in the service of rebuilding trust and critical consciousness – and that discomfort can, in fact, be productive and necessary to collaborative endeavours. In its valuing of process and uncertainty, then, such subjectivity is based upon a suspicion of objectification and a self-conscious deferral of authority in favour of what can be known through the processes of uncertainty itself.

It is tempting to position this research subjectivity as epochal. Indeed, this moment of uncertainty, and especially the self-conscious embrace of that uncertainty, seems much like the one in contemporary art that Kester describes as a programmatic adherence to the avant-garde notion that "we must endlessly prepare our subjectivities for political action through a deferred aesthetic reeducation."[71] Kester warns how a pro forma engagement can, in fact, produce a profound disengagement, foreclosing meaningful political action via its deferral. I see this deferral taking place in many forms in the Canadian context: in official rhetoric of reconciliation and resetting relations between First Nations and settlers, and projects that are bureaucratically elaborated and deferred or misrecognized through ever more precise measures of loss and calculations of repair (see the afterword).

This potential of collaborative paradigms to ignore what matters in favour of paranoid knowing – an endless elaboration of reifying protocol – is why I am cautious about asserting a clear coupling between advocacy and collaborative practice in which collaboration is seen as being more fluid and flexible, yet no less accountable. As I have been arguing, the idiom of collaboration for contemporary artists does not only come from an ethic of redress. It draws upon traditions and lineages in the art world and also upon more intimate community-drawn forms of objectification in complex ways. In the next section, I elaborate on anxieties in art worlds and among anthropologists about collaboration as a way of getting at these alternate sources of collaborative ethics and accountabilities.

ANXIETIES OF COMPLICITY

The values shared between art-based and anthropological discussions of collaborative connectivities build on and produce forms of political consciousness and particular research subjectivities. In spite of their local resonance, these same values of process and uncertainty also produce disciplinary anxieties about the ontological status of collaborative work: Is this work anthropology or advocacy? Is it art or activism? These anxieties are suggestive of the aforementioned ambivalence in both fields about efficacy and the dialectic of either/or; they are also, I suggest, a site where we see the unsettlement of a local research situation by the Indigenous cultural politics and sovereignties that rupture settler certainties and claims to territory.

As a researcher attempting to build upon the philosophies, methodologies, and complex histories of co-production, I was positioned to notice how these anxieties play out on both sides of the art/anthropology spectrum. For instance, at a local conference on art and Indigeneity, the transdisciplinary conversation among First Nations and Native

American artists, anthropologists, and art historians was continually brought back to the problem of how to ensure that the cross-talk had a life beyond the space of the conference. Conference participants voiced these concerns in two ways: first, via a critique of the museum that was hosting the conference for endlessly generating ephemeral conversations about decolonization that still had few material consequences for Native communities; and second, by making suggestions about alternative spaces wherein participants could continue the conversation, extending the life of the discussion through time. Both of these responses express concern through a language of effects: a desire to make tangible and lasting the accountabilities and connections that emerge from collaborative thinking.

Theorists in art and anthropology are similarly concerned with collaborative depth and the superficiality of its politics and effects. For instance, Menzies and Butler note that a danger of short-term community-based collaboration in anthropology is that it may result in a kind of "cultural tourism,"[72] drawing an implicit distinction between the lack of accountability of the tourist and the deep, slow-building connections of long-term fieldwork. Likewise, many critiques of artists' uses of ethnographic techniques, and of participatory art strategies more generally, have focused on the superficiality of their effects, expressing ambivalence about the lasting social intervention of relational aesthetics.[73] Yet there is also the overall discomfort that research or artwork that is too effective, too oriented towards producing desired outcomes, and too beholden to community interests runs the risk of becoming something other than disinterested scholarship; it is "advocacy" or "social work," according to the anthropological position previously mentioned. It is also in danger of becoming something other than art. Specifically, for critics and art historians, when artists try too hard to intervene in social relations, art risks giving up its aesthetic autonomy.[74] Autonomy is seen as a value that is much like the tension embodied in the position and claims of the semi-distanced and semi-autonomous participant-observer. Moreover, these anxieties are related: both signal insecurities and instabilities about judgment, about the criteria we use to identify rigorous scholarship and significant art. Critics grasp for terms to contain a history that is newly recognized as unruly, while anthropologists scan the found imaginary for grounds upon which to collaborate and new means by which knowledge might be co-produced via rapprochement.[75]

Reading and listening to art world treatises against the collaborative and the participatory, I was first struck by this concern over art and anthropology's autonomy and effects as a mere recapitulation of one strand of purifying Kantian aesthetics, which claims aesthetic experience as an autonomous domain that is separate from social life. Both anthropologists and Indigenous artists have challenged this mode of compartmentalization, insisting instead on the embeddedness of Indigenous art in social relations, which also works to destabilize the Romantic model of singular genius by distributing the relations of production and consumption.[76] In Northwest Coast art history, this purifying narrative has worked in complex ways. For instance, the idea of the singular genius master carver, a masculinizing rhetoric that circulates broadly on the art market, is simultaneously undermined by

various structures of apprenticeship and co-production that take place in both Indigenous and non-Indigenous art schools, and even by the routes of materials; wood for totem poles, for example, often travels through many hands, and the stories of its crafty acquisition and arrival are an important part of art-making.

Autonomy is also an anxiety worth exploring, for the particular danger of slippage, at least in art, is named. In her critique of participatory practices that involve audiences as producers, Bishop draws a compelling parallel between the values of art projects and cultural policy that links art production to bureaucratic "demonstrable outcomes"[77] – an instrumentality and objectification that most anthropologists would not wish upon their collaborative practices and with which every anthropological museologist or anyone who has received funding for a public performance or exhibit has had to contend. This instrumentalization is the point at which a locally grounded and appropriate ethic and aesthetic becomes a bureaucratic protocol. Claiming autonomy in the realm of art, then, is sometimes meant to fend off this appropriation.

Perhaps this appropriation is why the museum became the problematic site in the crosstalk between art and Indigeneity, in addition to its colonial legacies. As an institution bound up in complex ways with the settler state, the museum produces objectified practices (protocols, guidelines, rules) that are instead now debated, situationalized, and elaborated. What I suggest in the remainder of this chapter is how understanding the work of contemporary Aboriginal artists – and understanding collaboration itself as a source of knowledge – requires that we resist making assumptions about effects, or about bureaucratically desired, pigeon-holed outcomes, or about what an idealized collaboration might look like. In such work, the protocols that emerge out of community-based collaboration do not provide the only ethical statement. There are other sources and histories that are drawn upon in shaping collaboration, including concerns about autonomy that need to be taken seriously.

COLLABORATION AS FORM

Recent accounts of collaborative fieldwork point out the multiple ways in which knowledge in Americanist anthropology has always been co-produced, often through unexpected networks that include missionaries, artists, and other non-anthropologists.[78] On the Northwest Coast, for example, Judith Berman has reassessed the complexity of the central collaboration between Franz Boas and George Hunt to reveal the multiple modes of identification, voices, and ideas presented in the Kwakiutl texts. Far from being straightforward objects of salvage, the texts reflect how both Boas's and Hunt's proclivities shaped their form.[79] Aaron Glass has extended this complex reckoning of multiple agencies to the material world, examining how some objects were commissioned for didactic purposes rather than as documents of a mythic "Golden Age" of Northwest Coast art.[80] And most recently, all have worked on a digital edition of Boas and Hunt's work, recontextualizing Hunt's corrections and emendations within protocols around access,

generating a critical historiography while restoring Hunt's authorship.[81] Such projects assert Indigenous agency amidst complex and shifting colonial power relations; rather than heralding rapprochement, they document rupture and complexity in the ways that knowledge is produced. In this way, they have much in common with contemporary art practices that seek to unsettle how we know what we know by explicitly drawing on a network of relationships. As a way of concluding, I return to *Phantom Limbs* in the context of Luke Parnell's art practice and collaborative experiments as a particular local case that makes these relationships explicit.

NORTHWEST COAST "BILATERALISM"

As I hope is clear by now, the discursive histories of art and knowledge production on the Northwest Coast are such that Indigenous and settler epistemologies are entangled, enmeshed in co-productions that mediate between anthropology and art. This observation is not to dismiss the important political work of disentanglement, of asserting Indigenous epistemologies and sovereignties as alternatives to and of modernity.[82] Rather, reflecting on the entanglement itself – the shared sources of knowledge, the desire to rewrite histories in ways that do not naturalize the modernist terms of their production – may be regarded as another kind of ethical practice and, I suggest, a way of sharing ground in fieldwork that does and should feel tenuous and uncertain. It is also why co-production matters and is visible in the blurring of roles among artists, curators, and critics; between art and anthropology; and in the texts that mediate and document co-production. Crucially, these discursive resources are often themselves ephemeral: the pamphlets or didactic panels accompanying a show or limited-release exhibition catalogues are difficult to find. These resources circulate widely among artists and anthropologists alike, at least for a limited time frame. Suzanne Morrissette has argued that such eclectic sources as the catalogue "document art practice in the making and stand in opposition to texts that have historically been written to demote Aboriginal artistic production."[83] In attending to this discursive production – something that Parnell does in his art practice as much as I do in my anthropological writing – shared touchstones are identified as the potential ground of collaborations that proceed from local sources of knowledge.

The sources and destinations of art are also under scrutiny. Recent anthropological work on the Northwest Coast has emphasized the tensions between secrecy and shared intracultural and transcultural revelation in both Indigenous artwork and cultural politics. This emphasis has extended to collaborative aesthetics, taking the form of cultural policy – how to mediate between different worldviews regarding appropriate access, for instance – and other expressions of regional anxieties about circulation and efficacy. It is tempting to see in such anxieties an analogy with unwillingness to engage in actual politics (endless bureaucratic mystification through a discourse of preservation) at the expense of reckoning with other uncertainties of First Nations sovereignty. But, as I show throughout this book, this dialectic between concealing and revealing is also itself a fundamental aspect of

much First Nations law and social practice. Its objectification in theory might be read as a co-produced form, stemming from an engagement with formalism, postmodern aesthetics, and Indigenous law. These complex interrelationships, referred to as lineages, do not dilute the significance of this dialectic.

Parnell is interested in these lineages, particularly in the play between anthropological and art historical formalism as well as immaterial privileges, those aspects of culture that he terms "intangible wealth." In his critical writing, which challenges the stability of the categories of artist and anthropologist, Parnell explores the narrative expectations of "Northwest Coast art" as a co-constructed category. He repurposes the term "bilateralism" – a formal term for adherence to symmetrical design – to describe dual histories of Northwest Coast art and his own ability to use a highly recognizable visual language through his "binary practice" that values the intangible without giving too much away.[84] Responding to aesthetic philosopher Clive Cazeaux's reading of Plato's metaphysics, Parnell explains that, when an Indigenous artist "creates an object with little or no thought to the cultural or historical value of the tradition they are using, they are creating an 'apparition of the truth' or a mere representation of the essential form."[85]

Parnell's theorizing of bilateralism to intervene into metaphysics is striking and somewhat ambivalent. It appears to bolster an ethnographic interpretation of art and critique of formalism in which the tangible and the aesthetic only have meaning insofar as they embody intangible and profoundly cultural referents. Yet Parnell's rather cheeky use of a formalist term for this process of cultural meaning highlights his reflexive strategy, showing the value that Indigenous formalisms – documented, translated, and co-produced – have come to possess. Indeed, this ambivalence prefigures the act of burning a carved eagle, the ritual that Parnell stages in his 2018 film *Remediation*, which repairs the urge to salvage something that may never have been lost while insisting that the *real* thing worth saving is not contained in its effigy. Working beyond essentialism, Parnell's bilateralism is a way to navigate the risk that knowledge will be appropriated. In this way, it is a formal translation of dynamics of secrecy and revelation that are also anthropological, using this co-produced analysis as a strategy for contemporary art.

According to these bilateral criteria, authorship matters in a way that is different from the attempts of participatory practice to obliterate the traces of individual genius and its relations to the commodity market. Indeed, as Parnell has pointed out to me, while sharing labour is common practice in First Nations art-making – particularly in carving large-scale works like poles – it does not mean that the work has been collectively authored. Rather, the signature of the initiating artist or "master carver" is important to maintain and not subsume under a "third hand."[86] The collaborative aspect of the work, then, does not revoke particular power relations and social structures and does not challenge "master" authorship as the criterion of value for contemporary Northwest Coast art. Indeed, totem pole carving is not "participatory art" or even collaborative art as imagined by most theorists. But I think it is important to consider co-production another trajectory of this found imaginary, distinct from community-initiated research and telling us different things through its complex intersections with contemporary art.

Indeed, like *Phantom Limbs*, contemporary carving is connective according to Indigenous criteria. Parnell and I do not always agree about what is most important – I tend to favour the intercultural and he the culturally particular – but our dialogue is just as likely to draw upon shared art historical touchstones, including *Arts of the Raven*, a 1967 exhibition of Northwest Coast art as "art" rather than "ethnography," the potlatch ban as a difficult and damaging time, and the experimental movements of Dada and Fluxus, as it is to touch on issues of protocol. In the conversations we recorded, we both felt as though we were producing a public document, something that could be shared, that could work bilaterally across many publics. And this public commitment is perhaps also the crux of *Phantom Limbs*. As contemporary art and a document of the tangible relations of collaborative practice, it is meant to circulate.

POLITICS OF RETURN

Forty-eight figures encased in glass, witnesses to a specific repatriation, draw past and present together along the axis of collection that connects British Columbia and New York. *Phantom Limbs* is contemporary art not only because of its complicities with art worlds and anthropologists at a specific moment of networked practice but also because the specificities of the return matter. It should be apparent by this point that I am suggesting the need to attend to these matters, concerns that are specific to an Indigenous art world in a particular place that has been shaped by (and shapes) a particular found imaginary of collaborative practice (or previous lack of collaborative practice). I have illustrated why and by which histories the mutual influence has developed amidst anxieties over objectifying relations through cultural policy and through a commitment to art that unsettles. Participatory practice or social practice – or whatever we wish to call these post-studio, community-based art practices, the histories and effects of which are currently being written – overlaps in significant ways with anthropological values of collaboration. And these networked notions of knowledge production also influence material practices and objects that are not only residues or documents of performance but also contain within them privileges and connectivities that are beyond those imagined by much of the art world.

Crucially, collaborative work makes apparent these criteria and the networks and relations out of which they have been formed. The Transforming Image Project, for instance, can be a crucial revision of rigid formalisms as much as it is a source of inspiration for young carvers. Conscious practices of sharing research and knowledge are another such source. Not merely a gesture of good faith, such sharing is a way of being accountable to these histories, of critically and reflexively acknowledging the processes of knowledge production that have characterized this market and its formalisms from the very beginning. Indeed, bilateral practice is both participatory and performative.

I have attempted to account here for some of the terms of participation and the histories and disciplines that have generated them, as well as the uneasy terms of revising these

histories in light of the contemporary moment in which complicity is foregrounded according to multiple lineages in art, anthropology, and beyond. What is my role as an anthropologist in this mise-en-scène, in the found relations of the art market and collaborative imaginary? I can say with some certainty that it is not to stage a triumphant rapprochement, building on the bodies and knowledge of Americanist collaborations. As a participant-observer positioned in a complex set of ways – settler, critic, archivist, teacher, writer, and co-conspirator all being relevant aspects of this position – I am charged with expanding what collaboration can be; looking for guidance, yes, within the Americanist tradition of museum anthropology but also in other models that inform the practices of artists who are my contemporaries in all the senses of that word.

CHAPTER THREE

Across the *Beat Nation*

Four lowrider bicycles stand, static and upright, supported by their kickstands. Each one is painted – white, red, black, yellow – to match their respective rectangular pedestals. In formation as if to pitch forward, they invite us to picture riders who will launch them, fringe, fur, and formlines flying from the plinths and out of the gallery, onto the street. Titled *Anishnaabensag Biimskowebshkigewag/Native Kids Ride Bikes*, this 2012 formation is the Northwest Coast iteration of Métis artist, activist, and scholar Dylan A.T. Miner's ongoing social practice project of the same name. These particular bikes were produced collaboratively in a workshop in 2012 by four Vancouver-based (then) emerging Indigenous artists – Jeneen Frei Njootli (Vuntut Gwitchin), Trevor Angus/Tka'ast (Gitxsan), Julian Napoleon (Dane-Zaa Cree), and Gabrielle Hill (Cree and Métis) – who interpreted the four colours associated with the sacred directions of the Medicine Wheel to embellish each lowrider.

For almost a decade, Miner has worked with Indigenous youth living in cities across Turtle Island to build custom lowrider bikes. Fully mobile, the bikes are tied to the knowledge of local Elders and Indigenous language speakers who contribute to the workshops and to their places of making. Miner conceives of the project as generating an autonomous, non-capitalist space for Indigenous youth to gather and learn skills, with the bikes themselves, although visually stunning and fully functional, as remains of the practice. "We must be cautious to not focus on what is being made, but rather on the actual process of making and with whom we are doing this work," Miner writes, emphasizing that the bikes are merely a tangible form of what he has theorized as his "methodology of visiting" in which visiting and making as shared social activities take precedence over things.[1] The bikes also connect to Miner's theorization of "lowriding," which he uses as a metaphor for Indigenous sovereignty that is enacted through slow and deliberate movement, including seasonal migration.[2] For Miner, lowriding, like visiting, is both a temporal and spatial intervention into the presumed boundaries of colonial states and the frenetic pace of 24/7 capitalism.[3]

These particular "material remains of visiting"[4] have also had an afterlife that involves their own share of travel and connect to my own methodologies of moving through the spaces of the art world. Displayed in *Beat Nation: Art, Hip Hop, and Aboriginal Culture*, a major travelling exhibition of contemporary Indigenous art co-curated by the Kathleen Ritter and Tania Willard (Secwepemc) at the Vancouver Art Gallery (VAG), the lowrider bikes travelled from Vancouver to Toronto, Kamloops, Montreal, Halifax, and Regina from 2012 to 2014. An expansion of a much smaller exhibition held in 2008 at the grunt gallery, an artist-run centre in Vancouver, *Beat Nation* focused on hip hop culture and its visual, sonic, and material forms as markers of urban Indigenous identities. In a review for *C Magazine*, Lisa Myers noted the show's exhilarating tenor: "From my punk rock perspective," she wrote of the Vancouver installation, "stomping on a distortion pedal and hitting a heavy chord on my guitar gives me a similar lift to experiencing the work in *Beat Nation*."[5] Sprawling and immersive, *Beat Nation* showcased the work of twenty-eight Indigenous artists from across North America – from New Mexico to Nunavut and from Labrador to Alaska – working across photography, sculpture, painting, video, new media, and performance. The show became, in the words of one Indigenous curator I spoke with during the exhibition's run, a "juggernaut," forging forth across urban centres. In this larger context, the lowriders indexed a history of movement and migration – a challenge to settler expectations of static Indigeneity – while giving a sense that the *real* movement was beyond the gallery, located in the practices of making the bikes ready for revolution rather than display.[6] Indeed, the political moment of *Beat Nation*'s journey, which spanned the rise of Idle No More and Occupy social movements, anti-pipeline action, and protest of the Conservative government's omnibus Bill C-38 threatening lands and waters, added to this sense of potency.

This chapter revisits *Beat Nation* and its remixing of urban Indigenous cultural politics during a moment of tempered optimism – a moment in which, I argue, the contemporaneity of Indigenous cultural production became visible to broader Canadian publics. Situating this important exhibition and its work in its contemporary context, I explore the problems and paradoxes of displaying "remains" of practice in a gallery. These tensions intersect with the larger problem of institutionalization, as grassroots practices and artwork move from artist-run centres into larger galleries, and the space of exhibition risks becoming a space for containing political struggle.[7] Many of the artists, activists, and curators that I spoke with during the show's run shared these anxieties. Relevant here, too, is the much larger theoretical question of what happens to work as it circulates and how it is or is not enlivened by its repetition or re-enactment in new sites of display, as documents or remains of participatory practices like Miner's testify to other things that do not happen in the gallery – the sense of "lift" that Myers identified.

Apprehending these moments of activation around *Beat Nation* is another test of writing criticism that stays close to and refuses to resolve or reduce the multiple materialisms embodied in this exhibition – among them, attention to labour and what remains of it, to what is durable in an installation beyond its particular moment.[8] Tracking back and forth between my experiences around the exhibition and its retrospective assessment, I am

interested here in registers of collaboration beyond the "contact zone" of exhibition production and also in registers other than those suggested by the "participatory turn" in contemporary art. What are the efficacies imagined as exhibitions travel, as itinerant artists and critics transform the meanings of work through their words? How does "participation" – as I explore it here, a particular and contemporary fantasy of efficacy in the art world – include places, publics, and politics beyond the gallery or studio? Finally, if we as witnesses are open to the possibility of prophecy – a crucial aspect of Indigenous hip hop and, I will argue, of *Beat Nation* itself as a reparative and future-oriented exhibition – what kinds of spiritual efficacy do artworks themselves embody for their makers and movers?

In what follows, I explore these questions and issues by examining *Beat Nation* as an embodiment of political hopes around the contested categories of contemporary Indigenous art, focusing on the kinds of participation that the exhibition has enabled as it moves. I argue that its material components – didactic panels, performance regalia, immersive video works, to name just a few – are meaningful not only as artworks that expand on the exhibition's thematics but also as documents of connectivities that exist beyond its immediate gallery space. Tracking back and forth between anthropological and art critical modes, I explore how these forms of documentation and connectivity work to unsettle the category of "contemporary art" that is taken for granted in the space of a gallery. I show that important aspects of its contemporaneity – its connectivities – are located elsewhere, beyond the space of the gallery, and not only in political struggles. Part of my travel across major urban "Native hubs"[9] in Canada, which coincided with parts of *Beat Nation*'s tour, allowed me to witness some of these connections as they emerged or were reaffirmed, since artists and curators also travelled to participate in public openings and events, generating a network of "itinerant artists" that is characteristic of contemporary exhibition and biennial culture.[10] This travelling is another form of movement that connects with Miner's notion of a "methodology of visiting," as well as with the everyday intimacies and convivialities involved in the work of return – the "lift" that *Beat Nation* generates.

ELECTRIC OPENINGS

The beat thumps its way through the former courthouse on a Friday night and reverberates in our bodies as we navigate its crowded rooms. I am with Lisa and her partner, as well as our mutual friend, the artist Luke Parnell, and Luke's cousin, and we are all seeing *Beat Nation* together at the Vancouver Art Gallery. I cannot capture in my written notes the electricity in the air, the heat and neon thrum of Duane Linklater's glowing Thunderbird as it tinges the room red, or the rhythmic and repetitive fury of Nicholas Galanin breakdancing on-screen to a potlatch beat. Site and space are literally marked: Galanin has carved "Indians," the motorcycle logo font, into the pavement outside the gallery, while Maria Hupfield's performance space, jumping in her jingle boots, is marked with an "X," inviting visitors to face her projected image – a looped video entitled *Survival and Other Acts of Defiance* (2012) – and join in the jumping. As we move into the gallery's video projection

space, A Tribe Called Red's distinctive genre of "powwow-step" fills the room, turning Bear Witness's montage of scenes of Hollywood Indians into a mix that Lisa describes as "exhilarating." In those first moments, *Beat Nation* seems less like an exhibition and more like a party, shattering any pretenses of art's austerity with an insistent immersion.

I can still feel the memory of electric bass in the air as the beat thumped its way through my body, rhythmic and repetitive, and the heat from the crowds on opening night. Filling the entire second floor of the art gallery, the exhibition's organization itself draws on its subject matter for its categories. Works are grouped into four thematic categories – "the beat," "the stage," "the street," and "the tag" – all of which are media-based and spatial referents as well as cultural ones. For instance, as the curators explain in their exhibition essay, "the stage" refers to the literal site of performance, but also of ritual, as "a space of possibility for alternate identities."[11] Across the categories, artists ranged widely across nations and media, from well-established fine artists – photographer Dana Claxton, installation artist Brian Jungen, performance artist and painter Kent Monkman, earthwork and language-based conceptual artist Marianne Nicolson, Surrealist painter Lawrence Paul Yuxweluptun – to emerging and earlier career makers and emcees, including Jackson 2Bears, a Kanienke-haka multimedia artist, KC Adams, an Ojibway/Cree artist whose work explores sculptural hybrids, and Mark Igloliorte, an Inuk artist who projects video work onto a skateboard deck alongside minimal sculpture.

The exhibition's conceptual categories slip easily into one another and beyond the gallery – "the street," obviously, is a key site of tagging, as Galanin's contemporary petroglyph outside the VAG attests – and individual works fit more than one thematic category. Marianne Nicolson's twelve-foot-high petroglyph, *Cliff Painting*, a site-specific work that can only be seen from the water in Kingcome Inlet, British Columbia, is brought into the gallery via a large-scale photograph, making a visual connection between different kinds of tags. Raymond Boisjoly's *an other cosmos* series (2012; Figure 3.1), which layers Haida imagery over photographs from the Hubble Space Telescope in a complex alignment with moralities and album motifs of Afrofuturist music collective Parliament-Funkadelic, is classified under "the beat," although it also seems like a cosmic tag. This slippage has an expansive effect: the complexity of urban Indigenous youth culture is spatially marked by categories than cannot contain their works, as the shifting beats pull the body of the viewer through these spaces, suggesting both coherence – lands, water, and space are connected as locations of culture – and disjuncture: we are made aware of what is *not* in the gallery as much as what is.

That night in Vancouver I was also struck by the self-conscious witnessing that the space provokes as an assemblage of materially powerful works that articulate an absence – the still texture of Hupfield's felt jingle boots visible in a glass case, Skeena Reece's performance regalia mounted to suggest how it is worn. When we arrive at Jordan Bennett's *Turning Tables*, a pair of working turntables that juxtapose a wooden record of Bennett learning Mi'kmaq with one playing the natural, scratchy sounds of wood grain against needle, I turn to Lisa: "We've seen this before at A Space Gallery in Toronto, right?"

"Yup," she says. "I think it was also displayed at Urban Shaman in Winnipeg."

Figure 3.1. Raymond Boisjoly, *an other cosmos* (2012). Inkjet prints, plexiglass. Image courtesy of the artist and the Power Plant. Photograph by Toni Hafkenscheid.

"But couldn't the visitor *mix* the sounds at A Space?" We both look at the plinth under the turntables: DO NOT TOUCH.

I find out later from co-curator Kathleen Ritter that this message, a block to the immersion critical to Bennett's work, was made by the VAG's curatorial team in response to their anxiety about showing Bennett's delicate work in a large public gallery. But in that moment, Lisa and I felt its significance as an objectifying practice, a loss of meaning as the work and exhibition were detached from smaller venues. If a visitor is no longer implicated – as listener, a sympathetic DJ who can choose to drown out or highlight the regimented awkwardness of language lessons, to soothe the static of Bennett's voice with wooden sounds – then what happens to the artwork? Detached from its intended function, what does a work meant to "turn tables" between maker and viewer signify? And what is assembled when documents of performance are displayed as permanent features of an exhibition?

These are all questions that speak to the problem of "remixing" an exhibition whose political resonance matters. As it has travelled across the country and through a variety of media, *Beat Nation* has become a capacious frame for understanding contemporary Indigenous art and experience more broadly; the danger, expressed by many of the artists and curators I spoke with, is that, in its remix, this frame obscures more than it reveals as it acquires more power as taken-for-granted representation, bolstered by corporate and government funding. Yet reflecting at a distance upon *Beat Nation* and the social movements with which it intersects, not least of which was a self-conscious shift towards Indigenous programming in major Canadian institutions,[12] these tensions strike me as important

sources of animation for the exhibition. In what follows, I consider components of this remix: first through some of its object- and institutionally focused debates; then through the exhibition's reception; and finally, in relation to a particular framing of its efficacies as prophetic.

GLOBAL DIALOGUES

During the Vancouver run of the show, I also witnessed some of the backstage of *Beat Nation*'s transformation from grassroots project to blockbuster show through two related projects: first, as a participant in a Global Dialogue – a category of exhibition-related event held at the Museum of Anthropology at the University of British Columbia and the Vancouver Art Gallery – with the knowing title "Remixing Art and Indigeneity, Again"; and second, from an archival perspective in grunt gallery's *Activating the Archives* initiative to document performance and public events related to the artist-run centre's happenings. Both were contexts of reflexive judgment: the first, a present-oriented symposium that used *Beat Nation* as a catalyst for thinking about remix aesthetics in Indigenous contemporary art;[13] and the second, a past-looking attempt at assembling the ephemera or residues of display practices. They represent different kinds of institutionalization-in-process and revealed anxieties about what might be lost and gained in the movement of *Beat Nation* into the mainstream art world.

For instance, during the Global Dialogue, much discussion and debate focused on the VAG exhibition's promotional poster. A close-up shot of the artist Skeena Reece's face, the poster was a posed still from her performance entitled *Raven: On the Colonial Fleet* (Figure 3.2), which she first performed at the Sydney Biennale in 2010. Reece's gaze is defiant, and the image, cropped just below her bruised shoulder, reveals parts of her futuristic, volatile regalia; the rest of her outfit's components – a corset decorated with *Laqaqua'sa* or double-headed serpent motifs[14] and AK-47s, a dance apron embroidered with a weapon-throwing Thunderbird, and a button blanket with a glittery grenade on its back in place of a family crest – were displayed inside the gallery. In the cropped image, Reece also wears a dance headdress normally reserved for men, adding a gender-bending effect of "sacred clowning"[15] that Reece uses to characterize performance practice. Confronted with the circulating image, however, Reece raised the initial question of why the Vancouver Art Gallery had chosen her image to stand in for *Beat Nation* during its promotion and, indeed, the run of the show: a one-storey-sized banner hung from the VAG's back entrance, facing the public square that was a well-established site of protest.

To me and other attendees, Reece's pointed question articulated concerns about the image of a visibly bruised Indigenous woman now circulating on buses, the source of violence made even more ambiguous by cropping out the combat-ready regalia. Willard, one of the show's co-curators, explained that she was struck by and wanted to circulate Reece's strong female gaze, adding that "we also wanted to use an image that was an artwork itself, rather than just a picture *of* an artwork or artist." A posed performative image of the

Figure 3.2. Skeena Reece, *Raven: On the Colonial Fleet* (2010). Performance documentation, courtesy of the artist; performance regalia: feathered and beaded dance headdress, painted corset, dance apron, sequined robe and boots. Collection of the Vancouver Art Gallery, Acquisition Fund, VAG 2017.10.1 a-i.

"fe/male warrior"[16] seemed to resist the easy access of documentation. As viewers, we are forced to confront a *knowing* performance and witnessing of pain alongside the irreverence of Reece's *détourned* regalia on her terms. Unlike the other photographs of Native women that circulate in urban space – photos of missing women or glamorized drug-using "heroines"[17] – we are reminded that this image both is and isn't a contained work since it also documents a larger performance and indexes an international biennial.

Remixing art and Indigeneity in back rooms of the art gallery has become a standard practice. Those of us participating in the Global Dialogue had all previously experienced the "contact zones"[18] of critical museological space, meetings of conflicting worldviews where power is both shared and reinscribed, and we clung to small moments of honesty as signs of collaborative spirit. Skeena Reece's shared discomfort was such a moment, weighted by history (Reece was an original curator of *Beat Nation* before the show moved out of artist-run centres) and cutting across the Indigenous/non-Indigenous alliances that are often assumed or substantiated in such meetings. Sitting in that particular back room at the VAG, I was struck by the difference between the tensions inherent in trying to think critically with an exhibition and the other kinds of co-constructed meetings that the exhibition enabled: on one end, the massive and transient parties, an essential component of globalized contemporary art practice; and on the other, the less public, more ephemeral collective action enabled in making and thinking about *the art*, rather than just the exhibition as object of analysis, which is so easily deconstructed in critical museology.[19]

These tensions, I suggest, point to an important dual characteristic of *Beat Nation*'s articulation of histories and futures: it was both uplifting and deeply unsatisfying, even as it intervened into canonical understandings of Indigenous contemporary art, since much of the work it attempted to contain took their meaning from the pieces that happened in other kinds of spaces. This duality meant that *Beat Nation* was resolutely not some kind of easy redeeming of the VAG's colonial histories and presents. As Haidy Geismar has argued, the category of "contemporary art" is often taken for granted in museological assemblages that frame such work as a kind of self-evident salve to colonial institutions of display.[20] Indeed, *Beat Nation*'s use of the frame "contemporary Aboriginal art" – the use of "Aboriginal" in place of "Indigenous" as its connective category now sounds quite jarring as political categories have shifted – is notably undertheorized in the exhibition, as the fact of assemblage itself is presumed to adequately speak for and justify what this category is. And I wonder now if the category of "Aboriginality" does a kind of work that "Indigeneity" does not by figuring identities in relation with the Canadian state's terms, thus invoking a *direct* confrontation with the state's limiting terms of recognition. Indeed, it is Aboriginality, *not* Indigeneity, that Tsimshian/Haida art historian Marcia Crosby argues has been connected directly to issues of land title and figured as a resource.[21]

Such limits and failures are also materialized on a wall of the gallery in the 136 gleaming LPs comprising Sonny Assu's *Ellipsis* (2012), which record the (then up to date) years of the Indian Act. As a linguistic device, an ellipsis records an omission; it also works by implication, prompting a reader to look for contextual clues to fill in what is missing. Cast in copper, Assu's LPs prompt a reckoning with the cultural loss, economic marginalization, and generational gaps produced by this restrictive legislation, while at the same time signalling a personal history of social reproduction through sound: Chief Billy Assu, the artist's great-great-grandfather, who allowed anthropologist Viola Garfield to record Kwakwaka'wakw ceremonial music in order to preserve it for future generations who will keep the score.[22]

Beat Nation's particular focus on sound is also gendered in complex and local ways. Vancouver has long been an urban hub for influential Indigenous women in the arts,[23] and *Beat Nation*'s largely female production team and broad inclusion of women artists from across the country – a participation that is at odds with more misogynistic strands of hip hop culture – might also be read as a landmark in this capacity, reconstituting urban space in ways that are attuned to the gendered violence of settler colonialism and logic of conquest.[24] In *like a boss* (2012), for instance, Reece's performance at the opening night of *Beat Nation*'s Toronto run, she donned a carved Marlon Brando mask as a homage to the actor's 1973 refusal to accept his Academy Award due to the film industry's exploitation of Native Americans. In the performance, Reece embodied both Brando as Vito Corleone and Sacheen Littlefeather, the female Apache actor and activist who spoke on Brando's behalf. This play with gender and voice presences an act of white-Indigenous solidarity as it exceeds expectations of what it means to be a boss, a likeness that is not just carved and gendered male.

Moreover, the frame of urban space in the exhibition enables enquiry into Aboriginal women's roles in marking their presence in cities and on land, while at the same time drawing attention to what Crosby refers to as the "lines, lineages, and lies, or borders, boundaries, and bullshit" of settler colonial modes of reckoning Indigenous belonging in urban landscapes.[25] As J. Kēhaulani Kauanui has argued, settler colonial legal and property regimes are often designed in ways that standardize and quantify claims to identity and thus fail to encompass how many urban Indigenous people experience the linkages and *commitments* between multiple places.[26] In its articulation of modes of being that are resolutely mixed and trouble the equation of landscape and nation, *Beat Nation* stages the problem of how urban Indigenous space might be evoked otherwise, as an expansive meeting ground for new sincerities, solidarities, and an emergent aesthetic of resistance.

DIGITAL "DECENTRING" AND ARTIST-RUN CULTURE

In thinking about its political resonances beyond the gallery, I find it is also relevant that *Beat Nation* started in 2008 as a youth-oriented performance and digital initiative of the grunt gallery in Vancouver, an artist-run centre. *Beat Nation*'s original website, which is still maintained, was curated by Tania Willard, a Secwepemc artist, designer, and activist, and Skeena Reece, a performance artist of Tsimshian and Cree descent, as part of a Canada Council Aboriginal Curator residency.[27] The idea had come from Glenn Alteen, grunt's long-time non-Indigenous director, who had worked with Willard and Reece at the popular Native youth magazine *Redwire*; Alteen also produced the project. Setting the tone for subsequent iterations, the *Beat Nation* site was meant to bring together a wide range of Indigenous cultural production influenced by hip hop culture, making their presence visible for a wide audience through the site's audio-visual potential. Showcasing performance, music, and spoken-word forms of cultural production alongside visual art influenced by hip hop,

the site's key significance was its potential as, in Reece's words, a "massive documentation process" of urban Indigenous experience that could not be contained in a typical gallery space or archive.[28] Later, due to mounting interest, Willard and Reece installed a physical version of *Beat Nation* at the artist-run SAW Gallery in Ottawa in 2009 as part of the *BC Scene* showcase of British Columbia's art world, displayed at grunt in Vancouver later that year. *Beat Nation* also became a recognizable frame for performances through arts programming, including the PuSh International Performing Arts Festival in Vancouver – all artist-run, grassroots venues for showcasing art.

These multiple, early recontextualizations, as well as the primacy of the website form, suggest how compelling *Beat Nation* was for publics beyond the confines of a small artist-run centre or gallery; from its beginnings, *Beat Nation* provided a prescient way of thinking about contemporary urban Indigenous art *beyond* visual culture, highlighting ephemeral acts and their residues as forces to be taken seriously. In a *Canadian Art* interview in 2013, Willard described the early project as "immediate" and "flexible,"[29] signalling a responsiveness that is possible in digital space but requires some translation and compromise to work in a more permanent venue. This work of translation is important because it explains some of the hesitation around circulating the exhibition. To this end, an "artist-run centre" differs from other public gallery spaces, which helps explain some of the counter-cultural force that *Beat Nation* brought from its early days – as well as some of the constraints of working from these alternative locations. The all-lowercase rendering of grunt's name, for instance, marks both precarity and a resistance to authority. Founded in 1984 as an alternative venue for contemporary art, grunt's mandate at the time emphasized "diverse Canadian cultural identity" as a commitment, alongside the mission to "to inspire public dialogue by creating an environment conducive to the emergence of innovative, collaborative, and provocative contemporary Canadian art."[30] Such counter-hegemonic, dialogic identity is typical of artist-run centres[31] in Canada, and grunt's history in the mid-1980s maps directly onto this sort of institution's deeper roots in the history of contemporary art. Indeed, grunt's programming has been strongly shaped by tenets of critical postmodernism and postcolonial critiques, as well as the desire to create new pedagogical models that engage diverse publics – community members alongside art world constituents – as significant interlocutors in the production of meaning and value. "Artist-run culture," an everyday language around the arts in Canada, captures this constellation of beliefs and practices, drawing attention to the deliberate marginality and provocation of these formations as "decentring" practices.[32]

In Vancouver, this "decentring" has taken a particular form, shaped by the social and cultural conditions of unsettlement. In spite of their non-Native ownership, institutions like grunt have had to contend with the realities of inhabiting unceded territory. Due to its location in East Vancouver, a part of the city that has historically been home to many working-class and Indigenous residents, grunt shares space with many Indigenous organizations. As Kristin Dowell has documented in her history of Aboriginal media in Vancouver, grunt officially changed its mandate in the 1990s to highlight contemporary First Nations art in the wake of the Oka crisis, a series of violent clashes between Canadian authorities and Mohawk citizens that had escalated from long-standing settler exclusions and erasures

of the Mohawk Nation's sovereignty.[33] "Oka" refers to the site of one of these standoffs, while "crisis" is the Canadian mass media's term for the threat of (Mohawk) violence; this phrase reduces a multi-sited and historically deep conflict to a single space and moment that seemingly emerged out of nowhere, rather than from complex intercultural histories, settler violence, and Canada's repeated denials of Mohawk sovereignty. Nevertheless, as a moment of mediated consciousness-raising and a forced acknowledgment of Indigenous co-presence, Oka was an important catalyst for centring Indigenous participation in cultural institutions like grunt.

Much of grunt's *Activating the Archives* project was oriented around creating digital archives for Indigenous performances, conferences, and exhibitions affiliated with the gallery. These projects are diverse and include not only *Beat Nation* but also 2002's *INDIANacts*, a major performance art conference that brought together influential figures in contemporary Indigenous art, including James Luna, Archer Pechawis, Nadia Myre, and Rebecca Belmore. Of *INDIANacts*, web curators Tania Willard and Dana Claxton have written:

> This site is an Indian Act in and of itself – a chance to continue the heart journey that was the original INDIANacts: Aboriginal Performance Art conference (grunt gallery 2002) and carry that heart to others who could not attend the conference, but whose own hearts may be ignited by this archive and who can witness this conference through the material within this site.[34]

Their words emphasize how digital content can extend artist-run culture and its sentiments beyond the space of the centre itself, creating what queer literary theorist Ann Cvetkovich has called an "archive of feelings" in which such a shared "heart journey" becomes the stuff of public culture – "material" in both senses of the term, indexing both the collections and its potency.[35]

Yet questions remain about the extent of "decentring" possible in artist-run culture, particularly as it relates to institutional arrangements. Arts funding in Canada is largely provided by national and provincial government institutions, and nowhere is this arrangement more pronounced than in artist-run culture, where a lack of commercial viability is offset by a state emphasis on Canadian cultural value. At the grunt gallery, funding for operating costs and staff comes from a variety of government sources, including the Department of Heritage, the Canada Council for the Arts, and the British Columbia Arts Council, as well as the Audain Foundation, a private foundation with a mandate to promote arts and culture in British Columbia – in other words, a source with similarly regional public commitments as BC Arts and one that also tends to elide key differences in "artist-run culture" under the bureaucratic rubric of patrimony. This approach is echoed in the grunt's own language from 2012 of "diverse Canadian national identity," a curiously settled statement of nationalism given the nature of settler colonial crisis at Oka from which its commitment to diversity stems.

Many contemporary artists also feel this bureaucratic arrangement's underlying structural tensions and expectations, and reflect upon it as a problem in a variety of ways. Most often, they articulated this uncertainty in similar terms as the artist Luke Parnell, who put

this problem starkly to me: "I've been so busy being an artist, I haven't had time to make any art!"

Parnell framed the work of "being an artist" as a professional role that often got in the way of his primary identity as a maker, since filling out grant applications and reports, forming relationships with galleries (and anthropologists), and teaching took time away from his studio practice. This discussion is not to suggest that Parnell resented or shirked his multiple responsibilities – on the contrary, he balanced these multiple roles with fluidity and commitment. Rather, this incompatibility points to a problem in funding "artist-run culture" through state-administered granting programs: the amounts are often so small, and the reporting so elaborate, that the artist is caught in a perpetual cycle of "being an artist" with no time left to actually make works.

I raise this issue because it is also related to the more general problem of being legible as part of "artist-run culture" as a recognizable, fundable entity that brings with it the risk of increased monitoring, particularly when funding is distributed under the rubric of cultural heritage or patrimony. Artists are acutely aware of these constraints, and their own analyses make connections to governmentality. For instance, writing about these bureaucratic conditions in *decentre*, artist Danyèle Alain connects the rise of artist-run centres to increased wealth *and* increased monitoring, noting that "the demands of a technocratic society and technology quickly overtook those [financial] gains. Now more time is devoted to administration than creation."[36] Yet at the same time, in *decentre*'s acknowledgments, the collective editorial board notes that the book "celebrates the 50th anniversary of the Canada Council for the Arts, without whose insight and leadership, its topic – artist-run culture – would hardly exist." The irony of celebration is unmistakable, yet the praise is also sincere.

This ambivalence is even more pronounced for Indigenous artists, who may perceive state-administered cultural policy as a form of colonial governance that threatens Indigenous sovereignty. Importantly, this ambivalence may also be felt even when state governance results in huge gains for artists and institutions. While working in the archives in Thunder Bay, Ontario, a Métis artist, who was also doing research on histories of Indigenous art worlds in Canada, explained to me that she felt like many important task forces and policy documents – for example, the proceedings of the 1990 Task Force on Museums and First Peoples, which has enabled repatriation and increased Indigenous museum sovereignty – are tainted by their connections to Canadian cultural policy and that these interconnected histories are something to be ashamed of; in other words, the important writings and voices of many Native museum professionals and scholars found in many of these documents would somehow be better had they not been commissioned through government initiatives.

In her analysis of Canada's Aboriginal film policy, Dowell expresses related misgivings about the entanglement between Canadian cultural policy and Aboriginal art in Canada, noting that this "paradox" of government funding and Aboriginal sovereignty may generate conflict between Native autonomy and dependency.[37] Yet as Dowell argues, these relations do not necessarily *negate* Aboriginal sovereignties; on the contrary, the bureaucratic entanglement may actually enable self-determination through its legitimizing processes and by converting cultural value to monetary value.[38] Indeed, it is possible to recast artists'

misgivings as an expression of sovereignty due to the negotiations that underlie them – the pride that makes it possible, for instance, to simultaneously celebrate and complain or to perceive task force negotiations as an exercise of mutual recognition.

As I will argue below, the *ongoing* relations between its early forms and its present (and future) iterations are part of what makes *Beat Nation* so significant as a frame for understanding urban Indigenous art as culture and as political praxis. It is important to acknowledge the complex power relations inherent in artist-run culture and to avoid the flattening effects of seeing centres like the grunt gallery as neutral nodes along an even network of art production. This discussion of "artist-run culture" as something managed and mediated has all been to say the following: we should not assume from the outset – as do many people in the art world who regard state funding as a more neutral source of support – that a grass-roots, original, artist-centre version of *Beat Nation* is somehow less contaminated, more pure, than its later forms.

CHANGING THE BEAT, OCCUPYING MUSEUMS

Following its success as performance, website, and small artist-run exhibition, *Beat Nation* was eventually picked up by the Vancouver Art Gallery as a large-scale touring show, largely through the efforts of Kathleen Ritter. Ritter, a non-Native artist who was then curator of contemporary art, had been involved with putting on a *Beat Nation* music program at the VAG and approached Tania Willard about co-curating a major exhibition based on the original project, noting that "the ideas are really current and really strong."[39] Willard agreed to the project and has been enthusiastic in her interpretation of the larger *Beat Nation* as an extension of its early roots. In a statement to grunt gallery for its blog, she emphasized that "it all starts at grunt, where seeds that are always being planted sometimes grow into these beautiful creatures."

Given its connections to *Redwire* and artist-run culture, *Beat Nation*'s appeal for the grunt gallery and a broad Aboriginal audience is evident. But it is not entirely obvious why an institution like the Vancouver Art Gallery, which art world members often derided for its lack of local support and focus on artists who have "made it" elsewhere, would initiate a major exhibition of contemporary Aboriginal art in 2012, especially when many of the artists included in the exhibition were not represented in the VAG's permanent collection (a criterion that is little mentioned but nevertheless has a strong effect on exhibition planning). Processes of exhibition making are often much more opaque and improvisational than deconstructions of "curatorial authority" or memories of these intentions imply.[40] As such, the context for remounting *Beat Nation*, strongly shaped both by the city's economic climate in the wake of the 2010 Olympics and by its convergence with currents in contemporary art theory, is also an important aspect of its meaning beyond curatorial intentions.

Beat Nation opened at the VAG on 25 February 2012. In the autumn of 2011, the institution announced an $886,000 operational deficit for the previous year. Staff in the archive

where I was doing research were dismayed – there was even some debate about how many researchers would be able to access collections in the future – and the VAG spent a great deal of public relations effort trying to maintain public faith in an already dubious expansion plan. Communication theorist Duncan Low connects this deficit to overly ambitious forecasting during the 2010 Cultural Olympiad, the cultural programming meant to accompany the athletic events of the 2010 Winter Olympics in Vancouver.[41] The large-scale version of *Beat Nation* was conceived during this climate, which was much more open to First Nations–focused programming as a form of local cultural tourism.[42] The cross-Canada content of *Beat Nation* would have made it more viable as a statement of Canadian art that would work with the Cultural Olympiad's nationalist agendas.

Amidst these funding anxieties, in October 2011 protestors came together and set up tents in the gallery's public square. The Occupy movement, the international social justice movement focused on neoliberal austerity and corporate control of politics that had been sparked by the government bailout of large US banks following the 2008 subprime mortgage crisis, had come back to Vancouver. The initial call to "Occupy Wall Street" had originated in the summer issue of *Adbusters*, a Vancouver-based anti-consumerist magazine. As a former courthouse and current hub of downtown cultural life, the art gallery was a logical place to gather and one with a history as a site for social movements, including major anti-Olympic protests in 2010 and demonstrations against the Iraq War in 2003. As with most Occupy protests, the city tried many different approaches to evict residents from the gallery square, including the city's bizarre claim that rainwater could seep through tent-peg holes into the VAG art vault below the square and damage the collections.[43] This claim, although refuted as structurally impossible in an official statement by the VAG, continued to be circulated in national media, contributing to the image of the site as a besieged bastion of cultural patrimony, while even refutations invoked images of "dangerous trenching that imperilled valuable art stored beneath the surface of the plaza, and rats on site."[44] Although Occupy protestors were eventually evicted in November 2011 by a BC Supreme Court ruling, the square continued to be marked by a desire for social change and later became the site of a public protest during the Idle No More movement. These political events are inextricable from *Beat Nation*, not least because they are important to so many of the artists showcased in the exhibition.[45]

Situated in this political milieu, *Beat Nation*'s opening was an expression of possibility amidst the lull between protests: an electric and subversive sense of institutional invasion, an occupation of settler colonial space. This contagious, resonant beat is also suggestive of why *Beat Nation* became a "juggernaut": it showcases Indigenous art in a way that resonates with both cultural politics *and* the hedonistic tendencies of contemporary art worlds, participating in the backdrop set by Occupy while bristling against this movement's whiteness. Art historian Terry Smith has called out and criticized this current in contemporary art – a world of art stars, endless celebration, and tepid work dressed up as radical intervention – in his discussion of one strand of contemporary art's monstrous spectacle of surplus value.[46] For Smith, this sort of contemporary art and its parasitic institutional relations are unconscionable; he contrasts them with smaller scale globalizing tendencies and

art movements that preserve real commitments to social relations, such as artist-run centres, and contemporary Aboriginal Australian painting. From this pre–Occupy Museums moment, the large-scale *Beat Nation* actually does both: it provided a corporate-funded spectacle – TD Bank joined the roster of government and BC-based private foundations as a main funder of the travelling show – which produces an image of corporate social responsibility, while also providing crucial space for other kinds of relations and organizing.

Indeed, in addition to the public parties, hip hop battles, and heavily publicized lectures of the touring show, the curators made the decision to include more established and widely collected Northwest Coast artists like Sonny Assu and Michael Nicoll Yahgulanaas alongside the youth-oriented roster that had prevailed at grunt. Michael Audain, head of the Audain Foundation that co-funded the Vancouver Art Gallery's iteration of *Beat Nation*, is a supporter and collector of both artists' work. These connections, although symptomatic of the contemporary art world's spectacle-like interpenetration of art, industry, and finance, are what allowed *Beat Nation* to be experienced on a larger scale. It is a reminder that these worlds – of art and finance, spectacle and intimacy, city and remote community – are connected and that trying to purify these entanglements can easily slide into a renewed primitivism in which contemporary Indigenous art is expected to somehow retain a trace of uncontaminated "outside" to art's other contemporary spectacles.[47]

In showing these expectations and their disruptions, I turn now to an analysis of *Beat Nation*'s reception, both among the people I spoke with and in media responses. Both of these kinds of reception share a concern with what contemporary Indigenous art in Canada is or, more interestingly, what it *should* be. As Tsimshian/Haida art historian Marcia Crosby first argued, to speak about "Aboriginality" as a subject position necessarily invokes a set of proscriptions about ownership, since Aboriginality is legally and epistemologically bound to the problem of land title in Canada.[48] As such, critical judgments about who and what counts in contemporary Indigenous art are also about property and possession. I suggest that these judgments reveal an ambivalence about Indigeneity in Canada that is tied to notions of power and, specifically, to the problem of Indigeneity for contemporary art worlds and their entanglement with settler conceptions of the nation. As Nicholas Thomas has argued, "settler primitivism" is different from its modernist forms because in settler nations the coevalness of Indigenous peoples – peoples' visibility in land claims and political protest, for instance – is apparent.[49] What this co-presence means is that Aboriginality cannot be comfortably relegated to the nation's timeless past and instead becomes an unstable object whose value is continually asserted, debated, and claimed in the space of the nation.[50] In what follows, I consider how both modernist primitivism and settler primitivism are present in critical assessments of *Beat Nation*.

WITNESSING THE WORD: *BEAT NATION*'S RECEPTION

In her curatorial statement for the original *Beat Nation* website, co-curator Skeena Reece expands on issues of access behind the framework of hip hop:

> Where can Indigenous expression be seen? Or perhaps a better question is where can it NOT be seen? Mainstream television, blockbuster films, radio stations, government structure and even buildings themselves. The de-saturation of Indigenous expression is a sign of colonization. For some people a pencil and paper are the only tools seen as available to document the expression of oneself. The common denominator is spoken word. Thus, Indigenous hip hop is widely accessible and crosses over cultural barriers. What are they saying? What are they doing, and how is this impacting the world community?[51]

Reece's statement on the power of hip hop to make conditions of contemporary Indigenous life visible and vivid resonates strongly with other Indigenous intellectuals' accounts of the role of cultural producers in uniting diverse publics. Anishinabek scholar Dale Turner has described this role as being a "word warrior," by which Indigenous intellectuals "must work to ensure that indigenous ways of knowing are not devalued, marginalized, or ridiculed."[52] Reece echoes this sentiment in her emphasis on the importance of the "spoken word" as a powerful form of expression, one that is enabled by hip hop's accessibility as a popular genre.

"Word warriors" and their genres may also be at odds with the dominant forms of knowledge represented by the "pencil and paper," particularly as Indigenous expressive culture encounters the detached rhetoric of Western art worlds. There is a powerful model of interpretation in art criticism in which the critic produces knowledge through an encounter with an artwork, rendering this interpretation. Obviously, some voices are privileged in interpreting work, and disinterested criticism objectifies tangible, *legible* things, detaching them not only from social and cultural worlds but also from the *words* of Indigenous artists, which are dismissed as being too close or perhaps even too belletristic to represent real criticism.

During the Vancouver run of *Beat Nation*, a docent was guiding a tour group around the exhibition and paused at Skeena Reece's regalia. To my astonishment, rather than mentioning Reece's performance in *Raven: On the Colonial Fleet* – which has a long and international art history, having been originally performed at the 2000 Sydney Biennale – she delivered a monologue on the materials of the regalia and their meaning, noting the status-based associations of ermine furs on the Northwest Coast and the central role of the button blanket as a women's art. None of this detail was technically incorrect. But the docent's failure to acknowledge those other potent cultural symbols – the AK-47s, the corset, the glittery grenade – missed the point. Coupled with the already disembodied effect of performance wear being held up on a faceless, formless mount, the guide's words reduced Reece's regalia to its material components, and only those that were legible within the context of Northwest Coast form.

Such modernist primitivisms are well documented in the anthropology of art and museums.[53] Anthropologist Shelly Errington argues that many "tribal" or "non-Western" objects must be fit into the teleological assumptions of art history as usual lest they "embarrass the categories"[54] and that this problem has become more fraught as art history has self-consciously embraced globalization as a process with art historical relevance. Criticism is the process of writing meant to make this categorization happen, to smooth the transition from ceremonial context to the space of art, to purify the ermine furs as ritual materials into aesthetic ones.

But this purification is a real problem for contemporary art engaged with globalization, as Reece's work is. The meaning of a work like *Raven: On the Colonial Fleet* depends on these routes of colonial encounter and the contradictions of value that are embodied in its materials and provocation as performance. This is why the docent's decontextualized reading of Reece's regalia, while attentive to a certain kind of materiality and meaning, is incomplete. Its failure to register these routes at a material level serves as a reminder that forms of primitivism can and do persist in pedagogical modes, even when its subject is resolutely urban and contemporary.

With this caveat in mind, media responses to the touring version of *Beat Nation* were overwhelmingly celebratory across a wide range of news outlets, including reviews in mainstream papers like the *Vancouver Sun* and alternative publications like the *Toronto Standard*. *Cult MTL*, an online news source, called the Montreal version of *Beat Nation* "the best art show of the year," and the *Kamloops Daily* heralded the exhibition as a "brilliantly immersive experience for the viewer." Writers for more serious critical publications also unequivocally praised *Beat Nation*. In her review for *C Magazine*, for instance, Lisa Myers highlighted the diversity of Indigenous experience represented in the show, noting that "the artists in *Beat Nation* make art that asserts, both conceptually and aesthetically, nuanced details of histories and everyday life from varied perspectives."[55] Based on these reviews, the massive scope of the show was one of its most effective attributes, as the sheer volume of urban Native cultural expression contributed to the effect of immersion.

As well as praising *Beat Nation* for its sprawling vision, several of these reviews commented on the exhibition's ability to provoke reflection about the relationship between contemporary art and traditional forms of Indigenous culture. These binaries were most often listed in pairs: "traditional vs. modern" (*Kamloops Daily*), "the rural with the urban" (*Cult MTL*), "pop culture and Aboriginal traditions" (*Toronto Star*). Such reviews use these supposedly opposing cultural forces to produce tension. Because they are listed but never synthesized, these antinomies themselves become explanatory devices rather than points of departure for asking *how* these different aspects of hybrid works are resolved (or not). The review and, by extension, the artwork is left to signify only through the listing of these tensions.

I draw attention to this rhetorical move because, I suggest, it is a reductive one that brings primitivist discourse back into the space of contemporary art. In doing so, I do not mean to take away from *Beat Nation*'s obvious importance and impact but rather to consider the broader implications of terms of criticism that predominate in mainstream assessments of Indigenous art shows. By casting these discursive pairs as opposing forces, such reviews further essentialize each of them, leaving their unlikely juxtapositions to be written off as a mere quirk of postmodernism. There is also a temporal logic implied by this critical strategy that is related to what Johanna Drucker has called the "complicit formalism" of contemporary art,[56] which she argues is a quality of much contemporary art whose materiality performs and celebrates its relationship to the market. Drawing on Gregory Crewdson's flawlessly produced *Twilight* series of photographs, which are as beautiful and seductive as a fashion magazine editorial spread, Drucker interprets such works as guiltless assertions of their own artifice and consumable qualities. Referring to these qualities as a kind of "complicity" that

breaks from the political tenets of critical modernism, Drucker views Crewdson's practice as "emblematic of the twilight of resistance aesthetics."[57] Further, she argues that this complicity itself makes contemporary art "fresh" (and, one infers, refreshing).

One could hardly argue that a similar kind of complicity is present in *Beat Nation*'s overtly politicized works and contexts. But I suggest that Drucker's arguments about the complicit and formalist emphasis of much contemporary art *is* bolstered in critics' reliance and emphasis on the binary pair in describing *Beat Nation*. Indeed, these oppositions are rendered as timeless, self-explanatory, "fresh" qualities of the works themselves, rather than ideas *produced* by specific and tangible histories of art as it intersects with lives. Put another way, "the contemporary" can be irreducibly coeval, as these temporal and meaning-based categories co-exist in the present moment and in Indigenous art, but the coevalness is ahistorical and therefore still allochronic and distancing.[58]

Yet in spite of the formalism enacted by these binaries, the narrative of struggle that underlines these pairs – the "vs.," the trope of "intertwined yet conflicting worlds" (*Kamloops Daily*), and even the startling image of "hijacking" (*Cult MTL*) in relation to Indigenous art's use of pop culture symbols – arguably draws upon contemporary politics for its rhetorical force. *Beat Nation*'s tour – and reception – coincided with the rise of major, visible, and unsettling Indigenous social movements and "Native unrest" in Canada, including the Attawapiskat housing emergency and the Idle No More movement. With a few notable exceptions, this context is mostly submerged in *Beat Nation*'s reviews; yet it is also present, I suggest, in the aesthetics of struggle around meaning that permeates even the most celebratory responses to the exhibition. It is as if listing the antinomies sets them aside, exorcises them, or uses them as the irresolvable justification for breaking both literal and cultural blockades by representing culture in conflict *as* Native life. "Struggle" becomes a defining narrative of Indigenous contemporaneity, an ongoing state of conflict and crisis that is just a short logical jump away from narratives of failure that require state intervention.

These primitivist and settler colonial logics are not the whole story because these antinomies and conflicts are also *felt* as such by many of the Native artists with whom I worked and cannot be written off as mere false consciousness. They are real, inasmuch as they are subjectively experienced. Indeed, in one of the most nuanced reviews of *Beat Nation*, Indigenous writer Christian Allaire represents these binaries as personal conflicts felt from his position as a self-defined Native youth. For Allaire, the immersive qualities of the show are overwhelming and inspire reflection on "whether I have deviated too far from my ancestry or, like many others, adapted it in various ways."[59] As Allaire catches a glimpse of himself in the reflective surface of Maria Hupfield's Mylar emergency blankets in her work called *Space, Time, Interface* (2011), he connects the work to the 2011 state of emergency due to inadequate housing and freezing conditions in the Northern Ontario community of Attawapiskat, where Chief Teresa Spence would soon go on a hunger strike to protest the government's refusal to meet with her. The Harper government's appalling response to the state of emergency declared by Spence was to order an immediate audit of community spending as a condition of aid.[60] This sombre political moment, materialized and made personal in the bunched reflective surface of Hupfield's blankets, causes Allaire to wonder

about consumption in opposition to more politicized responses to conditions that give rise to hip hop culture, and he poses the question of "whether I am a youth purchasing a Jay-Z album or a youth sporting a sequined grenade on my back."[61] Tellingly, the glittery grenade provokes Allaire's only reported smile; the weight of the show is felt as a reflection on guilt, longing, and frustration rather than as a party.

Crucially, in casting the "conflict" as irrevocably related to politics, Allaire's response presents a very different experience of "hybridity" than its critical reduction to antinomies allows, although the language of conflict is also present. As the show travelled east, *Beat Nation*'s socio-cultural framing changed in relation to the nascent Idle No More movement, and these changes were registered in both reviews and programming around the exhibition. In the next section, I will argue that this political context became an integral part of *Beat Nation*'s meaning and that these interpretations present an alternative understanding of struggle, tension, and even hybridity to those implied by the critical tenets of complicit formalism.

POLITICS, AESTHETICS, AND IDLE NO MORE

By the time that *Beat Nation* opened at the Power Plant in Toronto on 15 December 2012, the tensions embodied in the previous year's housing crisis at Attawapiskat, and the Canadian government's racialized policies of audit that brazenly privileged control of land and resources over both aid and Indigenous sovereignty, had mounted. For many non-Indigenous Canadians, the crisis had made life on reserves newly visible, and there had been many editorials descrying both the deplorable conditions of the reserves and the perceived mismanagement of government funds by Indigenous nations. I do not have the space to fully represent this complex media climate, but overall non-Native public response deployed both sympathy and settler amnesia in a familiar and racist script about irresponsible Native spending and band corruption. At the same time, this narrative was almost immediately overwhelmed by Indigenous media networks that tried to clarify the complexity of issues involved in the crisis. One of the most widely circulated and detailed responses of this sort, widely shared on my Facebook newsfeed and the topic of many conversations I had with artists on the Northwest Coast and in Ontario, was a blog post by Métis-Cree teacher Chelsea Vowel under the alias *âpihtawikosisân* (half-son). In her post, entitled "Dealing with Comments about Attawapiskat," Vowel patiently explained the unique limits that the Indian Act places on reserve spending in contrast to other non-Native municipalities, such that the federal government does *not* fund education, health care, or social services on reserves. She also explained the elaborate system of Canadian government monitoring that makes it difficult for bands to exercise their right to self-governance as *structural* impediments rather than failures of leadership. In it, the author emphasizes the value of responding to painful settler misconceptions:

> Above all, my relations, don't let it get you down. You will see people call for the abolition of the Indian Act, for the abolition of reserves and the "assimilation" of First Nations into

"Canadian society." You will see horrible things said about aboriginal culture. What you will rarely see are people responding to facts. Don't be discouraged when facts are brushed off in favour of accusations. We *do* have the power to educate those around us, and even if we can't reach the most vocal of bigots, we can reach the "average" Canadian who is merely unaware rather than necessarily outright hateful.[62]

Following this post, many other Indigenous intellectuals began to contribute similarly nuanced accounts of the crisis, as well as other structural explanations of Indigenous poverty, violence, and social justice issues, highlighting the ways that settler demands for accountability – for example, of band spending in the crisis – evade these much larger explanatory frames.[63]

This crisis and its many responses represent a shift in the mediascape for Indigenous issues in Canada. Even though pundits have continued, in various ways, to advance the settler arguments that Indigenous social issues stem from a fundamental incapacity of First Nations peoples to self-govern, these views have become increasingly untenable in the wake of Attawapiskat. Moreover, when Idle No More took hold as a social justice movement in the autumn of 2012, many non-Native Canadians were eager to join the inclusive organizing, likely as a result of the spotlight on contemporary Indigenous issues that the previous year's Native activism had generated.

According to its official history, "Idle No More" started as a hashtag on Twitter (now X) for opposing the subtle environmental policy changes in the Canadian federal government's omnibus budget Bill C-45, although the movement traces its roots to "hundreds of years of resistance" starting in the sixteenth century.[64] Indigenous activists opposed Bill C-45 due to the treaty-impacting changes it was smuggling in as an omnibus piece of legislation. In particular, the bill would eradicate the Navigable Waters Act of 1882, removing government protection of small bodies of water and, as Chief Steve Courtoreille of the Mikisew Cree Nation pointed out, "giving industry open season on our territories."[65] On 10 November 2012, the movement was officially consolidated by four Indigenous and non-Indigenous women in Saskatchewan – Nina Wilson, Sylvia McAdam, Jessica Gordon, and Sheelah McLean – who organized a teach-in about the legislation and called it "Idle No More."

Since the autumn of 2012, the movement grew in Canada, with visible protests in all major cities and solidarity across the border, as many Native Americans and their allies also joined the movement. It is also not without opposition. Several of the artists I worked with expressed their concerns that it was too large a frame for Native issues in Canada, which tend to be regionally specific – there are very different problems facing urban Indigenous youth than those on reserves, for instance. Others were adamant that the movement harmfully glosses over real band corruption in its focus on structural problems, a focus that was no doubt shaped by the response to Attawapiskat. Finally, many artists and non-Native art world members objected to the implications of the word "Idle," correctly pointing out that Indigenous resistance in Canada has *never* been idle.

My sense of *Beat Nation*'s travel as meaningful visiting was also amplified by these changing political circumstances. Notably, around this time, the Idle No More social movement also started to be specifically referenced in media reviews of *Beat Nation*, even in

relatively conservative publications. For instance, in the dealer-run publication *Blouin Art Info*, Matthew Ryan Smith notes that the exhibition is both "urgent" and "timely" in reference to Chief Spence's contemporaneous hunger strike.[66] Allaire's nuanced review in the *Toronto Standard*, discussed above, directly referenced Idle No More, pointing out the irony of the movement's traditionalism in the face of the contemporaneities proposed by *Beat Nation*, while also emphasizing the timeliness of the youth-oriented focus of both projects. Overall, these responses and dialogues speak to the unintended transformations of meaning that exhibitions may have as they travel, even as curatorial prerogatives and form remain constant. This transformation of *Beat Nation* into an immersive backdrop for contemporary Native social movements also demonstrates that "the contemporary" is never fixed and that complicit formalism is actually impossible as a mode of apprehending work whose meaning is located beyond the gallery.

A "FOOTNOTE TO JAMES LUNA"?

The final kind of response to *Beat Nation* that I want to consider is that of contemporary artists and critics aligned in some way with Indigenous art worlds. By this, I mean people who have a stake and interest in Indigenous art in Canada, either from their vantage point as Indigenous public intellectuals or non-Indigenous commentators with a commitment to and situated knowledge of this work and its histories. Indeed, it would be disingenuous to deny my own complicity and commitment to *Beat Nation*'s effect. When I first started talking about co-writing a long-form piece of art criticism on *Beat Nation* with Lisa Myers, who had already written a glowing and thoughtful review of the Vancouver installation that we had attended together, we were both disheartened by the Toronto iteration of the show, which lacked the vitality of the Vancouver version. There was something lackluster about the display, and works from the Northwest Coast, in particular, seemed more like decontextualized museum objects than embodiments of histories, lineages, and sovereignties. Perhaps it was also that the grassroots qualities of the collaborative projects were less obvious and less immediate. Miner's bikes, for instance, were still the ones he had made in Vancouver with emerging local-to-there artists Jeneen Frei Njootli, Trevor Angus, Julian Napoleon, and Gabrielle Hill. Moreover, their maker was listed solely as Miner, eclipsing the evidence of the collaboration in favour of the Power Plant's insurance policy.

This lack of energy was particularly disappointing for me and Lisa because we were worried that it would force us to write a predictable lament on how grassroots artist-run culture is misappropriated and transformed for the worse by large corporate art galleries. Lisa was also concerned that, if we criticized the show on these grounds, it would be making a negative statement about contemporary Indigenous art more broadly – essentially, that *Beat Nation* was less of an infiltration than a selling out – and that this argument could be applied metonymically to all Native art everywhere. We were both concerned about the effect that our words would have on value judgments and funding opportunities in communities to which we were committed. From my standpoint as a settler outsider, my

attachments in the Indigenous art world felt tenuous at best, and I didn't want my criticism to harm the political momentum of the exhibition.

Our negative evaluation of the Toronto *Beat Nation* was also amplified by a comment made by another, much more prominent, curator. This person dismissed *Beat Nation* as a mere "footnote to James Luna," invoking the Luiseño artist, well known for his performance and installation work, to condemn *Beat Nation*'s contents as derivative and of relative unimportance. After reflecting on this assessment, Lisa and I were uneasy about our own authority to speak about *Beat Nation*. We truly felt that we were at an impasse, and after half-hearted proposals to art magazines, we abandoned the writing project.

I share this experience of a cancelled collaboration here because I think that it expresses some important things about fieldwork relationships in the anthropology of art, about the politics of "visiting" and writing on contemporary Indigenous art, and about what the "James Luna" comment might have been about. These problems are significant to the politics of collaboration in contemporary art more broadly, related as they are to anxieties about efficacy, the presumed effects of works and words on behaviour or on culture.

First, although it was likely intended as a dismissal, the curator's comparison of *Beat Nation* to Luna is also generative. As art historian Jennifer A. González has argued, Luna, who died in 2018, has had a huge impact on installation art since the 1980s, including his most famous work, *The Artifact Piece* (1987–90), for which Luna displayed his own body and personal belongings in museum vitrines at the San Diego Museum of Man.[67] As González documents it, Luna's influence, along with that of contemporaries Fred Wilson, Amalia Mesa-Bains, and other artists who drew on their racialized identities in the service of institutional critique, is undeniable as a significant insertion of racial politics and social critique that altered the terrain of installation art – an infiltration, to use Lisa Myers's term, that has had an effect.

González's argument provides a nuanced rendering of mutual influence and entanglement in this submerged history of installation. However, because she defines these artists' identities as racialized ones, she is unable to fully grapple with the implications of Luna's practice in settler contexts, where Indigeneity is only *partially* reckoned according to the state's racial terms, oriented towards elimination through blood quantum. Luna has been so influential precisely because his work plays with these terms of identity and expresses an uneasiness with the limits of both race and "hybridity,"[68] an equally essentializing category for his work that González interrogates but does not quite dismantle due to her commitment to privileging race as the most significant marker of oppression and belonging. Nevertheless, the important point is that there is something about Luna's intervention that is fundamental to installation art as we know it: it is the way in which his work brings an outside context and set of social relations and practices to bear on the space of the gallery – histories and lineages are *felt*, both playfully and with the potential for condemnation.

What happens, then, if we take that critic's comment on influence seriously and regard *Beat Nation* as a footnote to a powerful practice of installation? We can see the continuity with the reflexive and problematized hybridity of Luna's work, as the multiple signifiers that many of *Beat Nation*'s artists deploy draw on many traditions and make similar

Figure 3.3. Raymond Boisjoly, *an other cosmos: disaggregation* (2012). Inkjet prints, plexiglass. Image courtesy of the artist, Catriona Jeffries Gallery, and the Power Plant.

provocations. Indeed, the sense in which many of the works feel like archival relics or documents of a process that happened elsewhere merits a comparison to Luna's self-conscious interrogation of artifacts. The many responses to *Beat Nation* that I have analysed here are also a testament to its effectiveness as installation – a display that challenges the viewer in some way and resonates beyond the white cube. But things *have* changed since the 1980s, which make the metaphor of a "footnote" ultimately historically inaccurate, especially in the ways that these connectivities have come to be understood as social or relational practice.

For instance, Raymond Boisjoly, whose *an other cosmos* project (Figures 3.2, 3.3) I mentioned previously, conceives of his "hybrid" appropriations in rather different terms. In

a conversation with me, he explained his multiple influences as points of shared under-standing and intervention, including the Afrofuturist symbols and Swedish Black Metal cultures he draws on for their politicized, future-oriented, and in many cases, essentialized aesthetics. Boisjoly identifies these points of encounter in his work as solidarities rather than appropriations. Hybridity for him is not some "hybrid soup"[69] that neutralizes its compo-nents, but instead it identifies points of intersection and the *limits* of appropriation – in this case, moving beyond confining notions of identity via speculative space-time travel. Indeed, *Beat Nation* may be seen to propose a kind of participatory practice that is both indebted to and divergent from both identity politics as practised by Luna *and* distinct from the vision of participatory projects in contemporary art.

HIP HOP AS PROPHECY

In this final section, I turn to the emcee Ostwelve's words, spoken in conversation with Reece:[70]

> The system wants us to destroy ourselves, the system wants us to destroy ourselves, and they've used our own system of expression to do it, they've basically got us to enslave ourselves with the drug dealers, and the pimps, you know, and the murderers, and the social housing units, and it just perpetuates itself. So hip hop has a healing within it, but it's been coated in poison. So we have to repatriate that healing spirit in which it was started.

Placed in the context of *Beat Nation*'s resonance with broader aesthetic and political dis-courses, the significance of his metaphor of "repatriation" is palpable. It encompasses the sense in which the show's Indigenization of hip hop stages a return of consciousness, a sense in which the circulation of expressive forms enables healing from cultural loss and the multiple connectivities, solidarities, and sovereignties that are involved with this return. Such returns resonate with the words of the nineteenth-century Métis activist and spiritual leader Louis Riel, often quoted in relation to Idle No More – "My people will sleep for one hundred years, but when they awake, it will be the artists who give them their spirit back" – invoking the power of art to enact social change.

At the same time, repatriation is always a fraught process, one that is contested through intercultural dialogue that emphasizes property and propriety. Duane Linklater's work *Migrations* (2012), positioned alongside the music listening station and new media works in *Beat Nation*, speaks to this problem of misappropriation. Via stark black vinyl letters on a white wall, the text-based work remixes objectionable lyrics of mainstream hip hop tracks, including Jay-Z's popular *Girls, Girls, Girls*, one of whose verses refers to an "Indian squaw" who tells us that "all you need to know is I'm not a hoe, and to get with me you better be Chief Lots of Dough." *Migrations* interrogates the propriety of hip hop as a genre and warns that gendered oppression might "migrate" into the mix alongside its form. In these ways, "repatriation" indexes some of the objectifications, problems, and possibilities involved in aligning urban Native culture with conscious hip hop.[71]

While it is beyond the scope of this chapter to elaborate on the intricacies of *Beat Nation*'s genre sampling, I conclude with the possibility that hip hop as repatriation also provides a generative space for thinking about the future. In his analysis of the contemporary Indigenization of global hip hop, T. Christopher Aplin argues that the genre is an important form for articulating religiosities that defy "expectation" in their blending of secular and spiritual referents.[72] According to Aplin, Christian messages in Indigenous hip hop are about asserting religious ownership – a kind of spiritual sovereignty that refuses to separate Indigenous religion from contemporary Christianity. Coupled with Karyn Recollet's understanding of Indigenous hip hop in Canada as "aural" traditions that use wordplay and sampling to articulate activist sentiments,[73] this interpretation is compelling in relation to Ostwelve's comparison to repatriation: an assertion of ownership through the circulation and play of cultural property.

Near the end of the interview that Skeena Reece did with Ostwelve for the original *Beat Nation* site about the emcee's views on conscious hip hop, she asks Ostwelve whether he thinks there is going to be a "Second Coming"; in her abrupt question, Reece is vague on what she means by "Second Coming" and whether it conjures a religious revival or hip hop renaissance. Ostwelve responds that yes, he does think that a Second Coming is imminent, but he does not elaborate on the follow-up question of what such a movement might look like. Reece then provides her own answer to the question:

> I feel, like, personally, maybe listening to a speaker, I don't remember who he was, he's an old school guy who goes around doing conferences with hip hop, and he talks to a lot of the old school hip hoppers, and they talk about it as a government system, and that it is legitimate social grouping ... that has its own language, that has its own culture, and that it should be legitimized in what it outputs to the world, and that it should be legitimized within governmental systems and taken very seriously. And acted upon, in some cases. Because a lot of these hip hop songs are not just songs, they are codes of action. And I feel like that's the next step, personally.

Reece's words articulate many of the truths about *Beat Nation*'s deployment of hip hop and urban youth culture that I have documented here: the primacy of performance and exhibition as social, connective acts and their capacity to provide "codes of action" and "outputs," and their efficacies as forms of public culture.

Returning to Miner's work, I am struck by how the ontology of lowriding, "visiting," like fieldwork, is both intimate and time consuming, and may also be politically charged. Miner emphasizes both the connections and discomforts between different places in his personal history, as well as the different "routes" of Native activism, drawing explicitly on Chicana feminist activist Gloria Anzaldúa's theorizing of borderlands as spaces "wherever two or more cultures edge each other ... where the space between two individuals shrinks with intimacy."[74] To me, the challenge of this encounter was visceral: in Toronto, for example, the gallery felt charged by Miner and artist Bonnie Devine's public talk, enacting a methodology of visiting, as Corey Bulpitt and Gurl 23's graffiti mural *Raven Fin Whale* sampling the emcee KRS-One – "There can never really be justice on stolen land" – provided a resonant

backdrop. In this way, the gallery itself felt like a significant stop along Miner's trajectory of lowriding, making "visiting" a meaningful and lasting metaphor for connecting around art.

For all of its translations between emerging social movements, Indigenous art histories, and the art worlds in which these connections are forged, *Beat Nation* was an exhibition that articulated what "the contemporary" means in conversation with urban Indigeneity as a subject position and lived experience. Indeed, as an exhibition that spanned across many territories, *Beat Nation* was meaningful not only as an assemblage of artworks that expand on the exhibition's important interventions and themes but also as documents of the connections that exist beyond immediate gallery space, even when these reveal the limits and effects of participatory practice and its uncertain effects on the future. Skeena Reece's imagining of hip hop as a future-looking form, a Second Coming, perhaps, of Indigenous governance, also resonates with the hopes and dreams of Idle No More as a movement that will awaken sovereignties and religiosities that are not hybrids but draw upon multiple solidarities. This interlinked potency is why *Beat Nation* continues to matter, even as its meanings and methodologies have shifted through its travels.

CHAPTER FOUR

Cultural Resources and the Art/Work of Repair at the Freda Diesing School

In the autumn of 2011, a delegation of Indigenous leaders from the Northwest Coast arrived in the city of Beichuan, China. Travelling under the auspices of a larger "Native trade mission," the delegation, which included Shawn Atleo, then national chief of the Assembly of First Nations (AFN) in Canada, celebrated recent Indigenous participation in Asian markets, including a First Nations–run grain management group in Dalian, and possible partnerships with mining and mineral management companies in Beijing and Chengdu.[1] Yukon Regional Chief Eric Morris, who was in charge of the AFN's portfolio for economic development, expressed this potential for First Nations to "play a constructive role in helping China meet its vast food and energy needs and providing finished products made in our communities."[2]

In Beichuan, this trade also involved a specific art-based transaction: the raising of the China Friendship Pole, which teachers and students at the Indigenous-run Freda Diesing School of Northwest Coast Art in Terrace, British Columbia, had carved to commemorate the massive 2008 Sichuan earthquake. Nearly a third of the Qiang Indigenous population had died in earthquake-induced landslides and flooding in the mountain valley; following the disaster, Qiang lifeways were at risk both from the devastating loss of life and from relief programs that did not include plans for cultural preservation.[3]

These stories of cultural loss following disaster resonated deeply across the Pacific, where their effects were made tangible through images and news reports. Specifically, members of the First Nations Summit in British Columbia had seen a photograph of a Qiang Elder holding a drum outside the ruins of his home in Beichuan and arranged for a visit to the region. This initial act of solidarity prompted them to commission the Freda Diesing School to make the pole. Stan Bevan, a teacher and master carver at the Freda Diesing School who worked on the project and travelled to China for the pole raising, explained to me how he and other First Nations artists, seeing reports of the earthquake, felt a strong affinity with the struggles of the Qiang people. He wanted to send a gift that would both remember the

victims and serve as a symbol of healing for the community.[4] Working with students and other teachers at the school, Bevan carved the sixteen-foot pole depicting an eagle and a grizzly bear out of red cedar. Elders blessed the pole in Terrace and transported it to China on Canadian Governor General Michaëlle Jean's private plane, where it was raised in Beichuan at the site of a new school and elder-care centre funded by the province of British Columbia and Natural Resources Canada.

This vignette, recounted at the intersection of news media, material culture, and the recollections of my interlocutors at the Freda Diesing School, presents a complex brokering of Indigenous, Chinese, and Canadian sovereignties. Before spending time at the school as a visiting instructor, I had written of it as exemplifying an "art-resource nexus" on the Northwest Coast,[5] my phrase for an event in which natural and cultural resources are brought into exchange with one another and analogized by participants. My argument then, as now, is that such moments showed how art was used to broker relationships in complex and unexpected ways across contemporary extractive pathways. In the art-resource nexus, art *works* as a form of repair both discursively and materially; the pole is an example of how to *do* things – establishing relationships and transnational solidarities across sovereign territories – with words and belongings that circulate in the news.

Yet thinking about the real reparative stakes of these exchanges, there is another material piece to this nexus: the artistic and academic labour that is involved in projects like the China Friendship Pole and how this community-based work also intersects in complex ways with much larger regional extractive economies and art markets. As I will elaborate in this chapter, this sense of labour and its reparative work comes from my own experience as a teacher and, later, an invited visitor to the Freda Diesing School, practices that dovetail with my own concurrent socialization by fieldwork as an anthropologist in art worlds. Being at an art school at the centre of the art-resource nexus, I felt an acute sense of the stakes of the region's place in settler resource regimes; in other words, it was a space where taking – whether knowledge, timber, or minerals – had been a dominant mode of outsider engagement. Indeed, boarding a half-full plane to Terrace on one of my trips to the school in 2012, I was confused by a Hawkair attendant who warned me that my luggage might be left behind; when I arrived, I watched an improbable number of mattress-sized black cases, filled with mining equipment, glide past on the single conveyor. In that moment, the parallels between different kinds of extractive practice – mining and anthropology – seemed vividly drawn and disquieting. To put it a different way, I felt the familiar weight of being another visitor speculating about the region's futures. Freda Diesing felt to me like a fracture point on the metaphoric fault lines between resource prospecting and different ways of imagining community livelihood and repair at this juncture of extractive projects.

Indeed, as the example of the China Friendship Pole makes clear, Freda Diesing and its participants are also situated in complex political-economic networks that trouble both one-way routes of resource frontiers and understandings of remoteness vis-à-vis art world centres. As Jennifer Biddle has argued in relation to experimental art practices in so-called remote Aboriginal Australian communities,[6] one might more productively conceive of Freda Diesing as a kind of "remote avant-garde": spatially removed from the contemporary

(urban) art scene yet intimately tied to emergency, extraction, and other neoliberal forms of settler governance. Freda Diesing is, I suggest, a parallel remote avant-garde, shaped by its own conditions of labour and refusals of settler occupation. In this chapter, I consider these labour geographies, the school's connections with art markets "down South," and how these spatial relations resonate with other global Indigenous struggles to manage biocultural resources. As I will discuss later, many of these struggles take place on the ambivalent terrain of neoliberal development through attempts to "Indigenize" education while making communities' territorial and cultural rights claims legible and accountable through audit and monitoring.[7] Focusing on the stories that the school and its students tell about themselves, I emphasize the reparative work that is taught alongside learning to be an artist and the ways that these narratives allow for an understanding of cultural loss within a narrative of resilience. I argue that striking this balance is what it means to do the work of art and culture at the school, amidst conditions of flexible labour and the dubious ideologies of creativity that are sold as part of a contemporary art school education. My contention, however, is that, while these narratives are taught both explicitly and implicitly, they work in unexpected ways by dramatizing resource economies and histories of theft and resurgence.

In this chapter, I expand on these politics of exchange in the region, writing about the Freda Diesing School as distinct from the market and urban art schools in Vancouver, albeit still deeply connected to city life by family histories, institutional networks, and resource markets. For many artists who call the region around the Skeena and Nass Rivers home, Freda Diesing's so-called remoteness is not experienced as such at all. It is a place to learn traditional carving and painting, and one that inverts the spatial hierarchies of Western art worlds and the model of detached, urban, alienated cultural producers, suggesting a different kind of contemporaneity that can accommodate multiple spaces and sites.[8] Routes that artists take *between* spaces are also multidirectional. James Clifford has characterized these regional travels as forms of "indigenous commuting," a cyclical movement between the many sites that constitute Indigenous experience, territories, and feelings of home.[9] I expand on these deeply felt and dispersed obligations to the concept of "home" as they are intertwined with the work of art-making between Vancouver, Terrace, and students' communities of origin, all sites along the commute towards being and becoming artists.

This circulation is not merely exploitative, nor is it performed by "cultural dupes"[10] whose desire to live and work on their ancestral territories is somehow inhibiting "real" success "down South," as it is referred to by most Northerners, a reminder that the spatial terms of the "Northwest Coast" are always relative. Indeed, the Freda Diesing School, its cultural production, and its environs *are* a contemporary art world in all senses: inextricably linked to Northwest Coast property regimes and part of the ongoing articulation of neoliberal cultural policies with Indigenous values. These *are* the region's contemporary politics around biocultural heritage: the knowledge of harvesting and preparing bark for basket weaving, the Indigenous language worlds contained in the practice of making one's own set of carving tools, the local dyes and pigments that colour wool. Through its instruction in the discursive work of being an artist – work to which I directly contributed by teaching a narrative of regional art history and art world conventions of writing

oneself as an artist – the Freda Diesing School also generates a reflexive understanding of "culture" being experienced self-consciously as such,[11] as practices to be taught, developed, and preserved. Its teachers, founders, and students are deliberate in using the language of returns, explicit about their attempts to "get back" to traditional and "authentic" ways of being and making, and reflexive about "culture" as a thing that may be circulated, preserved, or lost.

All of these terms – "culture," "traditional," "authentic" – have been so dismantled in anthropological debates over the past thirty years that it is often difficult to listen to them without hearing spurious fabrication or, worse, a self-conscious buying-in to notions of selling out. Moreover, many artists in Terrace voice these concerns about culture in a language of recognition, which is similarly mistrusted by many critical Indigenous scholars and political theorists as a form of colonialism that reinscribes Western liberal values and prevents Indigenous disentanglement from settler regimes of power.[12]

Yet listening to artists' stories, I did not hear false or colonized consciousness. Rather, I understand and represent Freda Diesing here as a place of *work*, in its sense of cultural reproduction, whose products are both Northwest Coast art and a sense of cultural resilience and pride connected to students' many homes and their livelihoods as artists. In doing so, I suggest that the Indigenous sovereignties are worked out in a particular kind of return, a process of coming home as artists or returning to one's communities through the process of becoming artists. Striking is the external legibility of many of these projects, evident in the school's relationships with places *beyond* the Canadian nation-state, in China, in the United States, and in educational exchanges with Māori artists in Aotearoa/New Zealand. Detailed analysis of these activities is beyond the scope of this chapter, but I signal them here because they are relevant to the ways in which Indigenous sovereignties are interrelated in the spaces of global art worlds beyond the more familiar biennial circuit.[13]

Building on this analysis, this chapter also considers the Freda Diesing School in relation to the emergent categories of "community art" and "creativity" that are two less-common valences of "the global contemporary." In art history, this term refers to movements that started in the 1960s in the United Kingdom and North America, and used the form of art organizations to democratize the uses of art, generally in working-class neighbourhoods or remote areas.[14] This project intersects strongly with strands of conceptual practice that attempt to render meaning accessible beyond art world canons and with more recent participatory and relational social art practices.[15] Here, I emphasize another significant site of intersection: pedagogy. In this context, Freda Diesing may also be seen as a space for community art, both in terms of its labour agenda and students' commitments to crafting themselves as artists. At the same time, I suggest that its particular aesthetics and goals, which are tempered by complex histories of modernism on the Northwest Coast, are transformative of the category of community art. In particular, aesthetic controversies about "Northern style" in the region shape the school's history and purpose in relation to another institution, the famous Gitanmaax School of Northwest Coast Art (commonly called 'Ksan) that closed shortly before Freda Diesing opened in 2006. I suggest that this particular history makes the Freda Diesing School a compelling regional case of community art, and one that also calls

into question who or what constitutes a community of practice – one with *multiple* homes or centres – beyond the vague, utopian frame of consensus implied in community art. At Freda Diesing, art is labour and not only in the extractive sense.

COMMUNITY LEGACIES AND PEDAGOGICAL PROMISES

First, some orienting: the Freda Diesing School of Northwest Coast Art is located in the small city now called Terrace, British Columbia; its lands and waters are those of the Skeena River Valley below the Nass Watershed, a coastal-interior rainforest on an active fault line between the Kitimat and Hazelton mountain ranges. As a joining point, this location is important for the Kitselas and Kitsumkalum communities, Tsimshian peoples whose traditional territories are nearby, and for the neighbouring Gitxsan, Haida, and Nisga'a; farther north, Tahltan people also have territorial and felt connections to the region and its waters. Terrace was a hub for industry: a logging centre connected by rail to the rest of the province and a stop on the route to Kitimat, the desired outpost of the for-now defunct Enbridge oil pipeline.

Bringing together students from all of the First Nations named above, Freda Diesing is a site of intense pan-Indigenous collaboration around a distinctive model of contemporary Northwest Coast art. The status of this work as a consciously identified "Northern" style matters a great deal when the market hub for the art is located "down South," while Terrace and its environs are its heartland, a place where the business of being an artist is tempered by the demands of family and community. Here also, the politics of representation and the protocols of practice – who has the privilege to carve what, what can be done if these boundaries of property are overstepped – meet "wars in the woods" about territory, development, and extraction.[16] Here, we see the fault line *and* the meeting point enabled by neoliberal development in the province.

Indeed, the Freda Diesing School was founded in 2006 as a vocational program offered at the Terrace campus of Northwest Community College (NWCC) – now called Coast Mountain College – where Indigenous students comprise over 40 per cent of the student body.[17] Bureaucratically, the school was started as part of a larger "Indigenization" effort at the college during the mid-1990s, a project of education reform that precedes and parallels contemporary decolonizing and Indigenizing mandates in higher education.[18] Yet beyond this broader neoliberal mandate, Freda Diesing is also an intensely personal collaboration between the college and internationally known local artists: Dempsey Bob (Tahltan/Tlingit), master carver and senior advisor to the program; Stan Bevan (Tahltan/Tlingit/Tsimshian), Bob's nephew and a talented artist in his own right who is the program coordinator; Ken McNeil (Tahltan/Tlingit/Nisga'a), another of Bob's nephews and an experienced teacher and carver who is the program's main instructor. At the time I was at Freda Diesing, Rocque Berthiaume, an art historian at NWCC, was teaching art history; and Dean Heron (Kaska/Tlingit), one of the school's first students and a working artist, and Bill McLennan, curator of the Pacific Northwest at the Museum of Anthropology in Vancouver, were its faculty, alongside sessional instructors and visiting lecturers (Figure 4.1).

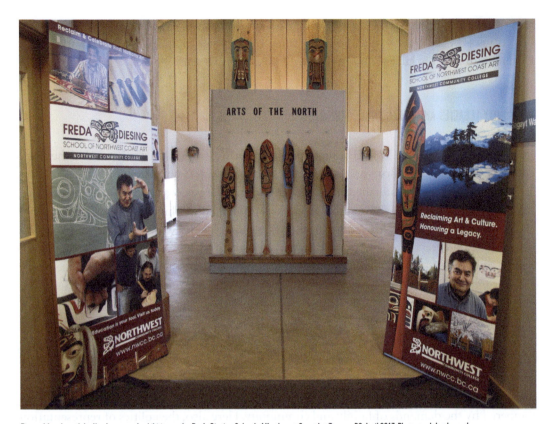

Figure 4.1. *Arts of the North*, year-end exhibition at the Freda Diesing School of Northwest Coast Art, Terrace, BC, April 2013. Photograph by the author.

As a participant-observer in this nexus, I had come to Terrace to learn about this First Nations–run and community-based college that specializes in Northwest Coast art practice – designing, painting, carving, and tool-making, along with language training, specialized artist-led workshops, and art history curriculum. My invitation to the school had been somewhat serendipitous and mediated by my own urban academic networks: one of my dissertation advisors, Faye Ginsburg, was visiting Vancouver from New York and had paid a visit to me and my collaborator Luke Parnell in his carving space in the Aboriginal Gathering Place at Emily Carr University. Luke had been worrying out loud about all the work he had to do on an art history syllabus for the Freda Diesing School while trying to finish his own master's thesis at Emily Carr. Faye pointed out that I was an excellent editor and would be happy to help with both pieces of writing. "Maybe she could even come with you to Terrace!" she suggested. We all laughed; I was privately mortified by my advisor's bold suggestion. I didn't want to be one of those creepy anthropologists who follow their key informants around like a shadow, video camera aloft.

But later, Luke told me that he had liked the idea so much that he wondered if we might develop and teach the class together. It was a Northwest Coast art history class covering the period from 1885–1951, he explained, as the school's curriculum was periodized to reflect

the political and aesthetic effects of the Canadian government's potlatch ban during those years. He thought that my archival and museum collections–based research skills would be helpful in finding good examples of work from the period, and we both liked the idea of co-teaching as reciprocal work (and I, who had not taught before, liked that he would be the instructor of record). We secured the necessary permissions from the school's administrators, but I was still nervous. I worried about my presence – this community-based detour from the urban art world had not been part of the plan – and the circulation of my writing. Would the things I learned make it back to the people who had shared words with me? Would my grant-writing and editing skills be enough to make up for being a nuisance in the carving shed where all the instruction took place? (The last problem, my total failure at using an adze, was solved by only having me help with basket weaving and materials preparation.)

For several weeks, we prepared course materials in Vancouver, poring over museum databases and catalogues for images that we could use to spark students' curiosity about this "Dark Age" of Northwest Coast art history; central to this project was a revaluing of items made for the tourist trade and objects made in residential schools. At the same time, sharing an interest in how historiography shapes the present, we both wanted our syllabus to highlight curatorial interventions that opened space for students to show their work in new narrative frames, including landmark shows such as *Robes of Power* (1986), an exhibition of button blankets that challenged the carved, masculinist narrative of fine art, and *Challenging Traditions* (2009), a reflexive group exhibition that interwove contemporary art with twenty-first-century Indigenous experiences of being an artist. With the assistance of Brenda Crabtree, the director of Aboriginal programs at his art school, Luke also arranged for us both to learn how to weave Haida-style basketry frogs – an experiential activity that would allow us to talk about textiles, miniatures, and the ways that belongings can be made for sale with students at Freda Diesing who were more familiar with tool-making, carving, and painting than harvesting, preparing, and weaving long strips of cedar bark.

I could not have known how important this initial preparation would be. Once we arrived in Terrace, after an initial welcome from the other teachers at the school – Stan Bevan, Dempsey Bob, and Dean Heron – the other teachers left to pursue their own artistic work and family obligations; we did not see them again until later in the semester. Luke and I quickly realized that we would be teaching art history full time, while also helping students finish their final projects in time to show at graduation. We spent twelve-hour days in the carving shed showing slides, organizing student presentations, editing grant applications, and talking with the students about their work, trying to steer it towards completion for the hard deadline of the school's year-end exhibition. In the evenings, we would retreat to the dorms, where we would work late into the night on the next day's lesson plan – consummate urbanites, neither Luke nor I had a car or knew how to drive, so our trips to town were very few and far between – until it was time to go to sleep. Some days, we travelled for five or six hours on a hired bus with students to visit totem poles, artist studios, and museums in the neighbouring towns and to meet with local artists. One evening, we tried to puncture this relentless pace by setting up a projector in the carving shed to screen a movie, *Scott Pilgrim Versus the World*. No one showed up; the students were all too busy working

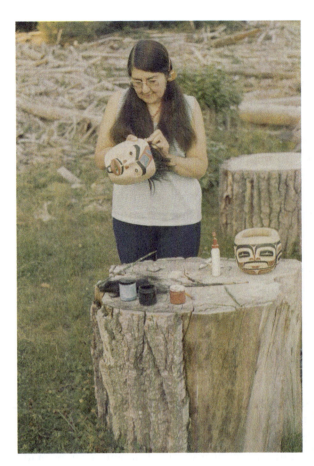

Figure 4.2. Freda Diesing finishing a mask at 'Ksan, 1972. Photograph from the research archive of George and Joanne MacDonald. Courtesy of Simon Fraser University, Vancouver, Canada.

on their projects. We joked about this at the time – clearly this lack of interest was evidence of our questionable taste in films – but it also felt isolating and lonely. Reflecting back on this preparation and pace, I now understand it as crucial work of knowledge transmission that highlights the many different educational routes and legacies of the Freda Diesing School, including its visitors.

Perhaps the most important figure in the school's intellectual lineage and founding is the late Freda Diesing, for whom it is named (Figure 4.2). Less known than many Northwest Coast artists working in the 1970s, Diesing was a Haida artist from Prince Rupert and remarkable for being one of the first female carvers of Northwest Coast art, a largely masculine discipline, particularly in its late modernist moment. She was also Dempsey Bob's teacher, encouraging him to attend 'Ksan, the Gitanmaax School of Northwest Coast Art, in Hazelton. Based on the many stories I heard while I was at the Freda Diesing School, she was an incredible mentor to a whole generation of Northwest Coast artists coming of age in the 1970s and 1980s. Diesing died tragically in a car accident in 2005, and the school is also a memorial to her legacy that extends her mentorship to the generation of artists beginning their professional lives in Terrace.

Students at the Freda Diesing School range in age from recent high school graduates to Elders and older community members. These more mature students are often attending

formal education for either the first time in their lives or, as was the case with the two cohorts I knew well, after traumatic experiences with non-Indigenous education. There are almost equal numbers of men and women, and the structures of courses are remarkably sensitive to other aspects of the students' lives, as students often take extended time away to raise families and fulfil community obligations but are remembered while they are gone and welcomed whenever they are ready to return. Stan Bevan, the school's then program coordinator, explained to me that instructors try to accommodate such a diverse student body by relying on mutual mentorship, a system in which students share their skills – younger students helping Elders with computer tasks and sometimes writing, and Elders sharing their linguistic knowledge and understandings of cultural practice with those who are only beginning to relate to their heritage through art. Bevan described the school's purpose as bringing together the many facets of artist Freda Diesing's work, teaching designing, painting, and carving in that specific order. "You have to know the basics to innovate," he explained to me, citing the famous Haida artist Robert Davidson's diligent study of the "grammar" of Northwest Coast art that preceded and enabled Davidson's abstract work.[19]

This consciousness about the intersection of past and present is also shared by students and is often expressed eloquently in their artist statements. Nathan Wilson, a Haisla artist and cousin of the older renowned painter-carver Lyle Wilson, reflected on his experience at the school in the following way for the program's 2013 calendar, which showcases student work:

> Growing up, I was always curious about the masks and paintings in my grandmother's house, but I never knew the meaning as I grew up outside traditional knowledge. Now that I attend [Freda Diesing], that curiosity has grown into a passion, one I wish to keep for a lifetime. This form of art allows me to express what I think, how I feel and to learn about a culture whose very existence was defined by "art." To see the old pieces that have survived for hundreds of years only drives me to attain the same knowledge the masters in the past once had.

Wilson's statement combines a narrative of rediscovery with recognition of the role of "old pieces" as catalysts for present work and self-expression. His statement also serves as the introduction to his work in the 2013 calendar co-produced by the school in Terrace and the Spirit Wrestler Gallery in Vancouver, a commercial art gallery that maintains a relationship with Freda Diesing and sells many of its students' (and teachers') work through an annual show organized by dealer Gary Wyatt, appropriately called *Northern Exposure*. In this relationship, another central function of the Freda Diesing School is visible: helping students locate and participate in markets for their work and learn to narrate their practice in relation to these spaces of the art world. As in many art schools, instruction is both geared towards formal techniques and the craft of *being* an artist both in community and commercial settings. As Wilson's words suggest, art is both a highly individualized form of expression and a practice that consciously honours tradition in ways that are legible.

An important component of the art history curriculum – perhaps owing to Luke Parnell's influence as an active participant in art school and the art market – was the crafting of such artist's statements, a key professionalizing component of Freda Diesing's curriculum. This genre of writing and self-construction is much more difficult than it seems. It straddles

introspection and performance with an eye to the market and requires the author to be both humble and striving in appropriate measure and to acknowledge teachers and lineage while portraying one's own distinction. As Parnell explained to me, for Indigenous artists, there is also the problem of delicate balance in deciding what to reveal and for whom. In these ways, as a public form legible to outsiders, artist statements must enact a kind of keeping-while-giving that renders the artist-self inalienable even as one is overtly on the market as an artist.[20]

In the year that I co-taught, Parnell's method of instruction for achieving this balance of secrecy and revelation struck me as quite anthropological and intertextual. Students were asked to study contemporary Northwest Coast artist's statements from the *Challenging Traditions* catalogue, a curatorial assemblage of the best contemporary Northwest Coast work.[21] The class then discussed what they thought of these statements. The terms were very vague and respectful – no one ever, *ever* directly derided another artist or their work, which signals a key difference between non-Indigenous art world mechanisms of exclusion and Indigenous ones. Nonetheless, the class was an assessment of who was doing well at striking the appropriate balance between tradition and innovation, and who was out of bounds, claiming a past that was not theirs to discuss, revealing too much about a technique, or selling out in a statement *only* meant for non-Indigenous audiences. From this discussion, it was obvious that learning how to narrate one's work was one of the most crucial lessons learned at art school and one with ties and obligations to other artists and communities through an acute sensitivity to possible audiences. Indeed, while Wilson's narrative of mastery might sound like a prototypical modernist "genius" narrative, it is also a protective packaging of multiple forms of intimacy and obligation.

The genre conventions of the artist's statement also reflect the Freda Diesing School's strong commitment to Northwest Coast art as a particular kind of trade that circulates community responsibility. Just as the school's relatively recent founding belies much deeper roots in the region, its constitution of art as economic *and* affective labour has a much longer history, both in art worlds more broadly and in Northwest Coast art history in particular. I expand on these roots in three ways: first, in relation to the history of entanglement between art, ethnography, and pedagogy in the region, a story that is captured in the life-work of Freda Diesing herself; second, in the school's aesthetic and temporal relationships with 'Ksan, the region's earlier school of Northwest Coast art; and finally, in greater detail as a project of neoliberal Indigenization at NWCC. Together, these aspects of the school's connection to place help to explain its function and meaning for those who teach and learn inside its walls.

"ON THE TRAIL OF PROPERTY WOMAN" IN THE SKEENA VALLEY AND BEYOND

As in many places where Indigenous peoples have made their livelihoods since time immemorial, people of the region have had centuries of practice in managing relations with outsiders. On the Northwest Coast, these relationships have often been carried out around art, given its dual role as intangible property and aesthetic product. As art historian Leslie

Dawn has described in his account of these relations as they pertain to part of the Skeena River Valley, a locus for the expansion of the Canadian National Railway (CNR) in the early twentieth century, tourism in a remote place "contacted" much later than others had focused on the aesthetic qualities of totem poles as a picturesque backdrop for emergent Canadian nationalism as well as an economic boon.[22] Crucially, although it was non-Native artists who were brought to the region to document these picturesque settings as relics, First Nations people carefully managed these encounters and enacted their sovereignty amidst this expansion.

At the Gitxsan village of Gitanyow (formerly Kitwancool in most scholarly texts), for instance, where I travelled with Freda Diesing students and teachers to learn about old poles and meet local artists, the anthropologist Marius Barbeau and his non-Native artist collaborator on the CNR project, W. Langdon Kihn, were forced by Gitxsan leaders to leave without documenting the landscape. As Dawn notes, this omission of Gitanyow from public representations of the region shows the Gitxsan community's successful management of their own image as well as their awareness of the larger territorial stakes of surrendering pictorial control to the state.[23] These relations also make the present permission to visit and learn from Gitanyow more meaningful as a sign of good faith *across* First Nations in the region.

This historic settler colonial combination of national interest and local economy, which, as Dawn shows, came to be paradoxical in light of the narrative of disappearance and salvage eventually constructed by Barbeau in the 1920s, is a tension that has manifested itself around art in the region ever since. Indeed, the earlier paradox of the federal ban of the potlatch while government Indian agents and missionaries promoted its ceremonial and material culture as aesthetic commodities – a conversion of meaning that was fiercely and covertly resisted by many First Nations – might be seen as a precursor to these tensions, combining a complex public glorification of artwork with a narrative of disappearance via economic assimilation.

In the 1950s, the anthropologist Wilson Duff visited Gitanyow with the intention of preserving its old poles by transporting them to museums down South, much in the same vein as his famous expedition to Haida Gwaii (see the introduction). Again, the Gitanyow proved to be tough negotiators and highlighted to Duff both their history of resistance and the crucial role of crest poles in land disputes.[24] Eventually, in 1958, the Gitanyow agreed to Duff's project on two conditions: first, that copies of the poles be made for Gitanyow; and second, that their "histories, territories, and laws were to be written down, published, and made available to the University [of Victoria, down South on Vancouver Island] for teaching purposes."[25] This dual mandate not only displays local savvy about the ways in which institutions like museums and universities can be aligned with other community interests but also shows a commitment to teaching as a mechanism for voicing these claims.

These core values and strategies are exemplified in the life and work of the artist Freda Diesing. Her Haida name, *Skil Kew Wat*, is translated both as "magical little woman" and "on the trail of Property Woman [*Skil*]," referring to a Haida story.[26] Diesing's name also reveals an important truth about the role that her teaching played in working a kind of

magic to attract wealth across many generations. In her life story, economic interests – which, as the case of the Gitanyow shows, are also always political ones – are coupled with profound attention to aesthetics, technique, and community values, as well as a firm resistance to the limitations imposed by the representational ideologies of Northwest Coast art history.

It is significant, for instance, that Diesing was a woman carver. As Tsimshian/Haida art historian Marcia Crosby has argued, the Northwest Coast narrative of "master carvers" is a highly gendered one that intersects in troubling ways with the limits on Indigenous subjectivity imposed by the Canadian settler colonial state. This narrative erases long histories of women's involvement in art and society on the Northwest Coast and excludes women from the forms of citizenship afforded by the political-economic constitution of "Aboriginality," as it comes to be associated only with male mastery.[27] But a narrative of "mastery" also generates value. Far from a mere recapitulation of a masculinist script in a woman's body, Diesing's carving and teaching is generative of forms of subjectivity that challenge the "savage slot"[28] afforded by liberal recognition and proposes a form of resistance that enables *resources* to circulate.

This rather different life "carving" is most apparent in Diesing's life story, which was recorded near the end of her life by the anthropologist Mary Anne Barbara Slade[29] but neither published nor circulated up North in 2012. In a touching and often awkward co-production between anthropologist and artist, Diesing reconstructs her own role in contributing to the renaissance of Northwest Coast art in the 1960s, which Slade situates in her framing text that emphasizes Diesing's relation to other woman carvers of the period, including Kwakwaka'wakw artist Ellen Neel. Based on Diesing's words and on the memories of those at the school that I spoke with, Diesing's status as a woman, her mixed blood, and her decision to live in Prince Rupert and Terrace, Native territory outside of her own ancestral land of Haida Gwaii, both confirms *and* disrupts the narrative of a Northwest Coast "Native Renaissance" at mid-century. Telling her life story, Diesing expresses the joy of rediscovery and connecting with traditional knowledge in terms of loss and recovery, but at the same time she complicates standard art historical scripts of who was "authentic" in this period, challenging the notion that "mastery" implies being tied to a single place or a male hand – indeed, she is known, too, unflinchingly, as a "master carver."[30]

During her life, Diesing was also witness to important changes in the market for Northwest Coast art beyond its renaissance "down South" in the 1960s. As art historian Aldona Jonaitis and others have argued, the "rediscovery" narrative of this artwork's resurgence also implies a history of loss, both in constituting a degenerative or dark period prior to renaissance and, more insidiously, devaluing work that does not adhere to art historian Bill Holm and artist Bill Reid's canonical stylistic codifications at mid-century. As I discussed in chapter one, students at the school unanimously shared the "renaissance" script and repeated the standard terms of connoisseurship, preferring "fine" work that mimicked the style of the "old masters" from the late nineteenth century. This period was in fact *also* a time of social upheaval, innovation, and entanglement with settler society rather than a static Golden Age of segregated mastery. Such histories render Northwest Coast art's

standard reconstruction at mid-century even more paradoxical, especially when considered in relation to the work of a proud and talented mixed-heritage woman.

Indeed, my initial bewilderment at students' disinterest in the years before the Native Renaissance was tempered by the knowledge, made more visceral in the life histories of teachers and students, that, before the 1960s, there *was* profound cultural loss in the region and elsewhere, as well as a sense of shame about losing traditions. Moreover, Diesing was profoundly shaped by the 1967 *Arts of the Raven* show in Vancouver, the exhibition of Northwest Coast art that most scholars take as the starting date of both contemporaneity and revival.[31] Diesing told Slade the story of shearing and selling her sheep to travel down South just for the exhibition:

> After I sold my sheep to come to the art show in Vancouver, and I saw the *Arts of the Raven* show and met Bill Reid, and I bought the book from the show. I copied the drawing and then I went to the library to take out more books and tried to copy the designs on the totem poles and things – just like Bill Reid had done.

This event was indeed Diesing's first serious foray into Northwest Coast art, and most scholars, including Slade, date the start of her carving career to 1967.[32] But after tethering her career as a carver to this important event and quite deliberately to the weighty legacy of Bill Reid, Diesing goes on to highlight other influences *before* 1967:

> And when I was living in Vancouver too, back in the 50s [when Diesing was a student at the Vancouver School of Art, now Emily Carr University], I went to visit Ellen Neel. She was a Kwakuitl woman who carved; she was really well known and she lived in Vancouver. So I went to see her there. She was the first woman I met who made her living from carving. Anthropologists always ask about being a woman carver – about resistance from other carvers who were men, or from other Indians. But I never encountered that resistance from Indians. And when we were all at Robert Davidson's pole raising in Masset [1969], and I was talking to my Mom's uncle, the old Chief WEAH, about the carvers in my family, and what the Elders might have thought about what I was doing, he said: "Your uncles would be proud."
>
> It seemed natural to me for women to carve, 'cause I'm sure that women always did carve. 'Cause in the old days, when you couldn't go to a store, and the men were in the middle of fighting or warring or something, and you needed something, who was going to do it? Who was going to make the containers? It was the women were the thinking people! That's what I told that woman from UBC at the interview, and she said she liked it so much she was going to use it in her thesis![33]

In this complex statement, Diesing effectively carves out another legacy for herself as a woman artist, disrupting both the masculinist modernism and the hegemony of a Charles Edenshaw–directed Haida art lineage proposed by *Arts of the Raven*[34] and making sure that we know Ellen Neel is Kwakwaka'wakw and *not* Haida. I also read Diesing's decision to implicate her anthropological audience in the discursive production of knowledge

("Anthropologists always ask about" and "That's what I told that woman from UBC in an interview") as a knowing caution about anthropologists' role in the construction of assumptions about the propriety of women carving, thus self-consciously revising the mid-century anthropological record.

Finally, amidst the romance and reality of selling sheep to travel down South, Diesing makes it clear that she has been in Vancouver before in the 1950s, which, we already know from other pieces of Slade's interview, were years that she spent at non-Native art school *and* in which she saw an earlier exhibition of Northwest Coast art: the *People of the Potlatch* show at the Vancouver Art Gallery in 1956.[35] In effect, even in a statement that acknowledges and locates her career amidst the standard narrative of revival, Diesing signals both her awareness of its discursive production and other entanglements in her life story that contradict the notion that Northwest Coast art is reborn at mid-century.

I suggest that this kind of double consciousness – acknowledging the importance of revival and repair amidst a history of loss, while subtly hinting at contexts for art production that exceed the story's frame – permeates the work of the Freda Diesing School and its teachers' and students' understandings of their role in "rebirthing" an art form, a natal metaphor that many of the teachers and students shared for their work. Even the sheep in Diesing's story signal a kind of transaction, a knowing conversion of different types of wealth. This kind of conversion is also prominent in both liberal and neoliberal tales of Indigenous art as a potlatch-like catalyst of economic and social welfare, but in Diesing's life story and, I suggest, in the work and values of the Freda Diesing School, the transaction occurs along much more intimate networks than those of cultural policy or the state. This aspect of Diesing's legacy – I am tempted again to invoke her name, "on the trail of Property Woman," as signalling one who attracts wealth – contradicts connoisseurship that devalues the impurity of artwork that transgresses supposedly bounded cultural styles.

Moreover, set in this broader context, we might understand the students' rejection of "Dark Age" artwork as a kind of rhetorical "infiltration" of canonical art historical narrative – an Indigenous appropriation of settler discourse parallel to Indigenous uses of the neoliberal nationalist agenda. In other words, the students' rehearsal of the renaissance script may also be analogous to the school's complex articulation and negotiation of neoliberal cultural policies with Indigenous values.

IN THE SHADOW OF 'KSAN

Another important facet of the Freda Diesing School is its relation to mid-century art pedagogy at a different Northern art school. The Gitanmaax School of Northwest Coast Art opened in Hazelton – a town about two hours northeast of Terrace by car – in 1970 as the first art school dedicated to the systematic instruction of a synthesized "Northwest Coast art" style. From its beginnings, the Gitanmaax School was an integral part of the much larger complex known as 'Ksan, which, since the 1950s, had included a museum, historical village, and the 'Ksan Performing Arts Group, the self-described "cultural ambassadors for

the Gitxsan people."[36] The school is also generally referred to as 'Ksan, and its art production recognized as "'Ksan style," which, as I will elaborate, is a controversial category among Northwest Coast artists, art historians, and connoisseurs. 'Ksan is strongly identified with the mid-century Native Renaissance as a space for formalist instruction according to Bill Holm's stylistic tenets in *Northwest Coast Art: An Analysis of Form*.[37] It is also regarded by many as the intellectual progenitor of the Freda Diesing School due to Hazelton's regional proximity and the fact that both Diesing and Dempsey Bob, the Freda Diesing School's senior advisor and Diesing's former student, were affiliated with 'Ksan in its early days,[38] as were other visiting teachers, such as the well-known print artist Roy Henry Vickers. Several students at the school trace their lineages to 'Ksan, including John Sterritt, son of the well-known artist and activist Art Sterritt who attended 'Ksan in the 1970s.

The comparison between the Freda Diesing School and 'Ksan is not always made favourably. While I was up North, I heard rumours that Freda Diesing had "stolen" all of the good prospective students from 'Ksan, which had largely ceased operations by 2011. Moreover, although the Freda Diesing School has a formal relationship with one of the most respected galleries for Northwest Coast art, the Spirit Wrestler Gallery, some collectors and art historians in Vancouver expressed to me their worry that work produced at the school was "uneven" in quality and lacked the distinctiveness of canonically defined regional styles (for example, Haida art, Tlingit art). To be sure, there *are* important differences between styles. Haida carving on totem poles, for example, tends to be shallower than Tsimshian or Nisga'a designs, which are deeper sculptural renderings of human and animal forms. But how these differences become canonical, "traditional," and value-based categories is a much more complicated story, as collectors look for particular features as markers of authenticity, and gallerists emphasize these differences as reassuring marks of provenance. Too much experimentation or mixing can alienate potential buyers, even though there are many examples of hybrid and transcultural forms even in the Golden Age of Northwest Coast art.

To wit, the art market–based critiques made of 'Ksan in the 1970s and beyond were that, with a few exceptions, artwork produced at 'Ksan was too experimental and didn't really understand or represent the formal rigours of Northwest Coast style or of traditions.[39] Indeed, even the name itself, a short form of "Gitxsan," suggests both brevity and uncertainty about its regional roots. Importantly, these formal dismissals of 'Ksan were *not* critiques of the community project itself, which is widely recognized as ushering in an era of Indigenous-run cultural production.[40] Rather, comfortably couched in formalist language, such critiques of the blending of canonical styles skirt the issues of *who* delineates Northwest Coast style, overlooking both external and internal cultural politics – the problematics, for example, of non-Indigenous art historian Holm's codification of Northwest Coast design principles.

These legacies of 'Ksan style had an impact on Freda Diesing, both the woman and the school. For her part, Diesing strongly clarified that she had neither taught nor first learned to carve at 'Ksan[41] and that her own style was *not* "'Ksan style" but "my own style."[42] She also responded to the outrage of some Haida people that the Gitxsan were claiming a carving legacy that didn't properly belong to them, replying that, as a resident of the region, she

had witnessed that claims of the Gitxsan were legitimate.[43] Moreover, she highlighted the salient features of 'Ksan style as a hybrid production: "it's not any one tradition, but sort of a mix of them all."[44] Similarly, while teachers at the Freda Diesing School spoke respectfully of 'Ksan, they differentiated their program on the basis of its firm grounding in "the basics": mastering the visual grammar of the art form in *all* of its regional styles before you can innovate – an approach that the teacher Dempsey Bob often rendered as "you gotta do your homework," a phrase that encompasses a complex set of aesthetic and moral values that I will explore in greater depth. Overall, the legacy of 'Ksan weighs on the Freda Diesing School, and all of its advisors hope to encourage work of consistently high quality.

I raise these comparisons not to affirm stylistic judgments – which, as I have argued throughout this book, are mediated by histories of contact and contestation that require a contextual reading of what constitutes a critical "eye" – but to show how the Native Renaissance continues to be *felt* at a contemporary art school as a meaningful discourse. Moreover, the work ethic of intercultural exchange at 'Ksan continues to inform cultural production at the Freda Diesing School, where students from many different Indigenous backgrounds come to work through their own position in histories of Northwest Coast art – a task not so different from that of any art student pursuing creative practice in the wake of modernism but one that has particular cultural contours. As such, students' engagement with the shadow and memory of 'Ksan informs the connectivities and affective ties that the Freda Diesing School provides. And lastly – speaking as a critic rather than an anthropologist – it is significant that the centrality of Bill Holm's *Northwest Coast Art* has been partially eclipsed at the school by Bill McLennan and Karen Duffek's *Transforming Image* catalogue, which documents a project at the Museum of Anthropology that used infrared photography to uncover previously unseen designs on nineteenth-century objects.[45] Indeed, many of the designs in *Transforming Image* go against the formal symmetries so carefully catalogued by Holm; this book and its stylistic variations are now regarded by most students at the school as "the bible of Northwest Coast art." McLennan told me that this replacement of one formal system for another makes him and other historians uneasy, as it recapitulates many of the "copying" traps that led to 'Ksan's failure. However, I tend, as a critic, to view it as an improvement: if there must be a bible, it might as well be a text that leaves room for uncertainty, improvisation, and discovery amidst the narratives of renaissance, canonical form, and cultural purity.

NEOLIBERAL INDIGENIZATION IN THE AGE OF RECONCILIATION

Northwest Community College's policy of "Indigenization" has also affected the scope of innovation at the Freda Diesing School. Geographers Suzanne Mills and Tyler McCreary have described the Indigenization process at NWCC as rife with "frictions" in Tsing's sense of the term:[46] as a conflict between faculty union liberal values and Indigenous epistemologies. Above all, the conflict was *generative* of new forms of neoliberal subjectivity that "complicate labour geographies" that assumed compatibility between Indigenous interests

and the left.[47] Mills and McCreary connect the push to Indigenize NWCC – the bureaucratic process under which Freda Diesing was founded – to broader labour histories and education policies in the province. The most notable of these was the vocationalization of labour that resulted from policies oriented to secure resource extraction in Indigenous territories in the North. "Reconciling Aboriginal claims with the dominant political economy," they write, "was therefore critical to securing economic development throughout northern Canada."[48]

This bureaucratic scale of analysis, which reveals the connectivities between resource economies and pedagogy, is a departure from the intimate lineages that I have documented so far. Yet it is an important one: the vocationalization of education – an eclipsing of liberal arts education and the critical thinking it teaches in favour of skills-based training for industry – has often been a problem in policies targeting Indigenous populations. It is tempting to see in it a Foucauldian disempowerment, providing security *and* territory for Canadian industry via governmental control of an Indigenous population.[49] Indeed, in her ethnography of the Free Form Art Trust's community art projects in Britain, Kate Crehan also points out that notions of "community" and the language of expertise introduced by such projects dovetails with the rise of audit culture, one mechanism of increased government monitoring of artists.[50] Vocational Indigenization is also similar in tone to the early-twentieth-century constitution of Aboriginal arts and crafts as a culturally appropriate productivity that I discussed in chapter one as an assimilative technology of the state. It is striking, for instance, that Freda Diesing's two-year program does not confer an associate of arts degree (the community college version of a bachelor of arts in Canada) but rather a certificate and a promise of future transfer to other programs, which, during my time at the school, was the bachelor of fine arts program at Emily Carr University for academically inclined students. While I was at Freda Diesing, one student seriously considered this option; once she graduated from Freda Diesing, however, she felt too tied to family obligations in the North and instead started an apprenticeship in language and carving with an Elder – a decision she is very happy with. But does "learning to labour"[51] in a practical art training program mean learning to give up other, potentially radical forms of cultural citizenship and, as Mills and McCreary suggest, even seek to reconcile the violent resource frontier of the North?

Yet much goes unseen in this Foucauldian critique of neoliberal governmentality in contexts of Indigenous biocultural heritage. Its scale of analysis – the state and a bounded, homogenous community-as-population with homogenous desires – cannot quite account for other contexts and meanings, ones beyond its own measures of value and justice. It is notable, for instance, that Mills and McCreary do not consider labour geographies beyond the nation-state, while the Freda Diesing School regularly invokes these routes in its projects, including the China Friendship Pole.

Furthermore, in choosing to stay up North for language learning and arts apprenticeship, the student mentioned above was arguably enacting what British cultural studies scholar Paul Willis recognized as "partial penetrations,"[52] in which members of a marginalized socio-economic class rupture the dominant cultural mode while simultaneously remaining limited by its particular symbolic forms within a historical formation. Willis's metaphor,

embarrassingly masculinist, echoes the art world language of "breaking in" to a market; yet it is also inadequate to the full meaning that this compromise has as refusal that enacts sovereignty. Indeed, students' modifications to a more mainstream route towards art market success intervenes into the settler colonial system that devalues Aboriginal workers, both by asserting the value of family relations and in privileging the recovery of a form of knowledge – language – that was forcibly removed. These world-building capacities are the stakes of decolonization outside of the mode of conquest, a rejection of the failure presumed in the limits of the "partial penetration."

COMING "HOME" AS ARTISTS

Dempsey Bob, senior advisor at the Freda Diesing School of Northwest Coast Art, is a master artist known internationally for his Northwest Coast–style work in wood and bronze. When naming teachers and influences, as they often do in presentations and at art openings, students of the school always mention Bob's name first. This primacy is meant both as a sign of respect and because, as students often emphasized to me, he is one of the best and most famous artists that they will work with in their lifetimes. Like many Northwest Coast artists of his generation who built their significant professional reputations during Vancouver's hosting of Expo 86, Bob punctuates his eloquent and playful speech with long, comfortable pauses, at ease in his talent and acquired wisdom. As we sit in the school cafeteria, sipping soup, he reveals a deep appreciation for art histories of the region and beyond. We speak about Picasso – a favourite of Bob's because of his ability to innovate *within* his own culture – and about the Surrealists' misappropriation of Northwest Coast art as understandable within the former's artistic rebellion, given the spirit and freedom embodied by so-called primitive art. But above all – and this is the refrain that Bob repeats, until both the timbre of his voice and the words themselves are imprinted on my mind – he imparts a message to the students and, perhaps, also to me: "You gotta do your homework."

It is a simple statement but deceptively so. Most obviously, homework is schoolwork. At the Freda Diesing School, lessons emphasize a balance between several kinds of skills that are crucial to being an artist. These include studio techniques, such as making tools and sourcing and mixing traditional pigments; how to assess and value one's own work according to art already circulating on the regional market in Vancouver and Seattle; and seminars in Northwest Coast art history, which students are expected to link and narrate in relation to their own ancestral traditions and lands through their practices – an expectation that places the emphasis in homework on "home." Learning to embody these connections between material and immaterial practices is not easy. What does it mean to truly "do your homework" when the cultural stakes of art production are so high? When your practice is an outward reflection of who you are, and the generational hopes of a richly artistic region have been pinned to your skill? When success down South is measured somewhat differently than local expectations of community involvement and cultural knowledge?

These are the dilemmas that are condensed in Bob's counsel, and learning to deal with them is taught both explicitly and implicitly at the school as part of becoming an artist. Attempting to capture this general complexity, Clifford characterizes Indigenous artists as negotiating this category of personhood as "a site of articulations and translations, lived differently in specific cultural force fields,"[53] emphasizing the contingency of this work. At Freda Diesing, teaching students what "homework" entails specifically makes visible the tensions between "Indigeneity," as an articulation of shared solidarity,[54] and the many divergent cultural protocols simultaneously being managed as part of this articulation. As anthropologist Jennifer Kramer has argued in her analysis of Acwsalcta in Bella Coola, the Nuxalk Nation's "place of learning," culture-based teaching on the Northwest Coast often has to balance deeply held values of cultural property and propriety with accessibility in order to ensure its survival through students.[55] Articulating how this balance is carefully cultivated through instruction and performance, Kramer illustrates the ways in which this process would limit, in the case of the *Nuxalkmc* (Nuxalk people), what "homework" could reasonably involve, since any representation of the self risks giving too much away.

At Freda Diesing, these politics of representation and cultural property are complicated by the school's diversity: there *is* no shared identity like "*Nuxalkmc*" to resort to in the event of a conflict, except for "First Nations," and the singularity of "nationhood," alongside the conflation of language with nation, is inappropriate for mixed-blood students. At Freda Diesing, the vagueness of "community" is actually an asset, as it can be made to include or exclude on the basis of shared practices and values rather than automatic or presumed membership.

The Freda Diesing School's diversity also predates the significant ruptures of colonialism to family lineages. Indeed, the Northern nations around Terrace had long histories of war and intermarriage before white settlement. The school's teachers also embody and assert these intercultural histories. Dempsey Bob draws a contrast between his younger years when he felt anxiety about his mixed ancestry and its acceptance in the present, explaining: "I don't care; I'm Tlingit. I'm Tahltan." But these shared obligations mean that he had to do his homework in *both* cultures, developing a connection to ancestry that is both known and felt as a part of "paying your dues" as an artist:

> It's like a Blues player; you can't play the Blues if you didn't live it. What are you gonna say, what are you gonna feel, you know, *express*, right? And if you don't got it in here [gestures to his chest] – you can't put it in there. That's how it is. And art don't lie.[56]

Moreover, "art don't lie" for people down South, too. As Freda Diesing is explicitly geared towards helping students break into the art market, there is much to be learned about making sure that one's work produces meaning for its publics just as well in Vancouver as it does in Terrace.

I suggest that "doing your homework" works as a shorthand for navigating two kinds of propriety: one's obligations at a local scale and in relation to the art market as an artist. These values are taught through situated learning at the school,[57] and the category of

"artist," as it is learned and experienced at Freda Diesing, is an important source of shared identity for young men and women learning to carve. These shared identities around the categories of Northwest Coast art also do an important kind of "homework," enabling intercultural connections amidst a history of loss and recovery. In this way, the Northwest Coast art school promotes a kind of labour that activates cultural resources through broader Indigenization programs and regional histories, complicating this structural account with students' and teachers' own interpretations of the work involved in *becoming* artists.

This juxtaposition is not meant to imply that these scales are always commensurable or even mutually translatable. Indeed, one of the school's recurring organizational problems is that it lacks a permanent administrator to keep an eye on fulfilling the professionalizing aspects of the program. While we were at the school, Parnell and I both sporadically tried to fill this role by working with students on grant applications, pricing their work for the market, and otherwise helping them strategically introduce themselves to galleries – a notoriously awkward role that has many precedents in the history of anthropological and artistic co-production. Crucially, however, these *attempts* to translate – the existence of Indigenization regimes – represent a very real chance to recognize and negotiate with alternative epistemologies, which is also a local "partial penetration" in Willis's sense.[58] There are many such stories of "neoliberal empowerment" from the school, and I document these here, drawing on students' and teachers' words about their work to show how its effects and connection extend beyond the immediate spaces and political economies of neoliberal education.

MAKING MEANINGFUL WORK

After Dempsey Bob met Freda Diesing and, at her urging, started carving in 1968, one way that he "paid his dues" was by teaching carving to First Nations men in prison, a difficult task he viewed as a test of whether or not he could be a "real teacher" like Diesing. Recounting this story, Bob emphasized that the art school provides "just a good introduction ... but it's up to [the students]," emphasizing once again the experiential nature of learning and the cultural authenticity. This "realness" is rendered here as a kind of cultural grit, given the disproportionate incarcerations of Indigenous people with whom Bob's story intersects.

As I shall elaborate, this tenacity is both embodied and performed by students. In Bob's narrative, it signals an ideology akin to those surrounding Western artists that emphasizes the necessity of suffering. At the same time, Bob's emphasis on service is a marked departure from the individualism of this ideology via the explicit value of teaching. In other words, "paying your dues" and "doing your homework" both mean serving your community, which includes teaching people who are unlikely to become professional artists.

Later, again on the subject of Picasso, Bob expanded on why strong cultural knowledge intersects with limits on its exchange. Narrating Picasso's intellectual lineage in Greek and European art histories, Bob commented on the artist's earned ability to exert freedom:

True innovation has to come from tradition. It can't come from somewhere else. You know, by knowing his tradition, his art, and mastering it, or … I don't think you ever truly master it, but you can get close … [Picasso] could innovate, he could do these things and make it work. Whereas if you don't know your tradition you can't make it work. It ends up just a gimmick, doesn't *mean* anything.[59]

Homework, then, includes an obligation to really know and understand history to produce meaningful work. And because "art don't lie," this understanding is not something you can fake. These statements are important as the philosophical underpinning for much of Freda Diesing's curriculum, and they also reveal the strong intertextual histories of Northwest Coast art – the keen and reflexive eye cast towards anthropological and art historical texts, alongside embodied and practical Indigenous knowledges – that I have been arguing is a distinctive feature of this art world. Indeed, Bob himself notes that he learned to innovate not at 'Ksan (which he attended in 1972 and 1974, carving "like hell" in between juggling a day job at a fish plant) but by looking at old artwork in books and in museums.

This value of texts and old pieces is emphasized in the curriculum at Freda Diesing through both hands-on assignments that require students to copy old designs and also in close reading of art historical texts. These parallel sources are intended to acquaint students with the range of Northwest Coast art books available. Here, glossy catalogues and the driest ethnographic texts are equivalent, inasmuch as they provide either good pictures or solid documentation. Rocque Berthiaume, an art historian who was the program's initial art history instructor, had assembled an impressive collection of materials pertaining to the region's artwork, which he made available to students in the library.

Working with these materials during my and Parnell's class, two students gave a presentation on anthropologist Aaron Glass's article "From Cultural Salvage to Brokerage: The Mythologization of Mungo Martin and the Emergence of Northwest Coast Art." Providing a discussion of Northwest Coast art from the period right before the Native Renaissance of the 1960s and of the relationships between Martin and his contemporaries, Glass's article documents Kwakwaka'wakw artist Martin's canny interventions into art institutions. In doing so, Glass draws on Christopher Steiner's theory of the "culture broker" to show Martin's capacity to negotiate across very different regimes of value in community and institutional contexts.

I was initially worried about how students would respond to this framing. In spite of its emphasis on Indigenous agency, "cultural brokerage" is jargon that may be interpreted as pejorative, since it can sound both duplicitous and accusatory. But the students not only read past the jargon; they presented Martin's life story as an exemplary and practical case study of how you could be an artist that sells *and* serves the community. Their interpretation honoured Martin, picking out and quoting all of the parts of the article that described his generosity at feasts. The students expanded on the article by pointing out things that they knew about Martin's character and talent from other sources, and even listed some of the possible family connections between Martin and other students in the class.

Some of this recontextualization likely stemmed from that fact that, as a man from Kwakwaka'wakw land that is practically "down South" compared to Terrace, Martin seemed somewhat exotic in Tsimshian territory. His story as an outsider was thus respectfully witnessed – an important reminder that, although the historiographies and even genealogies of art enact an equivalence between Kwakwaka'wakw forms and more Northern ones as "Northwest Coast art," the Central Coast is still far away from the North. At the same time, this presentation also rehearsed *how* to do one's homework: honouring the value of service to one's community as an important aspect of an Indigenous artist's life and the use of texts as testimony.

"Paying one's dues" was also apparent on fieldtrips. Because of the region's history of resistance to totem pole removal, and the more recent proliferation of local, community-focused museums, students at Freda Diesing have many opportunities to see older artwork in person through fieldtrips to Kitimat, Prince Rupert, Kitsumkalum, Kitselas, Gitanyow, and Laxgalts'ap – the site of the new Nisga'a museum. Lectures and tours at these sites are often accompanied by a studio visit to meet local artists, who are usually happy to share their life stories while displaying their recent work and, sometimes, their wealth. In Kitimat, the class visited Haisla artist Sam Robinson, who is well known to collectors and locals as a result of his exposure at Expo 86 but not recognized by scholars or galleries since the majority of his sales and commissions are private. Robinson embodied his "Elder carver" role with wit, poking fun at the students, proudly displaying his collection of furs and skins, and ushering us out of his studio to see both his crest pole and his most recent prized possession: a Cadillac that is activated by the sound of his voice. The students, normally a stoic bunch on fieldtrips, were noticeably impressed, taking dozens of photographs on their phones. Robinson wasn't just displaying his talent and wealth for recognition: he broke his joking demeanor to tell them, very earnestly, that they needed to stay away from drugs, alcohol, and bad influences if they wanted to be successful and that they should take their carving seriously, always giving back to their community as their fame grows.

This moralizing is common among guest lecturers and artists, and connected to "homework" as a cultural and spatial negotiation. Elders narrate their stories as redemptive accounts of giving up harmful vices to live the life of an artist and in generating both status and wealth. This morality is both functional, a way of trying to keep a generation of First Nations youth at risk alive and out of jail, and spiritual, a way of emphasizing the sacred nature of carving. For instance, during his visit, the artist Roy Henry Vickers (Tsimshian/Haida/Heiltsuk) spoke very candidly to the students about his own struggles with substance abuse and violence as a young artist and his later conversion to a sober life that made possible the acquisition of great cultural and material wealth. These stories, often echoed by Elder students in the class who are returning to school in the wake of residential school trauma, are instructions for living.

These artist subjectivities are also meant to be protectively deployed amidst the art world down South against the temptations of the city and as a mark of professionalism in the gallery system. Gallery owners often lamented the difficulties faced by young artists moving to the city, noting the toll that it takes on their productivity and ability to assess their own

work with a clear mind, making them more or less difficult to work with. Intersecting with a broad Protestant-capitalist work ethic, cultural propriety is thus connected explicitly to individual productivity both up North and down South. These intersections and their cultivation show how neoliberal values and Indigenous ones may overlap to produce artists as productive subjects.

Yet "serving one's community" and "paying your dues" also seems to mean something more for Native artists, at least in a region where one is accountable in bodily ways to many different First Nations communities. During a class discussion, Luke asked the students how they felt about producing work for the art market. The students, to my surprise, responded with ambivalence. Many of them were just working out how to balance different cultural styles in their work and were anxious about selling these early attempts at working out their identities – the works were too personal, they said, and revealed too much. Luke was sympathetic to their angst but reminded them of a statement we had recently read by the artist Marianne Nicolson:

> What I am learning is very powerful. I want to manifest it in visual works, but I don't want to limit their interpretation; I want the work to have layers.[60]

The moment was an intimate reiteration of the tensions between secrecy and revelation that are inherent to all cultural property on the Northwest Coast – an articulation of the worry that power is lost when things are seen, coupled with a parallel and paradoxical need for art to circulate in order to generate value. In this moment, the layered character of works and the situated nature of knowledge became explicit tools for living, instilling property values alongside the professional skills to make work that would sell – a lesson on selling without selling out. Getting this balance right is what it means to "do your homework."

"STARVING AND CARVING"

Angelo Cavagnaro stands at the front of the class. It is the end of term, and the students have reluctantly abandoned their stations in the carving shed, where they are working furiously to finish and paint their grease bowls, spoons, masks, and paddles for the end-of-year exhibition (Figure 4.3). Finishing the year also means giving a final oral presentation on their work, an exercise in narrating lineages, influences, and life stories. Pausing to acknowledge his audience, Angelo begins reading his artist statement: "I was born August 24th, 1992, at 5:36 am in a white Pontiac Tempest on Kalum Lake, Tsimshian territory. My mother is Nisga'a from the village of Gitlaxt'aamiks (New Aiyansh) and my father is from California with Irish and Italian descent. Best of both worlds, my aunts and uncles say."

We have heard this story before; here, I am telling it with Angelo's present-day permission and revisions. It is and was part of Angelo's style of speaking, and the learned practice of Freda Diesing students, to begin in precise detail the work of refining the tale of how he became a "jack of all trades," working with his hands in construction and now in art.

Figure 4.3. Angelo Cavagnaro, *Gitmidiik Wildman* (2013). This piece is Cavagnaro's rendition of a mask currently on display at the Nisga'a museum in Laxgalts'ap (Greenville). Cavagnaro writes: "I used the open mouth, baring teeth motif as a foundation for sculptural learning. *Gitmidiik* means people of the Grizzly, a migration group that is spread out in the north. Wildman label relates to the land and the nature of it." Photograph by Bruce Byfield. Courtesy of the artist and photographer.

It is also a story of cultural awakening, of being "not fully in tune" with his Nisga'a heritage, and of abandoning a program in mechanical engineering in Vancouver to come to the school and back to the North. "This program," Angelo explains, "I had a bit of an idea of what I was getting into. But what I was really learning was developing a traditional perspective on things. It makes life easier that way."

He goes on to tell how the program has allowed him to work during the summer at the new Nisga'a museum in Laxgalts'ap, reconnecting with old pieces that "have crossed the lines of life and death" and gaining knowledge of how to host a feast. "I feel that, in the future, I'll eventually become a chief, because we still eat with the Eagles even though we are Grizzly Bears. Traditionally speaking, this Grizzly was born by the water, raised by Eagles, and it's up to me to decide what's next."

Angelo's story encapsulates much of the confident and precise self-presentation encouraged at the school. Through his narrative, Angelo articulates his coming into cultural awareness as a life-changing event that was presaged and embodied in the conditions of his birth. His story also narrates the sacrifice that mirrors critical concerns about the effects of vocationalizing Aboriginal education: instead of becoming an engineer down South, breaking into the resource economy and shifting the relations between heartland and hinterland, Angelo will become an artist in his community up North, taking a mix of cultural and hard-labour jobs to survive in a way that "makes life easier" and *feels* right. Likewise, in her presentation, Loretta Quock Sort, a Tahltan woman from Telegraph Creek and previously a teacher in her community, communicates her connection to the school's teachings by laying out several deer skins that she has obtained by hunting or trading onto the desks. As she speaks, she wraps herself in a button blanket to display both her privilege – hand-sewn and embroidered by Loretta into felt – and networks of exchange that both her hunting and art practice have enabled.

Living up to these expectations can also be anxiety inducing. One of the most promising young artists at the Freda Diesing School – the teachers had purchased some of his projects, and he is now represented by Spirit Wrestler Gallery in Vancouver – would often introduce

his own work with ambivalence, drawing attention to what he hadn't quite accomplished or the mistakes he had made. On one occasion during a class discussion, this student, whom I will call Daniel, became very animated talking about the work of renowned Haida artist Robert Davidson, expressing frustration that no one in the classroom would ever be as good as him, either aesthetically *or* culturally. This anxiety had as much to do with the sense, shared by many students, of "homework" needing to be accountable as well as needing to fulfil exacting aesthetic standards, based somewhat unrealistically on such long-established artists as Davidson.

Another scene marks this careful détente and how this struggle with the value of innovation felt. Down South, at the opening of the students' *Northern Exposure* show in 2012 at Spirit Wrestler, I had congratulated all of the students who had graduated in the 2012 cohort and was chatting with the student who had been so frustrated by the seemingly unachievable conditions of artist Robert Davidson's legacy. We happened to be standing in a part of the gallery that had some of Davidson's prints on the wall, and our discussion looped back to the older artist's mastery – his effortless lines, the perfect balance between points of tension and release in the composition, and, again, the balance of his life as an artist who humbly serves his community while maintaining international prestige and wealth. I could see that this student was getting frustrated again – he was shaking his head and shifting from foot to foot.

"I just don't get it!" he exclaimed. "How does he do it? What *is* it about these paintings?"

I had never quite known how to make this student feel better about the long-term negotiations involved with carrying the burden of art history. I attempted something vague about trying not to compare himself to Davidson.

He angrily interjected: "Just *look* at them. What do *you* see?"

I looked, my eyes focusing between the formline design and the secondary split U-forms, the perfectly shaped ovoids, the delicate linework, and the subtle expression of traditional knowledge amidst abstract form, a visual archive of years spent crafting the self.

"I see freedom," I said finally.

The student's shoulders dropped.

"Yes," he said. "That is it exactly."

I think about this moment still and its somewhat capacious meaning of freedom shared between us. There was a mutual appreciation of Davidson's abstraction and play with formal rules as legitimized by both his stature in the art world and his significant community ties as someone who had indeed paid his dues – an earned freedom of form. And at the same time, for this student, it seemed to hold future promise and the reassurance that he could indeed do the same. I had found the right word for the formal quality *and* practice.

Indeed, all of these kinds of stories are very much in line with the tone and phrasing set by teachers and guest lectures on the value of living an artist's life – "paying your dues," "doing your homework" – and show how students take up these lessons, incorporating them into their own life stories and expectations. I came to think of these stories as both an extended "artist's statement" – communicating the cultural themes

and individual rights embodied in the act of making – and as articulations of something closer to cultural citizenship in which vernacular expressions of difference are *heard* as claims to cultural forms and assertions of the right to be different.[61] Cultural citizenship at the Freda Diesing School means taking up the life of an artist, which is both a sacrifice and a deeply fulfilling way to live that emphasizes connection with one's community and values beyond the monetary ones with which this kind of life is entangled: the gallery system down South and the resource relations of the North. Through these systems, the governmentalizing capacities of citizenship are always present alongside cultural ones – the vocationalization of Indigenous labour, the subjectivity that seems to require a sacrifice of criticality for a retreat into commodifiable "culture." In order to take claims to culture and repair seriously, we should not lose sight of the ways in which bright students such as Angelo and Loretta filter their skills and impact into the world of art in a deeply felt sacrifice, known as "starving and carving" – a phrase of Dempsey Bob's that has become vernacular among students as well, as much for its painful truth as for its romantic cadence.

To reduce analysis to a critique of cultural dupes learning to labour in ways that serve the interests of the state misses much about both how cultural conditions are felt as well as unseen relations and connectivities that are activated by their narration. Dean Heron's (Kaska/Tlingit) story embodies these tensions. A former Freda Diesing student, Heron worked at the school as a teacher and administrator while I was there, and his story is a tale about "starving and carving." Over the course of two hours, he explained to me his decision to give up a comfortable life, job, and house in Victoria to move with his wife and two sons up to the Freda Diesing School so he could connect with his Tlingit heritage by learning to be an artist. Like many life stories that introduce poignant and meaningful circumstances through individual experience, Heron's story of becoming an artist has taken on a life of its own. Everyone knows it, and long-time friends of the school will often ask newcomers to the community or at school-related gallery openings whether or not they have heard it. The sacrifices of his decision still feel fresh; Heron's story brings tears to my eyes and his. Here, I have chosen to paraphrase his words for clarity and to focus them towards the ways in which the work of the school enables a transformation of carvers into artists.

As a child, Heron was adopted by non-Native parents and moved from Watson Lake, Yukon, to Kitimat, British Columbia, and then later to Ottawa in Ontario, where, for the first time, he experienced racism and took what he calls a "tokenism course" on First Nations of Canada. Heron had always thought of himself as Tlingit, and his adoptive parents encouraged him to go to museums and learn about his Tlingit heritage. At first, he traced a few images of crests and old objects from books and read some secondary sources, but he didn't have a real interest in learning more until he was at university in Victoria, British Columbia, and he and his wife, Therese, were looking at totem poles in the Royal British Columbia Museum (RBCM). As Therese asked him to explain their meaning, Heron experienced a sense of disconnection from the monumental works: "I could only tell her [figures on the totem pole] by reading the description on the back [of the display]. She'd be looking up, and I'd be reading."

Heron started trying to find contemporary artists producing Northern work in Victoria, which brought him to the dealer Elaine Monds at the Alcheringa Gallery. She told Heron about Dempsey Bob and his two nephews, Stan and Ken; however, she couldn't show him any work in person, because Dempsey, Stan, and Ken's pieces always sold so fast. Heron shifted his search towards older work and started doing archival research at the RBCM on Tlingit art – notably, however, most late-nineteenth-century Tlingit work lives far away from Victoria at the Smithsonian in Washington, DC, and the American Museum of Natural History in New York – and attending as many gallery openings as he could in Victoria and Vancouver. Heron made the decision to become a carver, and the dealer Elaine introduced him to many Indigenous artists who travelled through Victoria. But Dempsey, Stan, and Ken were never among them.

One afternoon, Heron and Therese were at a neighbour's barbecue, where they met David, an Indigenous man who had also been adopted as a child and recently connected with his family in Terrace. His father, David explained, was the artist Dempsey Bob. Says Heron of the moment: "My wife and I fell off our chairs!" This chance meeting led to a visit with Dempsey when he was in Victoria to see a show at the Inuit Gallery.[62] Dempsey invited Heron to help him paint his new sculptures; without a moment's hesitation, Heron called in sick to work for the chance to apprentice with Dempsey.

Later that year, as a guest of Dempsey's at an opening for a show at Spirit Wrestler in Vancouver, he met Stan and Ken. They told him about their plans for the Freda Diesing School. After much equivocation – this move, after all, would mean giving up a stable job and leaving his family for two years to work towards an unknown future – Heron decided to attend the first cohort. He moved to Terrace, while Therese, who was very supportive of his attempts to reconnect with his heritage, stayed in Victoria with their young sons. From his first day at Freda Diesing, however, it became clear to Heron that "this wasn't really a two-year-long endeavour." By the time I arrived in Terrace, he had been there for eight years. His wife had left her salaried career to become an independent consultant, and the whole family joined him up North.

Shortly after his move to Terrace, the teachers put out the word in the community that he was looking for his father. Almost immediately, a neighbour guessed at Heron's mixed Tlingit and Kaska ancestry – the Kaska are Athabaskan-speaking First Nations people in the southeastern Yukon – by his particular gait. This assessment was then confirmed by a social worker, who now knew where to look for records; she helped Heron gain access to details of his adoption and get in touch with his uncle, who explained that no one in the family who was still alive had known he was born. Heron visited his father's community in Watson Lake in a gathering at the hall. His father, sitting at the centre of the hall, spoke in the Kaska language. Heron recounts his father's words:

In the early 1960s, his Elders told him that all these kids are disappearing from our land, because they were going to schools, going away far from the culture. But one day they will all come back, every single one of them will come back at some point in our lives. And it will only make our community stronger because they'll know the other ways of living … [A]ll those kids who were taken away will come back and make us stronger.

Heron's story acknowledges a painful community loss, as well as the hopes bound up with returns. In its many sites across communities, territories, and art worlds, his story also articulates how discursive knowledge of Northwest Coast art circulates and the ways in which this knowledge, objectified in books, can also bring together artists, scholars, art world practitioners, and even family members, mediating loss as they convey the story of the school as a connective site.

INDIGENOUS INDICATORS AND INTANGIBLE VALUES

Beyond these insider functions, such public presentations are also important markers of cultural legibility to outsiders in ways that intersect with neoliberal heritage regimes. The previous fall, the Freda Diesing School had been awarded a prestigious and unexpected grant from the newly established Margaret A. Cargill Foundation (now Margaret A. Cargill Philanthropies). This particular Cargill award, from the Native Arts and Cultures subprogram, is intended to produce three related outcomes: support of Native artists, the "intergenerational transference of Native artistic and cultural practices," and access to art – all goals that are shared explicitly by the Freda Diesing School.[63] But the problem – a problem in all arts funding – was that administrators at the school hadn't yet figured out how they were going to ensure that these goals were *visibly* met. Intergenerational transference is, after all, a gradual process, and one that doesn't always line up with an artist's or art form's commercial success.

That April, consultants from a third-party firm arrived in Terrace to perform an audit. Even though formal classes had ended, I was still in Terrace, helping with preparations for the year-end exhibition of student work to be held in the longhouse. Stan invited me to come along with him and the other teachers to show off the art program to the auditors. Stan hoped, he told me, that having a kind of "researcher-in-residence" from New York would help show the reach and influence of the school. I was both excited at this chance to see protocol in action around performing cultural transmission – an actual audit and a presentation intended to communicate measurable outcomes – and anxious on behalf of the school about its performance. How might it be possible to measure community impact in ways that don't necessarily reduce cultural values to monetary ones? And how could the history and profound impact of the school be communicated to outsiders in two days?

My anxiety was also structured, obviously, by anthropological suspicion of neoliberal heritage monitoring. The audit as cultural technology reveals the slippages between funding, extraction, and accounting discussed at the beginning of this chapter – fault lines that are clearly visible as intangible values, and economic indicators of success are entangled in the heritage-making process. Indicators, as modes of objectifying culture, are technologies of governance that are increasingly applied to matters of cultural property and in heritage regimes that seek to make culture legible.[64] These standardizing measures and development are processes of condensing knowledge, information, and embodied practices into objective markers of often very subjective things: growth, development, and even failure. Many of

the Freda Diesing School's most compelling outcomes for its students – pride, anti-violence, a sense of cultural self-worth – are not measures that easily correlate to economic impact in the same way that vocational training for jobs in industry might. Audit values also sit in tension with the school's attrition statistics: many students, due to the obligations of family life, come in and out of the program over a period of several years, and many more do not in fact go on to work exclusively as artists or in arts organizations. Many, like Angelo, and like Dempsey before him, continue "starving and carving" while working minimum-wage jobs, yet the values they bring to their communities extend the intangible wealth of cultural belonging – a sense of "realness" that looks different from the urban Native identities discussed in chapter five but is equally connective. How could these values be reflected in the audit's "tangible outcomes"?

But as the auditor and her assistant made clear as soon as they stepped into the carving shed, the purpose of their visit was to develop a series of collaborative indicators of success *with* the school. We learned that the visitors were from a Native American–run consulting firm, and they fundamentally understood what Freda Diesing is about, although they were still surprised – as are many visitors to the Northwest Coast – at the deep connections First Nations people maintain to their lands and waters. Throughout the visit, I watched as the consultants wrote down things like "cultural pride," "family," and "land claims" into their notebooks, working with the school's teachers to map these values into a flow chart that could communicate, for instance, why visiting a museum down South was about more than just technical instruction but also about building networks between galleries, Native youth, and First Nations people in other parts of the province; or how a computer course could help Elders, who were returning to education after residential school trauma, catch up with their younger peers.

Following student presentations, lunch with NWCC's deans, and a short visit to the First Nations longhouse on campus, Stan, Dempsey, Dean, Rocque, the consultants, and I all drove out to Kitselas, the First Nation and community centre that Stan regards as home. On the wall of one longhouse, Stan pointed out an oversized picture of his grandfather, George Bevan, posing in his Sunday best alongside other Gitselasu, "people of the canyon," in the early twentieth century. Stan explained to us that George and the others were posing for an unknown guest – respectfully welcoming visitors but marking through the formal and documented encounter that these were their territories, and visits would be on their terms. This story provided important historical background; it also enacted a boundary for all of us.

The disparate pieces of this encounter – the dynamics of homework, geographies of belonging, the work of crafting the self in the midst of neoliberal Indigenization and audit cultures – are intertwined by the school's regional cultural politics. As I have tried to show throughout this chapter, the Freda Diesing School draws on a long and complex local history, as well as on ongoing sovereignty claims in a region that is being mined for both its natural and cultural resources. Indeed, the school's labour, while it is organized around and inflected by neoliberal Indigenization policies, is also a carving out of everyday forms of belonging and a work of repair. These attachments, which are both felt and performed, destabilize much of the cynicism that pervades governmentality scholarship as well as

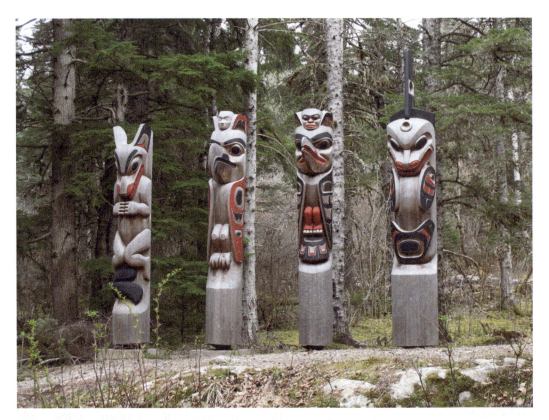

Figure 4.4. Stan Bevan's contemporary poles at Kitselas Canyon, British Columbia. Photograph by the author.

scepticism about what happens when culture or art becomes objectified in market systems, heritage protocol, and institutional regimes. The school's vernacular practices enact Indigenous belonging, inflected as they are by the ambivalences of "starving and carving" amidst widespread extractive projects and the threat – and promise – of free markets that they provide.

As we drove down into the canyon to look at four totem poles, carved by Stan Bevan with assistance from the school's teachers (Figure 4.4), the weight of the histories and futures contained in the land were palpable. The consultants barely spoke; we all just stood still and looked at those poles, visible markers of intangible values, intercultural exchange, and the circulation of wealth. At the end of the visit, as Stan and Dempsey passed out gifts – art prints and NWCC coffee mugs and T-shirts, material acknowledgments of the consultants witnessing something important – I saw how resources extracted and exchanged could be converted back into intangible wealth.

CHAPTER FIVE

Copper and the Conduit of Shame: Beau Dick's Performance/Art

On 27 July 2014 the artist Beau Dick, a member of the 'Namgis First Nation in British Columbia, arrived in Ottawa, Canada's federal capital. Travelling to Ottawa alongside Haida leader and activist Gidansda Guujaaw, as well as a growing caravan of Indigenous supporters from across the country, Dick carried with him a large copper, a shield-like object that had been blessed in different community stops. This copper, given to him by the Haida Nation, was named *Taaw*, which means "oil" – a reference to the anti-extractive environmental politics that compelled Dick and Guujaaw's journey. Both being and belonging, *Taaw* was also meant to visit other coppers from the Northwest Coast that were housed in the Canadian Museum of History. This gesture was also politically charged, as the museum had just signed onto an oil company sponsorship deal with the Canadian Association of Petroleum Producers (CAPP).[1] However, as Dick describes in a written text that tells the story of his journey, he and the other members of his party were denied access to the collections: "When our group approached the museum in Hull, Quebec, they wouldn't let us in to visit our coppers that were in there. They boast of how many pieces they have in their collection, a small fraction of which are on display for people to see."[2] Reflecting on the meaning of this refusal, Dick asserts that "it was embarrassing – but not for us."[3]

Denied access to the museum, the group of twenty-two artists, activists, and youth danced, sang, and made speeches on Parliament Hill. They proceeded to break the copper or, more accurately reflecting the language for this cultural practice, to cut it. Rending two small pieces from its form, the group worked on top of a large vinyl panel made by a non-Indigenous artist, Cathy Busby, and printed with her edited summary of Canadian Prime Minister Stephen Harper's 2008 public apology to survivors of Canada's Indian residential school system. The pieces of copper were wrapped, blanket-like, in the vinyl panel and deposited in the building's foyer – a gift that would return, or perhaps redistribute, a burden of care.

This complex event and contemporary act of display involved multiple layers of material. It testifies to both the vitality of First Nations cultural activism and the violent legacies of colonial governance. This journey, given the title *Awalaskenis II: Journey of Truth and Unity*, was made from 2–27 July in the wake of Idle No More, an Indigenous sovereignty movement uniting environmental and political struggles. It also extended an earlier manifestation, *Awalaskenis*, that Dick had carried out at the urging of his daughters, Geraldine and Linnea Dick, which had taken place the year before on the steps of the provincial legislature in Victoria, British Columbia. In Dick's publicly recorded words, "the copper is a symbol of justice, truth and balance, and to break one is a threat, a challenge, and can be an insult."[4] In Ottawa, Dick's action was questioning the sincerity of efforts at reconciliation and repair – indeed, Harper's apology was one of the "broken oaths" that the event poster references. For people who potlatch, breaking a copper is a ceremonial and dismembering act with a very specific affective intention for its audience: it is meant to shame.

Moreover, as a striking and photogenic spectacle, *Awalaskenis II* also generated – and often confounded – considerable media attention, as Dick and Guujaaw were interviewed on national television. Bewildered media coverage fixated on what the breaking of copper means and makes tangible for Indigenous and non-Indigenous relations in Canada, circulating uncomfortable reflections on *who* is shamed in such protests and why. As a result of Dick's action, the meaning of the shaming ritual had been made a matter of contemporary public relevance, and its connections to extractive economies – in the museum and beyond – made explicit.

But almost immediately, a parallel conversation emerged among critics, gallerists, and scholars about whether and how to claim this work as art. At the time of both actions, Dick was artist-in-residence at the University of British Columbia's Belkin Art Gallery and Department of Art History, Visual Art, and Theory. *Awalaskenis II* also became institutionally legible soon after its completion in three exhibitions, including *Lalakenis/All Directions* at the Belkin, which displayed a performance archive of the action to be witnessed by those who could not follow Dick's journey in person. In 2017, the year of Dick's death, curator Candice Hopkins installed work from *Lalakenis* at *documenta 14*, a high-profile contemporary art fair in Athens, alongside twenty of Dick's masks. In a moving memorial text, which is still active on the *documenta* archive, Hopkins wrote of Dick's wanting to come to Athens "so he could speak with people who have had to leave their homelands. For him, the loss of one's homeland rendered culture, language, and tradition vulnerable."[5] In these ways, Dick's action was connective as well as rupturing, not only in the spaces of public protest but also across regimes of value in the art world.[6] As curator Roy Arden notes in the documentary *Beau Dick: Maker of Monsters*, a film made by Dick's gallerist LaTiesha Fazakas, "anthropologists and art historians basically agree that Dick is the best West Coast artist since contact."[7]

During my fieldwork, I never formally interviewed Dick and did not know him well. We met first when I was a graduate student working on an exhibition of late-nineteenth-century Northwest Coast art in New York called *Objects of Exchange*. I had travelled with the curator, Aaron Glass, to Alert Bay to film interviews with contemporary artists about

the older works in the exhibition, which would be available on an audio-guide to bring the voices of this art world into the New York–based gallery. I remember setting up the shot of Dick outside U'Mista Cultural Centre, the tribal museum at the centre of Alert Bay's arts community, carefully framing his portrait to show off his iconic felt hat, adorned with a carved bird and a feather. Even from behind the camera, his low, melodious voice conveyed a deep knowledge of lineages and crests as he speculated with us about the role that one particular object – a model house – might have played in training future artists. Back in New York, the film footage was well received. Dick's flannel shirt, long beard, and twinkling eyes brought a legibility and hipness to his translation, and the video embodied a generosity of shared thinking about this moment of exchange with this towering maker.

Later, while I was doing my own research on the Northwest Coast, we met a handful of times at exhibition openings in Vancouver and Alert Bay, where we shared a meal at U'Mista. In Alert Bay towards the end of my fieldwork, I wrote parts of my dissertation in the restaurant where Dick often held impromptu fiddle concerts, stomping and whistling while he fiddled, playing to the audience. Most often, younger artists would speak of him as an inspiration for their work, and older ones, while always full of admiration, would sometimes point out where they thought he had gone too far into the contemporary art world, breaking with tradition. Heavily pregnant with my daughter in Toronto, I watched *Awalaskenis II* unfold remotely on my Facebook and on the news. And finally, after his death, I returned to the breaking of copper through its documentation and art world mediation.

I write all of this narrative detail to say that I experienced Dick's influence and charisma as a larger-than-life figure in the art world; unlike other chapters in this book, I arrived at my knowledge of his work from a distance through social media, exhibitions, and secondary sources – the toolkit of the art critic rather than the anthropologist. Yet this process, too, is a working between art and anthropology. I now understand Aaron's interview with him as a way of activating a collection and intervening into its routes through a reassertion of Indigenous presence and authority for display in the university gallery, a performative gesture on both sides that refuses to settle on one particular mode of apprehending art.

Building on the previous chapter's histories of repair and return, this chapter focuses on the multiple points of slippage between art and anthropology in *Awalaskenis II* and its circulation in the contemporary art world. What did this shaming art-action do, and how did it work across registers of politics and performance? What are the sources of value in this intercultural exchange? Here, I build on and diverge from Stó:lō scholar Dylan Robinson's approach to the "functional ontologies"[8] of copper as a materialist source of this action. Copper is indeed a resource in Dick's performance, and its breaking, display, and subsequent removal to a community museum on Haida Gwaii enables a release of surplus value – the "accursed share" in Georges Bataille's theory of excess in exchange.[9] I consider how this release might be thought about in relation to affect, specifically the distribution of a public feeling like shame. Thinking with anthropologist-critic Charlotte Townsend-Gault, I am also interested in aesthetic questions raised by Dick's work and how his ontological trafficking with copper is a knowing one that makes use of the materials and spaces of the intercultural art world, drawing together multiple registers and frames of spectacle through

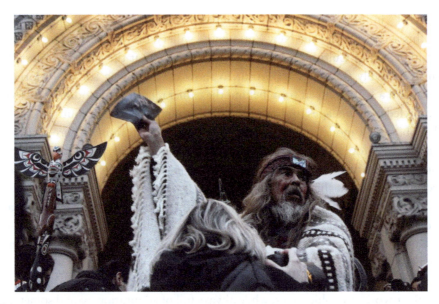

Figure 5.1. Beau Dick in Victoria on *Awalaskenis I*, 2013. Photograph by Scott Polson. Image courtesy of the photographer.

its "desire for transcultural transformation."[10] Poised on the steps of the provincial legislature in his regalia during *Awalaskenis* (Figure 5.1), Dick is as much messianic figure as hereditary chief – although, in Townsend-Gault's reckoning, he is "no angel of history" who would melancholically redeem the broken past. Instead, she interprets his paradoxical act of breaking to mend as a cultural technique bound up with ruin and failure, with "breaking the tangible exuding an ethical surplus, perhaps another opportunity to mend broken social intangibles."[11]

Is a form of repair that carries its brokenness into the present possible? In this chapter, I argue that, in this action and its efficacies, Dick dramatizes historical materialism alongside ontologies of copper. In this way, I am making a case that his work enacts what Jessica L. Horton has theorized as "transcultural materialism": a vibrancy of matter – the copper, the vinyl panel – that does not take the path of extractive fetishism *or* the claiming of radical alterity involved in some strands of the so-called ontological turn.[12] Much like Horton's emphasis on the environmental and materialist politics of the American Indian Movement generation of artists, my contention here is that this peripheral art world and its politics are in fact viscerally tied to other places through resource economies that cross national boundaries in the extraction of natural and cultural resources. Among these are the processes of social and cultural production in Northwest Coast art worlds – the valuing of particular contemporary forms and the heightened visibility of forms of extraction – that are set into motion through this specific act of performance and protest. Across such social and environmental routes, art may be a form of *action* that brings relationships between far-flung peoples, things, and territories into being.

But my analysis also departs from this vital materialism – of which "enchanted activism"[13] is a part – to consider the dynamics of redemption and revolution in the act of cutting copper. Focusing on shame as political affect, I suggest, allows us to apprehend something about Dick's work in the context of the age of reconciliation: how it works with therapeutic economies of emotion against a pathologized narrative of these sentiments that victimizes Indigenous people as traumatized subjects.[14] I argue that the breaking of copper allows for a reparative mode that exceeds the trauma and resilience–based model of state-licensed truth and reconciliation. Moreover, I suggest that this materialist critique also works against a related narrative of ecological damage that posits contaminated lands and waters as beyond repair and therefore also beyond an ethics of care.[15] By setting up a close study of one particular performative act, this chapter also theorizes these aspects of performance as "transitional properties," which I define as forms of cultural property that shift between the registers of reconciliation and other points of reference for revolutionary hope.

In what follows, I trace the transcultural materialisms of *Awalaskenis II* in three ways: first, in relation to the particular art-resource nexus that is invoked in the cutting of copper and its visual culture, and the texts and image that mediated the action; second, in the art world's incorporation of this action as performance art that contributes to the status of Dick's practice, in which I tell a marginal story of exchange between artists; and finally, in relation to the anthropological theorizing of shame as a political substance. Throughout, as a counterpoint to media responses that fixated on the alterities and hostilities of the copper breaking, I show how the materialities of this performance are profoundly intercultural: they draw on long histories of transaction between Native and non-Native peoples – *and* between First Nations – that emerge around Northwest Coast art as a stylistic and ideological category and in projects of resource extraction that cross many territories.

"THE REVOLUTION WILL NOT BE TELEVISED"

Through a lo-fi, red and black aesthetic – a canonical palette of Northwest Coast art – the poster for the first *Awalaskenis* in Victoria distributed Beau Dick's initial call to action (Figure 5.2). Circulating on Facebook and other social media outlets, this image declares both its anger through its imagery of a distinctly unwelcoming welcome pole on top of a television set and cheekily gestures to technological mediation. "The revolution will not be televised," it says, implying that if you want to be part of this revolution, you must meet it in public rather than from your home. The words belong to Black poet and musician Gil Scott-Heron, who recorded a song of the same title in 1970 in Harlem at the height of the Black Arts Movement. Mixing spoken-word lyrics and African conga beats, the song is widely recognized as a precursor to hip hop and rap, and its potent critique of political apathy and consumer culture was encapsulated as a slogan for Black Power.

Dick's citation of Scott-Heron in the promotion of his action may be read as both genuine tribute and playful invocation. By drawing an analogy between the Pan-Africanism of the Black Arts Movement and Idle No More, the political catalyst for his action, Dick frames

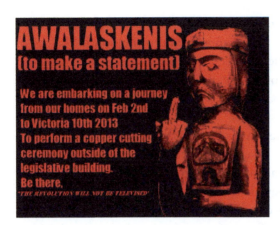

Figure 5.2. Poster for *Awalaskenis*. Uncredited poster circulated on Facebook in 2013 obtained by the author.

his action as a connective one, uniting many kinds of political struggle amidst conditions of racial capitalism. His nod to the beginnings of hip hop genres also riffs on the power of *Beat Nation*, a contemporaneous art exhibition about Indigenous hip hop and urban culture (I discuss *Beat Nation* at length in chapter three), evincing both a hipness and Dick's status as a larger-than-life art world figure. When I was in Alert Bay, Dick's home, the summer before *Awalaskenis*, a muscular Beau Dick action figure, complete with his wild, long grey hair and feather-adorned felt hat, was nestled in the window of the village's carving shed. Later, for *documenta 14*, Dick placed this effigy, adorned with a button blanket robe and Hamat'sa dance society cedar ring, to ride on the back of an orca whale mask. Of this addition to the exhibition that he would not live to see, curator Candice Hopkins writes: "True to form, he was the one pulling the strings."[16] There is a coolness to Dick's canny recontextualization of Black Power and also the sense of an incredible staging of the event, including its broader visual and material culture.

There is something intriguing, too, in Dick's disavowal of electronic transmission through a slogan against political apathy. Idle No More was also #IdleNoMore, a highly mediated digital social movement, and Dick tells the story of his daughters bringing the movement to his attention – an oral transmission through family channels.[17] Parts of *Awalaskenis* were also, in fact, televised and mediated by reporting, and other parts were posted on social media as the movement made its way from British Columbia to Ontario. In this context, the slogan of "the revolution will not be televised" also plays on the complex dynamic of display and concealment involved in mass-mediated social movements and suggests deliberate staging of how technology will or will not be incorporated into Indigenous practice. As Charlotte Townsend-Gault argues, Dick's performance of cutting copper was, at every turn, at risk of being read as primitivist spectacle, a showy revival of an ancient tradition that lacks teeth.[18] In her analysis, what redeems it is a kind of "protocol play" that works between excessively transgressive registers of contemporary performance art and the frisson of uncertainty involved in witnessing Indigenous ritual: "When such specific cultural capital is thrown into shared temporal space, and where its agency derives in part from primordial

claims and in part from broken outsider laws, broken treaties, broken promises, the potency of the action cuts across its untranslatability."[19]

Indeed, as Townsend-Gault notes, the inclusion of Busby's panel as the ground for this action also calls in the frame of contemporary art as it deepens the performance's intercultural grounding and networks. Following Townsend-Gault's suggestion of Busby's work for inclusion in *Witnesses*, her *WE ARE SORRY 2013* returned to Canada from Melbourne, where it had been wrapped around the corner of the CitiPower electrical substation's façade – indeed, in this site-specific version, the vinyl with Harper's apology was installed side by side with then Australian prime minister Kevin Rudd's apology to the "stolen generations" of Aboriginal peoples. Busby explains that, upon the vinyl's arrival at the Belkin, the work was cut "due to the severe disrespect that had been shown towards both the apology for the stolen generations in Australia and towards the Indian residential school survivors in Canada." Then, a section of the massive Canadian panel was gifted to Dick at his request. "When I gave [Beau] the section of this work," Busby notes, "we had a gifting event/witnessing by the grad students who we, as artists-in-residence, shared with them. When we were there disassembling the exhibition at the Belkin Gallery, Beau blanketed me."[20] In this way, Busby's work figures as a significant exchange object, deepening intercultural relations in the space of the gallery and extending them to Parliament Hill.

By bringing in other outsides – the frame of Black Power and a rejection, perhaps, of the excessively nationalist television channels of public culture in Canada in favour of the Indigenous space of social media–driven movements[21] – Dick insists on other kinds of protocol play. In this way, his mimetic action figure might be read as an avatar whose presence at a global art fair in Athens witnesses the untranslatable but also embodies a capacity to move through different kinds of cosmopolitan space, concealed in full regalia.

TRADE GOODS

Copper, the material at the centre of Dick and Guujaaw's action, is also central to the meaning of the performance. Coppers are both beings and belongings in ways that lend themselves easily to use as an art world resource in both the sense of ready-mades and new-materialist "vibrant matter,"[22] animate forces in the renegotiation of social relations. In parsing how matter comes to be of value across art worlds and anthropology, it is helpful to clarify what is at stake in debates around materialisms new and old, and how these approaches frame my analysis. Anthropology has long been interested in the relationships between people and things, addressing how social, cultural, and political-economic realities are mediated through the material world – means by which art *becomes* a form of social action that makes persons and generates social relations, particularly through exchange.[23] Materiality, as an area of concern crossing several subfields of the discipline, is concerned with these processes and the ways in which intangible aspects of being are given tangible form. Likewise, it attends to how the production, circulation, and reception of things – and even things themselves – shape social worlds.

Emerging as it does from the theories and life-worlds of Indigenous interlocutors, anthropology's understanding of the porosity of these human/more-than-human assemblages are a fixture of the discipline. A concern with the old materialism – the labour congealed in the commodity form under capitalism – has also been important for anthropologists concerned with revolution as well as varieties of commodity fetishism. In recent years, however, a "new" materialism has emerged from several different disciplines' concerns with the post-human and the ways that a "nature" previously considered inert and *separable* (or so the story goes) acts as a force upon humans. There are many different strands of the new materialism: Karen Barad's post-humanist performativity; Fred Moten's Black object-oriented ontology; Jane Bennett's political ecology of vibrant matter; Elizabeth Chin's auto-ethnographic materialism of her life as told through her things. The list multiplies.[24]

There is much at stake in these debates. Indeed, *where* agency is located in relation to objects is not just an analytic question but also a political one, with connections to earlier moments of primitivism and their uses of Indigenous animacies.[25] In settler societies, whose Indigenous-made materials have formed the basis of much anthropological and art historical theorizing on the resource frontier, Indigenous people have long critiqued what they perceive to be static and objectionable representations of their culture, as well as misappropriations of their property. These critiques have been particularly trenchant on the Northwest Coast – and on "the Northwest Coast" in its status as an anthropological artifact that bears the perspectival imprint of nineteenth-century scholarship. Nevertheless, the formulations "Northwest Coast" and "Northwest Coast art" continue to be locally meaningful for First Nations, reflecting histories of intercultural encounter and transaction between many different groups who speak mutually unintelligible languages. This point bears repeating: Beau Dick's community of Kwakwaka'wakw people, the 'Namgis, has long histories of political and economic negotiation with outsiders who do not speak Kwak'wala, the language that forms the basis for this scale of group differentiation. Indeed, in the shaming ceremony on Parliament Hill, the Haida source of the copper indexes historic trade relationships between Haida and Kwakwaka'wakw peoples that predate Euro-North American settlement.

Writing of Dick's action in the context of its ambivalent relation to Canadian performance art, Stó:lō ethnomusicologist Dylan Robinson argues for the need to resist its framing as "aesthetic resource," preferring instead to think of the performance as "enchanted activism," a very different repurposing of Jane Bennett's vital materialism.[26] Robinson's critique resonates with earlier First Nations and Native American political mobilizing around objects in the 1960s – calls for repatriation, critiques of the epistemological arrogance of "reading" objects, claims to cultural property – that have altered the shape of this theory-making in both art history and anthropology. In this way, theorists here have always been called to consider the *multiplicity* of "agencies" involved in moments of encounter and intercultural exchange, including in the present moment, as objects are claimed and interpreted simultaneously by art worlds, anthropologists, and Native communities in their entanglement.[27] This particular context for these understandings matters, showing that the "new" materialism doesn't emerge from some kind of laboratory of culture theory but in

relation – sometimes extractive but always recontextualizing – to lands, waters, and the ground of lived experience, including labour in the art world.[28] The Indigenous materialism is active in the cutting of copper works between Dick's ceremonial obligations and his legacies – and labour – in the art world.

And here is my more trenchant point: reckoning with a system of intercultural transactions is sometimes not adequate to capturing the generative *contestations* that attend the fixing of form in cultural objectifications. Indigenous artists and critics on the Northwest Coast, for instance, have long pointed out the limitations of framing objects depicting family crests as "art," when, according to Indigenous protocols, these are more properly regarded as legal documents that pertain to tribal governance. In this sense, objects materialize ongoing relationships and historiographies, their physicality a testament to negotiation rather than recalcitrant alterity.

COPPERS AND CONDUITS

Materials matter. Coppers, the large, flared metal forms that are the focal point of Dick and Guujaaw's ritual act, are one such object whose form navigates between illegibility and connective potential. As relatively rare and valued things, coppers are notoriously "enigmatic," and their sources and unique shape are much debated in the region's ethnohistory. I want to signal this interest as part of a generalized desire to know "about" things – an access that is often protested and protected by Indigenous interlocutors for whom knowledge is often bound up with the *right* to know. This dynamic of secrecy and revelation, a leitmotif of Northwest Coast art scholarship as well as a practice in cultures of display, is a crucial aspect of coppers' ceremonial exchange value.

Specifically, most of the Northern nations, including the Haida, Nisga'a, and Kwakwaka'wakw, to which the 'Namgis, Dick's community, belongs, have produced, kept, displayed, and circulated coppers for centuries through the potlatch. The potlatch is a ceremonial, social, and legal event in which property, including valuable objects as well as family names and "crests," the animal forms that display clan and lineage affiliations, are exchanged. Knowledge is intensely bound up with power in these acts of exchange – indeed, the abstraction characteristic of Northwest Coast art is integral to these cultures of display as a visual system for showing and protecting lineage rights without detailing too precisely what these are, such that they remain inalienable even as they are displayed. Potlatches are thus a sacred and *public* way of reckoning power, prestige, and status within and between communities, distributing wealth as well as raising the value of things that are exchanged.

Potlatching was illegal in Canada between 1886 and 1951, although many First Nations defiantly resisted this assimilative legislation either by holding covert versions under the guise of feasts or openly continuing to potlatch, risking imprisonment. During this time, people from many nations, including the 'Namgis, were arrested and had their regalia confiscated by colonial officials. This fact of the potlatch ban is a testament to the perceived legal *and* religious threat of this system of exchange – a threat that is quite deliberately

rekindled in this shaming ritual in the federal capital. The motivations behind the potlatch ban are a matter of considerable historical debate. Poststructuralist scholars, most notably Christopher Bracken, have argued that the Canadian legal system invented the Northwest Coast potlatch precisely so that it could be effectively problematized and prosecuted.[29] Such arguments resonate with what Elizabeth Povinelli calls the "cunning" nature of colonial recognition in which Indigenous alterities are constructed in ways that are repugnant such that they must be systematically rejected by the proprieties of liberal tolerance.[30] I signal this intellectual history and fact of suppression because it is relevant to the *political* nature of the intervention that this contemporary shaming ceremony makes in calling up potlatch protocols. Indeed, invoking the ban makes legible histories of settler oppression and makes its associated cultures of display a source of both unease and excitement for its publics.

Amidst the massive exchange of materials during a potlatch, coppers are precious.[31] According to ethnohistorical accounts from the late nineteenth century, the height of pot-latching for reasons that included a massive influx of wealth from intensified trade with settlers, a copper's value was equivalent to that of all the property exchanged in the potlatch in which it was displayed.[32] Beau Dick refers to coppers as a kind of "credit card" due to their value-accruing role, and their circulating, breaking, or repairing in the context of a potlatch – a chiefly prerogative – signals the power of the hereditary chief.[33] Coppers are also implicitly connected to salmon through their colour and as a form of wealth,[34] and as Katherine Damon suggests, based on her discussions with Dick and research on Kwak'wala orthography, the Kwak'wala word for copper – *tłak̓wa* – can also mean blood or, in Dick's words, the "life veins of the earth."[35] Drawing on these meanings, breaking a copper is thus tied to valuable resources and social relations of reciprocity and is also a dismembering act.

Their material preciousness and quality of being is amplified by the fact that each cop-per has a name. As I mentioned, the Haida copper that was broken on Parliament Hill is called "*Taaw*," which means oil. As Guujaaw, the Haida chief who provided the copper and accompanied Dick across the country, explained to witnesses in Ottawa, oil in this case refers "not to the oil that comes out of the ground but the oil that comes from a beauti-ful little fish [specifically, the oolichan] that lives in the Pacific and goes to the creeks and spawns, bringing life early in the spring." These animate qualities of coppers are also inher-ent to their unique form, which deliberately mirrors the shape of house fronts and Chilkat blankets, a precious textile that is also displayed and exchanged on ceremonial occasions. In Haida and Kwakwaka'wakw cosmology, all of these forms are also analogous to bodies, as they wrap and contain wearer or occupant in the symbols of their lineage. From this perspective, which draws on Indigenous epistemologies, coppers do not merely articulate value – they *embody* it.

During the run of *Lalakenis*, the exhibition at the Belkin showcasing Dick's performance archive, the gallery officially adopted curatorial assistant Jordan Wilson's language of "belongings" for things previously called art or objects.[36] As Damon observes, this language highlights both a proprietary claim involved in the work of return – coppers on display in a gallery do not belong to it – and a sense of action and process, as relationships with belong-ings are ongoing and specific, rather than the generalized primitivist "Indigenous other"

of the ontological turn and some new materialist theorizing.[37] "Belongings" also exerts the chiefly privilege embodied in such acts, as it disrupts art world and anthropological categories used in extractive research relations on the Northwest Coast to claim, instead, a non-belonging in these broader frames.

What does it mean to cut or break such beings? With regard to the performance on Parliament Hill, Dick has emphasized that such an act is a rare one. As Dick points out, according to historical precedents, when coppers were cut or even destroyed during pot-latches, these "last-resort" actions would compel rival hosts to reciprocate by breaking their own or be publicly shamed. Breaking coppers did *not* necessarily reduce or alienate their value; rather, when riveted back together, they would be even more valuable than before. Indeed, these public interactions were not only carried out between clans of a single nation but all along the coast between linguistically different peoples. What this practice means is that such material conduits have *always* played a role in brokering relations with outsiders, mediating different kinds of relationships of being and belonging. Drawing on these precedents, a Kwakwaka'wakw artist breaking a Haida copper signals these intercultural histories of transaction and extends them into the present.

THE GIFT OF CONTEMPORARY ART

The Haida copper's name, *Taaw*, oil, is also significant beyond the cultural value of ooli-chan fish. But what about the other kind of oil that is invoked as its opposite? It also specifies resource relations that are being protested and brought to bear on a national stage in the performance, connecting territories from British Columbia all the way to Parliament Hill. As Guujaaw revealed the copper's name in Ottawa, he had the audience repeat its name, then further sharpened its meaning: "Not the oil that comes out of the ground. Not the oil that is contaminating the Athabasca River. Not the oil that causes this government to put a big, festering sore in the heartland of Canada. This [*Taaw*] is the oil that brings life."

In this way, Guujaaw's words also implicate the copper cutting display into a specific resource frontier – that of oil extraction – whose networks cross many treaty lands. I turn now to the materialities of breaking copper in relation to particular conditions of art and resources in what is now called British Columbia. Stemming from Dick and Guujaaw's ancestral belonging to these lands and waters, these conditions are significant for expanding *Awalaskenis* beyond its Victoria iteration. Although an extension rather than a re-enactment, such revisiting connects a regional context of performative protest with a national one, activating translocal connections through networks of activists.

Long histories of entanglement between First Nations art and extractive politics also shape what it means to *break* a copper in the present moment of increasing pipeline infra-structure. Writing of the "zone of awkward engagement" that is produced when capitalist interests, environmental activisms, and extractive projects intersect on Indigenous territories, Tsing theorizes "resource frontiers" as sites of generative encounter from which new social relations and forms of agency emerge.[38] On the Northwest Coast, as I have already

suggested in my discussion of the intercultural relations around copper, such "frictions" have constituted the region, shaping its conditions of interaction and conflict.

Two specific political-economic conditions of British Columbia matter as it is evoked in a national protest. First is the fact that, with very few historic and several recent exceptions, the land that is now known as British Columbia is unceded by treaty. I and other anthropologists and cultural historians have argued that this lack of formalized settlement – part of what contributes to a sense of unsettlement in the region[39] – combines in particular ways with extractive interests in a resource-rich province such that *settling* claims to land through contemporary treaties acquires an urgent character. Imperatives to preserve and settle form a political aesthetic; these shape the claims about territory that are made in framing biocultural resources as, variously, worthy of protection or open to removal. For instance, in British Columbia, trees that are culturally modified are protected from logging by virtue of their Indigenous use, just as forestry corporations have also donated logs to totem pole carvers since at least the 1960s. In such instances, the protection of biocultural resources becomes the ground of this political aesthetic. This condition is also articulated precisely in Townsend-Gault's naming of these relations as "art claims," a term whose meaning depends on local analogies between land claims and the work of art on unceded lands and waters. Throughout this book, I am concerned with how such "art claims" become *thinkable* as regional imaginings of art's efficacy in ways that draw on Indigenous protocols – the "copper ontologies"[40] that render the cutting of a being an intelligible act in an intercultural space.

Second, oil and gas projects are also central to Northwest Coastal resource frontiers. Tlingit scholar and activist Anne Spice has called these projects "infrastructures of invasion"[41] to signal their ongoing work in settler colonial expansion. In elaborating on how and *which* claims are materialized through art, I turn to a work by Kwakwaka'wakw artist Marianne Nicolson. Rendered in ovoids and split U-forms, a seal, an otter, and a killer whale retreat from an inky blackness that swallows the canvas, seeping through the creatures' surrounding formlines. Titled *Oilspill: The Inevitability of Enbridge* (2011; Figure 5.3), Nicolson's painting is a beautiful and terrifying representation of environmental risk and the forms of accounting and infrastructure that render marine kin vulnerable to contaminants – an inevitability that disrespects Indigenous sovereignty, marine kinships, and the land and waters from which these forms of political organization are drawn.[42] Embedded in the painting's surface are coins from the year that Enbridge, an energy company based in the Athabasca tar sands, was incorporated. Their embedding and emergence materializes the false coin of extractive projects and the awkward transubstantiation of oil into currency. Although activists were successful in preventing Enbridge's Northern Gateway Pipelines project, which proposed to connect Kitimat, British Columbia, with Bruderheim, Alberta, via twin pipelines – one that would carry natural gas east into Alberta and one that would transport raw bitumen west from the Athabasca tar sands to the coast and into Asian markets – "Enbridge" continues to be shorthand for the threat of extraction and the undermining of Indigenous governance within and across national borders. Specifically, like most pipelines, both the Enbridge and Keystone projects cut across many territories and were extremely controversial both within and beyond these communities. For Indigenous people,

Figure 5.3. Marianne Nicolson, *Oilspill: The Inevitability of Enbridge* (2011). Image courtesy of the artist.

these projects threaten land-based sovereignty by risking contamination of the intricate system of rivers that provide the livelihood and spiritual sustenance of many First Nations communities. Regardless of their outcomes – and at this moment, in the wake of Canadian Prime Minister Justin Trudeau's Trans Mountain pipeline purchase, more invasive infrastructure certainly seems inevitable – these struggles mediate Indigenous sovereignty, drawing on these histories of resource-based struggle.

There are also powerful eco-art precedents for making "art claims" with contemporary coppers that warrant comparison with Dick's action. Haida artist Michael Nicoll Yahgulanaas's *Coppers from the Hood* series is comprised of "copper-like" objects made from the hoods of cars from a junkyard near the Fraser River in Hope, British Columbia. The first prototype from Yahgulanaas's *Coppers from the Hood* series, *Stolen But Recovered* (2007; Figure 5.4) is assembled from the abandoned hoods of cars recovered from an impounding site near Hope, where many vehicles had been left to leak toxic chemicals into the Fraser River; this work is comprised of the fused hoods of a Pontiac and a Plymouth, and its title, *Stolen But Recovered*, is itself repurposed from a police label on the underside of the Plymouth hood.[43] These found objects are then conjoined in the artist's studio into shield-like sculptures, taking on the form of this important Haida ceremonial and legal belonging. As anthropologist Nicola Levell has argued, the *Coppers from the Hood* series also indexes cars' particular associations with wealth and status,[44] while evincing a particular hip and punny vernacular – indeed, Yahgulanaas's copper from the hood that was displayed in *Beat Nation* was titled *Terse Cell* (2010), a serious play on both the car's make (a Toyota Tercel)

138　　Aesthetics of Repair

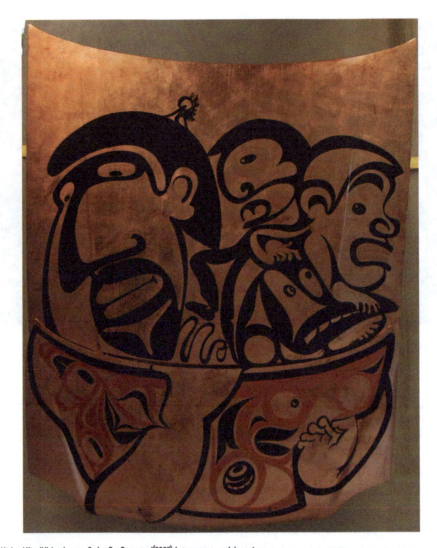

Figure 5.4.　Michael Nicoll Yahgulanaas, *Stolen But Recovered* (2007). Image courtesy of the artist.

and animation structure (cells). *Stolen But Recovered* enacted forms of reciprocity in its original display as part of Yahgulanaas's solo installation *Meddling in the Museum* (2007) at the Vancouver Museum of Anthropology in which his repurposed car part objects were juxtaposed with other coppers from the Pacific Northwest to perform an institutional critique of the separation of form from context. Through its use of traditional formline technique to depict Japanese manga-like characters and its environmental implications, *Stolen But Recovered* embodies mutual obligations, applying traditional Indigenous knowledge and currency to enact change in contemporary social conditions. Its title also asserts the power of objects to return to their makers – a source of great unease in today's museum world amidst calls for the repatriation of cultural heritage.

Like Dick's performance of breaking, the power of Yahgulanaas's copper resides in its capacity to reference multiple lineages at once. It also activates productive alliances between environmentalists, First Nations, museum professionals, and critics as it mediates a toxic landscape and reclaims discarded materials for critical museology. In this way, it activates a particular kind of knowledge to perform an institutional critique – something that is almost the same, but not quite, as other moves to disrupt museological space. What I want to call attention to here is how the revision present in Yahgulanaas's work depends upon a deep unsettlement in terms of *how* it signifies; the regional meanings resonate with concerns over specific toxic sites, while its chiefly form lends it authority to signify both as "art" and as something more.

Extending the experimentation with beings and bodies, Yahgulanaas's most recent elaboration of the *Coppers* series are his *Flappes*, a series of copper-painted gas cap lid doors – a smaller piece of the car than the hood and one that seems to reference the cutting of copper as bodily fragmentation. Importantly, the supply of these items is limited by the automobile industry and environmental considerations. Yahgulanaas explains that he avoids wrecking parts because "these works are frequently exhibited within atmospherically controlled conditions in museums … I avoid [the] possibility of contamination and minimize the use of solvents which would be required to clean off carbon and other pollutant deposits found on used car parts." He goes on to explain his supply problem: "I understand that all the unused gas cap lid doors available from Nissan in North America and Japan are exhausted."[45] This logic, in which sovereignty and objects are entangled as analogous properties through the particular shape of intercultural politics in unceded territories of British Columbia, is thus extended in Ottawa through *Awalaskenis II*. Situated in this context, the name of *Taaw* – oil – captures both precedents, scales, and stakes for environmental struggle.

DECOMMODIFICATION AND SOCIAL PRACTICE

As a performance with an active exhibitionary life, *Awalaskenis II* is also shaped by modes of perception in performance art and social practice. Some of the more marginal pieces of the performance archive of Dick's action show how his work's circulation in contemporary art worlds complicates and extends these copper ontologies. Joining a long lineage of cosmopolitan Indigenous art world participants, Dick has been one of few Indigenous artists working in Northwest Coast histories and styles whose work has crossed over into international art circles. He was, without question, in the words of *New Yorker* journalist Andrea K. Scott, "ferociously talented."[46] His particular *habitus* as an artist – ceremonial expert, hereditary chief, "maker of monsters,"[47] wearer of many hats – also lends itself to avant-garde mythologizing. As a graduate student filming an interview with Aaron Glass for a New York–based exhibition of Dick's work, I remember being dazzled by Dick's deep knowledge of carving traditions in Alert Bay, his careful certainty about the right way to do things, and his impromptu and virtuosic fiddle concerts on late afternoons in the Bay's main restaurant. This sense of vitality and spirit extends to his work, leading the curator

Roy Arden – one of the first to exhibit Dick's work alongside a non-Indigenous artist, Neil Campbell, for the exhibition *Supernatural* – to assert the "liveliness" of Dick's masks.[48] This liveliness extends to his archive, and since his death, the work of *Awalaskenis* has been exhibited in *documenta 14* and an exhibition, *Devoured by Consumerism*,[49] which repurposes much of the performance archive from the Belkin Gallery's *Lalakenis* show.

In getting at another source of this liveliness, I turn to one of the items that was shown adjacent to the coppers in *Lalakenis* and has since circulated to Athens, New York, and Saskatoon: a copper ingot made from pre-1997 Canadian pennies, melted down and then reshaped into a bar-like form. Situated in the archive of *Awalaskenis*, the ingot plays with another kind of currency that is, paradoxically, worth more in its destruction: the melting of pennies releases the exchange value of copper while affirming its value-neutral quality as art material. Displayed alongside this work is a letter of permission from the late Canadian finance minister, granting permission to the artist to deform currency.

Although this work is attributed to Dick at *documenta 14* and in *Devoured by Consumerism*, the artist named in this letter is not Beau Dick but Russell Gordon, who was an art student at the University of British Columbia while Dick was artist-in-residence at the Belkin preparing *Lalakenis*. Gordon, who has a background in economics and had made many copper ingots as part of his practice, had given one to Dick during a studio visit; it was displayed alongside the other materials of *Awalaskenis I* and *II* and correctly attributed to Gordon at the Belkin. Yet in an intriguing transfer of agency, the copper ingot changed makers somewhere between Vancouver and Athens. In displaying this curious misattribution, I do not intend to shame either curators or artists – Gordon told me that had Dick not fallen ill, he is certain that the work would have continued to be correctly attributed – but rather to think about how this failure contributes to the complex activation of the copper at the heart of this chapter's story. As an object that analogizes the magic of currency and its alchemical properties, the gift of the ingot contributes to Dick's art world fame. Its destruction quite literally releases a surplus and joins Gordon's practice to Dick's, while the ingot becomes singular in a way that Gordon did not intend – in his studio, it was only one of many.[50] In this way, in the absence of *Taaw*, the pieces of which have returned to Haida Gwaii, Gordon's work signals the multiple hands and routes that contribute to the manufacture of art world, while undoing these through the misattribution. In addition, the letter of permission signals the epistolary form of colonial discourse around the potlatch, while the colonial anxiety over failing to stabilize the practice is playfully paired with the transubstantiation of money. Indeed, museological protocols of preservation are something that Dick has often called into question in his practice. At the 2012 exhibition *ceremonial / art* at the commercial art gallery Macaulay & Co., for instance, Dick displayed Atlakim or forest spirit masks that were in transit to being danced at their final potlatch, after which they would be burned. By installing these non-commercial beings at the end of their life cycle alongside works for sale, Dick's display extended his renown in both ceremonial and gallery settings, invoking the power of performance in the gallery as a site of multiple exchanges.

Throughout, this frame of art matters. In his writing and interviews, Dick insisted that breaking a copper means many things, and one of his chosen frames for this meaning was

performance art. Why not just a protest? What does the category of art *do* as a conduit of shame that other kinds of public action do not? First, this "*work* of art," in the sense of its imagined efficacy, has much to do with the imaginaries and aesthetics of the Idle No More social movement to which it is publicly connected. Idle No More and its online presence, #IdleNoMore, started as a movement opposing the subtle environmental policy changes in the Canadian federal government's omnibus budget Bill C-45, although the movement traces its roots to "hundreds of years of resistance" starting in the sixteenth century. In particular, Indigenous activists emphasized that the omnibus bill would eradicate the Navigable Waters Act of 1882, removing government protection of small bodies of water and thus paving the way for industry encroachment on Native land. Since the autumn of 2012, the movement has continued to grow in Canada, with visible protests in all major cities and solidarity in the United States, as many Native Americans have also taken up the movement. As I described in chapter three, this movement is not without its critics, largely due to its lack of regional specificity and the implications of prior idleness. Regardless, as a multifaceted and *contested* movement, Idle No More has emphasized the role of art and artists in its cultural activism.

Second, and of direct relevance to my argument, invoking the terms of "performance art" also links copper breaking to contemporary art worlds in which "social art practice" or "participatory art" are forms of art that are intended to *do* things, to be transformative of social relations. Contemporary performance has its own conventions of display and concealment; much more could be said about socially engaged art as a particular and problematic frame of meaning, but for my purposes here, I want to emphasize a central tenet: that such practices are often presumed to be emancipatory by transforming audiences who are implicated in the work or performance in some way.

What I am suggesting here is that this art-based "semiotic ideology" of art's agency – Webb Keane's term for the tacit rules that make meaning around semiosis[51] – intersects powerfully with the political and legal work of a copper and with its Indigenous contexts of circulation. Spectators on Parliament Hill are specified as an obligated audience according to the conventions of performance art. They are also asked to *witness* an exchange that, according to 'Namgis epistemologies, solidifies these reciprocities through potlatch precedents. This double signification and obligation are mirrored in the copper's name: *Taaw* invokes past and present negotiations, experiences, and grievances over land, signalling both the life-giving and life-taking properties of different oil-based networks.

BREAKING AND RESETTING

In Ottawa, the literal ground of the copper-breaking ceremony is also significant: it is a vinyl panel printed with text from Conservative Prime Minister Stephen Harper's 2008 public apology to survivors of Canada's Indian residential school system. Since Harper's apology, Canada has been engaged with a Truth and Reconciliation Commission (TRC) on the violence of this church- and state-run system, a transitional justice process that attempts to publicly

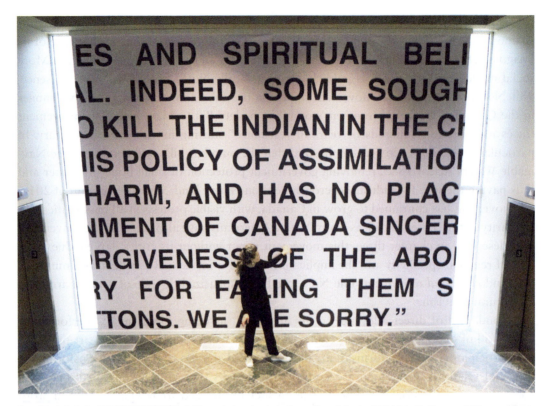

Figure 5.5. Cathy Busby, *WE ARE SORRY 2013* (2013). Busby's banner is shown here in the Koerner Library, University of British Columbia, Vancouver, BC. Photograph by Caroline Halley. Image courtesy of the artist and photographer.

account and atone for a system that forcibly removed Native children from their home communities for over a century. In Vancouver, where Dick was based as artist-in-residence, public awareness of this shameful history and its traumas recently culminated in an official "Year of Reconciliation" in 2013–14, accompanying the city's formal recognition of its land as unceded First Nations territory. Non-Indigenous Canadian artist Cathy Busby's vinyl panel, entitled *WE ARE SORRY 2013* (Figure 5.5), was made for *Witnesses*, a 2013 show of residential school–influenced art in Vancouver in which Dick was also a contributing artist. This panel was one iteration of a larger project focused on public apology in both settler states, Canada and Australia; its pink background is lifted from the tone of Harper's skin during his televised apology, forming a kind of synthetic hide that clearly announces its bodily stakes in Helvetica type. Earlier, in 2010, Busby had installed similarly scaled large fabrics of apologies spoken by Australian Prime Minister Kevin Rudd to the "stolen generation" of Aboriginal Australians and Harper's 2008 apology, accompanied by prints of their apologizing mouths, as a provocation of public witnessing as well as "post-apology negotiation and healing."[52]

In Vancouver, the interaction around the work was similarly public, yet also more intimate and unassuming. Busby displayed a large piece of the vinyl with Harper's apology in

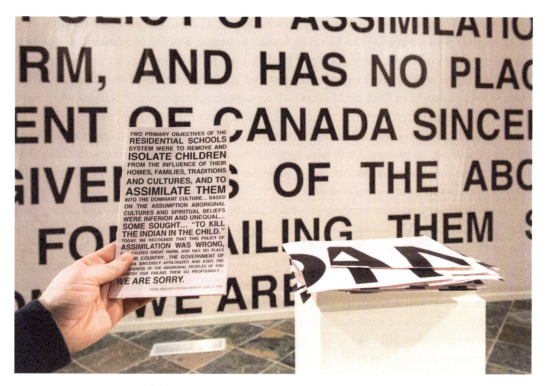

Figure 5.6. Cathy Busby, *WE ARE SORRY 2013* (2013), detail with fragment. Photograph by Scott Massey. Image courtesy of the artist and photographer.

a library on campus at the University of British Columbia, hung outside the elevators in a busy corridor. The vinyl's remaining fragments were left in a pile on a nearby plinth, with a sign urging visitors to take them home. Busby explains: "I like the idea of many people dispersing this work and that pieces of it find their way into homes and workplaces where it can be a reminder of the need to take responsibility for a justice-based co-existence/relationship between Aboriginal and settler peoples in Canada, which was the intent and the spirit of the 2008 apology."[53]

Significantly, although they are markedly different materials, the copper and the vinyl also share a sensory journey across sites and mediums. Indeed, Busby notes that, as they travelled in tandem across the country, "these materials were passed through different hands, gathered stories, and acted as protection for those using them," with a small piece of the vinyl cut and left behind in communities along the way (Figure 5.6). "In Ottawa it defined a space by providing a surface and boundary for the ceremony to take place on," Busby writes of the action. "In television reporting and in still images, the work became a graphic element that helped to visually describe the focus of the ceremony."[54]

Incorporating Busby's work as an object of exchange, a ground, and later a wrapping for the pieces of *Taaw*, Beau Dick's shaming ritual also rejects an apology that many people feel has not been honoured. On a spatial level, inclusion imbues the already collaborative

and intercultural performance with alliances as distant as Australia and also through intimate fragments of an apology to be taken home. Arguably, a political aesthetic of potlatch exchange also informs the fragmenting of Busby's text; these fragments are analogous both to those created in the breaking of a copper and to gifts distributed to witnesses in the context of a potlatch. In Dick and Guujaaw's repurposing, fragments of Busby's work have already been distributed elsewhere. The vinyl signals reassembled power, made stronger, of the formal obligations involved in this prior act of circulating tangible pieces of an apology. At the same time, its present wholeness suggests that the apology is perhaps the thing that has yet to be meaningfully distributed, a promise and challenge that the breaking of the copper instantiates as it conducts shame.

These material arguments bring me back to the contexts and work of shame, that most public feeling. The classic distinction between guilt and shame is that one is private and internalized while the other is public facing or externalized, having to do more with the social and a breach of its obligations. As anthropologist Marilyn Ivy has suggested, "anthropology has long provided a home for shame"[55] when psychoanalysts were more interested in guilt and anxiety. Tracing the Boasian/Americanist interest in shame through the controversial work of Ruth Benedict on Japan's national "shame culture," Ivy makes the provocative point that, although many Japanese people and scholars of Japan have objected to this characterization, it provides a culturalist alibi for wartime atrocities because shame, and its attendant responsibility, is only felt in relation to one's social world. For Ivy, shame should have an "uncanny" home in anthropology, existing in between different nations and subjects, becoming relational rather than confined to national boundaries.[56] Uncanny too, perhaps, since the return of anthropological concepts to bolster horrific cultural politics of remembering is always a reminder of the power of cultural analysis to circulate and inform policy not necessarily of the anthropologist's own choosing.

The shame that is brought as a gift to the seat of Parliament is also uncanny. We are, as Indigenous studies scholar Dian Million has argued, in a moment of "therapeutic nations" in which healing from the shame of residential schools and other human rights violations comes with a biopolitics, a disciplining of disordered Indigenous subjectivity through the therapeutic release of shame and other negative affects.[57] Therapeutic culture, and its expectations of the performance of a victimized Indigenous subjectivity, is thus complexly bound to settler colonialism, as Indigenous people are expected to first perform shame in order to have their sovereignty recognized. For Million, however, it is also important to remember that Indigenous women *initiated* the turn to trauma theory, insisting that violence previously confined to the domestic sphere become matters of public justice, yet painfully "subscribes subjects for healing."[58]

Similarly, in his analysis of reconciliation as a transitional justice process, human rights anthropologist Ronald Niezen argues convincingly that the political transformation expected of this reconciliation is not, as in other truth and reconciliation commissions, a transition to democracy but rather a moral transformation that governs emergent forms of consciousness.[59] Most notably, Niezen argues, a kind of national shame is brought into being through the spectacles of reconciliation, including legal processes of financial

reparation for survivors and public events that emphasize the collecting, compiling, and sharing of survivor testimony.

Returning shame to the public frame of justice, then, rather than healing, is perhaps one way of mediating these traps of recognition, and an inscription of national shame is certainly at work in Dick and Guujaaw's ritual. Indeed, it is the desired affect of copper cutting – shame – that brings traditional exchange protocols to bear on this contemporary moment. Like the information-gathering process of reconciliation, the coppers' display is meant to activate relations of atonement for and in the future. At the time I was living and working on the Northwest Coast, then prime minister Stephen Harper and Shawn Atleo, the former national chief of the Assembly of First Nations in Canada, captured this form of future consciousness in their shared characterization of the moment as one of "resetting" relations between Indigenous peoples and settlers, drawing an analogy between the fixing of bones and the repairing of relationships.[60] Given the willful forgetting involved in a "reset," we might legitimately ask, like Niezen and other critics of reconciliation do, whether these material acts constitute a harmful deferral in which collection for the future takes precedence over meaningful reciprocities and assemblages in the present. Métis art historian and cultural critic David Garneau has argued that the temporal play of terms like "reconciliation" – always a "re," signifying a return to presumed just relations – forecloses what might be called "conciliation" in the present.[61]

Yet as an act that inculcates these contemporary forms of affect and understanding, the *intercultural* prototypes of Dick's performance and its materials also matter, as does the fact of "breaking," which *precedes* "resetting." Moreover, as Dick writes of being shut out of the history museum, "it was embarrassing – but not for us."[62] Shame is rerouted in this action, moved out of Indigenous bodies and into the nation-state, where it is dramatized as a public and political feeling and connected to other kinds of value and interspecies relationships, the relationship between life-giving oil and oil that should stay in the ground.

What I have been proposing here is that, as a result of its routes – temporal and spatial – across resource frontiers and intercultural systems of value, the copper may work as a conduit that *does not* presume a former state of just relations or that everything will be revealed or made known through the performance, a selective showing and withholding that materializes Indigenous sovereignty without giving it away. Indeed, breaking *invites* reciprocation; otherwise, its effects end with shame as the dominant affect in a therapeutic age of reconciliation.

And what has been returned? It is easy to despair that the act of breaking copper and calling witnesses was merely a diversion, a spectacle whose currency was converted back to the crocodile tears of settler sympathy or contemporary art's primitivisms. Yet Dick's act *has* had effects and maybe even fulfils its messianic promise. As Wanda Nanibush writes, "the copper-breaking ceremony gives the shame back to those who should rightly feel the shame,"[63] while returning this affect to the sphere of law to bring about material returns. Dick's action preceded the TRC's final report; many of its calls to action *have* resulted in material returns, including a requirement to include Indigenous law in all law schools across the country. This result is meaningful beyond the stilted and contained repair of

a land acknowledgment; it is a statement that other forms of justice continue to matter on these lands and waters, including the mode of justice involved in cutting copper. With *documenta* and installations of Dick's work in New York, his art world renown also seems secured, having successfully transubstantiated the primitivist expectations of his ceremonialism into contemporary art.

Indeed, the breaking of a copper materializes and conducts shame for a national public according to particular political aesthetics of sovereignty. Specifically, this performance instantiates shame through potlatch protocols and asks us to *witness* a coeval Indigenous present and to emerge with a sense of injustice that is transformative rather than sentimental, playing on and maintaining boundaries of knowing and not knowing. In this sense, breaking a copper is *not* a reparative act but a material challenge that exceeds discursive limits of reconciliation – and also, perhaps, of art.

CHAPTER SIX

Transitional Properties of Art and Repair

In the autumn of 2013, before the release of the final report of the Truth and Reconciliation Commission (TRC), the Belkin Art Gallery in Vancouver mounted an exhibition of modern and contemporary art on the histories and legacies of residential schools. *Witnesses: Art and Canada's Indian Residential Schools* brought together works by twenty-two artists that articulated the schools' history, their wrenching personal and social effects in Indigenous and non-Indigenous communities. Encompassing a broad historical scope, variety of mediums, and Indigenous affiliations, the show included diverse contemporary and modern perspectives that ranged from mid-century work by the modernist painter Henry Speck (Kwakwaka'wakw), photocollages from the 1990s by Carl Beam (Ojibwe), and contemporary drawings by survivor Gina Laing (Uchucklesaht), which documented the artist's traumatic memories in therapeutic process. Performance, installation, and video also animated the space; black hair from Tahltan artist Peter Morin's *This is not a simple movement* (2013) accumulated a new map of Canada on the gallery floor, its performative cutting a gesture of grief and re-enactment of many severed ties between generations and nations.

In its collapsing of many of the categories that differentiate artistic movements and mediums, *Witnesses* provided a critical, reflexive reassessment and reorientation of the many things art *is* in relation to traumatic history: therapeutic salve, historical documentation, education, an attempt to re-member the social body through public forms of display and address. In the curators' words, *Witnesses* provided perspective on "how this issue has become embedded in Canadian art history," demonstrating a responsive turn towards the political and social contexts – and efficacies – of art. The embedding also suggests a durability of the exhibition's archival orientation. It reflexively assembled a record and reassessment, such that it would become impossible to forget these histories and presents.

This implication of art as a witness to repair and its failures has only become more visible and pressing as art institutions struggle to decolonize amidst cruel reminders that this past is not buried or gone. Most urgently, the archaeological discovery and excavations of

mass graves of Indigenous children, killed in residential schools, has reopened this wound in communities who already knew that the graves were there; as many have observed, international news media's sensationalizing coverage of these exhumations – an outrage dependent on scientific evidence that comes too late and retraumatizes through its ignorant shock – has only added to the cruelty, reinscribing a narrative of damaged Indigenous lives for consumption. This injurious present matters to how I write about representations of residential schools; and likewise, this recent past matters to the present as a moment that was grappling with this problem of representation and institutional complicity. As in the rest of this book, I am suggesting that its models of repair constitute a moment less settled into the narrative of damage beyond repair.

When I saw *Witnesses* at the Belkin in this earlier moment, it was a rainy weekday afternoon after the end of my fieldwork in Vancouver. I had returned to the city to tie up some lose archival ends and to see family and friends. All departures from the so-called field are messy and incomplete. I was still trying to figure out how to write from a distance and grappling with the unevenness that defines "our" difference and distance as ethnographers, the fact that I could cut off social relations and accountabilities simply by moving. But my departure felt particularly ill-timed as things were very much in transition. The city where I had based much of my work on art and its cultural properties was preparing for an official "Year of Reconciliation" following the city's National Reconciliation Gathering, an official meeting of the TRC for survivors. Even more momentously, moved by months of protest during the anti-Olympics, Occupy, and Idle No More, the city council had announced its decision to publicly recognize its occupation on unceded territory.[1]

Both forms of public acknowledgment felt hopeful to me as steps towards realizing the things Indigenous artists and activists had been saying for a very long time. The tone of these announcements was also several steps behind the language of healing and critique that was already taking place in many cultural institutions; yet they called to me, and I felt as though I was leaving prematurely, just as witnessing was becoming important. Re-reading my notes from a much later time, I now understand the longing and guilt as defensive moves that enable "us," still complicit in the uneven encounter of fieldwork, to write by temporarily cutting off relations and accountabilities. I could not actually leave a process of display that was so directly addressing me as a settler. And I didn't, really. My body may be elsewhere, but the sticky thread of witnessing continues to attach to me, and I feel its obligations as I write these words.

The effect of *Witnesses* felt similarly mixed. On that day in November, as I walked through the cavernous white space of the gallery, I saw that the show's desired function of raising awareness was clearly happening in action: undergraduate students were taking notes in front of artworks, and almost all of the computers, which elaborated the backstories to the works and performances on display, were occupied, visitors absorbed in their navigation. Crowded as the space was, the empty school desks of Joane Cardinal-Schubert's *The Lesson* (1989), positioned in front of a chalkboard covered with messages of student experience, drew attention to their former occupants, the ten Indigenous people who had originally activated the installation through performance in 1989. Adrian Stimson's *Sick*

and Tired (2004), an architectural intervention, is composed of an infirmary bed and three windows salvaged from Old Sun Residential School; a bison robe, wrapped like a corpse on the bed, casts shadows on the floor in the shape of a hide stretched over bedsprings.[2] Both of these installations furnished the gallery with an absence, yet the sounds of visitors talking made the space feel much more like a place of learning than a reliquary. Indeed, to my surprise, such serious subject matter did not instill hushed reverence or quiet shame. Rather, the works' sense of interaction was carried over into a flurry of activity that edged around these incomplete and durable witnesses.

As I rounded a corner into the gallery's long back corridor, I spotted a short-haired woman in sandals talking exuberantly with a small group of visitors. We had never met before, but something about the way she was standing close to the paintings on the wall suggested that she was not a docent. As I drew closer, I could hear enough of the conversation to realize that she was explaining the paintings in the first person, identifying them as hers and herself as their maker. Gina Laing was, at that point in her career, the only pre-professional artist in the Belkin's show, and her works, nightmarish portraits of the abuse she suffered at the hands of demon-like teachers made during her period of recovery, were the most direct and figurative representations of trauma in the whole exhibition. Laing's face was animated as she spoke next to her paintings. She seemed energized by telling her story in person, and the visitors were listening and nodding, looking engaged rather than uncomfortable.

I waited nearby, listening, until the visitors had moved on to the computer station, and then approached Laing to introduce myself, explaining that I knew her work from writing about art and residential schools. I asked how she felt about being included in the show. She smiled broadly and told me that she was happy about being able to tell her story at the Belkin to so many visitors, connecting her work to her healing process. I remember feeling embarrassment, as I realized that I had been bracing for a confessional encounter, tear-filled on both sides. Why had I assumed that she would somehow match her paintings? I relaxed into the conversation. We chatted a bit more, and I thanked her, wishing her a safe journey back home on the ferry.

It was the most banal exchange you could imagine, as the many painted eyes beside us – the central feature of the paintings in the series – testified to Laing's memories of being watched. But as Laing had been careful to point out to the group of visitors and then to me, her paintings were documents of a particular moment in her recovery; they were not her. And for me to confuse the two reveals one of the traps of settler colonialism that some of us carry in our bodies: the implicit expectation that Indigenous artists whose work engages with traumatic themes will be traumatized subjects, at risk of "breaking down" in a way that forces me as a settler to witness what is, at its root, an injustice that unsettles my position and my distance. Moreover, my expectation of fixed meaning also denies the liveliness of her works; even though they were fastened to a wall in a climate-controlled space, they too were witnesses to her healing and not mere objects of my witnessing.

But these are all interpretations that have come later, as the critique of the spectacle of reconciliation, and the forms of settler absolution on which it depends, has started to sink into my bones.[3] Returning to that moment, it was apparent to me that the validation Laing's

work received by being there was not necessarily that it was included as "art." It mattered to her that her truth was being witnessed in a space of validation that is a contemporary art gallery. She also expressed her reservations with her words and her body. Showing and narrating her work to visitors – an informal post she occupied frequently while in Vancouver, she told me – Laing also wished to maintain control over interpretation. Indeed, in accordance with her wishes, her series of paintings is not reproduced in the show's catalogue alongside her artist statement, limiting their circulation to the exhibition space and resisting the archive of reconciliation. Instead, her statement emphasizes both the eyes and the light she holds in several paintings – "I never let this light inside me go out" – noting their importance and *work*. "These paintings allowed me to begin to heal and recover from this time in my life," she writes.[4]

Laing's complex negotiation of truth, agency, and circulation in *Witnesses* raises many important questions about art's efficacy in an age of reconciliation and about the work of transforming expressive forms into testimony for an archive. Canada's TRC, carried out from 2008 to 2015, was unique among truth commissions in actively soliciting art as a form of testimony. In this way, the TRC was also an archival practice, transforming enormously complex experiences into a variety of more permanent substances – among them, memory, history, and evidence – while transforming the bearers of these lived experiences into "survivors," or "claimants" of reparation, their stories into what local news media coined as "terabytes of testimony."[5]

And all of these display spaces and categories for preserving memory are *not* equivalent in terms of their effects. As Andrea Walsh, a visual anthropologist of settler Irish, British, Scottish, and Nlaka'pamux ancestry who has worked extensively with Laing, pointed out to me, part of the tension produced in displaying Laing's work in *Witnesses* stemmed from the artist's dissatisfaction with the frame of contemporary art. Walsh explained that Laing was hesitant to include her work in an exhibition in an urban gallery – a very different setting from former contexts of display, which were community and family restricted – where she could not control how they were received. According to Walsh, Laing was concerned that her paintings, created as part of a treatment program, were "designed for a purpose other than making art, and as such they reflect this healing work, not an artistic agenda."[6] Laing worried about her work being misread and also about its potential to harm others through retraumatizing or through pedophiles deriving pleasure from her images. Here, an "artistic agenda" and its display conventions – little didactic support from text panels, assumptions of unmitigated access, art as a separable frame of cultural practice – has the potential to obscure other risks that obtain from showing harm in public.[7]

Walsh's interpretation of the many iterations of this collaboration draws attention to the risks of witnessing diverse forms of cultural production that are brought together under the rubric of testimony. She also raises the question of *whose* witnessing should be privileged in contexts of display and the risks of contemporary art over community-based exhibitions. As I understand them, for Walsh and Laing these risks include enacting inappropriate equivalence between survivors' therapeutic artworks and those that belong more obviously to

the realm of contemporary art. The crux of these objections is that contemporary art may be devoid of moral obligations by virtue of its ties to broader non-Indigenous art worlds and systems of judgment. By juxtaposing survivors' sincere expressions of their experiences with contemporary artistic interpretations, the former are minimized by the latter's *lack* of accountability and potentially damaging openness. By contrast, Walsh's close collaborations with Laing in community exhibitions articulate her commitments to survivors and argue that they are the audience for whom representations of residential schools should ultimately be made.

Indeed, Walsh's objections echo concerns about circulation and the capacities of objects to be misappropriated and even dangerous once they "become art." In his analysis of Pintupi paintings as they enter international art worlds, Fred Myers explains that objections to circulation in these spaces of criticism hinge on an uncertainty about whether or how critics, analysts, or audiences will be incorporated into Indigenous networks; art that circulates too easily detaches viewers from the social and cultural obligations of witnessing.[8] Drawing attention to similar issues in the context of Laing's work, Walsh elaborates this problem of accountability in *Witnesses*. The show's attention to how residential schools "become embedded" in art history also marks this ambivalence in showing effects of residential schools through art. It is not, after all, only artists that "embed" art history with its contents, but critics, curators, and publics. This phrasing also understates and articulates uncertainty about how much *Witnesses* itself participates in and performs this embedding, and what it means to do so. What are the obligations of witnessing the embedded story, of turning – or returning – art into testimony? And what are the material afterlives of these public transitions?

In this chapter, written after the conclusion of the TRC and release of its final report, and amidst widespread discussion of the political and social failures of reconciliation, I return to some of these forms of cultural production to consider the tensions between display, access, repair, and care that arise from embedding the story of residential schools self-consciously into the story of art. Set against the particular conditions of art, activism, and their discursive mediation through public conversations about aesthetics that I have laid out in this book, my focus here is about the problem and possibility of equivalence that arises in an age of reconciliation. My argument is that, in validating art *of all sorts* as testimony, the TRC standardizes, archives, and governmentalizes something that, by its very nature, exceeds and destabilizes these socio-legal and bureaucratic frames. Indeed, like Laing's performative and sustained intervention into how her work is read (or not), these acts of making equivalence may also produce unexpected opportunities for healing *and* contestation through careful control of access, aesthetics of refusal, or cultural production that compels witnesses to comply with Indigenous protocols of interaction. I argue that, in the context of truth and reconciliation, belongings acquire what I am calling "transitional properties," a reflexively acknowledged capacity to transform political and social worlds in conversation with questions of justice and legal regimes of knowledge.

In attending to how belongings are made animate and acquire transitional properties through exhibition, my analysis draws on the work of Indigenous scholars, including Dylan

Robinson, about the return of "functional ontologies" of belongings in the Canadian public sphere, the engaged aesthetics of art about residential schools, and the robust critiques of reconciliation as settler spectacle.[9] To these conversations, I hope to add an account of how belongings that were previously categorized outside the frame of transitional justice are brought into these contexts, and how these qualities of things – their abilities to heal, to repair, to enable justice – become durable and persist over time. What, precisely, of that preserved as art, becomes a testimonial substance? And how does witnessing persist into contemporary contexts of display?

This chapter returns to the question of what art *is* in the politicized context of the TRC and its complex material afterlives. As with other contexts and practices of repair considered in this book, the work of art also reveals slippage between religious and secular contexts, as well as the cultural and legal expectations of reconciliation. Indeed, these parallel concerns about art as human rights work are a productive space within which to think about reconciliation and connect to analyses of the power of the image in legal regimes.[10] In drawing these frames together, I first expand on the TRC's framing of art and some of its contestations. Second, I return to a discussion of *Witnesses*, focusing on its participatory forms and engagements with performative protocols across registers of art and witnessing. Next, I put these protocols in conversation with another kind of repository: the bentwood box that the TRC circulated during national gatherings to hold survivor belongings and memories. I conclude by reflecting on how transitional properties are visible in permanent collections through a discussion of *There Is Truth Here*, a more recent exhibition of residential schoolchildren's art in Vancouver. Moving from *Witnesses* towards other transitional properties, this chapter considers how the political possibilities of revelatory practice must also be taken seriously in order to understand the healing work of showing art.

As responses to and critiques of the TRC have proliferated, I believe that scholars, particularly non-Indigenous ones, bear a responsibility for staying with forms of identification that hold meaning for our interlocutors. As we are still living in the wake of the TRC, I am worried that its findings are too quickly instrumentalized or dismissed by locating the obligation of repair in an overwhelming and extractive inclusion of Indigenous bodies and knowledge – a displacement of real material questions of decolonization and an added form of labour that Indigenous scholars critique as a new "burden of reconciliation."[11] But what a focus on effects, outcomes, and moving past the TRC misses is the complexities of survival and resilience that this process has allowed to circulate in public. Indeed, the logic and *pathos* of art as testimony has opened up many new conversations about art and efficacy in the public sphere; this repositioning comes with corresponding risks and possibilities of contextualizing one's work within these governmental systems of collection and display. Working across these different contexts of cultural policy, I argue that expressive acts and legal settlements are mutually informed by shared logics of revelation, those processes and tacit rules by which showing and telling are made to do cultural work, including healing.

COMMISSIONING TRUTH

Throughout its existence, the TRC – a physical commission made up of a changing roster of scholars, bureaucrats, and activists – has emphasized its material- and information-based practices. These include the collection and exhibition of art, as well as providing funding for artists and scholars in various capacities, including conferences and exhibitions. At TRC-hosted national gatherings, events where survivors gather to have their oral testimonies recorded while connecting with others who share their experiences, expressive culture is foregrounded in film screenings, art displays, and dancing. Through the collection of these different materials, the TRC assembled a multimedia and polyvocal archive of residential schools in Canada. This repository of experience is housed at the National Centre for Truth and Reconciliation (NCTR) at the University of Manitoba in Winnipeg.

As is the case with any centralized archive, the establishment of a National Centre for Truth and Reconciliation has a complex materiality and socio-legal life. Indeed, the decision to house the NCTR at the University of Manitoba is the outcome of the university's successful bid to the TRC to make itself publicly accountable for these records as a national archive;[12] the university also played a role as an intervener in a court case about knowledge and access during the commission in which the TRC took the federal government to court for its failure to make residential school records housed at the national archive readily available to TRC officials.[13] Crucially, the decision to move all records to the NCTR is not an uncontroversial choice. Indeed, as archivists Krista MacCracken and Skylee-Storm Hogan have argued, community-based, site-specific residential school archives like the Shingwauk Residential Schools Centre have long followed emergent protocols to address access barriers for survivors and other community members.[14] And while they don't mention the NCTR, their points about the importance of emergent strategies for supporting visitors and removal of records are certainly applicable to the scale of a centralized repository.

Nevertheless, through these archival and legal processes, material forms of knowledge are given weight alongside oral testimony. Moreover, the importance of collecting and preserving different forms of testimony is given added heft by these mediations through Canadian law. Just as preserving cultural resources depends upon notions of a future good, commissioning and housing truth in material form affords those objects and records a kind of efficacy. They are about much more than merely truth; they are also about how that truth may be activated to bring about justice. Indeed, we might think of the archive of the TRC as a particularly lively one, with after-effects that reach far beyond its original context of assemblage. For example, one of its outcomes has been new protocols around access for professional archivists in Canada.[15]

Of importance to this new complex of images and objects, in 2010 the TRC issued an "open call" for artists to submit work to it in any medium, including performance, film, literature and poetry, and visual art such as paintings or photographs. This call was open to all artists, not only those who identify as residential school survivors, and solicited different kinds of art: works that address "experiences" and those that focus on "legacy and impact"

in recognition of the multigenerational aspect of trauma; and, more broadly, works that relate to the TRC's themes, listed as "apology, truth, cultural oppression, cultural genocide, resistance, resilience, spirituality, remembrance, reconciliation, rejuvenation, and restoration of Aboriginal and cultural pride."[16]

Under a heading "Why is the Truth and Reconciliation Commission of Canada gathering artistic works?" the open call went on to emphasize their value. Noting that the TRC is "an important part of the agreement that ended most of the lawsuits about Indian Residential Schools," the call articulates a need to "create a permanent record of what happened in the Indian Residential Schools," which includes art: "the TRC believes that collecting artistic works is an important and meaningful way to express the truth, impact and legacy of the Residential School experience and to assist with reconciliation."[17]

Mixing a commitment to archiving with belief in its effect, the call articulates and constructs material forms as tangible and cultural testimony. In its emphasis on "legacy and impact" – and, again, the call repeats for good measure, "impact and legacy" – the TRC shows its investment in reconciliation and art as projects about the future and about the promise of justice. Their assured durability – again, the "permanent record" – is crucial in all of this, showing the archival emphasis of the TRC's information-gathering activities.

In spite of the TRC's close ties to legal settlements, this open call is separate from litigation. Initially, the end of lawsuits is framed as a fact, although the insertion of "most" does suggest an ongoing ambiguity; regardless, the statement distances the TRC from legal activities relating to residential schools. The overall effect of this distancing is the implication that art, although crucial to the TRC, will *not* play a role in settling legal claims but rather in reshaping imaginaries and cultural justice that are separate from those bound up with settlement. As Niezen argues, such distancing is characteristic of the TRC, which is itself notably confused about what, if any, legal weight it carries, in spite of the fact that it emerged from litigation.[18] This archive thus carries a specific moral rather than legal weight. As with other forms of testimony gathered during the commission, if a perpetrator of violence is named or depicted in a performance, for instance, it is not entered into the record of the event or showing. The TRC is not a tribunal, and survivor testimony also does not automatically translate into material reparations.

Paulette Regan, a non-Indigenous scholar of Indigenous governance and former director of research for the TRC, expands on these hopes. She explains that residential school experiences, including those represented in art, must serve a pedagogical purpose in Canada's future because their complex trauma works to unsettle national myths of settler benevolence. "To my mind," she writes, "Canadians are still on a misguided, obsessive, and mythical quest to assuage colonizer guilt by solving the Indian problem. In this way, we avoid looking at ourselves and the collective responsibility for the status quo."[19] Here, reconciliation is about the conversion of memory into action, a hope that the respectful and unsettling gathering of testimony will collapse persistent structures of settler colonialism. Again, these recalibrations of settler consciousness are described as interventions into public culture.

In this official capacity, then, art is presumed to be a functional source of knowledge or testimony about residential school experience, something with a purchase on the future. As

forms of documentation,[20] the TRC's discursive and archival tendencies are standardizing, enacting an equivalence between different genres of testimony.

The inclusion of artwork in this archive as a form of testimony is an incredible recognition of the capacities of the material world to bear witness to history and loss – to be counted as a viable testimonial substance.[21] Métis scholar and artist David Garneau has argued in an important and influential critique that such faith in collecting draws on Euro-North American and Christian beliefs in the salvific potential of knowledge. For Garneau, the notion of collecting art and testimony for future use enacts a temporal sleight of hand. In this formula, *re*conciliation, which implies an initial and Edenic state of benevolent relations, forecloses the possibility of conciliation in the present and projects it into a continually deferred future: "Truths are told," he writes, "the destroyed are mourned, the broken repaired, order restored, and the national identity endures."[22]

For many artists who have worked under the auspices of reconciliation, an official legitimization on showing alongside telling is deeply necessary and compassionate, since so many horrors of the residential school system are simply unspeakable. Indeed, for many, the process of making work and having it valued in this official capacity may be cathartic, meaningful, and contribute to cultural resilience. For example, Adrian Stimson, one of the artists whose work was included in *Witnesses*, explains how applying for Common Experience Payments – one of the forms of financial compensation available to residential school survivors – revealed to him how poorly legal settlements enact repair. "I am not a supporter of the 'Common Experience,'" Stimson writes, asserting that the process of proving psychological damage and cultural loss has proved harmful to many. "I cannot help but feel a new wound is being inflicted."[23] For this reason, the artist sees his work as an alternative source of healing, of reconciling his experience of residential school. About *Sick and Tired*, the work installed at the Belkin, he explains this healing in spiritual terms: "For me, creating this installation has been a way to exorcise and transcend the colonial project, a way to forgiveness, healing and obtaining a state of grace."[24]

Scholars and activists working both on and with the TRC draw attention to these many conflicting hopes and dangers of the TRC's cultural and legal productions. The range of affect in this work is considerable. Publications by the Aboriginal Healing Foundation have tended to echo the TRC's official emphasis on the restorative value of telling one's truth through testimony.[25] Many artists and activists share their words in these publications, connecting testimony to assertions of cultural pride, resilience, and sovereignty. For instance, Inuk artist, curator, and scholar Heather Igloliorte defines cultural resilience as an outcome of contemporary Inuk artists' work, using art "as a vehicle to preserve and fortify our cultural heritage and as an instrument of both personal and collective healing."[26] In this sense, art is a vehicle for multifaceted resilience, which encompasses hope and mourning, future and past.

At the same time, criticisms of the commission draw attention to the disjunctures between what the TRC wants and what people actually *do* when giving their statements or speaking out in public. For instance, anthropologist Ronald Niezen argues that survivor testimony must follow a redemptive narrative in order to be taken seriously at public events, and thus it discursively fulfils the healing prophecy of the TRC through Christian and New Age

faith-based imperatives of speaking one's truth.[27] For Niezen, these forms of articulation as well as the human rights context of truth commissions stifle peoples' capacities to show and tell in ways that are actually disruptive. Adjacent to these criticisms are the writings of many Indigenous intellectuals, including Métis scholar David Garneau, who ask whether reconciliation is, in fact, genuine in its conciliatory aspirations or merely another state-led mode of governing Indigenous subjects as victims of their trauma within the settler state.

Writing from an earlier moment in the process of the TRC's national gatherings, for instance, media scholar Naomi Angel argues that forms of public remembering also challenge the limits of the confessional model proposed by the TRC.[28] According to Angel, survivors at national gatherings subvert official expectations of testimony with their silence and rage. These expressive forms are intensely political and cannot be easily compressed into a narrow, archival, and human rights–based definition of testimony. Angel proposes that visual forms on display at gatherings – photographs, films, and other visual materials – also work to subvert the TRC's bias towards the presumed communicative transparency of the spoken word.[29]

Indeed, throughout this process of commissioning truth, there is a similar presumed transparency of art and a faith in the act of assemblage. Specifically, both the TRC's open call and emphasis on the NCTR as a perpetual archive articulates a belief that the act of collection and display *itself* will result in both truth and reconciliation. In resisting this logic, many Indigenous scholars have asserted that the careful control of information is imperative in disrupting colonial knowledge practices that assume open access.[30] Likewise, curator Garneau is adamant that such refusals are a necessary form of Indigenous resistance[31] and that these should be located in the material world as much as in textual ones:

> Primary sites of resistance, then, are not the occasional open battles between the minoritized, oppressed, or colonized and the dominant culture, but the perpetual, active refusal of complete engagement: to speak with one's own in one's own way; to refuse translations and full explanations; to create trade goods that imitate core culture without violating it; to not be a Native informant.[32]

Garneau's polemic disrupts the presumed "openness" of the TRC's open call. In addition, it enacts a refusal of redemptive narratives, which depend upon such full explanations and are premised on translatability. In this way, deferral, silence, and irreconcilability – an opposite of reconciliation – are important strategies of resistance that challenge assumptions about the work of information gathering.[33]

Critiquing the language of the open call, Indigenous studies scholar Jonathan Dewar and artist Ayumi Goto correctly observe that "what is unclear in the [open call] is the role of artists, arts administrators, and curators in informing the process – including issues of consent, copyright, and use of works,"[34] asserting the dubious nature of the equivalences that art as testimony embodies. Yet at the same time, their fixation on legal and ethical claims around art is significant. It shows the extent to which objections to the so-called cultural activities of the TRC are apprehended in relation to other kinds of claims about art, including property regimes.[35]

Garneau's notion of imitative trade goods also resonates with display protocols integral to the Northwest Coast art histories. Such protocols manage access to First Nations objects and knowledge that are at once deeply felt, strategic, and profoundly ethical refusals to

engage in intercultural transactions. Building on Audra Simpson's notion of ethnographic refusal, in which refraining from revealing information in research contexts may be generative of sovereignty,[36] these arts workers' challenge to "reconcile *this*" might be seen as a powerful example of an aesthetic of refusal that generates new vision and affect around art. This aesthetic of refusal is at odds with the presumed open access of the TRC's information gathering and troubles the equation of truth with freedom through assertions of informational sovereignty.

As theatre-worker and scholar Jill Carter explains, the question of *whose* catharsis should also be foregrounded in thinking about these risks. Writing on the dangers of sympathetic settler responses to trauma-based performance, she reveals the differences and unevenness between Indigenous and settler experience and power in display contexts. "There are dangers that come when we bare our throats," she writes, arguing that settler sympathy and catharsis miss that these performances are acts of endurance and calls to action.[37] In this context, refusing catharsis or redemption is a way of guarding against pathologization and misrecognition of Indigenous sovereignty as trauma.

As visual testimony, art circulates alongside legal notions of injury as technologies for adjudicating loss. These risks of connecting art, healing, and injury hinge upon what S. Lochlann Jain has analysed as the capacity of injury law to distract from social and political explanations by locating injury in individual bodies rather than in social worlds.[38] In relation to Indigenous cultural practices, these risks are compounded since they also disavow the processes by which Indigenous bodies are damaged by colonialism and the collective nature of the forms of violence bound up with settler conquest.[39]

Legal anthropologist Carole Blackburn's arguments about the pathologization of Indigeneity in residential school claims settlements expand on how it may be so in the particular context of British Columbia. In her analysis of *Blackwater v. Plint*, a civil lawsuit in which former students of the United Church–run Alberni Indian Residential School sued Canada and the church for trauma inflicted upon them, Blackburn details how First Nations culture and language loss was explicitly connected to injury. She explains how the plaintiffs' lawyers argued that culture and language loss should be included as damages and thus factored into the compensation for school survivors.[40] According to Blackburn, this argument had the curious and ambivalent effect of transforming culture loss into injury in the legal sense.[41] Perhaps unsurprisingly, given the cunning nature of such legal forms of recognition, the defence came back with an argument that associated injury *itself* with Aboriginality, invoking an ahistorical image of Native alcoholism, violence, and family dysfunction such that the "damaged lives"[42] performed before the court were already on an unchanging course of injury before residential schools. Here, culture loss is made out to be unfortunate, but natural, perversely casting Indigenous people as agents of their own injuries.

Yet these articulations may also be risky ones when such unstable objects and their cultural losses are "reconciled" as injury through the justice system. Specifically, in *Blackwater v. Plint*, a lawyer for the defendant, during cross-examination of a former employee at Alberni Indian Residential School, focused on the school's curriculum in Native-style arts and crafts. In response to the lawyer's questions, the former employee confirmed the existence of such a program and noted that it had even produced at least one successful

professional artist. Following this exchange, there were no further questions about art, and the topic of cross-examination shifted to whether or not the witness could confirm whether or not sexual abuse had occurred at the school.[43]

My point is that, in the context of this legal exchange, an art program, and art itself, cast doubt on the claim that the school discouraged Native cultural practices. The fact of a successful artist emerging from the program suggests the opposite of cultural loss, showing a present vitality stemming from residential school programs. Since I was not present at the trial, I cannot say how this doubt was received on either the part of the lawyer or the court. However, based on the transcript, the abrupt shift to a discussion of sexual abuse works to commensurate different kinds of injury, cultural and physical. In this way, and through this slippage, art and art worlds may be invoked to *show* cultural resilience and *disprove* cultural loss.

Resilience narratives, many of them redemptive and focused on healing, are important to many artists and survivors. But art itself can be dangerous evidence when it is entangled with legal notions of injury and presumptions of art's transparency as an index of experience. As a process that emerged out of injury settlements, the TRC is freighted with this baggage, this capacity of art to signify many things simultaneously. Moreover, in disavowing the legal slippages of testimony, the TRC risks performing a similar twisted transformation in the case of art – and one that is perhaps more insidious, because as a "cultural" response to the injuries of residential schools, it is not obviously tied to a legal system of logic. Perhaps one reason that the redemptive narrative of transformation from trauma to healing continues to inform so many of the TRC's cultural activities is *because* it fails to really challenge the settler state's complicity in creating these conditions.

ANTI-THEATRICAL WITNESSING

Unlike earlier historical exhibitions of residential schools, *Witnesses*'s connections to testimony were made explicit, as were the demands it placed on its publics.[44] Co-curator and art historian Geoffrey Carr articulates this onus in connection to the show's multiple forms of media in his catalogue essay:

> Visitors to this exhibition have been asked – through artwork, accounts of survivors, and the catalogue – to share in the work of witnessing the history and present-day legacy of the Indian residential schools. It is up to each who have looked upon the testimony to consider what has been seen and to ask themselves not only how they are connected to this difficult history, but also how they can contribute to some measure of justice, healing, and reconciliation.[45]

In this way, *Witnesses* was intended to be both pedagogical and performative, connecting it with other art movements that draw together the participatory turn and trauma – a dual call to its publics to reappraise art histories and feel implicated.

Walking through the space of the exhibition, this sense of ongoing practice and consciousness about the *work* of art was immediately apparent. Indeed, exceeding its pedagogical register is the sense that each work in *Witnesses* is either poised to do something or to document action, which is, indeed, itself an act: the empty desks of Blood/Kainai artist Joane Cardinal-Schubert's *The Lesson* (1989), facing a "blackboard of truth"(Cardinal-Schubert's words) on which the repetitive horrors of colonialism had been inscribed in chalk, were at several points occupied by Indigenous people in the context of the work's performance life; pieces of fabric and cut hair assembled in a pile on the gallery's floor, the remainder of Tahltan artist Peter Morin's in situ performance *This is not a simple movement* (2013). "The pieces of hair land to create a new map of Canada," Morin writes of this cutting and its refuse. "The hands make these scissors travel. Today we are remembering a nation-building act."[46]

Reviews also registered the increasing importance of public programming and the pedagogical potential of the gallery as an "otherwise" kind of space of freedom. But what kind of teaching space is the gallery? What does it allow and register, and what does it continue to silence or forget? *The Lesson* is perhaps instructive here, as it holds the ambivalence of teaching in a gallery on unceded land.

Witnesses also displays its ambitions to reconcile stubborn divisions in art. Such divisions include spatial and hierarchical ones between Woodlands and Northwest Coast, each of which was represented by Native art heavyweights such as Norval Morrisseau (Anishinaabe) and Lawrence Paul Yuxweluptun (Coast Salish); divisions between past and present "contemporaries," such as modernist painter Chief Henry Speck (1908–71) and well-known carver Beau Dick; between the categories of "Native" and "settler," as in the case of photographer Sandra Semchuk, who self-identifies as "a member of the Settler culture, and widow of a traditional Cree speaker,"[47] and even around the unspoken boundaries of the category of professional artist, like Gina Laing's paintings that had been made as part of a healing program in the mid-1990s. Such therapeutic work is not generally admitted into the display spaces of contemporary art, bearing, instead, the mark of "outsider" art; yet this public embracing of art's instrumentality is one of the most significant interventions in which *Witnesses* participates.

Non-Indigenous artists, too, contributed relics for these ongoing acts of remembrance. Cathy Busby's *WE ARE SORRY 2013*, the massive vinyl panel featured in Beau Dick's copper cutting action that I discussed in the previous chapter, is a section of a public vinyl work, printed with the Canadian government's 2008 apology to survivors as well as the Australian apology to the "stolen generations" of Aboriginal people and exhibited in Melbourne. For the Belkin show, Busby displayed a piece of this work, the Canadian apology, on campus at the University of British Columbia in Koerner Library. Its remaining fragments were left in a pile on a table near the installation; visitors were urged to take them home along with an informational pamphlet giving a timeline of the TRC and links to online resources and documentation.

In the context of *Witnesses*, such an emphasis on intercultural acts is at once obvious – reconciliation is, by definition, intended to bring together different groups within a

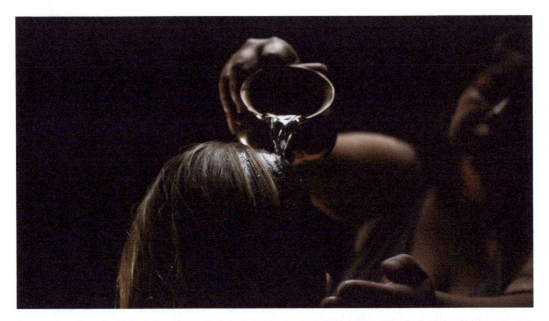

Figure 6.1. Skeena Reece, *Touch Me* (production still), 2013, video. Collection of the Morris and Helen Belkin Art Gallery, University of British Columbia, purchased with support from members of the Belkin Curator's Forum, 2013. Photograph by Pete Hagge.

nation – and difficult to untangle in terms of how such acts are borne out in relation to location and experience. In Skeena Reece's video work *Touch Me* (2013; Figure 6.1), the artist bathes photographer Semchuk, the complexly identified "settler" artist, offering forgiveness. Both artists' characters are distillations of their categories – the tensely opposed Native and Settler – yet there is a surprising intimacy to the performance and a sense that a genuine act of healing is taking place for both characters and artists. Reece tenderly pours water from a copper cup over Semchuk's body, drawing from the significance of copper as a material of wealth and benediction in Northwest Coast art. As media anthropologist Kristin Dowell has argued, part of what made Reece's gesture so arresting for publics in an age of reconciliation *is* its conciliatory benediction for survivors who feel alienated from their parents.[48] This frame of repair is, perhaps, less easy to witness than one of traumatic injury and its repetitions.

Although *Witnesses* is by no stretch a Northwest Coast art show, some of the region's social relations and modes of creating belonging necessarily spill over into the curatorial emphasis on materialized witnessing. Like the small everyday items given to guests at potlatches, the exhibition's fragments, documentation, pamphlets, and even the catalogue itself create quite deliberate obligations between hosts and guests – they are shared objects and tangible reminders of the act of witnessing. Moreover, the very categories of "host," "guest," and "witness" are knowingly unsettled by the gallery's location on unceded territory and through its relational emphasis. In these ways, the works in *Witnesses* materialize the social action they hope to effect, and do so in a regional register of reciprocity.

These roles have also left a permanent pedagogical mark on the campus on which the Belkin is located. In 2017, the university raised a Reconciliation Pole beside the Forestry building,

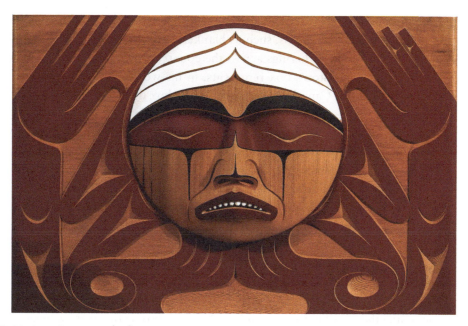

Figure 6.2. Luke Marston, *The Medicine Box* (2009). Image courtesy of the artist and the National Centre for Truth and Reconciliation. For more information about the box and its journey, please visit nctr.ca.

a monument to remember, honour, and continue to educate about histories and legacies of the residential schools. Commissioned by the philanthropist Michael Audain and carved by James Hart (Haida), the pole tells a story of the time before, during, and after the residential schools through an iconography of the life cycles of the salmon, a residential school structure, and imagery of children united by their shared struggles. At the top of the pole, two vessels, a Haida canoe and a European longboat, move side by side in what Hart identifies as parallel forms of governance.[49] An intercultural object, it was raised with the permission of the Musqueam Nation whose land the university occupies, and witnesses at the pole raising were invited to hammer in one of more than 68,000 copper nails, each honouring a child who died in the schools. In tandem, the university established an Indian Residential School History and Dialogue Centre to extend these acts of witnessing and participation. These campus features might also be considered transitional properties, as they materialize the effects of transitional justice by building an accountability for witnessing into the built environment.

BOXES AND KNOWLEDGE

Moving away from *Witnesses*, these transitional properties are particularly visible in a work made for use in the commission itself, Coast Salish artist Luke Marston's *The Medicine Box* (2012; Figure 6.2).[50] At the request of the TRC and the federal Department of Indian Affairs, Marston created a large bentwood box (three feet long, eighteen inches

wide, and twenty-one inches high) to be used as a repository for collecting survivor's school mementos – small and personal items, such as blankets, cassette tapes, and photographs – at the commission's national gatherings across the country. Through its four carving- and paint-embellished sides, Marston's box represents, in his words, "all the survivors of the residential schools system in Canada." Three sides of the box depict different faces of abuse and resilience across the country, representing, respectively: an Inuit man; a young Woodlands Native man, shown alongside Métis cultural symbols; and an old woman whose hands are held up at the loss of her children. Two of the woman's fingers are bent, a reference to Marston's own grandmother's disfiguring injury, the result of being pushed down the stairs by a school official during her childhood at Kuper Island Residential School. On the fourth side of the box is a Thunderbird, a unifying and pan-Native symbol of strength.

During its tour of different national gatherings, Marston's work drew on these unifying symbols to become a kind of ritual object for collective healing, encapsulating personal relics of the schools.[51] A striking centrepiece at gatherings, the box is frequently photographically reproduced in the TRC's publicity materials. Although its Northwest Coast motifs index the West Coast, the box also represents many different Indigenous experiences across Canada, containing these within its cedar sides. Marston's box's effectiveness hinges on this capacity: the box materializes the TRC's goals as a physical, unifying repository.

Yet in spite of its "commissioned" origin and public prominence, the work that Marston's box does in these public spaces is also more subtle and intimate. In an interview with Marston that aired on a CHLY People First Radio broadcast on Vancouver Island, the artist describes how the details of its making also leave marks on the work.[52] In addition to the "tribute" to his grandmother on the box's front – Marston's careful choice of word calling up all of the obligations contained in such modes of giving and receiving on the coast – the artist explains that it was his brother who actually steamed the red cedar into its box shape in Port Alberni, long before the commission. Marston's own carving and painting is thus also a kind of repurposing that extends his family ties. Marston animates this box with its need to travel. "This box is going to be a loud voice for Canada," he insists. "It *has* to be heard."

The artist expands on this desire – both his and that of the box, for the two merge as he speaks – noting that it is not about "just the box itself [but] the movement of all the people it is going to create." Marston explains that, as it travels, the box can work as a healing object, helping people let go of their trauma: "The box will take it away."

This ritual of refuse amplifies the TRC's emphasis on telling, but it does so in a way that emphasizes kinship over collection. As a vessel of intimate containment and disposal, Marston's box also evokes local display protocols that are unsaid but present. Boxes, houses, and bodies are indexically related for Coast Salish people through mortuary practices.[53] As with the wrapping of bodies, Marston's box offers a protective concealment that is paradoxically carried out in public with reference to these other cultural purposes – a reference to another kind of mortuary box, which could be called a "prototype" for Marston's, using anthropologist Alfred Gell's term for an initial referent in these indexical relationships.[54] Not everything is shown, or told, and the more public, pan-Indigenous symbols as well as

Marston's careful rendering of his grandmother's story literally provide cover for relics, the material testimony contained and concealed within. In this way, in the public space of national gatherings, Marston's work may function as a storehouse of memory and disposal that resists more acquisitive practices of archiving through its prototypical form whose meaning is located beyond the space of the gathering.[55]

This dynamic extends *beyond* art in the age of reconciliation. It visibly organizes just relations that cohere around selective withholding, giving local and ethical imperative to the intercultural transactions required by the process of commissioning truth. It is a different kind of efficacy from that required by the TRC itself. As I have discussed throughout this book, the presence of this dynamic is a powerful trope for localizing the art of reconciliation and one that Indigenous scholars and artists use strategically in contesting reconciliation even as they contribute to its work. In other words, it is a poetics and politics of display that has consequences for art's efficacy in reconciliation, exceeding the pedagogical efficacies of the TRC's model of art as testimony.

The objects that were deposited in Marston's box are now housed as the Bentwood Collection at the National Centre for Truth and Reconciliation at the University of Manitoba, where some have been displayed and others are still being catalogued. While it is beyond the scale of this research to describe them fully, it is important to note the extraordinary range of the everyday – sports equipment and other mementos and offerings, as well as religious items including rosaries, drums, and medicine – and the influence that TRC collections such as this one have had on archival practice. Indeed, as historians Cynthia E. Milton and Anne-Marie Reynaud have argued in their analysis of the Bentwood Collection, their care has resulted in a model of "sacred storage" in which the offerings are regularly smudged by Elders, and archivists are required to purify their hands with spruce before handling objects.[56] In this way, the power of these offerings extends to their afterlives in the testimonial archive, showing another kind of collective effect: the recognition of their animate qualities. As the authors note, these modes of care also have the potential to disrupt the redemptive narrative of healing from trauma through the extension of its rituals into archival stewardship in the present – arguably, an extension of these objects' agential capacities.

In this light, artist Luke Parnell's challenge to the salvage paradigm of preservation in his film *Remediation* (2018; Figure 0.1), which records the endurance of shouldering his family eagle crest, carved in wood, across the country to be burned on a beach, is more than an act of creative destruction or ritual of release that reinscribes loss. Seeing his reflection, the burden of history on his back, in the glass of museum storage, Parnell acknowledges this space as extractive, yet also sees in these belongings the source of his own archival impulse. Like a bentwood box, the film intertextually remediates the story of art's preservation, accounting for cultural loss while rendering that which really matters intangible.

AFTERWORD

There Is (Still) Truth Here

I am writing now more than a decade after the coalescing forms and freedoms of art that I stitch together in this book as aesthetics of repair. Looking back on this decade and its intertwined environmental and social crisis, I am unsurprised by the recent flourishing of interest in care in the art world and how it is that museums have, once again, become the site of heated debates about what decolonizing looks and feels like across settler states. As critic Maggie Nelson explains in her recent treatise on care, freedom, and art, aesthetic care is important because it allows for a space of care that is not necessarily tied to human others. "Aesthetic care entails caring about other things, such as paper quality, pigment, gravity, oxidization, chance, pattern, the dead, and the unborn," she writes. "All of this is also the world, also constitutes forces to which one might feel compelled or obliged."[1]

If this statement sounds like a formalist argument, somewhat at odds with the anthropology of art's interest in art's social relations, circulation, and aesthetics of accountability, that's because it is. For Nelson, aesthetic care is exciting precisely because it leads us to new forms, moving on from the problem of how it is that art can *do* things, whether that is to heal or harm. Given my interests and commitments, this idea might seem like a dissonant thought to include, particularly at the end of a book about repair. But Nelson's argument resonates strongly with many of the object relations and cosmopolitanisms that this book has explored, particularly the Indigenous forms of repair that are at odds with "official" reconciliation and object ontologies – indeed, formalisms – that enact repair through their play with the ambiguity of art's categories in Western as well as Northwest Coast registers.

Indeed, some of the most striking outcomes of this decade of upheaval and reconciliation are in its after-effects of obligation to the material: the problem of how to care for these objects now properly recognized as belongings in archives and museums. On what ethical bases might tenets of preservation be altered to more adequately distribute care for records that are at once evidence, witnesses to history, and cultural belongings? Melanie Delva, a non-Indigenous archivist who holds the position of reconciliation animator for

the Anglican Church of Canada, has written about the challenges of reconciling international Indigenous rights protocols – which Canada is now ostensibly bound to through its signing-on to the United Nations Declaration on the Rights of Indigenous Peoples – with standard archival codes of ethics.[2] As with many conversations about returns, at issue is the distributed authorship of many of these records: what to do with settler-authored "manifestations of culture" like photographs of and records about Indigenous people.

Though obviously not always paper records, art made or housed in residential schools represents an analogous problem, particularly because many of these belongings are intercultural productions that mediate relationships between settler and Indigenous cultural worlds, particularly once their meaning shifts from "collection" to "testimony" – a bentwood box, for instance, that was collected as an example of "Kwakwaka'wakw art" or "style," being newly seen as holding difficult knowledge due to its residential school provenance.[3] In the wake of the Truth and Reconciliation Commission (TRC), exhibitions are visibly grappling with how to reconcile these shifting meanings while continuing to deal with the overarching problem of representing cultural resilience alongside cultural loss and the risks in a settler society that come with publicly displaying vulnerability. As scholar and theatre practitioner Jill Carter (Anishinaabe/Ashkenazi) puts it, "there are dangers that come when we bare our throats."[4] These dangers are partially what Eve Tuck is worried about in her call to researchers and educators to "suspend damage," to consider what is at stake in a narrative of Indigenous brokenness, and to refuse to perpetuate it with a narrow representation of suffering.[5] Overall, in spite of their apparent permanence, these collections have transitional properties, too, that are complexly mediated around the category of art.

What do these properties and forms of aesthetic care look like now? By way of conclusion, I turn to these mediations in a recent exhibition of children's Northwest Coast artwork produced in four different British Columbia residential schools, installed at the Museum of Vancouver (MOV) in late 2019. Entitled *There Is Truth Here*, the exhibition was curated by visual anthropologist Andrea Walsh, drawing on her long-time collaborative work with survivors and first shown at the Legacy Art Gallery in Victoria, British Columbia. Sharon Fortney, curator of Indigenous collections and engagement at MOV, facilitated the remounting and added to it from the museum's permanent collection. The exhibition showcased children's work from Inkameep Day School (Okanagan), St. Michael's Indian Residential School (Alert Bay); the Alberni Indian Residential School (Vancouver Island), and Mackay Indian Residential School (Manitoba). Several of Gina Laing's paintings were also included in this exhibition alongside other work by children and school paraphernalia, including costumes and videos from school dramas and furniture that had belonged to teachers at the schools.

As the presence of a position like "curator of Indigenous collections and engagement" suggests, MOV has been active in decolonizing its practices through digital and physical repatriation programs. Much of this work is not new; museums in British Columbia were sites of friction, repatriation, and difficult, generative exchange for decades before social movements like #decolonizethisplace and the TRC's human rights framing of links between

community belonging and restitution.[6] Moreover, as Fortney pointed out to me over email, MOV had already been working with the "culturally specific paradigm" of belongings since their installation of *C̓əsnaʔəm: The City before the City*, the multi-sited exhibition and knowledge-sharing process focusing on Vancouver as Musqueam cultural landscape.[7]

Central to the truth of *There Is Truth Here* was a reappraisal of these belongings, largely made by children, as art in their own right and the conferral of dignity that this category can offer. In the opening text of the exhibition, Walsh writes:

> The artworks in this gallery are the material traces of children's lives and they must be honoured first as the artworks of daughters, sons, cousins, grandchildren, nieces, nephews, aunties, uncles, and parents … [T]hey did not create their art as a record of history for Canada, but that is what it has become. Upon humble reflection, when one stands in the gallery and bears witness to the lives of children through their art, one becomes aware that there is truth here.

As I walked through the exhibition, the grounding smell of cedar infused the space while sounds of children's voices from the video looped in the second gallery. The paintings were hung comfortably close to one another, and the walls were painted warm earth tones – all deliberate rejections of clinical white walls and distanced display techniques.[8] As is the case in many exhibitions of violence and atrocity, there was a space in the exhibition for quiet reflection and support, replete with tissues, comfortable seating, and a view, billed as a "quiet space to enjoy nature and gather your thoughts." As in *Witnesses*, the spectator is called to an exchange as the performative and participatory importance of art in witnessing is realized. Even more so here, the care for collections is made explicit and analogized to other forms of care bound up in witnessing. Indeed, near the beginning of the exhibition, visitors are invited to touch plaster hands by contemporary artist Roxane Charles, including a cast of her grandmother's hand.[9] Through this materialized gesture of outreach, *There Is Truth Here* makes no secret of the complicities involved in care and how acknowledging these can disrupt both redemptive and pathologizing readings of trauma by replacing them with complex stories of individuals and the many worlds, subject positions, and communities that they inhabit.

Indeed, the status of art – and by this I mean its work as a value category – is also an important thing displayed in this exhibition. Work by unknown makers from St. Michael's Residential School in Alert Bay is attributed to "unknown artists," making sure that this status is preserved even for those whose names have not yet been recovered.[10] The value of art in its most cosmopolitan sense is also visible in the section of children's drawings from the Inkameep Day School, whose teacher, Anthony Walsh (no relation to curator Andrea Walsh), encouraged art-making and the submission of student work to the Royal Drawing Society's Children's Art Exhibitions and Competitions in London, England, in the 1930s and 40s. Many of these works won awards, including Edith Kruger's (Penticton First Nation) *Sin-nam-hit-quh* drawings *Playing at School* and *Going to Town* (c. 1934–42); these labels bestowing First Class Honours remain affixed to the drawing's frames, situating their recognized merit in their historical moment and extending this appraisal into the

present. In her review of the exhibition, journalist Lucy Lau commends the exhibition for "aiming to showcase the resiliency of residential school survivors using a language that crosses borders: art."[11]

The frame of exchange within larger decorative art worlds is also shown in the correspondence between students and larger cultural institutions. An exhibition label tells the story of how students at Inkameep wrote cards and letters to Walt Disney about the artistic activities at the school, highlighting an instance in which Disney responds to their drawings of animals with news that he is working on a film about deer; the animated feature *Bambi* (1942) was released the year after this exchange. This section of the exhibition also suggests exchange with the wider world of decorative arts, illustrated through a framed watercolor of a floral and foliate design for a Wedgewood plate by student Ernest Baptiste (although, as the label text notes, it is still unknown whether the famous china company actually received or manufactured the design). Regardless of their material influence, these examples suggest how the schools taught students to imagine themselves as artists involved in a cultural milieu far beyond the Pacific Northwest – a cosmopolitanism that is not normally connected with children's art.

In this vein of establishing provenance, *There Is Truth Here* takes great care to present local exhibition histories through the images of residential school "handicraft" displays at the Pacific National Exhibition in the 1930s, showing the circulation of art beyond the walls of the school and into broader regimes of value. In an email exchange with me, MOV curator Fortney pointed out that this particular story was also an important localizing device as it enabled her to identify and update catalogue records for objects in the permanent collection that had been part of these exhibitions.[12] This reassessment of permanent collections through exhibitions is not unusual in the museum world – it is a major way in which curators come to know more about collections in storage – but in this case, these are reassessed as transitional properties that shift across frames of art and evidence.

In her correspondence with me, Fortney also explained how her cataloging of brown paper exhibition tags led her to associate this exhibition history with a collection from Plains Cree communities – thirty-three beaded objects and a book of psalms and hymns in Cree script – on which Fortney had noticed similar tags while showing them to her daughter's school. These belongings had not been previously connected with residential schools, and by returning to their donor files, she has been able to uncover their association with St. Andrew's Mission School in Alberta. She has added a note on this connection to the artifact history for these belongings.[13]

Notably, the exhibition also allows for a complex place of Christianity, mostly through the inclusion of an incomplete Stations of the Cross series of painted cedar panels by unknown child makers depicting Jesus Christ in traditional buckskin clothing. An accompanying text highlights the co-existence of Okanagan and Christian motifs as evidence of the teacher Walsh's comparatively high tolerance for syncretism, while drawing the viewer's attention to the leather ties on the tops of some of the panels as evidence of their use. This display suggests the role of expressive culture in mediating complex religious truths and transitions in spiritual life at the school.

In spite of the exhibition's historical focus, the performativity of the archive and its capacity to bring about healing in the present is also emphasized. This capacity is particularly the case in a display of six large-scale photographs by Métis artist Amanda Laliberte of the demolition of St. Michael's Indian Day and Residential School in Alert Bay. Presenting the abandoned school as ruin, the series shows members of the community gathered to ceremonially mark the beginning of the demolition. The late artist and hereditary chief Beau Dick, who performed the ceremony, is prominent in the two middle images, wearing a *naxeen* and shaking a chief's rattle as the demolition crane edges the frame. In comparison with his larger-than-life portrayal in the contemporary art world, these images suggest a more intimate and everyday integration in the spiritual life of the community, as he is accompanied by others – holding flowers, mourning, smiling – who mark the complexity of such an event and emphasize, once again, how the social relations around the TRC continue to matter.

I was struck by these images, too, as markers of the work of art in community settings and by how the performative power and fame of Dick, acquired in the art world, could also enhance a community-based ritual. But when I asked Indigenous Curator Fortney what she thought of highlighting the late artist in the exhibition, her response was telling: "When I looked at those images, I saw a community coming together, not just one person doing the work." Here, the work of care and healing is distributed beyond the individual artist.

To compare with the earlier *Witnesses* that I wrote about in the previous chapter, and the particular work of complicity it demanded of viewers, *There Is Truth Here* struck me as subtler and more intimate but no less potent. Laing's work, which appears in both exhibitions, offers a useful point of comparison on which to conclude. True to Andrea Walsh's critique of the risks *Witnesses* was taking, the didactic text for Laing's work, for example, was offered in the first person, and the darker images from *Witnesses* were not included in the show. Complicity is also embodied by objects: the schoolteacher Mr. Aller's moccasins, displayed relic-like, embody the complexity of the story as he seems to have been one of the good ones – indeed, Laing's didactics emphasize him as a respite from the trauma. The empty, worn moccasins recall the hands through the scale of their intimacy. In a newspaper review of the exhibition, Walsh explains the importance of nearness: "We can understand those terms on a human scale, as opposed to these anesthetized numbers of 150,000 kids, 139 schools," she says. "That's why I named the exhibition *There Is Truth Here* – because truth is much more nuanced than facts."[14]

It is here, in these gestures of care – among them, witnessing, collaboration, scholarship, and collections management – that we can see how the permanence of the permanent collection may be altered by transitional justice. To return to the overarching argument of this book, these forms of mending and mutual accountability emerge within and against present conditions, the politicized modes of reckoning with the past and its unsettlements, with that which is unceded. In this final example, the archive is transformed into a location and substance of repair, the stability of objects unsettled through their transformations. The Truth and Reconciliation Commission's conceptualization of art as visual testimony has certainly played a significant role in these activations and efficacies, but ultimately, it is

the interplay between multiple frames of accountability and repair across art worlds that artists have used in a process of remediation that is both knowing and incomplete, refusing a redemptive storyline.

Thinking back to the space for quiet contemplation in *There Is Truth Here*, I can also remember the sounds of the museum's permanent history installation next door – a bombastic and boosterish tour through the province of British Columbia. The shared space is nuanced by this truth, too, witnessing the art and repair still to come.

Acknowledgments

This book was sustained by so many sources of thought and encouragement, with the usual caveat that any mistakes or misinterpretations in this work are mine alone.

I thank all of the artists, archivists, curators, writers, and activists who shared their time, work, and words with me during my research. In and around Vancouver, I would especially like to thank Glenn Alteen, Sonny Assu, Raymond Boisjoly, Cathy Busby, Bruce Byfield, Ann Cameron, Angelo Cavagnaro, Marcia Crosby, the late Beau Dick, Karen Duffek, Alano Edzerza, Roberta Kremer, Peter Lattimer, Cody Lecoy, Kyla Mallett, Michael Nicoll Yahgulanaas, Skeena Reece, Douglas Reynolds, Solen Roth, Steve Smith, Tania Willard, Nathan Wilson, and Gary Wyatt. For attentive archival help, I thank Blair Galston at the Bob Stewart Archives, Krisztina Laszlo at the Museum of Anthropology, Alastair MacKay at the Thunder Bay Art Gallery, and Cheryl Siegel at the Vancouver Art Gallery Library.

I thank my friend and co-conspirator Luke Parnell for his patience, wisdom, and good humour. I hope this book conveys how much I owe to his thinking and making.

I am also indebted to the Freda Diesing School of Northwest Coast Art in Terrace for welcoming me into their histories and futures. I thank Stan Bevan, Dempsey Bob, Ken McNeil, Rocque Berthiaume, Dean Heron, Roy Henry Vickers, and all of the students who shared space and time with me. You have all taught me a lot about how to do my homework.

In and around Toronto, I thank Suzanne Morrissette, Lisa Myers, and Michael Prokopow for curiosity, criticism, and friendship. I thank David Garneau, Mimi Gellman, Richard Hill, Gordon Brent Ingram, Cheryl L'Hirondelle, Amish Morrell, Steven Loft, and Dot Tuer for their conversations with my work at various stages. At York University, I thank Rosemary J. Coombe for her collaborative generosity and mentorship. I extend heartfelt thanks to the late Naomi Angel for her commitment to critical hope. Her mind and memory flood these pages.

In New York, I thank Aaron Glass at the Bard Graduate Center for initiating me into the "Northwest Coast orbit" and for teaching me so much about collaborative exhibition

practice. I thank Audra Simpson for creating a space for critical Indigenous theory at Columbia.

I thank Faye Ginsburg and Fred Myers for outstanding mentorship, brilliance, and savvy. I am so very grateful for your kind and persistent support throughout my graduate training, and I am proud to be in both of your scholarly lineages. I thank Haidy Geismar for your critical editing, practical recommendations, and for keeping my fieldwork on an even keel; Renato Rosaldo for sharing your incisive mind and your gentle, committed approach to scholarship as an *anthropoeta*; and Charlotte Townsend-Gault for the gift of your criticism.

I thank the Department of Anthropology at New York University (NYU), especially Emily Martin, the late Sally Merry, and Bambi Schieffelin. I am grateful to the Culture and Media Program for focusing my work in visual anthropology, and I thank Cheryl Furjanic and Noelle Stout for their essential training in visual research methods. For friendship and sanity, I thank Dwaipayan Banerjee, Jamie Berthe, Wenrui Chen, Lee Douglas, Luther Elliott, Jen Heuson, Tate LeFevre, Amy Lasater-Wille, Ram Natarajan, Sandra Rozental, Will Thompson, Sabra Thorner, Chantal White, and Emily Yates-Doerr. I am especially grateful to Lily Defriend for her warmth and wisdom.

I thank Candace Greene and Nancy Parezo at the Smithsonian Institution's Summer Institute in Museum Anthropology (SIMA) program for invaluable training in museum and archival methods. I thank the Institute of Fine Art's Graduate Forum on Forms of Seeing at NYU for clarifying my research around debates in visual culture. At the Museum of Anthropology in Vancouver, I thank Jennifer Kramer, Nicola Levell, Carol Mayer, Curator Emerita Miriam Clavir, Anthony Shelton, and the late Michael Ames. I thank the late Martha Black, curator emerita at the Royal British Columbia Museum, who was responsible for my interest in Northwest Coast art in the first place. At the University of British Columbia, I thank Carole Blackburn, Michael Blake, Vinay Kamat, and Maureen Ryan for their early support.

A postdoctoral fellowship at the Jackman Humanities Institute at the University of Toronto provided an intellectual home and wonderful colleagues. I thank all of them for their humanities hospitality, especially the members of our phenomenology reading group, Chris Dingwall, Gabriel Levine, Alyson Brickey, Marlo Burkes, Elizabeth Parke, and Yan Liu.

Colleagues and students at the Gallatin School have supported this work immensely. For creating space and will to write, I thank Stephen Duncombe, Louise Harpman, Dean Susanne Wofford, and my WetLab co-directors Karen Holmberg and Cyd Cipolla. I thank Patrick Bova, Valerie Forman, Anne DeWitt, Sybil Cooksey, Gregory Erickson, and Hugh Zhang, all of whom provided generous commentary on drafts. For fellowship at the NYU Humanities Center, I thank Ulrich Baer, Molly Rogers, and all the members of our seminar, especially Daniella Gitlin, Anna Kendrick, Tatiana Linkhoeva, Susanah Romney, and Alexandra Vasquez for excited engagement with my ideas. I am grateful to Jacob Remes for our two-person Canadian studies department, for your careful editing, and for your friendship.

At the University of Toronto Press, I thank my editor Jodi Lewchuk for patient assistance in shepherding this book through the publication process. I also thank former acquisitions editor Douglas Hildebrand for seeing this project's potential. In production, I am grateful to

the four anonymous reviewers whose attentive reading made this work stronger, to Cathryn Piwinski for her persistence with complex image permissions, to Carolyn Zapf for careful copy-editing, and to Tim Pearson for writing an illuminating index.

This research was generously funded by a New York University Henry MacCracken Fellowship, Fieldwork Grant, and Graduate School of Arts and Sciences Dean's Dissertation Writing Fellowship; a Council for Library and Information Resources Andrew W. Mellon Fellowship for Research in Original Sources; a Wenner-Gren Foundation Dissertation Fieldwork Grant; and a Social Science Research Council International Dissertation Research Fellowship.

I am deeply grateful to my family. I thank my parents, Alex Kisin and Darla Rhyne. Your love and support have always allowed me to follow my dreams. I thank Carol and Liz Beattie, Kristina Davies, Deb Kanter, Alister MacLusky, the late Michelle McKelvey, and Evan Roberts for being with me these long years. I thank my brilliant daughter Lila. You have taught me so much about art and care, and I'm so grateful for your patience with me. And dearest Eugene Vydrin, your close and non-coercive reading has brought new meaning to every word of this book and to my life.

Finally, I thank Chris Marchand, who has been a fierce supporter from beginning to end. Your love in its many forms has made this possible, together and apart.

Notes

Introduction: Remediating Loss and Repair

1 For footage of the opening, see Danielle Rochette, "Indigenous Artist Carves Seven Foot Totem to Reignite His Heritage," *APTN National News*, 6 June 2016, https://www.aptnnews.ca/national-news/luke-parnell/.

2 *Bill Reid's Rescue Mission for Haida Art*, Canadian Broadcasting Corporation (CBC), Program 8, aired 21 May 1959.

3 *Bill Reid's Rescue Mission* [8:59].

4 Luke Parnell in conversation with Lisa Myers, "Repeat the Chorus Three Times," in *Contingencies of Care* virtual residency," 13 July 2020, https://www.youtube.com/watch?v=qADMEPQQTWE&list=PLB2txaKEXi6s-Vl2YvUvtQK1z704BhE0j&index=1.

5 Clementine Deliss, *The Metabolic Museum* (Berlin: Hatje Cantz, 2020).

6 Truth and Reconciliation Commission of Canada, *Honouring the Truth, Reconciling for the Future: Summary of the Final Report of the Truth and Reconciliation Commission of Canada* (Ottawa, ON: Truth and Reconciliation Commission of Canada), 6.

7 My interpretive account of this age of reconciliation emphasizes intercultural forms and circulation, and is not meant to stake any kind of claim to its conceptualization. Indeed, in a recent volume that uses this same epochal phrasing, Heidi Kiiwetinepinesiik Stark, Aimée Craft, and Hōkūlani K. Aikau have theorized the age of reconciliation in ways that centre Indigenous voices and knowledge. I understand our approaches as distinct and complementary, pointing to a shared consciousness of this moment as one of marked epistemological shift. Please see Heidi Kiiwetinepinesiik Stark, Aimée Craft, and Hōkūlani K. Aikau, eds., *Indigenous Resurgence in an Age of Reconciliation* (Toronto: University of Toronto Press, 2023).

8 Maggie Nelson, *On Freedom: Four Songs of Care and Constraint* (Minneapolis, MN: Graywolf Press, 2021), 54.

9 Nelson, *On Freedom*, 53.

10 Anna Lowenhaupt Tsing, *Friction: An Ethnography of Global Connection* (Princeton, NJ: Princeton University Press, 2005).

11 On the idea of the Northwest Coast art renaissance, see Aaron Glass, "History and Critique of the 'Renaissance' Discourse," in *Native Art of the Northwest Coast: A History of Changing*

Notes to pages 7–11

Ideas, ed. Charlotte Townsend-Gault, Jennifer Kramer, and Ḳi-ḳe-in (Vancouver, BC: UBC Press, 2013), 487–517.

12 Bruce Ruddell, *Beyond Eden*, Vancouver Playhouse, Vancouver, BC, and Epcor Centre for the Performing Arts, Calgary, AB, 2010.

13 Tsing, *Friction*.

14 This situation is still very much live and unfolding. For a timeline of events, see Canadian Press, "Timeline of the Coastal GasLink Pipeline in British Columbia," *Vancouver Sun*, 24 January 2021, https://vancouversun.com/business/energy/timeline-of-the-coastal-gaslink-pipeline-in-british-columbia.

15 "Reconciliation Is Dead. Revolution Is Alive," *Unist'ot'en* (website), accessed 23 March 2022, https://unistoten.camp/reconciliationisdead/.

16 Eve Tuck and K. Wayne Yang, "Decolonization Is Not a Metaphor," *Decolonization: Indigeneity, Education & Society* 1, no. 1 (2012): 1–40.

17 Paul Rabinow, *Designs for an Anthropology of the Contemporary* (Durham, NC: Duke University Press, 2008); Terry Smith, *What Is Contemporary Art?* (Chicago: University of Chicago Press, 2008); Néstor García Canclini, *Art beyond Itself: Anthropology for a Society without a Storyline*, trans. David Frye (Durham, NC: Duke University Press, 2014).

18 Arthur Danto, *After the End of Art: Contemporary Art and the Pale of History* (Princeton, NJ: Princeton University Press, 1997).

19 See, for example, George E. Marcus and Michael F. Fischer, *Anthropology as Cultural Critique: An Experimental Moment in the Human Sciences* (Chicago: University of Chicago Press, 1986).

20 On moving away from extractive styles of scholarship and criticism through new materialism, see Julietta Singh, *Unthinking Mastery: Dehumanism and Decolonial Entanglements* (Durham, NC: Duke University Press, 2018).

21 Trinh T. Minh-ha, in Nancy N. Chen, "'Speaking Nearby': A Conversation with Trinh T. Minh-ha," *Visual Anthropology Review* 8, no. 1 (March 1992): 82–91.

22 Paul Rabinow, *Unconsolable Contemporary: Observing Gerhard Richter* (Durham, NC: Duke University Press, 2017); Jennifer Biddle, *Remote Avant-Garde: Aboriginal Art under Occupation* (Durham, NC: Duke University Press, 2016); Jessica Metcalfe, "Reclaiming the Body: Strategies of Resistance in Virgil Ortiz's Fashion Design," *Settler Colonial Studies* 3, no. 2 (2013): 172–8.

23 Bill Holm, *Northwest Coast Indian Art: An Analysis of Form* (Seattle: University of Washington Press, 1965); Franz Boas, *Primitive Art* (1927; repr. New York: Dover Publications, 1955).

24 Charlotte Townsend-Gault, Jennifer Kramer, and Ḳi-ḳe-in, eds., *Native Art of the Northwest Coast: A History of Changing Ideas* (Vancouver, BC: UBC Press, 2013).

25 For a review of the anthropology of art's post-1986 Indigenous-influenced turn towards the social, see Eugenia Kisin and Fred R. Myers, "The Anthropology of Art, After the End of Art: Contesting the Art-Culture System," *Annual Review of Anthropology* 48 (2019): 317–34. On the relational qualities of art and anthropological theory, see Roger Sansi and Marilyn Strathern, "Art and Anthropology after Relations," *HAU* 6, no. 2 (2015): 425–39.

26 Charlotte Townsend-Gault, "Art Claims in the Age of *Delgamuukw*," in Townsend-Gault, Kramer, and Ḳi-ḳe-in, *Native Art of the Northwest Coast: A History of Changing Ideas*, 684–935.

27 Zoe Todd, "Relationships," Theorizing the Contemporary, *Fieldsights*, 21 January 2016, https://culanth.org/fieldsights/relationships.

28 Elizabeth Povinelli, "Geontologies: The Concept and Its Territories," *e-flux* 81 (2017), https://www.eflux.com/journal/81/123372/geontologies-the-concept-and-its-territories/.

29 Elizabeth Povinelli, *Geontologies: A Requiem to Late Liberalism* (Durham, NC: Duke University Press, 2016), 6.

30 On re-enchantment in contemporary art, see James Elkins and David Morgan, eds., *Re-enchantment* (New York: Routledge, 2008). On purification, see Bruno Latour, *We Have Never Been Modern* (Cambridge, MA: Harvard University Press, 1993).

31 My account of these religious influences is not intended to be systematic or to make a localized argument about religious syncretism. Instead, I focus on Protestant doctrines of work as non-secular sources of value, arguing that these have influenced the market for contemporary Northwest Coast art by contributing to present-day apprehensions of this work as cultural resources in *particular* social justice regimes and art movements.

32 See Fred R. Myers, *Painting Culture: The Making of an Aboriginal High Art* (Durham, NC: Duke University Press, 2002); Howard Morphy, *Becoming Art: Exploring Cross-Cultural Categories* (Sydney, AU: University of New South Wales Press, 2008). On stereotypes in art, see Nancy Marie Mithlo, *"Our Indian Princess": Subverting the Stereotype* (Santa Fe, NM: SAR Press, 2009).

33 Donald Preziosi, *Rethinking Art History: Meditations on a Coy Science* (New Haven, CT: Yale University Press, 1991).

34 See, for instance, Jonathan Harris, ed., *Globalization and Contemporary Art* (Malden, MA: Wiley-Blackwell, 2011).

35 Chika Okeke-Agulu, *Postcolonial Modernism: Art and Decolonization in Twentieth-Century Nigeria* (Durham, NC: Duke University Press, 2015).

36 Dilip Parameshwar Gaonkar, ed., *Alternative Modernities* (Durham, NC: Duke University Press, 2001).

37 Biddle, *Remote Avant-Garde.*

38 Biddle, 8.

39 Biddle, 4.

40 Jessica L. Horton, *Art for an Undivided Earth: The American Indian Movement Generation* (Durham, NC: Duke University Press, 2017). On Indigenous cosmopolitan art worlds, see also Bill Anthes, *Edgar Heap of Birds* (Durham, NC: Duke University Press, 2017).

41 On mastery's relation to self and colonial conquest, see Singh, *Unthinking Mastery.*

42 Elizabeth Harney and Ruth B. Phillips, eds., *Mapping Modernisms: Art, Indigeneity, Colonialism* (Durham, NC: Duke University Press, 2019).

43 Smith, *What Is Contemporary Art?*, 133–47.

44 Terry Smith, *Art to Come* (Durham, NC: Duke University Press, 2019), 19.

45 Mary Louise Pratt, *Imperial Eyes: Travel Writing and Transculturation* (New York: Routledge, 1992).

46 Eve Kosofsky Sedgwick, *Touching Feeling: Affect, Pedagogy, Performativity* (Durham, NC: Duke University Press, 2003).

47 Eve Tuck, "Suspending Damage: A Letter to Communities," *Harvard Educational Review* 79, no. 3 (Fall 2009): 409–27.

48 Nelson, *On Freedom*, 31.

49 Jordan Wilson, "'Belongings' in 'Cəsnaʔəm: The City before the City,'" *Intellectual Property Issues in Cultural Heritage* (IPinCH; blog), 27 January 2016, https://www.sfu.ca/ipinch/outputs /blog/citybeforecitybelongings/.

50 Shelly Errington, *The Death of Authentic "Primitive Art" and Other Tales of Progress* (Berkeley: University of California Press, 1998).

51 Dylan Robinson, "Enchantment's Irreconcilable Connection: Listening to Anger, Being Idle No More," in *Performance Studies in Canada*, ed. Laura Levin and Marlis Schweitzer (Montreal and Kingston: McGill-Queen's University Press, 2017), 211–35.

52 Deborah A. Thomas, *Political Life in the Wake of the Plantation: Sovereignty, Witnessing, Repair* (Durham, NC: Duke University Press, 2019).

53 Thomas, *Political Life*, 212.

54 Building on media anthropologist Faye Ginsburg's work on the social practices of Indigenous art and media worlds, I am suspicious of the boundaries imposed by asserting a singular "Indigenous aesthetics" and of associated claims that the "radical" autonomy of Indigenous ontologies is somehow separate from their discursive and material mediation. See Faye Ginsburg, "Embedded Aesthetics: Creating a Discursive Space for Indigenous Media," *Cultural Anthropology* 9, no. 3 (1994): 365–82; and Faye Ginsburg, "Decolonizing Documentary, On-Screen and Off: Sensory Ethnography and the Aesthetics of Accountability," *Film Quarterly* 71, no. 1 (2018): 39–49.

55 Myers, *Painting Culture*.

56 Fred Myers, "Ontologies of the Image and Economies of Exchange," *American Ethnologist* 31, no. 1 (2004): 5–20.

57 Alfred Gell, "The Technology of Enchantment and the Enchantment of Technology," in *Anthropology, Art and Aesthetics*, ed. Jeremy Coote and Anthony Shelton (Oxford: Clarendon Press, 1992), 40–63.

58 Howard Morphy, "Art as a Mode of Action: Some Problems with Gell's Art and Agency," *Journal of Material Culture* 14, no. 1 (2009): 5–27.

59 Liana Chua and Mark Elliott, eds., *Distributed Objects: Meaning and Mattering After Alfred Gell* (Oxford: Berghahn, 2013). For a curatorial interpretation of art and agency, see Carolyn Christov-Bakargiev, "Worldly Worlding: The Imaginal Fields of Science/Art and Making Patterns Together," *Mousse Magazine*, 1 April 2014. On art and traps, see Alberto Corsín Jiménez and Chloe Nahum-Claudel, "The Anthropology of Traps: Concrete Technologies and Theoretical Interfaces," *Journal of Material Culture* 24, no. 4 (2019): 383–400.

60 Adam Jasper. "No Drums or Spears," *Res: Anthropology and Aesthetics* 67–68 (2016–17): 299–315.

61 Tim Ingold, *Making: Anthropology, Art, and Architecture* (London: Routledge, 2013), 8.

62 Ingold, 96.

63 Sansi and Strathern, "Art and Anthropology."

64 Proceeding from and reinforcing artists' tendencies to talk about objects as though *they* are the sources of action can also be a depoliticizing move, recapitulating commodity fetishisms that limit Indigenous lives and livelihoods. However, speaking from, as well as about objects – and sometimes *not* speaking about or from objects at all – is resonant with and respectful of Indigenous conceptualizations of art and the limits on access and knowledge that attend to them in the contemporary moment. I try to signal this representational choice even as I practice it, since I am also sceptical about its effects and corresponding practices of collaboration that too easily objectify and celebrate these conventions as an unquestionable political aesthetic.

1. Re-enchanting Repair: Teaching from the "Dark Age" of Northwest Coast Art

1 Carvers Humzeed and Wakas, both members of the Raven clan.

2 Office of the Premier, Ministry of Aboriginal Relations and Reconciliation, "Aboriginal Celebration Marks Historical Repatriation," 21 June 2006, https://archive.news.gov.bc.ca /releases/news_releases_2005-2009/2006otp0108-000836.htm.

3 Miriam Clavir, *Preserving What Is Valued: Museums, Conservation, and First Nations* (Vancouver, BC: UBC Press, 2002).

4 Here, my thinking is indebted to Joanne MacDonald's influential glossing of this transformation as a move "from ceremonial object into curio." See Joanne MacDonald, "From Ceremonial

Object to Curio: Object Transformation at Port Simpson and Metlakatla in the Nineteenth Century," *Canadian Journal of Native Studies* 10, no. 2 (1990): 193–217.

5 United Church Bob Stewart Archives, Vancouver, BC.

6 I cannot find definitive evidence that there was financial support for this particular repatriation, although it is mentioned by name in the minutes. Regardless, this early positive "party line" on repatriation suggests the United Church's support of material gestures alongside immaterial apologies.

7 Gerald Amos, quoted in Mark Hume, "B.C. Totem Comes Home from Sweden," *The Globe and Mail*, 27 April 2006, https://www.theglobeandmail.com/news/national/bc-totem-comes-home-from-sweden/article18161058/.

8 Journals of the Lewis and Clark Expedition, 4 February 1806, https://lewisandclarkjournals.unl.edu/item/lc.jrn.1806-02-24.

9 At present, there is some scientific disagreement on whether oolichan are, in fact, endangered, partly because there are some years when they are in great abundance; in 2022, the Haisla Nation expressed their concern that oolichan stocks were dwindling again, drawing connections between climate change and ocean acidification as the culprits, another register of loss and repair in the Anthropocene.

10 Anna Lowenhaupt Tsing, *The Mushroom at the End of the World: On the Possibility of Life in Capitalist Ruins* (Chicago: University of Chicago Press, 2015).

11 Zoe Todd, "Fish Pluralities: Human-Animal Relations and Sites of Engagement in Paulatuuq, Arctic Canada," *Études Inuit Studies* 38, nos. 1–2 (2014): 217–38. On the promising nation-to-nation Eulachon Project in Bella Coola, see Rachelle Beveridge et al., "The Nuxalk *Sputc (Eulachon) Project*: Strengthening Indigenous Management Authority through Community-Driven Research," *Marine Policy* 119 (2020): 103971.

12 Cara Krmpotich, *The Force of Family: Repatriation, Kinship, and Memory on Haida Gwaii* (Toronto, ON: University of Toronto Press, 2013).

13 For a discussion of this repatriation in relation to cultural property discourses, see Stacey R. Jessiman, "The Repatriation of the G'psgolox Totem Pole: A Study of Its Context, Process, and Outcome," *International Journal of Cultural Property* 18, no. 3 (2011): 365–91.

14 Lyle Wilson, *Haislakala: Spoken from the Heart*, Exhibition at Coastal Peoples Gallery, Vancouver, BC, 5 November–18 December 2016.

15 Alfred Gell, "The Technology of Enchantment and the Enchantment of Technology," in *Anthropology, Art and Aesthetics*, ed. Jeremy Coote and Anthony Shelton (Oxford: Clarendon Press, 1992), 42.

16 Pamela E. Klassen, *The Story of Radio Mind: A Missionary's Journey on Indigenous Land* (Chicago: University of Chicago Press, 2018), 11.

17 This date is connected to the display of Northwest Coast art in two major exhibitions, the Vancouver Art Gallery's *Arts of the Raven* show and Montreal's World's Fair, Expo 67.

18 This attribution is disputed by some art historians, but for purposes of clarity, I maintain Alexcee's authorship, which is endorsed by the MOA.

19 Jan Hare and Jean Barman, *Good Intentions Gone Awry: Emma Crosby and the Methodist Mission on the Northwest Coast* (Vancouver, BC: UBC Press, 2006). One of the reasons for Duncan's departure from Port Simpson was his knowledge of the smallpox epidemic that was spreading up the coast; in 1862, he moved with his Anglican converts to the winter village of Metlakatla. As Joanne MacDonald points out, this move to avoid suffering likely increased Duncan's prestige among his converts (MacDonald, "Ceremonial Object to Curio," 196). The village was and is also a major site of Native rights movements, as the Native Brotherhood of British Columbia was founded there in 1931.

20 Paul Tennant, *Aboriginal Peoples and Politics: The Indian Land Question in British Columbia, 1849–1989* (Vancouver, BC: UBC Press, 1990).

21 Susan Neylan, *The Heavens Are Changing: Nineteenth Century Protestant Missions and Tsimshian Christianity* (Montreal and Kingston: McGill-Queen's University Press, 2003), 259–65.

22 For an overview of these accounts, see John Barker, "Going by the Book: Missionary Perspectives," in *Native Art of the Northwest Coast: A History of Changing Ideas*, ed. Charlotte Townsend-Gault, Jennifer Kramer, and Ḵi-ḵe-in (Vancouver, BC: UBC Press, 2013), 234–64.

23 MacDonald, "Ceremonial Object to Curio."

24 MacDonald, 199.

25 Martha Black, "Looking for Bella Bella: The R.W. Large Collection and Heiltsuk Art History," *Canadian Journal of Native Studies* 9, no. 2 (1989): 275.

26 MacDonald, "Ceremonial Object to Curio."

27 Gloria Cranmer Webster, "From Colonization to Repatriation," in *Indigena: Contemporary Native Perspectives in Canadian Art*, ed. Gerald McMaster and Lee-Ann Martin (Vancouver, BC: Douglas & McIntyre, 1991), 25–37.

28 Kaitlin McCormick, "Frederick Alexcee's Entangled Gazes," *ab-Original* 2, no. 2 (2018): 248–64.

29 Renato Rosaldo, *Ilongot Headhunting: 1883–1974: A Study in Society and History* (Stanford, CA: Stanford University Press, 1990), 22.

30 Diana Taylor, *The Archive and the Repertoire: Performing Cultural Memory in the Americas* (Durham, NC: Duke University Press, 2004).

31 On the Americanist legacy, see Regna Darnell, *Invisible Genealogies: A History of Americanist Anthropology* (Lincoln: University of Nebraska Press, 2001).

32 During this expedition, Boas and a series of contract collectors acquired regalia, language data, photographs, and body measurements primarily from Kwakwaka'wakw communities in order to fill in "gaps" in the AMNH's collection that were an effect of prior collector George T. Emmons's northern focus. See Aldona Jonaitis, *From the Land of the Totem Poles: The Northwest Coast Indian Art Collection at the American Museum of Natural History* (New York: American Museum of Natural History, 1988). See also Molly Lee and Nelson H.H. Graburn, "Diffusion and Colonial Anthropology: Theories of Change in the Context of Jesup 1," in *Constructing Cultures Then and Now: Celebrating Franz Boas and the Jesup North Pacific Expedition*, ed. Laurel Kendall and Igor Krupnik (Washington, DC: Arctic Studies Center, National Museum of Natural History, Smithsonian Institution, 2003), 79–87.

33 Aldona Jonaitis, *Art of the Northwest Coast* (Seattle: University of Washington Press, 2006).

34 Douglas Cole, *Captured Heritage: The Scramble for Northwest Coast Artifacts* (Vancouver, BC: UBC Press, 1985).

35 Ira Jacknis, "Franz Boas and Exhibits: On the Limitations of the Museum Method of Anthropology," in *Objects and Others: Essays on Museums and Material Culture*, ed. George W. Stocking, 75–111 (Madison: University of Wisconsin Press, 1988).

36 Aaron Glass, "Objects of Exchange: Material Culture, Colonial Encounter, Indigenous Modernity," in *Objects of Exchange: Social and Material Transformation on the Late Nineteenth-Century Northwest Coast*, ed. Aaron Glass (New York: Bard Graduate Center, 2011), 3–35.

37 Annette Weiner, *Inalienable Possessions: The Paradox of Keeping-While-Giving* (Berkeley: University of California Press, 1992). See also Charlotte Townsend-Gault, "Circulating Aboriginality," *Journal of Material Culture* 9, no. 2 (2004): 183–202.

38 It is significant that in *Primitive Art*, Boas often writes off discrepancies between Native interpretations of objects as mere confusion. See Franz Boas, *Primitive Art* (1927; repr. New York: Dover Publications, 1955), 214; see also Glass, "Objects of Exchange." Such examples demonstrate the ways in which Indigenous agency both influenced and deflected anthropological theorizations of objects.

39 Megan A. Smetzer, "Beadwork for Basketry in Nineteenth-Century Tlingit Alaska," in Glass, *Objects of Exchange*, 72.

40 Megan A. Smetzer, "Tlingit Dance Collars and Octopus Bags: Embodying Power and Resistance," *American Indian Art Magazine* 34, no. 1 (Winter 2008): 64–73; see also Sharon Bohn Gmelch, *The Tlingit Encounter with Photography* (Philadelphia: University of Pennsylvania Museum of Anthropology and Archaeology, 2008).

41 The agencies of objects and subjects from this period are also reactivated in the present in discourses, including those that have emerged around critical museology. See Ruth B. Phillips, *Museum Pieces: Towards an Indigenization of Canadian Museums* (Montreal and Kingston: McGill-Queen's University Press, 2011). As I described in the introduction, such decolonizing historiographies work to recontextualize Boas's archive and its complex colonial legacies.

42 Cole, *Captured Heritage*.

43 Claude Lévi-Strauss, "Split Representation in the Art of Asia and America," in *Structural Anthropology*, trans. Claire Jacobson and Brooke Grundfest Schoepf (New York: Basic Books, 1963), 245–68.

44 This map circulated in a 1929 special issue of the Brussels-based *Variétés* magazine, titled *Le Surréalisme*.

45 Marie Mauzé, "A Kwakwaka'wakw Headdress in Andre Breton's Collection," in *The Colour of My Dreams: The Surrealist Revolution in Art*, ed. Dawn Ades (Vancouver, BC: Vancouver Art Gallery, 2011), 265–67.

46 Mauzé, "A Kwakwaka'wakw Headdress."

47 Colin Browne, "Scavengers of Paradise," in Ades, *The Colour of My Dreams*, 245.

48 Author's interview with Dempsey Bob, March 2013. See also Sarah Milroy, "The Eagle Down Dance," in *Tsimshian Treasures: The Remarkable Journey of the Dundas Collection*, ed. Donald Ellis (Vancouver, BC: Douglas & McIntyre, 2007), 22–36.

49 Dawn Ades, trans., "A Conversation with a Tsimshian," translation of "Interview with a Tsimshian," by Kurt Seligmann, published in *Minotaure* nos. 12/13 (1939), in Ades, *The Colour of My Dreams*, 222.

50 Cranmer Webster, "Colonization to Repatriation," 34.

51 Jean Barman, *The West beyond the West: A History of British Columbia*, 3rd ed., (Toronto, ON: University of Toronto Press, 2007), 199.

52 Barman, *The West*, 199.

53 John Sutton Lutz, *Makúk: A New History of Aboriginal-White Relations* (Vancouver, BC: UBC Press, 2008), 204.

54 This period was also when the Vancouver School of Theology was founded at the University of British Columbia.

55 Gerta Moray, *Unsettling Encounters: First Nations Imagery in the Art of Emily Carr* (Vancouver, BC: UBC Press, 2006).

56 Barman, *The West*, 260.

57 "An optimism which verged on recklessness," Margaret Ormsby, quoted in Barman, *The West*, 191.

58 Ronald W. Hawker, *Tales of Ghosts: First Nations Art in British Columbia, 1922–61* (Vancouver, BC: UBC Press, 2003), 66–81; see also Molly Mullin, *Culture in the Marketplace: Gender, Art, and Value in the American Southwest* (Durham, NC: Duke University Press, 2001).

59 Hawker, *Tales of Ghosts*.

60 Paige Raibmon, "'A New Understanding of Things Indian': George Raley's Negotiation of the Residential School Experience," *BC Studies* 110 (Summer 1996): 71.

61 Pamela Klassen, in Alicia Fahey and Chelsea Horton, "*The Iron Pulpit*": *Missionary Printing Presses in British Columbia*, catalogue for exhibition of the same name, 4 September–31 October 2012, UBC Rare Books and Special Collections.

62 UBC Special Collections, Raley fonds. *Na-Na-Kwa* issues from 1898–1900 are now digitally accessible on Early Canadiana Online, https://www.canadiana.ca/view/oocihm.8_04503.

63 Fahey and Horton, "*The Iron Pulpit*," 20.

64 Johannes Fabian, *Time and the Other: How Anthropology Makes Its Object* (New York: Columbia University Press, 1983).

65 Raibmon, "A New Understanding," 90.

66 See, for instance, George Raley, "Canadian Indian Art and Industries: An Economic Problem of Today," *Journal of the Royal Society of Arts* 83, no. 4320 (1935): 999–1001; George Raley, "Suggesting a New Industry Out of an Old Art: BC Indians Revive Their Dying Skill to Become Revenue-Producing Artisans?" *Vancouver Daily Province*, 9 May 1936.

67 Other churches in Canada, including the Anglicans, made similar resolutions, although the United Church is quite vocal in claiming this Aboriginal history as evidence of its distinct social justice orientation.

68 Hawker, *Tales of Ghosts*, 75–7.

69 Hawker, 75.

70 This moral vision arrived somewhat earlier in Native American art history's incorporation of Arts and Crafts moralities. Art historian Elizabeth Hutchinson has documented the traffic between Indigenous arts and crafts and American modernism through art education in both vocational curricula and non-Native art school, showing how the "Indian craze" constituted modernism as a transcultural phenomenon at the turn of the century. See Elizabeth Hutchinson, *The Indian Craze: Primitivism, Modernism, and Transculturation in American Art, 1890–1915* (Durham, NC: Duke University Press, 2009).

71 Sarah de Leeuw, "Artful Places: Creativity and Colonialism in British Columbia's Indian Residential Schools" (PhD diss., Queen's University, 2007).

72 Raibmon, "A New Understanding," 92.

73 Robert W. Winter, "The Arts and Crafts as a Social Movement," *Record of the Princeton University Art Museum* 34, no. 2 (1975): 34–40.

74 See Wilson Duff, *Arts of the Raven: Masterworks by the Northwest Coast Indian* (Vancouver, BC: Vancouver Art Gallery, 1967).

75 Winter, "The Arts and Crafts," 37.

76 "Letter to the DIA," 4 May 1934, Raley Papers, Provincial Archives of British Columbia.

77 Hawker, *Tales of Ghosts*, 76.

78 For example, see Scott Watson, "Art/Craft in the Early Twentieth Century," in Townsend-Gault, Kramer, and Ḵi-ḵe-in, *Native Art of the Northwest Coast*, 354.

79 Watson, "Art/Craft," 368

80 Raley, "Canadian Indian Art and Industries."

81 Solen Roth, *Incorporating Culture: How Indigenous People Are Reshaping the Northwest Coast Art Industry* (Vancouver, BC: UBC Press, 2019), 143.

82 Roth, *Incorporating Culture*, 143.

83 See also Jessica Metcalfe, "Native Designers of High Fashion: Expressing Identity, Creativity, and Tradition in Contemporary Customary Clothing Design" (PhD diss., University of Arizona, 2010).

84 George Raley, "Suggesting a New Industry."

85 Carole Blackburn, *Beyond Rights: The Nisga'a Final Agreement and the Challenges of the Modern Treaty Relationship* (Vancouver, BC: UBC Press, 2021).

86 For an anthropological account of the treaty-making process, and particularly on the meaning of self-government, see Blackburn, *Beyond Rights*.

87 See, for instance, Anthony Depalma, "Canada Pact Gives a Tribe Self-Rule for the First Time," *New York Times*, 5 August 1998, https://www.nytimes.com/1998/08/05/world/canada-pact-gives-a-tribe-self-rule-for-the-first-time.html. Depalma's reactive take also circulated in the *Kitsap Sun*, the major news source in Nisga'a territory.

88 On figurative repatriation, see Jennifer Kramer, "Figurative Repatriation: First Nations 'Artist-Warriors' Recover, Return, and Reclaim Cultural Property through Self-Definition," *Journal of Material Culture* 9, no. 2 (2004): 161–82.

89 See Phillips, *Museum Pieces*.

90 John Siebert correspondence, 1996, UCC Archive Division of Mission in Canada fonds.

91 Siebert correspondence, 1996.

92 Christopher Steiner, *African Art in Transit* (Cambridge: Cambridge University Press, 1994).

93 De Leeuw, "Artful Places."

94 See, for example, Smetzer, "Tlingit Dance Collars."

95 David Garneau, "Imaginary Spaces of Conciliation and Reconciliation," *West Coast Line #74* 46, no. 2 (2012): 29.

96 Consider, for instance, Cara Krmpotich, Heather Howard, and Emma Knight's parallel case of urban Indigenous women at First Story Toronto, a community organization, commenting on both the fineness and crudeness of women's souvenir beadwork collected (and returned) by Anglican missionaries. For these women, the "crude" objects suggested an authentic, pre-contact context of production, while the finely made objects offered a different yet equally significant source of cultural pride. This comparison is useful because it amplifies how much my students' taste is locally situated in historiographies of Northwest Coast art, their experience of history and generational loss, and perhaps also in the pedagogical context of training one's eye in a particular visual language. See Cara Krmpotich, Heather Howard, and Emma Knight, "From Collection to Community to Collection Again: Urban Indigenous Women, Material Culture, and Belonging," *Journal of Material Culture* 21, no. 3 (2016): 343–65.

2. Finding Repair: Contemporary Complicities and the Art of Collaboration

1 This chapter was first published in an earlier version as Eugenia Kisin, "Terms of Revision: Contemporary Anthropology and the Art of Collaboration," *Collaborative Anthropologies* 7, no. 2 (Spring 2015): 180–210.

2 Michael Wilson, "Planning a Homecoming for Indians' Remains," *New York Times*, 16 September 2002, https://www.nytimes.com/2002/09/16/nyregion/planning-a-homecoming-for-indians-remains.html.

3 For an account of Parnell's tree spirit references, see his blog entry http://haidatotempoles.blogspot.com/2010/.

4 Aaron Glass, "Objects of Exchange: Material Culture, Colonial Encounter, Indigenous Modernity," in *Objects of Exchange: Social and Material Transformation on the Late Nineteenth-Century Northwest Coast*, ed. Aaron Glass (New York: Bard Graduate Center, 2011), 11.

5 George E. Marcus, "Contemporary Fieldwork Aesthetics in Art and Anthropology: Experiments in Collaboration and Intervention," *Visual Anthropology* 23, no. 4 (2010): 263.

6 Marcus, "Contemporary Fieldwork Aesthetics," 268.

7 Marcus, 268.

8 Marcus, 268.

9 Aaron Glass, *Writing the Hamat'sa: Ethnography, Colonialism, and the Cannibal Dance* (Vancouver, BC: UBC Press, 2021), 23. Moreover, such intertextuality and its relations are an important motif in anthropological approaches to the contemporary more broadly. For example, see Tarek Elhaik, *The Incurable-Image: Curating Post-Mexican Film and Media Arts* (Edinburgh: University of Edinburgh Press, 2016).

10 Margaret Iverson, "Readymade, Found Object, Photograph," *Art Journal* 63, no. 2 (2014): 57.

11 Iverson, "Readymade," 57.

12 Orin Starn, "Here Come the Anthros (Again): The Strange Marriage of Anthropology and Native America," *Cultural Anthropology* 26, no. 2 (2011): 182.

13 Faye Ginsburg and Fred Myers, "A History of Aboriginal Futures," *Critique of Anthropology* 26, no. 1 (2006): 29.

14 Regna Darnell, *Invisible Genealogies: A History of Americanist Anthropology* (Lincoln: University of Nebraska Press, 2001); Luke Eric Lassiter, "Collaborative Ethnography and Public Anthropology," *Current Anthropology* 46, no. 1 (2005): 83–106; Martha Black, "Collaborations: A Historical Perspective," in *Native Art of the Northwest Coast: A History of Changing Ideas*, ed. Charlotte Townsend-Gault, Jennifer Kramer, and Ḳi-ḳe-in (Vancouver, BC: UBC Press, 2013).

15 Emma LaRocque, *When the Other Is Me: Native Resistance Discourse, 1850–1990* (Winnipeg: University of Manitoba Press, 2010), 6.

16 Audra Simpson, "Settlement's Secret," *Cultural Anthropology* 26, no. 2 (2011): 212.

17 *Testify* also travelled to different sites across the country. For a description of the Vancouver program, see https://www.cle.bc.ca/testify-a-project-of-the-indigenous-laws-the-arts-collective/.

18 Arnd Schneider and Christopher Wright, "Between Art and Anthropology," in *Between Art and Anthropology: Contemporary Ethnographic Practice*, ed. Arnd Schneider and Christopher Wright (Oxford: Berg, 2010), 5.

19 Haidy Geismar, "The Art of Anthropology: Questioning Contemporary Art in Ethnographic Display," in *Museum Theory: An Expanded Field*, ed. Andrea Whitcomb and Kylie Message (Malden, MA: Wiley-Blackwell, 2015), 183–210.

20 Grant H. Kester, *The One and the Many: Contemporary Collaborative Art in a Global Context* (Durham, NC: Duke University Press, 2011); Clair Bishop, *Artificial Hells: Participatory Art and the Politics of Spectatorship* (New York: Verso, 2012). On the archival impulse in contemporary art, see Hal Foster, *Bad New Days: Art, Criticism, Emergency* (New York: Verso, 2017), 31–60.

21 Linda Tuhiwai Smith, *Decolonizing Methodologies: Research and Indigenous Peoples* (London: Zed Books, 1999); Carolyn Fluehr-Lobban, "Collaborative Anthropology as Twenty-First-Century Ethical Anthropology," *Collaborative Anthropologies* 1 (2008): 175–82.

22 Grant H. Kester, *Conversation Pieces: Community and Communication in Modern Art* (Berkeley: University of California Press, 2013).

23 Beryl Graham and Sarah Cook, *Rethinking Curating: Art after New Media* (Cambridge, MA: MIT Press, 2010).

24 Aaron Glass and Corinne Hunt, "Collection, Colonialism, and Conversation: A Dialogue" (pamphlet produced in conjunction with an exhibition entitled *The Story Box: Franz Boaz, George Hunt, and the Making of Anthropology* at the Bard Graduate Center, New York, 14 February–7 July 2019), https://www.bgc.bard.edu/storage/uploads/BGC_BoasBrochure.pdf.

25 Charlotte Townsend-Gault, "Circulating Aboriginality," *Journal of Material Culture* 9, no. 2 (2004): 183–202; Jennifer Kramer, *Switchbacks: Art, Ownership, and Nuxalk National Identity* (Vancouver, BC: UBC Press, 2006).

26 Bruno Latour, *We Have Never Been Modern* (Cambridge, MA: Harvard University Press, 1993)

27 Lassiter, "Collaborative Ethnography," 89.

28 For example, see Anna Grimshaw, Elspeth Owen, and Amanda Ravetz, "Making Do: The Materials of Art and Anthropology," in Schneider and Wright, *Between Art and Anthropology*, 147–62.

29 Marcia Crosby, "Indian Art/Aboriginal title" (MA thesis, University of British Columbia, 1994).

30 Marilyn Strathern, "Introduction: New Accountabilities," in *Audit Cultures: Anthropological Studies in Accountability, Ethics, and the Academy*, ed. Marilyn Strathern (London: Routledge, 2000), 1–18.

31 Miriam Clavir, *Preserving What Is Valued: Museums, Conservation, and First Nations* (Vancouver, BC: UBC Press, 2002); Gwyneira Isaac, *Mediating Knowledges: Origins of a Zuni Tribal Museum* (Tucson: University of Arizona Press, 2007).

32 Wayne Modest, "Introduction: Ethnographic Museums and the Double Bind," in *Matters of Belonging: Ethnographic Museums in a Changing Europe*, ed. Wayne Modest, Nicholas Thomas, Doris Prlić, and Claudia Augustat (Leiden: Sidestone Press, 2019), 13.

33 Daniel Miller, *Material Culture and Mass Consumption* (Oxford: Basil Blackwell, 1987).

34 Catherine Bell and Robert K. Paterson, eds., *Protection of First Nations Cultural Heritage: Laws, Policy, and Reform* (Vancouver, BC: UBC Press, 2009).

35 The program description can be found in "As for Protocols 2020–2022," Vera List Center for Art and Politics, https://veralistcenter.org/focus-theme/as-for-protocols.

36 Rosemary J. Coombe, "The Work of Rights at the Limits of Governmentality," *Anthropologica* 49, no. 2 (2007): 285.

37 Gloria Cranmer Webster, "From Colonization to Repatriation," in *Indigena: Contemporary Native Perspectives in Canadian Art*, ed. Gerald McMaster and Lee-Ann Martin (Vancouver, BC: Douglas & McIntyre, 1991), 25–37; Ronald W. Hawker, *Tales of Ghosts: First Nations Art in British Columbia, 1922–61* (Vancouver, BC: UBC Press, 2003).

38 Faye Ginsburg, "Institutionalizing the Unruly: Charting a Future for Visual Anthropology," *Ethnos* 63, no. 2 (1998): 173–201.

39 Steven Feld, "Editor's Introduction," in *Ciné-Ethnography* (Jean Rouch), ed. and trans. Steven Feld (Minneapolis: University of Minnesota Press, 2003), 19.

40 Maureen Mahon, "The Visible Evidence of Cultural Producers," *Annual Review of Anthropology* 29 (2000): 483.

41 Eugenia Kisin and Fred R. Myers, "The Anthropology of Art, After the End of Art: Contesting the Art-Culture System," *Annual Review of Anthropology* 48 (2019): 317–34.

42 George E. Marcus and Fred R. Myers, "The Traffic in Art and Culture: An Introduction," in *The Traffic in Culture: Refiguring Art and Anthropology*, ed. George E. Marcus and Fred R. Myers (Berkeley: University of California Press, 1995), 6.

43 Schneider and Wright, "Between Art and Anthropology," 12.

44 Deborah Rose, in Lassiter, "Collaborative Ethnography," 100.

45 Crosby, "Indian Art/Aboriginal Title," 54.

46 Marcus and Myers, "The Traffic in Art and Culture," 25; see also Kisin and Myers, "The Anthropology of Art."

47 Bill McLennan and Karen Duffek, *The Transforming Image: Painted Arts of Northwest Coast First Nations* (Vancouver, BC: Museum of Anthropology, 2000).

48 Walter Benjamin, *The Arcades Project*, trans. Howard Eiland and Kevin McLaughlin (Cambridge, MA: Harvard University Press, 2002). See also Susan Buck-Morss, *The Dialectics of Seeing: Walter Benjamin and the Arcades Project* (Cambridge, MA: MIT Press, 1989).

49 Loretta Todd, "What More Do They Want?" in McMaster and Martin, *Indigena*, 72; Patrick Wolfe, "Settler Colonialism and the Elimination of the Native," *Journal of Genocide Research* 8, no. 4 (2006): 389.

50 See Smith, *Decolonizing Methodologies*, 28–40.

51 Charles R. Menzies and Caroline F. Butler, "Collaborative Service Learning and Anthropology with Gitxaała Nation," *Collaborative Anthropologies* 4 (2011): 186.

52 Menzies and Butler, "Collaborative Service Learning," 187.

53 Daniel Gross and Stuart Plattner, "Commentary: Anthropology as Social Work: Collaborative Models of Anthropological Research," *Anthropology News* 43, no. 8 (November 2002): 4.

54 Fluehr-Lobban, "Collaborative Anthropology."

55 See Arjun Appadurai, "Introduction: Commodities and the Politics of Value," in *The Social Life of Things: Commodities in Cultural Perspective*, ed. Arjun Appadurai (Cambridge: Cambridge

University Press, 1986), 3–63; Fred R. Myers, "Introduction," in *The Empire of Things: Regimes of Value and Material Culture*, ed. Fred R. Myers (Santa Fe, NM: SAR Press, 2001), 3–61.

56 Bishop, *Artificial Hells*, 2.

57 Nicolas Bourriaud, *Relational Aesthetics*, trans. Simon Pleasance and Fronza Woods (Dijon, FR: Presses du réel, 2002). See also Charles Green, *The Third Hand: Collaboration in Art from Conceptualism to Postmodernism* (Minneapolis: University of Minnesota Press, 2001).

58 Bishop, *Artificial Hells*, 6.

59 Dilip Parameshwar Gaonkar, ed., *Alternative Modernities* (Durham, NC: Duke University Press, 2001).

60 Nancy Marie Mithlo, *"Our Indian Princess": Subverting the Stereotype* (Santa Fe, NM: SAR Press, 2009.)

61 Schneider and Wright, *Between Art and Anthropology*, 11.

62 Paul Rabinow, *Designs for an Anthropology of the Contemporary* (Durham, NC: Duke University Press, 2008); Anna Tsing, "On Collaboration" in "A New Form of Collaboration in Cultural Anthropology: Matsutake Worlds," ed. Matsutake Worlds Research Group, *American Ethnologist* 36, no. 2 (2009): 380–4; Marcus, "Contemporary Fieldwork Aesthetics."

63 For an example of this approach involving collaboration between protein modelers, dancers, and "lively" protein, see Natasha Myers, *Rendering Life Molecular: Models, Modelers and Excitable Matter* (Durham, NC: Duke University Press, 2015).

64 Tsing, "On Collaboration," 381.

65 Kester, *The One and the Many*, 11.

66 Kester, 7.

67 Marcus, "Contemporary Fieldwork Aesthetics," 273.

68 Graham and Cook, *Rethinking Curating*.

69 Menzies and Butler, "Collaborative Service Learning," 170.

70 Paulette Regan, *Unsettling the Settler Within: Indian Residential Schools, Truth Telling, and Reconciliation in Canada* (Vancouver, BC: UBC Press, 2011), 22–3.

71 Kester, *The One and the Many*, 59.

72 Menzies and Butler, "Collaborative Service Learning," 17.

73 For example, see Hal Foster, "The Artist as Ethnographer?," in Marcus and Myers, *The Traffic in Culture*, 302–9.

74 Bishop, *Artificial Hells*, 7.

75 Indeed, recent ethnographic works have also grappled with what it means for anthropologists to reflexively adapt to curatorial practice. For a range of these perspectives, see Roger Sansi, ed., *The Anthropologist as Curator* (London: Bloomsbury Academic, 2020).

76 Faye Ginsburg, "Embedded Aesthetics: Creating a Discursive Space for Indigenous Media," *Cultural Anthropology* 9, no. 3 (1994): 365–82; Dylan Robinson, "Enchantment's Irreconcilable Connection: Listening to Anger, Being Idle No More," in *Performance Studies in Canada*, ed. Laura Levin and Marlis Schweitzer (Montreal and Kingston: McGill-Queen's University Press, 2017), 211–35.

77 Bishop, *Artificial Hells*, 7.

78 Darnell, *Invisible Genealogies*; Lassiter "Collaborative Ethnography."

79 Judith Berman, "'The Culture as It Appears to the Indian Himself': Boas, George Hunt, and the Methods of Ethnography," in *Volksgeist as Method and Ethic: Essays on Boasian Ethnography and the German Anthropological Tradition*, ed. George W. Stocking, Jr. (Madison: University of Wisconsin Press, 1996), 215–56.

80 Glass, "Objects of Exchange," 22.

81 Aaron Glass and Judith Berman, "Reassembling the Social Organization: Museum Collections, Indigenous Knowledge, and the Recuperation of the Franz Boas/George Hunt Archive" (paper delivered at the Royal Anthropological Institute, London, 1 June 2018).

82 Townsend-Gault, "Circulating Aboriginality," 230.

83 Suzanne Morrissette, "Stories of Place, Location, and Knowledge" (MFA thesis, OCAD University, Toronto, 2011), 13.

84 Luke J. Parnell, "The Convergence of Intangible and Material Wealth" (MAA thesis, Emily Carr University, Vancouver, 2012).

85 Parnell, "Convergence," 4.

86 Green, *The Third Hand*.

3. Across the *Beat Nation*

1 Dylan A.T. Miner, "Mawadisidiwag miinawaa wiidanokiindiwag/They Visit and Work Together," in *Makers, Crafters, Educators: Working for Social Change*, ed. Elizabeth Garber, Lisa Hochtritt, and Manisha Sharma (London: Routledge, 2018), 133.

2 Dylan Miner, *Creating Aztlán: Chicano Art, Indigenous Sovereignty, and Lowriding Across Turtle Island* (Tucson: University of Arizona Press, 2014), 3.

3 Jonathan Crary, *24/7: Capitalism and the Ends of Sleep* (New York: Verso, 2013).

4 Miner, "They Visit and Work Together," 133.

5 Lisa Myers, "Review of *Beat Nation: Art, Hip Hop and Aboriginal Culture*" (exhibition at the Vancouver Art Gallery, 25 February–3 June 2012), *C Magazine* 115 (2012): 58–9.

6 Here, my sense of their making is in dialogue with Dana Claxton's concept of the "made to be ready" articulated in her 2016 solo exhibition of the same name held at Simon Fraser University's Audain Gallery. See Dana Claxton, *Dana Claxton: Made to Be Ready*, curated by Amy Kazymerchyk (exhibition at the Audain Gallery, Vancouver, BC, 14 January–12 March 2016), https://www.sfu.ca/galleries/audain-gallery/past1/Dana-Claxton-Made-To-Be-Ready.html.

7 Kirsty Robertson, *Tear Gas Epiphanies: Protest, Culture, Museums* (Montreal and Kingston: McGill-Queen's University Press, 2019), 223–60; see also Aruna D'Souza, *Whitewalling: Art, Race and Protest in Three Acts* (New York: Badlands, 2018).

8 Eugenia Kisin, "Durable Remains: Indigenous Materialisms in Duane Linklater's *From Our Hands*," *ARTMargins Online* 7, no. 2 (2018). My notion of duration and the durability of empire is drawn from Anne Stoler's concept of "duress." See Ann Laura Stoler, *Duress: Imperial Durabilities in Our Times* (Durham, NC: Duke University Press, 2016).

9 Renya K. Ramirez, *Native Hubs: Culture, Community, and Belonging in Silicon Valley and Beyond* (Durham, NC: Duke University Press, 2007).

10 Bill Anthes, "Contemporary Native Artists and International Biennial Culture," *Visual Anthropology Review* 25, no. 2 (2009): 109–27.

11 Kathleen Ritter and Tania Willard, "Beat Nation: Art, Hip Hop, and Aboriginal Culture," in *Beat Nation: Art, Hip Hop, and Aboriginal culture*, ed. Kathleen Ritter and Tania Willard (Vancouver, BC: Vancouver Art Gallery and grunt gallery, 2012), 9–13.

12 For example, the landmark exhibition *Sakahàn: International Indigenous Art*, which first opened at the National Gallery of Canada in 2013, continued this momentum, expanding the categories and discursive framing of Indigenous contemporary art as global; it is often lauded as the exhibition that shifted the dialogue. However, this mediation between local and global was also arguably there in *Beat Nation*, albeit more focused around youth culture and hip hop.

13 On remixing, see Jarrett Martineau and Eric Ritskes, "Fugitive Indigeneity: Reclaiming the Terrain of Decolonial Struggle through Indigenous Art," *Decolonization, Education & Society* 3, no. 1 (2014): i–xii.

14 On these motifs in Reece's work, see Gizem Sözen's analysis for grunt gallery's *Activating the Archives* project, https://grunt.ca/wp-content/uploads/2013/12/Regalia-of-Skeena-Reece-written-by-Gizem-Sozen.pdf

15 Skeena Reece, "Purple Turtle Speaks and Breaks" (curatorial statement on *Beat Nation: Hip Hop as Indigenous Culture*, 2008), https://www.beatnation.org/curatorial-statements.html.

16 Ritter and Willard, "Beat Nation," 48.

17 "Heroines," here, refers to street photographer Lincoln Clarkes's disquieting portraits of heroin users living in Vancouver's Downtown Eastside, many of whom are Indigenous women. The portraits, which capture both agency and exploitation, have been collected in a controversial exhibition at the Museum of Vancouver and in books. See Lincoln Clarkes, *Heroines: The Photographs of Lincoln Clarkes* (Vancouver, BC: Anvil Press, 2002).

18 Mary Louise Pratt, "Arts of the Contact Zone," *Profession* (1991): 33–40; see also James Clifford, *Routes: Travel and Translation in the Late Twentieth Century* (Cambridge, MA: Harvard University Press, 1997), 192.

19 On this critical tendency, see Ruth B. Phillips, *Museum Pieces: Towards an Indigenization of Canadian Museums* (Montreal and Kingston: McGill-Queen's University Press, 2011), 17.

20 Haidy Geismar, "The Art of Anthropology: Questioning Contemporary Art in Ethnographic Display," in *Museum Theory: An Expanded Field*, ed. Andrea Whitcomb and Kylie Message (Malden, MA: Wiley-Blackwell, 2015).

21 Marcia Crosby, "Indian Art/Aboriginal Title" (MA thesis, University of British Columbia, 1994).

22 For an account of this work, see Verity Seward, Dennison Smith, and Lindsay Nixon, *Sonny Assu: A Radical Mixing* (London: Baldwin Gallery, 2019), http://www.thebaldwingallery.com/wp-content/uploads/2018/12/Sonny_Assu_Catalogue_Digital.pdf.

23 Kristin L. Dowell, *Sovereign Screens: Aboriginal Media on the Canadian West Coast* (Lincoln: University of Nebraska Press, 2013), 119.

24 Andrea Smith, *Conquest: Sexual Violence and American Indian Genocide* (Cambridge, MA: South End Press, 2005).

25 Marcia Crosby, "Lines, Lineage and Lies, or Borders, Boundaries and Bullshit," in *Nations in Urban Landscapes: Faye HeavyShield, Shelly Niro, Eric Robertson*, ed. Marcia Crosby (Vancouver, BC: Contemporary Art Gallery, 1997).

26 J. Kēhaulani Kauanui, *Hawaiian Blood: Colonialism and the Politics of Sovereignty and Indigeneity* (Durham, NC: Duke University Press, 2008).

27 The *Beat Nation* site can be accessed at www.beatnation.org.

28 Reece, "Purple Turtle Speaks."

29 Leah Sandals, "Q&A: Tania Willard on Life beyond *Beat Nation*," *Canadian Art*, 28 June 2013, https://canadianart.ca/interviews/tania-willard-beat-nation/.

30 grunt gallery mandate, 2012, https://web.archive.org/web/20121117111242/https://grunt.ca/about/.

31 In Canadian orthography, "center" is rendered as "centre," and I use this spelling here to index the particular history of this alternative approach to arts programming in Canada.

32 An edited volume published by Toronto-based art press YYZ Books in 2007 was titled *decentre: Concerning Artist-Run Culture* (see Elaine Chang et al., *decentre*).

33 Dowell, *Sovereign Screens*, 12.

34 Dana Claxton and Tania Willard, "NDN AXE/IONS: A Collaborative Essay," in *INDIANacts: Aboriginal Performance Art*, curated by Tania Willard and Dana Claxton, https://indianacts.gruntarchives.org/essay-ndn-axe-ions-claxton-and-willard.html.

35 Ann Cvetkovich, *An Archive of Feelings: Trauma, Sexuality, and Lesbian Public Cultures* (Durham, NC: Duke University Press, 2003).

36 Elaine Chang et al., eds., *decentre: Concerning Artist-Run Culture* (Toronto: YYZ Books, 2007), 16.

37 Dowell, *Sovereign Screens*, 51.

38 Dowell, 74.

39 Sandals, "Q&A."

40 On these mediated qualities, see Gwyneira Isaac, *Mediating Knowledges: Origins of a Zuni Tribal Museum*. (Tucson: University of Arizona Press, 2007).

41 Duncan Low, "Content Analysis and Press Coverage: Vancouver's Cultural Olympiad," *Canadian Journal of Communication* 37, no. 3 (2012): 511.

42 Natalie Baloy, "Spectacle in Circulation: Linking the Everyday and the Spectacular through Ethnography," *Anthropology News* 52, no. 2 (2011): 14.

43 Alexis Stoymenoff, "Ruling Expected Friday in Occupy Vancouver Injunction Hearings," *Vancouver Observer*, 17 November 2011, https://www.vancouverobserver.com/politics/news/2011/11/17/ruling-expected-friday-occupy-vancouver-injunction-hearings.

44 Rod Mickleburgh, "City Wins Injunction against Occupy Vancouver," *The Globe and Mail*, 18 November 2011, https://www.theglobeandmail.com/news/british-columbia/city-wins-injunction-against-occupy-vancouver/article4183905/.

45 The sense of possibility in this moment was also palpable but harder to capture. One tangible effect was that Occupy succeeded in galvanizing many more people about the environmental issues facing British Columbia in the wake of increased resource extraction; this effect was apparent in both the mainstream media response and in the organizing that emerged as branches of Occupy, including a major anti-pipeline movement, swept the city.

46 Terry Smith, *What Is Contemporary Art?* (Chicago: University of Chicago Press, 2008), 95.

47 On this dynamic, see Faye Ginsburg and Fred Myers, "A History of Aboriginal Futures," *Critique of Anthropology* 26, no. 1 (2006): 27–45.

48 Crosby, "Indian Art/Aboriginal Title."

49 Nicholas Thomas, *Possessions: Indigenous Art/Colonial Culture* (London: Thames and Hudson, 1999).

50 For a discussion of this dynamic, see Fred R. Myers, *Painting Culture: The Making of an Aboriginal High Art* (Durham, NC: Duke University Press, 2002), 277.

51 Skeena Reece's curatorial statement may be accessed on the original *Beat Nation* project site at https://www.beatnation.org/curatorial-statements.html.

52 Dale Turner, *This Is Not a Peace Pipe: Towards a Critical Indigenous Philosophy* (Toronto, ON: University of Toronto Press, 2006), 113.

53 George E. Marcus and Fred R. Myers, "The Traffic in Art and Culture: An Introduction," in *The Traffic in Culture: Refiguring Art and Anthropology*, ed. George E. Marcus and Fred R. Myers (Berkeley: University of California Press, 1995); Hal Foster, "The 'Primitive' Unconscious of Modern Art," *October* 34 (Autumn 1985): 45–70.

54 Shelly Errington, "Globalizing Art History," in *Is Art History Global?* ed. James Elkins (New York: Routledge, 2007), 430.

55 Myers, "Review of Beat Nation."

56 Johanna Drucker, *Sweet Dreams: Contemporary Art and Complicity* (Chicago: University of Chicago Press, 2005), xvi.

57 Drucker, *Sweet Dreams*, xvi.

58 Johannes Fabian, *Time and the Other: How Anthropology Makes Its Object* (New York: Columbia University Press, 1983).

59 Christian Allaire, "Beat Nation: How Has Hip Hop Affected Aboriginal Culture?" *Toronto Standard*, 3 April 2013, https://www.torontostandard.com/culture/beat-nation-how -has-hip-hop-affected-aboriginal-culture/.

60 Gloria Galloway, "Attawapiskat Audit Raises Questions about Millions in Spending," *The Globe and Mail*, 7 January 2013, https://www.theglobeandmail.com/news/politics /attawapiskat-audit-raises-questions-about-millions-in-spending/article6995751/.

61 Allaire, "Beat Nation."

62 The original blog post, "Dealing with Comments about Attawapiskat," may be found at https:// apihtawikosisan.com/2011/11/dealing-with-comments-about-attawapiskat/. In it, the author emphasizes the value of responding to painful settler misconceptions with information. See also Chelsea Vowel, *Indigenous Writes: A Guide to First Nations, Métis, and Inuit Issues in Canada* (Winnipeg, MB: Highwater Press, 2016).

63 Shiri Pasternak, "The Fiscal Body of Sovereignty: To 'Make Live' in Indian Country," *Settler Colonial Studies* 16, no. 6 (2016): 317–38.

64 A timeline of the movement may be found at www.idlenomore.ca.

65 Chief Steve Courtoreille, quoted in Leslie MacKinnon, "Native Bands Challenge Omnibus Budget Bill in Court," *CBC News*, 7 January 2013, https://www.cbc.ca/news/politics/native -bands-challenge-omnibus-budget-bill-in-court-1.1371476.

66 Matthew Ryan Smith, "Aboriginal Artists Engage with Urban Youth Culture in the Urgent and Timely 'Beat Nation,'" *Blouin Art Info*, 20 December 2012.

67 Jennifer A. González, *Subject to Display: Reframing Race in Contemporary Installation Art* (Cambridge, MA: MIT Press, 2008), 38.

68 Homi K. Bhabha, *The Location of Culture* (London: Routledge, 1994); Nicholas Thomas, "Cold Fusion," *American Anthropologist* 98, no. 1 (1996): 9–16.

69 Charlotte Townsend-Gault, "Struggles with Aboriginality/Modernity," in *Bill Reid and Beyond: Expanding on Modern Native Art*, ed. Karen Duffek and Charlotte Townsend-Gault (Vancouver, BC: Douglas & McIntyre, 2004), 242; see also Marcus and Myers, "The Traffic in Culture."

70 A video of this interview is available online at www.beatnation.org/music.html.

71 The complex tensions between politicizing or conscious hip hop and the perpetuation of racialized and gendered forms of objectification have also been robustly interrogated in relation to African American cultural production. See, for instance, Byron Hurt's 2006 documentary film, *Hip-Hop: Beyond Beats and Rhymes*.

72 T. Christopher Aplin, "Expectation, Christianity, Ownership in Indigenous Hip-Hop: Religion in Rhyme with Emcee One, RedCloud, and Quese, Imc," *MUSICultures* 39, no. 1 (2012): 42–69.

73 Karyn Recollet, "Aural Traditions: Indigenous Youth and the Hip-Hop Movement in Canada" (PhD diss., Trent University, 2013).

74 Gloria Anzaldúa, *Borderlands/La Frontera: The New Mestiza*, 3rd ed. (San Francisco: Aunt Lute Books, 1987), 19.

4. Cultural Resources and the Art/Work of Repair at the Freda Diesing School

1 Gloria Galloway, "Atleo Leads Native Trade Mission to China," *The Globe and Mail*, 21 October 2011, https://www.theglobeandmail.com/news/politics/ottawa-notebook/atleo-leads -native-trade-mission-to-china/article618949/.

2 Eric Morris, quoted in "First Nations Trade Mission to China a Multicultural Celebration," *ICT* (*Indian Country Today*), 13 September 2018, https://ictnews.org/archive/first-nations -trade-mission-to-china-a-multicultural-celebration.

3 Qiaoyun Zhang, "Disaster Response and Recovery: Aid and Social Change," *Annals of Anthropological Practice* 40, no. 1 (2016): 86–97.

4 Stan Bevan, personal communication to author, 2 April 2013.

5 Eugenia Kisin, "Unsettling the Contemporary: Critical Indigeneity and Resources in Art," *Settler Colonial Studies* 3, no. 2 (2013): 141–56.

6 Jennifer Biddle, *Remote Avant-Garde: Aboriginal Art under Occupation* (Durham, NC: Duke University Press, 2016)

7 For an overview of these neoliberal heritage regimes and their impact on Indigenous communities, see Rosemary J. Coombe and Eugenia Kisin, "Archives and Cultural Legibility: Objects and Subjects of Neoliberal Heritage Technologies," in *Objectification and Standardization: On the Limits and Effects of Ritually Fixing and Measuring Life*, ed. Tord Larsen et al. (Durham, NC: Carolina Academic Press, 2021).

8 Miwon Kwon, "One Place after Another: Notes on Site Specificity," *October* 80 (1997): 85–100.

9 James Clifford, *Returns: Becoming Indigenous in the Twenty-First Century* (Cambridge, MA: Harvard University Press, 2013), 51.

10 Stuart Hall, "Notes on Deconstructing 'the Popular,'" in *People's History and Socialist Theory*, ed. Raphael Samuel (London: Routledge and Kegan Paul, 1981).

11 Manuela Carneiro da Cunha, *"Culture" and Culture: Traditional Knowledge and Intellectual Rights* (Chicago: Prickly Paradigm Press, 2009).

12 Glen Coulthard, *Red Skin, White Masks: Rejecting the Colonial Politics of Recognition* (Minneapolis: University of Minnesota Press, 2014).

13 Bill Anthes, "Contemporary Native Artists and International Biennial Culture," *Visual Anthropology Review* 25, no. 2 (2009): 109–27.

14 Kate Crehan, *Community Art: An Anthropological Perspective* (Oxford: Berg, 2011).

15 On creativity as a value in these contemporary projects, see Lily Chumley, *Creativity Class: Art School and Culture Work in Postsocialist China* (Princeton, NJ: Princeton University Press, 2016).

16 Carole Blackburn, "Searching for Guarantees in the Midst of Uncertainty: Negotiating Aboriginal Rights and Title in British Columbia," *American Anthropologist* 107, no. 4 (2005): 588. See also Bruce Braun, *The Intemperate Rainforest: Nature, Culture, and Power on Canada's West Coast* (Minneapolis: University of Minnesota Press, 2002).

17 NWCC has nine different locations across the Northwest, both on the mainland and on Haida Gwaii. Many of these campuses explicitly serve Aboriginal communities, providing a mix of liberal arts education and hands-on vocational training towards careers in industry and resource markets in the North.

18 Suzanne E. Mills and Tyler McCreary, "Negotiating Neoliberal Empowerment: Aboriginal People, Educational Restructuring, and Academic Labour in the North of British Columbia, Canada," *Antipode* 45, no. 5 (2013): 1298–1317.

19 Karen Duffek, ed., *Robert Davidson: The Abstract Edge* (Vancouver, BC: Museum of Anthropology, 2004).

20 Annette Weiner, *Inalienable Possessions: The Paradox of Keeping-While-Giving* (Berkeley: University of California Press, 1992); Charlotte Townsend-Gault, "Circulating Aboriginality," *Journal of Material Culture* 9, no. 2 (2004): 183–202.

21 Ian Thom, *Challenging Traditions: Contemporary First Nations Art of the Northwest Coast* (Seattle: University of Washington Press, 2009).

22 Leslie Dawn, *National Visions, National Blindness: Canadian Art and Identities in the 1920s* (Vancouver, BC: UBC Press, 2006), 149.

23 Dawn, *National Visions*, 234.

24 Ronald W. Hawker, *Tales of Ghosts: First Nations Art in British Columbia, 1922–61* (Vancouver, BC: UBC Press, 2003), 160.

25 Wilson Duff, quoted in Hawker, *Tales of Ghosts*, 161.

26 Public versions of this story are told in Charles F. Newcombe, "Notes on the Haida," (manuscript in the Charles Newcombe Notes Collection, British Columbia Archives, Victoria, BC, 1902); and in George F. MacDonald, *Haida Monumental Art* (Vancouver, BC: UBC Press, 1983).

27 Marcia Crosby, "Indian Art/Aboriginal Title" (MA thesis, University of British Columbia, 2004).

28 Michel-Rolph Trouillot, "Anthropology and the Savage Slot: The Poetics and Politics of Otherness," in *Recapturing Anthropology*, ed. Richard Gabriel Fox (Santa Fe, NM: SAR Press, 1991).

29 Mary Anne Barbara Slade, *Skil Kew Wat: On the Trail of Property Woman* (PhD diss., University of British Columbia, 2002).

30 Jeff Bear and Marianne Jones, dirs., *On the Trail of Property Woman*, Ravens and Eagles, Series 2 (Vancouver, BC: Moving Images Distribution, 2003), 24 mins.

31 Karen Duffek, "Value Added: The Northwest Coast Art Market since 1965," in *Native Art of the Northwest Coast: A History of Changing Ideas*, ed. Charlotte Townsend-Gault, Jennifer Kramer, and Ḳi-ḳe-in (Vancouver, BC: UBC press, 2013).

32 Slade, *Skil Kew Wat*, 30.

33 Slade, 275.

34 Crosby, "Indian Art/Aboriginal Title," 30.

35 Slade, *Skil Kew Wat*, 401. See also Audrey Hawthorn, *People of the Potlatch* (Vancouver: British Columbia Art Gallery, 1956).

36 This history may be found on the 'Ksan website, which continues to operate at https://ksan .org/.

37 Bill Holm, *Northwest Coast Indian Art: An Analysis of Form* (Seattle: University of Washington Press, 1965).

38 Although Diesing never officially taught at 'Ksan, she worked as an artist-in-residence there during the 1970s, which is where she met Dempsey Bob.

39 Peter L. Macnair, *The Legacy: Tradition and Innovation in Northwest Coast Indian Art* (Victoria: Royal British Columbia Museum, 1984).

40 Judith Ostrowitz, *Interventions: Native American Art for Far-Flung Territories* (Seattle: University of Washington Press, 2009), 118.

41 Slade, *Skil Kew Wat*, 286.

42 Slade, 294. Again, that she never taught at 'Ksan is a fact that Diesing clearly wants to get straight in the record of her life. Unfortunately, Bear and Jones's 2003 film about Diesing, *On the Trail of Property Woman*, continued the misconception, showing the importance of recorded life stories in revising the tales that surround living artists.

43 Slade, *Skil Kew Wat*, 278.

44 Slade, 294.

45 Bill McLennan and Karen Duffek, *The Transforming Image: Painted Arts of Northwest Coast First Nations* (Vancouver, BC: Museum of Anthropology, 2000).

46 Anna Lowenhaupt Tsing, *Friction: An Ethnography of Global Connection* (Princeton, NJ: Princeton University Press, 2005).

47 Mills and McCreary, "Negotiating Neoliberal Empowerment," 1299.

48 Mills and McCreary, 1301.

49 Carole Blackburn, "Differentiating Indigenous Citizenship: Seeking Multiplicity in Rights, Identity, and Sovereignty in Canada," *American Ethnologist* 36, no. 1 (2009): 66–78.

50 Crehan, *Community Art*, 137.

51 Paul Willis, *Learning to Labour: How Working-Class Kids Get Working-Class Jobs* (New York: Columbia University Press, 1977).

52 Willis, *Learning to Labour*, 119.

53 Clifford, *Returns*.

54 James Clifford, "Varieties of Indigenous Experience: Diasporas, Homelands, Sovereignties," in *Indigenous Experience Today*, ed. Marisol de la Cadena and Orin Starn (Oxford: Berg, 2007), 197–223.

55 Jennifer Kramer, *Switchbacks: Art, Ownership, and Nuxalk National Identity* (Vancouver, BC: UBC Press, 2006).

56 Dempsey Bob, personal communication to author, 17 April 2013.

57 Jean Lave and Etienne Wenger, *Situated Learning: Legitimate Peripheral Participation* (Cambridge: Cambridge University Press, 1991).

58 Willis, *Learning to Labour*, 119.

59 Dempsey Bob, personal communication to author, 17 April 2013.

60 Marianne Nicolson, quoted in Thom, *Challenging Traditions*, 208.

61 Renato Rosaldo, "Cultural Citizenship and Educational Democracy," *Cultural Anthropology* 9, no. 3 (1994): 402–11.

62 The Inuit Gallery is a gallery where Gary Wyatt, the dealer at Spirit Wrestler in Vancouver who has been so supportive of Freda Diesing students, used to work.

63 See the website for the Margaret A. Cargill Foundation (now Philanthropies), https://www.macphilanthropies.org/domains/arts-cultures/.

64 Sally Engle Merry, "Measuring the World: Indicators, Human Rights, and Global Governance," *Current Anthropology* 52, no. S3 (2011): S83–S95; Lawrence Busch, *Standards: Recipes for Reality* (Cambridge, MA: MIT Press, 2001).

5. Copper and the Conduit of Shame: Beau Dick's Performance/Art

1 For a discussion of Dick and Guujaaw's action in relation to oil sponsorship in museums, see Kirsty Robertson, *Tear Gas Epiphanies: Protest, Culture, Museums* (Montreal and Kingston: McGill-Queen's University Press, 2019), 213–18.

2 Beau Dick, "The Coppers," in *Lalakenis/All Directions: A Journey of Truth and Unity*, ed. Scott Watson and Lorna Brown (Vancouver, BC: Morris and Helen Belkin Art Gallery, 2014), 23.

3 Dick, "The Coppers," 23.

4 Judith Lavoie, "First Nations Chief to Perform Rare Shaming Rite on Legislature Lawn," *Times Colonist*, 9 February 2013, https://www.timescolonist.com/local-news/first-nations-chief-to-perform-rare-shaming-rite-on-legislature-lawn-4578414.

5 Candice Hopkins, "In Memoriam: Beau Dick (1955–2017)," *documenta 14*, 4 April 2017, https://www.documenta14.de/en/notes-and-works/17052/in-memoriam-beau-dick-1955-2017.

6 Arjun Appadurai, "Introduction: Commodities and the Politics of Value," in *The Social Life of Things: Commodities in Cultural Perspective*, ed. Arjun Appadurai (Cambridge: Cambridge University Press, 1986).

7 LaTiesha Fazakas, dir., *Maker of Monsters: The Extraordinary Life of Beau Dick*, Athene Films, 2017.

8 Dylan Robinson, "Enchantment's Irreconcilable Connection: Listening to Anger, Being Idle No More," in *Performance Studies in Canada*, ed. Laura Levin and Marlis Schweitzer (Montreal and Kingston: McGill-Queen's University Press, 2017), 212.

9 Georges Bataille, *The Accursed Share: An Essay on General Economy*, vol. 1, trans. Robert Hurley (New York: Zone Books, 1988).

10 I am indebted here and in conversation with Charlotte Townsend-Gault's recent work on the performative dimensions of concealment and revelation in Dick's action. See Charlotte Townsend-Gault, "Failed Social Relations and the Volatility of Cultural Techniques in British Columbia" (lecture at the Bard Graduate Center, New York, 17 April 2019).

11 Townsend-Gault, "Failed Social Relations." Townsend-Gault is drawing on an understanding of "cultural techniques" delineated by media theorist Bernhard Siegert. See Bernhard Siegert, *Cultural Techniques: Grids, Filters, Doors, and Other Articulations of the Real*, trans. Geoffrey Winthrop-Young (New York: Fordham University Press, 2015).

12 Jessica L. Horton, *Art for an Undivided Earth: The American Indian Movement Generation* (Durham, NC: Duke University Press, 2017), 11.

13 Robinson, "Enchantment's Irreconcilable Connection," 218.

14 On the formation of this victimizing position in relation to human rights discourses, see Dian Million, *Therapeutic Nations: Healing in an Age of Indigenous Human Rights* (Tucson: University of Arizona Press, 2013).

15 On how toxicity fits into this narrative of trauma, see Michelle Murphy, "Alterlife and Decolonial Chemical Relations," *Cultural Anthropology* 32, no. 4 (2017): 494–503.

16 Hopkins, "In Memoriam: Beau Dick."

17 Beau Dick, "The Beginning of the Journey," in Watson and Brown, *Lalakenis/All Directions*, 19.

18 Charlotte Townsend-Gault, "Lalakenis: Mode and Situation," in Watson and Brown, *Lalakenis/All Directions*, 76.

19 Townsend-Gault, "Lalakenis," 80.

20 Cathy Busby, personal communication to author, 19 February 2023. I am deeply grateful to Busby for clarifying the site-specific aspects of the work in both countries.

21 For an analysis of Idle No More's Indigenous digital and cultural protocols, see Vincent Raynauld, Emmanuelle Richez, and Katie Boudreau Morris, "Canada Is #IdleNoMore: Exploring Dynamics of Indigenous Political and Civic Protest in the Twitterverse," *Information, Communication & Society* 21, no. 4 (2018): 626–42.

22 Jane Bennett, *Vibrant Matter: A Political Ecology of Things* (Durham, NC: Duke University Press, 2010).

23 Marilyn Strathern, *The Gender of the Gift: Problems with Women and Problems with Society in Melanesia* (Berkeley: University of California Press, 1988). For a discussion of Strathern's theory of personification through exchange and its influence on studies of materiality, see Roger Sansi, *Art, Anthropology, and the Gift* (London: Routledge, 2014).

24 See Karen Barad, *Meeting the Universe Halfway: Quantum Physics and the Entanglement of Matter and Meaning* (Durham, NC: Duke University Press, 2007); Fred Moten, *In the Break: The Aesthetics of the Black Radical Tradition* (Minneapolis, University of Minnesota Press, 2003); Bennett, *Vibrant Matter*; Elizabeth Chin, *My Life With Things: The Consumer Diaries* (Durham, NC: Duke University Press, 2015).

25 See, for example, Amiria Henare, Martin Holbraad, and Sari Wastell, "Introduction: Thinking Through Things," in *Thinking Through Things: Theorising Artefacts Ethnographically*, ed. Amiria Henare, Martin Holbraad, Sari Wastell (London: Routledge, 2007), 1–31.

26 Robinson, "Enchantment's Irreconcilable Connection," 231.

27 Nicholas Thomas, *Entangled Objects: Exchange, Material Culture, and Colonialism in the Pacific* (Cambridge, MA: Harvard University Press, 1991).

28 Building on Zoe Todd's understandings of accountability in Indigenous governance – how to work with the site-specificity of theory – Dick's performance also has implications for an ethics of care. See Zoe Todd, "Relationships," Theorizing the Contemporary, *Fieldsights*, 21 January 2016, https://culanth.org/fieldsights/relationships.

29 Christopher Bracken, *The Potlatch Papers: A Colonial Case History* (Chicago: University of Chicago Press, 1998).

30 Elizabeth Povinelli, *The Cunning of Recognition: Indigenous Alterities and the Making of Australian Multiculturalism* (Durham, NC: Duke University Press, 2002).

31 Uses of copper from Indigenous sources of the metal precede contact; when European sheet copper became readily available on the Northwest Coast, First Nations people extended these uses of copper in forming these items of renown.

32 Sergei Kan, *Symbolic Immortality: The Tlingit Potlatch of the Nineteenth Century*, 2nd ed. (Seattle: University of Washington Press, 2016).

33 Dick, "The Coppers," 23.

34 Marcel Mauss, *The Gift: The Form and Reason for Exchange in Archaic Societies* (1925; repr. New York: W.W. Norton, 1990), 46. Drawing on accounts of the Kwakwaka'wakw potlatch from the late nineteenth century, Marcel Mauss described coppers as "the money of renown" or powerful objects that may be inalienable and are held within families in order to attract wealth, pointing out that "titles, talismans, coppers, and the spirits of chiefs are homonyms and synonyms." While it is beyond the scope of this chapter to provide a comprehensive account of coppers, these objects have animated a great deal of anthropological discussion around value. In addition to Mauss's work, see also Maurice Godelier, *The Enigma of the Gift* (Chicago: University of Chicago Press, 1999).

35 Katherine Damon, "Copper Ontology: Being, Beings, and Belongings" (MA thesis, University of British Columbia, 2016), 3.

36 Jordan Wilson, "'Belongings' in 'C̓əsnaʔəm: The City before the City,'" *Intellectual Property in Cultural Heritage* (*IPinCH*; blog), 27 January 2016, https://www.sfu.ca/ipinch/outputs/blog/citybeforecitybelongings/.

37 Damon, "Copper Ontology," 4.

38 Anna Lowenhaupt Tsing, *Friction: An Ethnography of Global Connection* (Princeton, NJ: Princeton University Press, 2005).

39 See also Eva Mackey, *Unsettled Expectations: Uncertainty, Land, and Settler Decolonization* (Halifax, NS: Fernwood Publishing, 2017).

40 Damon, "Copper Ontology."

41 Anne Spice, "Fighting Invasive Infrastructures: Indigenous Relations against Pipelines," *Environment and Society* 9, no. 1 (2018): 40–56.

42 Zoe Todd, "Fish Pluralities: Human-Animal Relations and Sites of Engagement in Paulatuuq, Arctic Canada," *Études Inuit Studies* 38, nos. 1–2 (2014): 217–38.

43 Nicola Levell, *Michael Nicoll Yahgulanaas: The Seriousness of Play* (London: Black Dog Publishing, 2016), 109.

44 Levell, *Michael Nicoll Yahgulanaas*, 97.

45 See Michael Nicoll Yahgulanaas's gallery at https://mny.ca/en/work/218/Flappe%25202013-06-10/.

46 Andrea K. Scott, "Beau Dick," *The New Yorker*, 8 April 2019, https://www.newyorker.com/goings-on-about-town/art/beau-dick.

47 Fazakas, *Maker of Monsters*.

48 Roy Arden, *Supernatural: Neil Campbell, Beau Dick* (Vancouver, BC: Contemporary Art Gallery, 2004), 18.

49 LaTiesha Fazakas, *Beau Dick: Devoured by Consumerism* (Vancouver, BC: Figure 1, 2019).

50 I am grateful to Russell Gordon for filling in the missing pieces of this story.

51 Webb Keane, "On Semiotic Ideology," *Signs and Society* 6, no. 1 (2018): 64–87.

52 Cathy Busby, *We Are Sorry*, https://www.cathybusby.ca/galleries/wearesorry_winnipeg/images/we-are-sorry_panels.pdf. Earlier versions of this work were done in Winnipeg, Manitoba,

version (2010) and Melbourne, Australia (2009–13). This latter work was part of the Laneway Commissions, an annual festival of national and international artists commissioned to make art for the event. It was displayed for five years.

53 Cathy Busby, quoted in the pamphlet accompanying *WE ARE SORRY 2013*, https://www .cathybusby.ca/galleries/wearesorry_2013/images/CB_WeAreSorry2013_booklet.pdf.

54 Cathy Busby, "Journeys," in *Weaving Histories*, ed. Sydney Hart and Clay Little (Vancouver: Presentation House, 2015), 48–57.

55 Marilyn Ivy, "Benedict's Shame: Translating the Chrysanthemum and the Sword," *Cabinet* 31 (Fall 2008), https://www.cabinetmagazine.org/issues/31/ivy.php.

56 Ivy, "Benedict's Shame."

57 Million, *Therapeutic Nations*.

58 Million, 102.

59 Ronald Niezen, *Truth and Indignation: Canada's Truth and Reconciliation Commission on Indian Residential Schools* (Toronto, ON: University of Toronto Press, 2013).

60 Gloria Galloway, "After Six Years in Office, Harper to Meet with First-Nations Leaders," *The Globe and Mail*, 1 December 2011, https://www.theglobeandmail.com/news/politics/after -six-years-in-office-harper-to-meet-with-first-nations-leaders/article4180229/.

61 David Garneau, "Imaginary Spaces of Conciliation and Reconciliation," *West Coast Line* #74 46, no. 2 (2012): 28–38.

62 Dick, "The Coppers," 23.

63 Wanda Nanibush, "The Coppers Calling: *Awalaskenis II*: Journey of Truth and Unity," in Watson and Brown, *Lalakenis*, 67–71.

6. Transitional Properties of Art and Repair

1 Ian Austin, "Vancouver Sits on Unceded First Nations Land, Council Acknowledges," *The Province*, 27 June 2014, https://theprovince.com/news/metro%20vancouver /vancouver-sits-on-unceded-first-nations-land-council-acknowledges.

2 Scott Watson, Keith Wallace, and Jana Tyner, eds., *Witnesses: Art and Canada's Indian Residential Schools* (Vancouver, BC: Belkin Gallery, 2014), 54.

3 For a critique of settler sympathy and catharsis in witnessing wounding performance, see Jill Carter, "Discarding Sympathy, Disrupting Catharsis: The Mortification of Indigenous Flesh as Survivance-Intervention," *Theatre Journal* 67, no. 3 (2015): 413–32.

4 Watson, Wallace, and Tyner, *Witnesses*, 45.

5 "Terabytes of Testimony: Digital Database of Residential School Stories Opens to the Public," CBC Radio, 30 October 2016, https://www.cbc.ca/radio/unreserved/opportunities-for -reconciliation-pop-up-in-unexpected-places-1.3294030/terabytes-of-testimony-digital-database -of-residential-school-stories-opens-to-the-public-1.3296657.

6 Andrea Walsh, personal communication to author, 28 January 2015.

7 Andrea Walsh, personal communication to author, 28 January 2015.

8 Fred R. Myers, *Painting Culture: The Making of an Aboriginal High Art* (Durham, NC: Duke University Press, 2002), 336.

9 Dylan Robinson, "Enchantment`s Irreconcilable Connection: Listening to Anger, Being Idle No More," in *Performance Studies in Canada*, ed. Laura Levin and Marlis Schweitzer (Montreal and Kingston: McGill-Queen's University Press, 2017), 212; Dylan Robinson and Keavy Martin, eds., *Arts of Engagement: Taking Aesthetic Action In and Beyond the Truth and Reconciliation Commission* (Waterloo, ON: Wilfred Laurier University Press, 2016).

10 Costas Douzinas and Lynda Nead, eds., *Law and the Image: The Authority of Art and the Aesthetics of Law* (Chicago: University of Chicago Press, 1999).

11 I thank Lisa Jackson for drawing my attention to these conversations and precise framing as a burden, borne unequally.

12 The University of Manitoba's NCTR bid may be accessed at https://ehprnh2mwo3.exactdn .com/wp-content/uploads/2021/01/NRC-for-partners.pdf.

13 See Mia Rabson, "Release All Papers on Residential Schools: Judge," *The Brandon Sun*, 31 January 2013, https://www.brandonsun.com/breaking-news/release-all-papers-on-residential -schools-judge-189157531.html.

14 Krista MacCracken and Skylee-Storm Hogan, "Laughter Filled the Space: Challenging Euro-Centric Archival Spaces," *The International Journal of Information, Diversity, and Inclusion* 5, no. 1 (2021): 97–110.

15 "Truth and Reconciliation," Association of Canadian Archivists/Association canadienne des archivistes (website), https://archivists.ca/Truth-and-Reconciliation.

16 Truth and Reconciliation Commission of Canada, "Open Call for Artistic Submissions," 2010, https://www.artstno.com/sites/nwtarts/files/TRC_Art_Submissions_en_p6.pdf.

17 Truth and Reconciliation Commission of Canada, "Open Call."

18 Ronald Niezen, *Truth and Indignation: Canada's Truth and Reconciliation Commission on Indian Residential Schools* (Toronto, ON: University of Toronto Press, 2013), 38. Moreover, Niezen points out that, unlike other truth commissions in Latin America and South Africa, the Canadian TRC officially does not identify and denounce perpetrators. This difference is further evidence that the justice of the Canadian TRC lies elsewhere, as a *cultural* justice, and is intended to exert a moral influence on people rather than place blame.

19 Paulette Regan, *Unsettling the Settler Within: Indian Residential Schools, Truth Telling, and Reconciliation in Canada* (Vancouver, BC: UBC Press, 2011), 11.

20 Annelise Riles, ed., *Documents: Artifacts of Modern Knowledge* (Ann Arbor: University of Michigan Press, 2006). See also Anne Laura Stoler, *Along the Archival Grain: Epistemic Anxieties and Colonial Common Sense* (Princeton, NJ: Princeton University Press, 2009).

21 On this use of "substance" in relation to cultural property, see Marilyn Strathern, *Property, Substance, and Effect: Anthropological Essays on Persons and Things* (London: Athlone Press, 1999).

22 David Garneau, "Imaginary Spaces of Conciliation and Reconciliation," *West Coast Line #74* 46, no. 2 (2012): 36.

23 Adrian Stimson, "Used and Abused," *Humanities Research* 15, no. 3 (2009): 72.

24 Stimson, "Used and Abused," 75.

25 For example, see Marlene Brant Castellano, Linda Archibald, and Mike DeGagné, *From Truth to Reconciliation: Transforming the Legacy of Residential Schools* (Ottawa, ON: Aboriginal Healing Foundation, 2008).

26 Heather Igloliorte, "Inuit Artistic Expression as Cultural Resilience," in *Response, Responsibility, and Renewal: Canada's Truth and Reconciliation Journey*, ed. Gregory Younging, Jonathan Dewar, and Mike DeGagné (Ottawa, ON: Aboriginal Healing Foundation, 2010), 122.

27 Niezen, *Truth and Indignation*, 93.

28 Naomi Angel, "Before Truth: The Labors of Testimony and the Canadian Truth and Reconciliation Commission," *Culture, Theory and Critique* 53, no. 2 (2012): 199–214.

29 Naomi Angel, *Fragments of Truth: Residential Schools and the Challenge of Reconciliation in Canada*, ed. Dylan Robinson and Jamie Berthe (Durham, NC: Duke University Press, 2022). On this posthumously published text's very situated scope, see Jamie Berthe and Eugenia Kisin, "Preface: Tracing Memory in Naomi Angel's Archive," in Angel, *Fragments of Truth*, ix–xviii.

30 Audra Simpson, "On the Logic of Discernment," *American Quarterly* 59, no. 2 (2007): 479–91; Dale Turner, *This Is Not a Peace Pipe: Towards a Critical Indigenous Philosophy* (Toronto, ON:

University of Toronto Press, 2006). See also Jane Anderson and Kimberly Christen, "'Chuck a Copyright on It': Dilemmas of Digital Return and the Possibilities for Traditional Knowledge Licenses and Labels," *Museum Anthropology Review* 7, nos. 1–2 (2013): 105–26.

31 Garneau, "Imaginary Spaces of Conciliation," 29.

32 Garneau, 29.

33 Garneau's essay is also part of a larger critical response to the TRC, a special issue of *West Coast Line* magazine. In this issue, emphatically titled *Reconcile This!*, artists, critics, and scholars take up the question of what the role of art might be in reconciliation. *Reconcile This!* emerged from a TRC-funded event held at the Centre for Innovation in Culture and the Arts at Thompson Rivers University in Kamloops, BC – a funding path that reveals the bureaucratic entanglement between the TRC's forms of representation and resistance to it. As Indigenous studies scholar Jonathan Dewar and artist Ayumi Goto note in their introduction to the issue, throughout the event, participants reframed reconciliation as a contemporary practice, asserting that its relations are ongoing and necessarily so. Such a notion of practice also implies that art's *meaning* in this process cannot be singular or settled if room is to be left for untranslatability, particularly amidst its complicities with governmental regimes. This framing of *Reconcile This!* also elaborates anxieties about circulation in relation to the openness of the TRC's open call.

34 Jonathan Dewar and Ayumi Goto, "Introduction," *Reconcile This!*, edited by Jonathan Dewar and Ayumi Goto, Special issue, *West Coast Line* #74 46, no. 2 (2012): 10.

35 Charlotte Townsend-Gault, "Art Claims in the Age of *Delgamuukw*," in *Native Art of the Northwest Coast: A History of Changing Ideas*, ed. Charlotte Townsend-Gault, Jennifer Kramer, and Ḳi-ḳe-in (Vancouver, BC: UBC Press, 2013).

36 Simpson, "On the Logic of Discernment."

37 Carter, "Discarding Sympathy," 419.

38 Sarah Lochlann Jain, *Injury: The Politics of Product Design and Safety Law in the United States* (Princeton, NJ: Princeton University Press, 2006).

39 Mary-Ellen Kelm, *Colonizing Bodies: Aboriginal Health and Healing in British Columbia 1900–50* (Vancouver, BC: UBC Press, 1998); Andrea Smith, *Conquest: Sexual Violence and American Indian Genocide* (Cambridge, MA: South End Press, 2005).

40 Carole Blackburn, "Culture Loss and Crumbling Skulls: The Problematic of Injury in Residential School Litigation," *PoLAR* 35, no. 2 (2012): 289.

41 Blackburn, "Culture Loss," 295.

42 Blackburn, 301.

43 I am grateful to Carole Blackburn for sharing her transcript of this part of the trial with me.

44 Following a gathering held at the University of British Columbia's First Nations House of Learning, Chief Robert Joseph, hereditary chief of the Gwawaenuk First Nation and official Reconciliation Canada ambassador, had asked those at the gathering, including Belkin Director Watson, "if we could act to raise awareness" of residential schools. From this impetus, Watson, Wallace, and Tyner's *Witnesses* emerged as a local art world's response.

45 Geoffrey Carr, quoted in Watson, Wallace, and Tyner, *Witnesses*, 19.

46 Watson, Wallace, and Tyner, *Witnesses*, 46.

47 Watson, Wallace, and Tyner, 63.

48 Kristin Dowell, "Residential Schools and 'Reconciliation' in the Media Art of Skeena Reece and Lisa Jackson," *Studies in American Literatures* 29, no. 1 (Spring 2017): 116–38.

49 For in-situ documentation of the pole, see "Reconciliation Pole," https://aboriginal-2.sites.olt .ubc.ca/files/2017/10/UBC_Plaque_2017-Reconciliation_Pole-8-1.pdf.

50 Images of the four sides of the box may be viewed on Luke Marston's personal website, https:// lukemarston.com/.

51 Niezen, *Truth and Indignation*, 66.

52 "Ark of Truth: Luke Marston's Contribution to the Healing from Residential Schools," CHLY First People Radio, 30 April 2009, https://archive.vimhs.org/?p=6881.

53 Kathryn McKay, "Recycling the Soul: Death and the Continuity of Life in Coast Salish Burial Practices" (Master's thesis, University of Victoria, 2002).

54 Alfred Gell, *Art and Agency* (Oxford: Oxford University Press, 1998).

55 Elizabeth Kalbfleisch has also suggested that Marston's box owes its "numinous nature" to its connections with Tlingit *at.óow*. I am uncertain about the box's Northwest Coast style being extended into its ontological dimensions in a non–Coast Salish context, unless the power of this analogy is partly to conceal or circulate familiar dynamics of revelation as a screen for other things that are refused. See Elizabeth Kalbfleisch, "Gesture of Reconciliation: The TRC Medicine Box as Communicative Thing," in *Arts of Engagement: Taking Aesthetic Action In and Beyond the Truth and Reconciliation Commission of Canada*, ed. Dylan Robinson and Keavy Martin (Waterloo, ON: Wilfrid Laurier University Press, 2016), 297.

56 Cynthia E. Milton and Anne-Marie Reynaud, "Archives, Museums and Sacred Storage: Dealing with the Afterlife of the Truth and Reconciliation Commission of Canada," *International Journal of Transitional Justice* 13, no. 3 (2019): 533.

Afterword: There Is (Still) Truth Here

1 Maggie Nelson, *On Freedom: Four Songs of Care and Constraint* (Minneapolis, MN: Graywolf Press, 2021), 53–4.

2 Melanie Delva, "Decolonizing the Prisons of Cultural Identity: Denominational Archives and Indigenous 'Manifestations of Culture,'" *Toronto Journal of Theology* 34, no. 1 (2018): 3–20.

3 Erica Lehrer, Cynthia E. Milton, and Monica Eileen Patterson, *Curating Difficult Knowledge: Violent Pasts in Public Places* (London: Palgrave Macmillan, 2011).

4 Jill Carter, "Discarding Sympathy, Disrupting Catharsis: The Mortification of Indigenous Flesh as Survivance-Intervention," *Theatre Journal* 67, no. 3 (October 2015): 419.

5 Eve Tuck, "Suspending Damage: A Letter to Communities," *Harvard Educational Review* 79, no. 3 (2009): 409–27.

6 For a fuller account of this work in the context of Walsh's practice as a visual anthropologist, see Bradley A. Clements and Andrea N. Walsh, "'Something from My Past that I Saw and Recognized': Renewed Efforts in Repatriating and Exhibiting Art from Residential and Day Schools," *Roundup: The Voice of the BC Museums Association* 274 (2019): 16–21.

7 The MOV maintains the exhibition site at https://museumofvancouver.ca/csnam-the -city-before-the-city.

8 Sharon Fortney, personal communication to author, 8 May 2020.

9 Emily McCarty, "There Is Truth Here: The Power of Art from Residential Schools on Display," *The Tyee*, 4 April 2019, https://thetyee.ca/Culture/2019/04/04/Power-Art-Residential-Schools -Students-Tribute/.

10 Fortney notes that the MOV obtained community permission from U'Mista to display these images, showing a decolonizing institutional reorientation around image permissions. Sharon Fortney, personal communication to author, 8 May 2020.

11 Lucy Lau, "Museum of Vancouver's *There Is Truth Here* Illustrates Humanity of Residential School Survivors," *Vancouver Magazine*, 5 April 2019, https://www.vanmag.com /museum-of-vancouvers-there-is-truth-here-illustrates-humanity-of-residential-school -survivorsefbbbf.

12 Sharon Fortney, personal communication to author, 8 May 2020.

13 The note reads: "Part of a collection of Cree artifacts collected by the donor's mother circa 1918 from Whitefish Lake, Alberta. The collector worked with the community and spoke their language. The collection includes thirty-three beaded objects and books for promoting Christianity, including Psalms and Hymns in Cree script.

This collection likely relates to the St. Andrew's Mission School, which opened in 1903 with ten student boarders at Whitefish Lake, in what is now Alberta. A new building was built three years later, and in 1908 the federal government recognized Whitefish Lake as a boarding school and began funding it. The school enrolment increased when the St Peters Anglican School was closed in 1932 and when the Gift Lake Métis settlement was created in 1938. In 1950 the residential school was closed and replaced with a church-run day school."

14 Andrea Walsh, quoted in McCarty, "There Is Truth Here."

Bibliography

Ades, Dawn, ed. *The Colour of My Dreams: The Surrealist Revolution in Art*. Vancouver, BC: Vancouver Art Gallery, 2011.

–, trans. "A Conversation with a Tsimshian." Translation of "Interview with a Tsimshian," by Kurt Seligmann, published in *Minotaure*, no. 12/13 (1939). In Ades, *The Colour of My Dreams*, 221–8.

Ahmed, Mohsen al Attar, Nicole S. Aylwin, and Rosemary J. Coombe. "Indigenous Cultural Heritage Rights in International Human Rights Law." In *Protection of First Nations' Cultural Heritage: Laws, Policy and Reform*, edited by Catherine Bell and Robert Paterson, 311–42. Vancouver, BC: UBC Press, 2009.

Alfred, Taiaiake. "From Sovereignty to Freedom: Towards an Indigenous Political Discourse." *Indigenous Affairs* 3, no. 1 (2001): 22–34. https://www.iwgia.org/images/publications/IA_3-01.pdf.

– *Heeding the Voices of Our Ancestors: Kahnawake Mohawk Politics and the Rise of Native Nationalism*. Don Mills, ON: Oxford University Press, 1995.

– *Peace, Power, Righteousness: An Indigenous Manifesto*. Don Mills, ON: Oxford University Press, 1999.

– "Sovereignty." In *A Companion to American Indian History*, edited by Philip J. Deloria and Neal Salisbury, 460–74. Malden, MA: Blackwell, 2004.

– *Wasáse: Indigenous Pathways of Action and Freedom*. Toronto, ON: Broadview Press, 2005.

Allaire, Christian. "Beat Nation: How Has Hip Hop Affected Aboriginal Culture?" *Toronto Standard*, 3 April 2013. https://www.torontostandard.com/culture/beat-nation-how-has-hip-hop -affected-aboriginal-culture/.

Ames, Michael. *Cannibal Tours and Glass Boxes: The Anthropology of Museums*. Vancouver, BC: UBC Press, 1992.

– "Museum Anthropologists and the Arts of Acculturation on the Northwest Coast." *BC Studies* 49 (Spring 1981): 3–14. https://doi.org/10.14288/bcs.v0i49.1085.

Anaya, S. James. *International Human Rights and Indigenous Peoples*. Austin, TX: Wolters Kluwer Art and Business, 2009.

Anderson, Jane, and Kimberly Christen. "'Chuck a Copyright on It': Dilemmas of Digital Return and the Possibilities for Traditional Knowledge Licenses and Labels." *Museum Anthropology Review* 7, nos. 1–2 (2013): 105–26. https://scholarworks.iu.edu/journals/index.php/mar/article /view/2169.

Andrew, Caroline, Monica Gattinger, M. Sharon Jeannotte, and Will Straw, eds. *Accounting for Culture: Thinking Through Citizenship*. Ottawa, ON: University of Ottawa Press, 2005.

Angel, Naomi. "Before Truth: The Labors of Testimony and the Canadian Truth and Reconciliation Commission." *Culture, Theory and Critique* 53, no. 2 (2012): 199–214. https://doi.org/10.1080/14735784.2012.680257.

– *Fragments of Truth: Residential Schools and the Challenge of Reconciliation in Canada*. Edited by Dylan Robinson and Jamie Berthe. Durham, NC: Duke University Press, 2022.

Anthes, Bill. "Contemporary Native Artists and International Biennial Culture." *Visual Anthropology Review* 25, no. 2 (2009): 109–27. https://doi.org/10.1111/j.1548-7458.2009.01037.x.

– *Edgar Heap of Birds*. Durham, NC: Duke University Press, 2017.

Anzaldúa, Gloria. *Borderlands/La Frontera: The New Mestiza*. 3rd ed. San Francisco: Aunt Lute Books, 1987.

Aplin, T. Christopher. "Expectation, Christianity, Ownership in Indigenous Hip-Hop: Religion in Rhyme with Emcee One, RedCloud, and Quese, Imc." *MUSICultures* 39, no. 1 (2012): 42–69. https://journals.lib.unb.ca/index.php/MC/article/view/24616.

Appadurai, Arjun. "Introduction: Commodities and the Politics of Value." In *The Social Life of Things: Commodities in Cultural Perspective*, edited by Arjun Appadurai, 3–63. Cambridge: Cambridge University Press, 1986.

Arden, Roy. *Supernatural: Neil Campbell, Beau Dick*. Vancouver, BC: Contemporary Art Gallery, 2004.

"Ark of Truth: Luke Marston's Contribution to the Healing from Residential Schools." CHLY First People Radio, 30 April 2009. https://archive.vimhs.org/?p=6881.

Asch, Michael, ed. *Aboriginal and Treaty Rights in Canada: Essays on Law, Equality, and Respect for Difference*. Vancouver, BC: UBC Press, 1997.

– *On Being Here to Stay: Treaties and Aboriginal Rights in Canada*. Toronto, ON: University of Toronto Press, 2014.

Askren, Mique'l. "Bringing Our History into Focus: Re-developing the Work of B.A. Haldane, 19th Century Tsimshian Photographer." *Backflash* 24, no. 3 (2007): 41–7. https://notartomatic.wordpress.com/2010/04/16/bringing-our-history-into-focus/.

– "Dancing Our Stone Masks Out of Confinement: A Twenty-First Century Tsimshian Epistemology." In *Objects of Exchange: Social and Material Transformation on the Late Nineteenth Century Northwest Coast*, edited by Aaron Glass, 37–47. New York: Bard Graduate Center, 2011.

– "From Negative to Positive: B.A. Haldane, Nineteenth Century Tsimshian Photographer." MA thesis, University of British Columbia, 2006. https://dx.doi.org/10.14288/1.0092671.

Austin, Ian. "Vancouver Sits on Unceded First Nations Land, Council Acknowledges." *The Province*, 27 June 2014. https://theprovince.com/news/metro%20vancouver/vancouver-sits-on-unceded-first-nations-land-council-acknowledges.

Baloy, Natalie. "Spectacle in Circulation: Linking the Everyday and the Spectacular through Ethnography." *Anthropology News* 52, no. 2 (2011): 14. https://doi.org/10.1111/j.1556-3502.2011.52214.x.

Banting, Keith, Thomas J. Courchene, and F. Leslie Seidle, eds. *Belonging? Diversity, Recognition, and Shared Citizenship in Canada*. Montreal: Institute for Research on Public Policy, 2007.

Barad, Karen. *Meeting the Universe Halfway: Quantum Physics and the Entanglement of Matter and Meaning*. Durham, NC: Duke University Press, 2007.

Bargh, Maria, ed. *Resistance: An Indigenous Response to Neoliberalism*. Wellington, NZ: Huia Publishers, 2007.

Barker, Joanne, ed. *Sovereignty Matters: Locations of Contestation and Possibility in Indigenous Struggles for Self-Determination*. Lincoln: University of Nebraska Press, 2005.

Barker, John. "Going by the Book: Missionary Perspectives." In *Native Art of the Northwest Coast: A History of Changing Ideas*, edited by Charlotte Townsend-Gault, Jennifer Kramer, and Ḵi-ḵe-in, 234–64. Vancouver, BC: UBC Press, 2013.

– "Tangled Reconciliations: The Anglican Church and the Nisga'a of British Columbia." *American Ethnologist* 25, no 3 (1998): 433–51. https://doi.org/10.1525/ae.1998.25.3.433.

Barman, Jean. *The West Beyond the West: A History of British Columbia*. 3rd ed. Toronto, ON: University of Toronto Press, 2007.

Bataille, Georges. *The Accursed Share: An Essay on General Economy*, vol. 1. Translated by Robert Hurley. New York: Zone Books, 1988.

Bear, Jeff, and Marianne Jones, dirs. *On the Trail of Property Woman*. Ravens and Eagles, Series 2. Vancouver, BC: Moving Images Distribution, 2003. 24 mins.

Becker, Howard. *Art Worlds*. Berkeley: University of California Press, 1982.

Beier, J. Marshall, ed. *Indigenous Diplomacies*. New York: Palgrave MacMillan, 2009.

Bell, Catherine, and Val Napoleon, eds. *First Nations Cultural Heritage and Law: Case Studies, Voices, and Perspectives*. Vancouver, BC: UBC Press, 2009.

Bell, Catherine, and Robert K. Paterson. "International Movement of First Nations Cultural Heritage in Canadian Law." In *Protection of First Nations Cultural Heritage: Laws, Policy, and Reform*, 78–109.

–, eds. *Protection of First Nations Cultural Heritage: Laws, Policy, and Reform*. Vancouver, BC: UBC Press, 2009.

Benjamin, Walter. *The Arcades Project*. Translated by Howard Eiland and Kevin McLaughlin. Cambridge, MA: Belknap Press of Harvard University Press, 2002.

Bennett, Jane. *Vibrant Matter: A Political Ecology of Things*. Durham, NC: Duke University Press, 2010.

Bennett, Tony. "Putting Policy into Cultural Studies." In *Cultural Studies*, edited by Laurence Grossberg, Cary Nelson, and Paula Treichler, 23–37. New York: Routledge, 1992.

Bergland, Renée L. *The National Uncanny: Indian Ghosts and American Subjects*. Hanover, NH: University Press of New England, 2000.

Berman, Judith. "'The Culture as It Appears to the Indian Himself': Boas, George Hunt, and the Methods of Ethnography." In *Volksgeist as Method and Ethic: Essays on Boasian Ethnography and the German Anthropological Tradition*, edited by George W. Stocking, Jr., 215–56. Madison: University of Wisconsin Press, 1996.

Berthe, Jamie, and Eugenia Kisin. "Preface: Tracing Memory in Naomi Angel's Archive." In *Fragments of Truth: Residential Schools and the Challenge of Reconciliation in Canada*, by Naomi Angel, ix–xviii. Durham, NC: Duke University Press, 2022.

Berthiaume, Rocque. *The Gitselasu: The People of Kitselas Canyon*. Kitselas, BC: First Nations Education Centre of School District 82, 1999.

Beveridge, Rachelle, Megan Moody, Grant Murray, Chris Darimont, and Bernie Paulie. "The Nuxalk *Sputc (Eulachon) Project*: Strengthening Indigenous Management Authority through Community-Driven Research." *Marine Policy* 119 (2020): 103971. https://doi.org/10.1016/j.marpol.2020.103971.

Bhabha, Homi K. *The Location of Culture*. London: Routledge, 1994.

Biddle, Jennifer L. *Remote Avant-Garde: Aboriginal Art under Occupation*. Durham, NC: Duke University Press, 2016.

Bierwert, Crisca. *Brushed by Cedar, Living by the River: Coast Salish Figures of Power*. Tucson: University of Arizona Press, 1999.

Bill Reid's Rescue Mission for Haida Art. Program 8. Aired 21 May 1959 on the Canadian Broadcasting Corporation (CBC). https://www.cbc.ca/player/play/1742147179.

Biolsi, Thomas. "Imagined Geographies: Sovereignty, Indigenous Space, and American Indian Struggle." *American Ethnologist* 32, no. 2 (2005): 239–59. https://doi.org/10.1525/ae.2005.32.2.239.

Bishop, Claire. *Artificial Hells: Participatory Art and the Politics of Spectatorship*. New York: Verso, 2012.

Black, Martha. "Collaborations: A Historical Perspective." In *Native Art of the Northwest Coast: A History of Changing Ideas*, edited by Charlotte Townsend-Gault, Jennifer Kramer, and Ḳi-ḳe-in, 785–827. Vancouver, BC: UBC Press, 2013.

- "Looking for Bella Bella: The R.W. Large Collection and Heiltsuk Art History." *Canadian Journal of Native Studies* 9, no. 2 (1989): 273–91. https://cjns.brandonu.ca/wp-content/uploads/9-2-black.pdf.

Blackburn, Carole. *Beyond Rights: The Nisga'a Final Agreement and the Challenges of the Modern Treaty Relationship*. Vancouver, BC: UBC Press, 2021.

- "Culture Loss and Crumbling Skulls: The Problematic of Injury in Residential School Litigation." *PoLAR* 35, no. 2 (2012): 289–307. https://doi.org/10.1111/j.1555-2934.2012.01204.x.

- "Differentiating Indigenous Citizenship: Seeking Multiplicity in Rights, Identity, and Sovereignty in Canada." *American Ethnologist* 36, no. 1 (2009): 66–78. https://doi.org/ 10.1111/j.1548-1425 .2008.01103.x.

- "Searching for Guarantees in the Midst of Uncertainty: Negotiating Aboriginal Rights and Title in British Columbia." *American Anthropologist* 107, no. 4 (2005): 586–96. https://doi.org/10.1525 /aa.2005.107.4.586.

Blaser, Mario, Ravi de Costa, Deborah McGregor, and William D. Coleman, eds. *Indigenous Peoples and Autonomy: Insights for a Global Age*. Vancouver, BC: UBC Press, 2010.

Boas, Franz. "Decorative Designs of Alaskan Needlecases: A Study in the History of Conventional Designs, Based on Materials in the U.S. National Museum." *Proceedings of the U.S. National Museum* 34, no. 1616 (1908): 321–44. https://doi.org/10.5479/si.00963801.34-1616.321.

- *Primitive Art*. 1927. Reprint, New York: Dover Publications, 1955.

Borrows, John. *Recovering Canada: The Resurgence of Indigenous Law*. Toronto, ON: University of Toronto Press, 2002.

Bourdieu, Pierre. *Distinction: A Social Critique of the Judgment of Taste*. Translated by Richard Nice. Cambridge, MA: Harvard University Press, 1984.

Bourriaud, Nicolas. *Relational Aesthetics*. Translated by Simon Pleasance and Fronza Woods. Dijon, FR: Presses du réel, 2002.

Bowden, Ross. "A Critique of Alfred Gell on *Art and Agency*." *Oceania* 74, no. 4 (2004): 309–24. https://doi.org/10.1002/j.1834-4461.2004.tb02857.x.

Bracken, Christopher. *The Potlatch Papers: A Colonial Case History*. Chicago: University of Chicago Press, 1998.

Braun, Bruce. *The Intemperate Rainforest: Nature, Culture, and Power on Canada's West Coast*. Minneapolis: University of Minnesota Press, 2002.

Brown, Michael F. *Who Owns Native Culture?* Cambridge, MA: Harvard University Press, 2004.

Brown, Steven C. *Native Visions: Evolution in Northwest Coast Art from the Eighteenth Century through the Twentieth Century*. Seattle, WA: Seattle Art Museum, 1999.

Browne, Colin. "Scavengers of Paradise." In *The Colour of my Dreams: The Surrealist Revolution in Art*, edited by Dawn Ades, 245–62. Vancouver, BC: Vancouver Art Gallery, 2011.

Bruyneel, Kevin. *The Third Space of Sovereignty: The Postcolonial Politics of U.S.–Indigenous Relations*. Minneapolis: University of Minnesota Press, 2007.

Bryan-Wilson, Julia. "Comment on 'A Questionnaire on Materialisms.'" *October* 155 (Winter 2016): 16–18. https://dspace.mit.edu/handle/1721.1/113914.

Buck-Morss, Susan. *The Dialectics of Seeing: Walter Benjamin and the Arcades Project*. Cambridge, MA: MIT Press, 1989.

Busch, Lawrence. *Standards: Recipes for Reality*. Cambridge, MA: MIT Press, 2001.

Büscher, Bram, and Veronica Davidoff, eds. *The Eco-Tourism Extraction Nexus: Political Economies and Rural Realities of (Un)comfortable Bedfellows*. London: Routledge, 2013.

Canadian Press. "Timeline of the Coastal GasLink Pipeline in British Columbia." *Vancouver Sun*, 24 January 2021. https://vancouversun.com/business/energy/timeline-of-the-coastal-gaslink -pipeline-in-british-columbia.

Canclini, Néstor García. *Art beyond Itself: Anthropology for a Society without a Storyline*. Translated by David Frye. Durham, NC: Duke University Press, 2014.

Cannell, Fenella. "Review of *Christian Moderns: Freedom and Fetish in the Mission Encounter*." *Indonesia* 85 (2008): 147–60. https://hdl.handle.net/1813/54437.

Cannon, Martin J., and Lisa Sunseri. *Racism, Colonialism, and Indigeneity in Canada*. Toronto, ON: Oxford University Press, 2011.

Cardinal, Gil, dir. *Totem: The Return of the G'psgolox Pole*. National Film Board of Canada, 2003. 73 min.

Carter, Jill. "Discarding Sympathy, Disrupting Catharsis: The Mortification of Indigenous Flesh as Survivance-Intervention." *Theatre Journal* 67, no. 3 (October 2015): 413–32. https://doi.org/10.1353/tj.2015.0103.

Castellano, Marlene Brant, Linda Archibald, and Mike DeGagné. *From Truth to Reconciliation: Transforming the Legacy of Residential Schools*. Ottawa, ON: Aboriginal Healing Foundation, 2008.

Cattelino, Jessica R. "The Double Bind of American Indian Needs-Based Sovereignty." *Cultural Anthropology* 25, no. 2 (2010): 235–62. https://doi.org/10.1111/j.1548-1360.2010.01058.x.

– *High Stakes: Florida Seminole Gaming and Sovereignty*. Durham, NC: Duke University Press, 2008.

Chang, Elaine, Andrea Lalonde, Chris Lloyd, Steve Loft, Jonathan Middleton, Daniel Roy, and Haema Sivanesan, eds. *decentre: Concerning Artist-Run Culture*. Toronto, ON: YYZ Books, 2007.

Chen, Nancy N. "'Speaking Nearby': A Conversation with Trinh T. Minh-ha." *Visual Anthropology Review* 8, no. 1 (March 1992): 82–91. https://doi.org/10.1525/var.1992.8.1.82.

Chin, Elizabeth. *My Life with Things: The Consumer Diaries*. Durham, NC: Duke University Press, 2015.

Christen, Kimberly. "Does Information Really Want to Be Free? Indigenous Knowledge Systems and the Question of Openness." *International Journal of Communication* 6 (2012): 2870–93. https://ijoc.org/index.php/ijoc/article/view/1618.

Christov-Bakargiev, Carolyn. "Worldly Worlding: The Imaginal Fields of Science/Art and Making Patterns Together." *Mousse Magazine*, 1 April 2014. https://www.moussemagazine.it/magazine/carolyn-christov-bakargiev-claire-pentecost-2014/.

Chua, Liana, and Mark Elliott, eds. *Distributed Objects: Meaning and Mattering after Alfred Gell*. Oxford: Berghahn, 2013.

Chumley, Lily. *Creativity Class: Art School and Culture Work in Postsocialist China*. Princeton, NJ: Princeton University Press, 2016.

Clarkes, Lincoln. *Heroines: The Photographs of Lincoln Clarkes*. Vancouver, BC: Anvil Press, 2002.

Clavir, Miriam. *Preserving What Is Valued: Museums, Conservation, and First Nations*. Vancouver, BC: UBC Press, 2002.

Claxton, Dana. *Dana Claxton: Made to Be Ready*. Curated by Amy Kazymerchyk. Exhibition at the Audain Gallery, Vancouver, BC, 14 January–12 March 2016. https://www.sfu.ca/galleries/audain-gallery/past1/Dana-Claxton-Made-To-Be-Ready.html.

Claxton, Dana, and Tania Willard. "NDN AXE/IONS: A Collaborative Essay." In *INDIANacts: Aboriginal Performance Art*, curated by Tania Willard and Dana Claxton. https://indianacts.gruntarchives.org/essay-ndn-axe-ions-claxton-and-willard.html.

Clements, Bradley A., and Andrea N. Walsh. "'Something from My Past that I Saw and Recognized': Renewed Efforts in Repatriating and Exhibiting Art from Residential and Day Schools." *Roundup: The Voice of the BC Museums Association* 274 (Winter 2019): 16–21. https://issuu.com/bcmuseumsassn/docs/274_roundup_reconciliation_and_repa.

Clifford, James. "Indigenous Articulations." *The Contemporary Pacific* 13, no. 2 (2001): 468–90. https://doi.org/10.1353/cp.2001.0046.

- *The Predicament of Culture: Twentieth-Century Ethnography, Literature, and Art*. Cambridge, MA: Harvard University Press, 1988.
- *Returns: Becoming Indigenous in the Twenty-First Century*. Cambridge, MA: Harvard University Press, 2013.
- *Routes: Travel and Translation in the Late Twentieth Century*. Cambridge, MA: Harvard University Press, 1997.
- "Varieties of Indigenous Experience: Diasporas, Homelands, Sovereignties." In *Indigenous Experience Today*, edited by Marisol de la Cadena and Orin Starn, 197–223. Oxford: Berg, 2007.
- Cole, Douglas. *Captured Heritage: The Scramble for Northwest Coast Artifacts*. Vancouver, BC: UBC Press, 1985.
- Collison, Jisgang Nika, and Cara Krmpotich. "Saahlinda Naay – Saving Things House: The Haida Gwaii Museum Past, Present and Future." In *The Routledge Companion to Indigenous Repatriation: Return, Reconcile, Renew*, edited by Cressida Fforde, C. Timothy McKeown, and Honor Keeler, 44–62. London: Routledge, 2020.
- Comaroff, Jean, and John L. Comaroff. *Of Revelation and Revolution*. Chicago: University of Chicago Press, 1997.
- Comaroff, John L., and Jean Comaroff. *Ethnicity, Inc.* Chicago: University of Chicago Press, 2009.
- Coombe, Rosemary J. *The Cultural Life of Intellectual Properties: Authorship, Appropriation, and the Law*. Durham, NC: Duke University Press, 1998.
- "The Expanding Purview of Cultural Properties and their Politics." *Annual Review of Law and Social Sciences* 5 (2009): 393–412. https://doi.org/10.1146/annurev.lawsocsci.093008.131448.
- "Managing Cultural Heritage as Neoliberal Governmentality." In *Heritage Regimes and the State*, edited by Regina F. Bendix, Aditya Eggert, and Arnika Peselmann, 375–89. Göttingen, DE: Göttingen University Press, 2012.
- "The Work of Rights at the Limits of Governmentality." *Anthropologica* 49, no. 2 (2007): 284–9. https://www.jstor.org/stable/25605365.
- Coombe, Rosemary J., and Melissa F. Baird. "The Limits of Heritage: Corporate Interests and Cultural Rights on Resource Frontiers." In *A Companion to Heritage Studies*, edited by William Logan, Máiréad Nic Craith, and Ullrich Kockel, 337–54. Malden, MA: Wiley Blackwell, 2016.
- Coombe, Rosemary J., and Eugenia Kisin. "Archives and Cultural Legibility: Objects and Subjects of Neoliberal Heritage Technologies." In *Objectification and Standardization: On the Limits and Effects of Ritually Fixing and Measuring Life*, edited by Tord Larsen, Michael Blim, Theodore M. Porter, Kalpana Ram, and Nigel Rapport, 257–92. Durham, NC: Carolina Academic Press, 2021.
- Coombes, Annie E. *Rethinking Settler Colonialism: History and Memory in Australia, Canada, Aotearoa New Zealand, and South Africa*. New York: Palgrave, 2006.
- Corntassel, Jeff, Chaw-win-is, and T'lakwadzi. "Indigenous Storytelling, Truth-Telling, and Community Approaches to Reconciliation." *English Studies in Canada* 35, no. 1 (2009): 137–59. https://doi.org/10.1353/esc.0.0163.
- Correctional Service Canada. *Working Together: Enhancing the Role of Aboriginal Communities in Federal Corrections*. Ottawa, ON: Correctional Service Canada, 2012.
- Corsín Jiménez, Alberto, and Chloe Nahum-Claudel. "The Anthropology of Traps: Concrete Technologies and Theoretical Interfaces." *Journal of Material Culture* 24, no. 4 (2019): 383–400. https://doi.org/10.1177/1359183518820368.
- Coulthard, Glen. *Red Skin, White Masks: Rejecting the Colonial Politics of Recognition*. Minneapolis: University of Minnesota Press, 2014.
- "Subjects of Empire: Indigenous Peoples and the 'Politics of Recognition' in Canada." *Contemporary Political Theory* 6, no. 4 (2007): 437–60. https://doi.org/10.1057/palgrave.cpt.9300307.

Cowan, Jane K., Marie-Bénédicte Dembour, and Richard A. Wilson, eds. *Culture and Rights: Anthropological Perspectives*. Cambridge: Cambridge University Press, 2001.

Cowlishaw, Gillian. "Disappointing Indigenous People: Violence and the Refusal of Help." *Public Culture* 15, no. 1 (2003): 103–26. https://doi.org/10.1215/08992363-15-1-103.

Cranmer Webster, Gloria. "From Colonization to Repatriation." In *Indigena: Contemporary Native Perspectives in Canadian Art*, edited by Gerald McMaster and Lee-Ann Martin, 25–37. Vancouver, BC: Douglas & McIntyre, 1992.

Crary, Jonathan. *24/7: Capitalism and the Ends of Sleep*. New York: Verso, 2013.

Crehan, Kate. *Community Art: An Anthropological Perspective*. Oxford: Berg, 2011.

Crosby, Marcia. "Indian Art/Aboriginal Title." MA thesis, University of British Columbia, 1994.

– "Lines, Lineage and Lies, or Borders, Boundaries and Bullshit." In *Nations in Urban Landscapes: Faye HeavyShield, Shelley Niro, Eric Robertson*, edited by Marcia Crosby, 23–30. Vancouver, BC: Contemporary Art Gallery, 1997. Published as a catalogue to an exhibition of the same title displayed at the Contemporary Art Gallery, Vancouver, BC, 28 October–9 December 1995.

– "Making Indian Art 'Modern.'" Essay on the website *Ruins in Progress: Vancouver Art in the Sixties*, Morris and Helen Belkin Art Gallery, 2009. https://vancouverartinthesixties.com/essays /making-indian-art-modern.

Cruikshank, Julie. *The Social Life of Stories: Narrative and Knowledge in the Yukon Territory*. Vancouver, BC: UBC Press, 1998.

Culhane, Dara. *The Pleasure of the Crown: Anthropology, Law, and First Nations*. Vancouver, BC: Talonbooks, 1998.

Cvetkovich, Ann. *An Archive of Feelings: Trauma, Sexuality, and Lesbian Public Cultures*. Durham, NC: Duke University Press, 2003.

Dace, Karen L., ed. *Unlikely Allies in the Academy: Women of Color and White Women in Conversation*. New York: Routledge, 2012.

da Cunha, Manuela Carneiro. *"Culture" and Culture: Traditional Knowledge and Intellectual Rights*. Chicago: Prickly Paradigm Press, 2009.

Damon, Katherine. "Copper Ontology: Being, Beings, and Belongings." MA thesis, University of British Columbia, 2016.

Danto, Arthur. *After the End of Art: Contemporary Art and the Pale of History*. Princeton, NJ: Princeton University Press, 1997.

– "The Artworld." *The Journal of Philosophy* 61, no. 19 (1967): 571–84. https://doi.org/10.2307 /2022937.

Darnell, Regna. *Invisible Genealogies: A History of Americanist Anthropology*. Lincoln: University of Nebraska Press, 2001.

– "Text, Symbol, and Tradition in Northwest Coast Ethnology from Franz Boas to Claude Lévi-Strauss." In *Coming to Shore: Northwest Coast Ethnology, Traditions, and Visions*, edited by Marie Mauzé, Michael E. Harkin, and Sergei Kan, 6–21. Lincoln: University of Nebraska Press, 2006.

Dauenhauer, Nora. "Tlingit *At.óow*: Traditions and Concepts." In *The Spirit Within*, edited by Steven Brown, 20–30. Seattle: University of Washington Press, 1995.

Dawn, Leslie. *National Visions, National Blindness: Canadian Art and Identities in the 1920s*. Vancouver, BC: UBC Press, 2006.

Day, Richard, and Tonio Sadik. "The B.C. Land Question, Liberal Multiculturalism, and the Spectre of Aboriginal Nationhood." *BC Studies* 134 (Summer 2002): 5–34. https://doi.org/10.14288/bcs .v0i134.1626.

De La Cadena, Marisol, and Orin Starn, eds. *Indigenous Experience Today*. Oxford: Berg, 2007.

De Leeuw, Sarah. "Artful Places: Creativity and Colonialism in British Columbia's Indian Residential Schools." PhD diss., Queen's University, 2007.

– "Intimate Colonialisms: The Material and Experienced Places of British Columbia's Residential Schools." *Canadian Geographer* 51, no. 3 (2006): 339–59. https://doi.org/10.1111/j.1541-0064.2007.00183.x.

Deliss, Clementine. *The Metabolic Museum*. Berlin: Hatje Cantz, 2020.

Deloria, Philip J. *Indians in Unexpected Places*. Lawrence: University of Kansas Press, 2004.

Delva, Melanie. "Decolonizing the Prisons of Cultural Identity: Denominational Archives and Indigenous 'Manifestations of Culture.'" *Toronto Journal of Theology* 34, no. 1 (2018): 3–20. https://doi.org/10.3138/tjt.2017-0016.

Depalma, Anthony. "Canada Pact Gives a Tribe Self-Rule for the First Time." *New York Times*, 5 August 1998. https://www.nytimes.com/1998/08/05/world/canada-pact-gives-a-tribe-self-rule-for-the-first-time.html.

Derrida, Jacques. *Archive Fever: A Freudian Impression*. Translated by Eric Prenowitz. Chicago: University of Chicago Press, 1998.

Dewar, Jonathan, and Ayumi Goto. "Introduction." *Reconcile This!*, edited by Jonathan Dewar and Ayumi Goto. Special issue, *West Coast Line* #74 46, no. 2 (2012): 4–11.

Dick, Beau. "The Beginning of the Journey." In *Lalakenis/All Directions: A Journey of Truth and Unity*, edited by Scott Watson and Lorna Brown, 17–19. Vancouver, BC: Morris and Helen Belkin Art Gallery, 2014.

– "The Coppers." In *Lalakenis/All Directions: A Journey of Truth and Unity*, 20–3.

Douzinas, Costas, and Lynda Nead, eds. *Law and the Image: The Authority of Art and the Aesthetics of Law*. Chicago: University of Chicago Press, 1999.

Dowell, Kristin. "Residential Schools and 'Reconciliation' in the Media Art of Skeena Reece and Lisa Jackson." *Studies in American Literatures* 29, no. 1 (Spring 2017): 116–38. https://doi.org/10.5250/studamerindilite.29.1.0116.

– *Sovereign Screens: Aboriginal Media on the Canadian West Coast*. Lincoln: University of Nebraska Press, 2013.

Drucker, Johanna. *Sweet Dreams: Contemporary Art and Complicity*. Chicago: University of Chicago Press, 2005.

D'Souza, Aruna. *Whitewalling: Art, Race and Protest in Three Acts*. New York: Badlands, 2018.

Duff, Wilson. *Arts of the Raven: Masterworks by the Northwest Coast Indian*. Vancouver, BC: Vancouver Art Gallery, 1967.

– *The Indian History of British Columbia: The Impact of the White Man*. 1964. Reprinted, Victoria: Royal British Columbia Museum, 1997.

Duffek, Karen. "The Contemporary Northwest Coast Indian Art Market." MA thesis, University of British Columbia, 1978.

–, ed. *Robert Davidson: The Abstract Edge*. Vancouver, BC: Museum of Anthropology, 2004.

– "Value Added: The Northwest Coast Art Market since 1965." In *Native Art of the Northwest Coast: A History of Changing Ideas*, edited by Charlotte Townsend-Gault, Jennifer Kramer, and Ḳi-ḳe-in. Vancouver, BC: UBC Press, 2013.

Duffek, Karen, and Charlotte Townsend-Gault. "Introduction: Image and Imagination." In *Bill Reid and Beyond: Expanding on Modern Native Art*, edited by Karen Duffek and Charlotte Townsend-Gault, 7–18. Vancouver, BC: Douglas & McIntyre, 2004.

Elhaik, Tarek. *The Incurable-Image: Curating Post-Mexican Film and Media Arts*. Edinburgh: University of Edinburgh Press, 2016.

Elkins, James, ed. *Is Art History Global?* New York: Routledge, 2007.

Elkins, James, and David Morgan, eds. *Re-enchantment*. New York: Routledge, 2008.

Ellis, Donald, ed. *Tsimshian Treasures: The Remarkable Journey of the Dundas Collection*. Vancouver, BC: Douglas & McIntyre, 2007.

Emberley, Julia V. *Defamiliarizing the Aboriginal: Cultural Practices and Decolonization in Canada*. Toronto, ON: University of Toronto Press, 2007.

Engle, Karen. *The Elusive Promise of Indigenous Development: Rights, Culture, Strategy*. Durham, NC: Duke University Press, 2010.

Errington, Shelly. *The Death of Authentic "Primitive Art" and Other Tales of Progress*. Berkeley: University of California Press, 1998.

– "Globalizing Art History." In *Is Art History Global?*, edited by James Elkins, 405–40. New York: Routledge, 2007.

Fabian, Johannes. *Time and the Other: How Anthropology Makes Its Object*. New York: Columbia University Press, 1983.

Fahey, Alicia, and Chelsea Horton. *"The Iron Pulpit": Missionary Printing Presses in British Columbia*. Catalogue accompanying an exhibition by the same name at the University of British Columbia Rare Books and Special Collections, 4 September–31 October 2012.

Fazakas, LaTiesha. *Beau Dick: Devoured by Consumerism*. Vancouver, BC: Figure1, 2019.

–, dir. *Maker of Monsters: The Extraordinary Life of Beau Dick*. Athene Films, 2017. 92 mins.

Feld, Steven. "Editor's Introduction." In *Ciné-Ethnography*, by Jean Rouch, edited and translated by Steven Feld, 1–25. Minneapolis: University of Minnesota Press. 2003.

"First Nations Trade Mission to China a Multicultural Celebration." *ICT* (*Indian Country Today*), 13 September 2018. https://ictnews.org/archive/first-nations-trade-mission-to-china-a -multicultural-celebration.

Fisher, Robin. *Contact and Conflict: Indian-European Relations in British Columbia, 1774–1890*. 1977. Reprinted, Vancouver, BC: UBC Press, 1992.

Flanagan, Tom. *First Nations? Second Thoughts*. Montreal and Kingston: McGill-Queen's University Press, 2008.

Fluehr-Lobban, Carolyn. "Collaborative Anthropology as Twenty-First-Century Ethical Anthropology." *Collaborative Anthropologies* 1 (2008): 175–82. https://doi.org/10.1353/cla.0.0000.

Fortun, Kim. *Advocacy after Bhopal: Environmentalism, Disaster, New Global Orders*. Chicago: University of Chicago Press, 2001.

Foster, Hal. "The Artist as Ethnographer?" In *The Traffic in Culture: Refiguring Art and Anthropology*, edited by George Marcus and Fred R. Myers, 302–9. Berkeley: University of California Press, 1995.

– *Bad New Days: Art, Criticism, Emergency*. New York: Verso, 2017.

– "The 'Primitive' Unconscious of Modern Art." *October* 34 (Autumn 1985): 45–70. https://doi.org /10.2307/778488.

Fraser, Nancy. *Scales of Justice: Re-imagining Political Space in a Globalizing World*. New York: Columbia University Press, 2009.

Fraser, Nancy, and Axel Honneth. *Redistribution or Recognition? A Political-Philosophical Exchange*. Translated by Joel Golb, James Ingram, and Christiane Wilke. London: Verso, 2003.

Freedberg, David. *The Power of Images: Studies in the History and Theory of Response*. Chicago: University of Chicago Press, 1991.

Freire, Paulo. *Pedagogy of the Oppressed*. 1968. Translated by Myra Bergman Ramos. Reprinted, New York: Bloomsbury Academic, 2000.

Galloway, Gloria. "After Six Years in Office, Harper to Meet with First-Nations Leaders." *The Globe and Mail*, 1 December 2011. https://www.theglobeandmail.com/news/politics /after-six-years-in-office-harper-to-meet-with-first-nations-leaders/article4180229/.

– "Atleo Leads Native Trade Mission to China." *The Globe and Mail*, 21 October 2011. https://www .theglobeandmail.com/news/politics/ottawa-notebook/atleo-leads-native-trade-mission-to-china /article618949/.

– "Attawapiskat Audit Raises Questions about Millions in Spending." *The Globe and Mail*, 7 January 2013. https://www.theglobeandmail.com/news/politics/attawapiskat-audit-raises-questions-about-millions -in-spending/article6995751/.

Gaonkar, Dilip Parameshwar, ed. *Alternative Modernities*. Durham, NC: Duke University Press, 2001.

Garneau, David. "Imaginary Spaces of Conciliation and Reconciliation." *West Coast Line #74* 46, no. 2 (2012): 28–38. https://inhabitinginheritance.files.wordpress.com/2016/02/pages-from-west -coast-line-74-1.pdf.

Geertz, Clifford. "Art as a Cultural System." In *Local Knowledge: Further Essays in Interpretive Anthropology*, 94–120. New York: Basic Books, 1983.

Geismar, Haidy. "The Art of Anthropology: Questioning Contemporary Art in Ethnographic Display." In *Museum Theory: An Expanded Field*, edited by Andrea Whitcomb and Kylie Message, 183–210. Malden, MA: Wiley-Blackwell, 2015.

– "'Material Culture Studies' and Other Ways to Theorize Objects: A Primer to a Regional Debate." *Comparative Studies in Society and History* 53, no. 1 (2011): 210–18. https://www.jstor.org /stable/41241738.

– *Treasured Possessions: Interventions into Cultural and Intellectual Property*. Durham, NC: Duke University Press, 2013.

Gell, Alfred. *Art and Agency*. Oxford: Oxford University Press, 1998.

– "The Network of Standard Stoppages." In *Distributed Objects: Meaning and Mattering after Alfred Gell*, edited by Liana Chua and Mark Elliott, 88–113. Oxford: Berghahn, 2015.

– "The Technology of Enchantment and the Enchantment of Technology." In *Anthropology, Art and Aesthetics*, edited by Jeremy Coote and Anthony Shelton, 40–63. Oxford: Clarendon Press, 1994.

Gilroy, Paul. *Postcolonial Melancholia*. New York: Columbia University Press, 2005.

Ginsburg, Faye. "Decolonizing Documentary, On-Screen and Off: Sensory Ethnography and the Aesthetics of Accountability." *Film Quarterly* 71, no. 1 (2018): 39–49. https://doi.org/10.1525 /fq.2018.72.1.39.

– "Embedded Aesthetics: Creating a Discursive Space for Indigenous Media." *Cultural Anthropology* 9, no. 3 (1994): 365–82. https://doi.org/10.1525/can.1994.9.3.02a00080.

– "Indigenous Counter-Publics: A Foreshortened History." In *Sensible Politics: The Visual Culture of Nongovernmental Activism*, edited by Yates McKee and Meg McLagan, 87–108. Brooklyn, NY: Zone Books, 2012.

– "Institutionalizing the Unruly: Charting a Future for Visual Anthropology." *Ethnos* 63, no. 2 (1998): 173–201. https://doi.org/10.1080/00141844.1998.9981571.

– "Screen Memories: Resignifying the Traditional in Indigenous Media." In *Media Worlds: Anthropology on New Terrain*, edited by Faye Ginsburg, Lila Abu-Lughod, and Brian Larkin, 51–66. Berkeley: University of California Press, 2002.

Ginsburg, Faye, and Fred Myers. "A History of Aboriginal Futures." *Critique of Anthropology* 26, no. 1 (2006): 27–45. https://doi.org/10.1177/0308275X06061482.

Glass, Aaron. "From Cultural Salvage to Brokerage: The Mythologization of Mungo Martin and the Emergence of Northwest Coast Art." *Museum Anthropology* 29, no. 1 (2006): 20–43. https://doi .org/10.1525/mua.2006.29.1.20.

– "History and Critique of the 'Renaissance' Discourse." In *Native Art of the Northwest Coast: A History of Changing Ideas*, edited by Charlotte Townsend-Gault, Jennifer Kramer, and Ḳi-ḳe-in, 487–517. Vancouver, BC: UBC Press, 2013.

– "Objects of Exchange: Material Culture, Colonial Encounter, Indigenous Modernity." In *Objects of Exchange: Social and Material Transformation on the Late Nineteenth-Century Northwest Coast*, 3–35.

–, ed. *Objects of Exchange: Social and Material Transformation on the Late Nineteenth-Century Northwest Coast*. New York: Bard Graduate Center, 2011.

– "Return to Sender: On the Politics of Cultural Property and the Proper Address of Art." *Journal of Material Culture* 9, no. 2 (2004): 115–39. https://doi.org/10.1177/1359183504044368.

– "Was Bill Reid the Fixer of a Broken Culture or a Culture Broker?" In *Bill Reid and Beyond: Expanding on Modern Native Art*, edited by Karen Duffek and Charlotte Townsend-Gault, 190–206. Vancouver, BC: Douglas & McIntyre, 2004.

– *Writing the Hamat'sa: Ethnography, Colonialism, and the Cannibal Dance*. Vancouver, BC: UBC Press, 2021.

Glass, Aaron, and Judith Berman. "Reassembling the Social Organization: Museum Collections, Indigenous Knowledge, and the Recuperation of the Franz Boas/George Hunt Archive." Paper delivered to the Royal Anthropological Institute, London, 1 June 2018.

Glass, Aaron, and Corinne Hunt. "Collection, Colonialism, and Conversation: A Dialogue." Pamphlet produced in conjunction with an exhibition entitled *The Story Box: Franz Boaz, George Hunt, and the Making of Anthropology* at the Bard Graduate Center, New York, 14 February–7 July 2019. https://www.bgc.bard.edu/storage/uploads/BGC_BoasBrochure .pdf.

Gmelch, Sharon Bohn. *The Tlingit Encounter with Photography*. Philadelphia: University of Pennsylvania Museum of Anthropology and Archaeology, 2008.

Godelier, Maurice. *The Enigma of the Gift*. Translated by Nora Scott. Chicago: University of Chicago Press, 1999.

González, Jennifer A. *Subject to Display: Reframing Race in Contemporary Installation Art*. Cambridge, MA: MIT Press, 2008.

Graeber, David. *Toward an Anthropological Theory of Value: The False Coin of Our Own Dreams*. New York: Palgrave, 2001.

Graham, Beryl, and Sarah Cook. *Rethinking Curating: Art after New Media*. Cambridge, MA: MIT Press, 2010.

Green, Charles. *The Third Hand: Collaboration in Art from Conceptualism to Postmodernism*. Minneapolis: University of Minnesota Press, 2001.

Greenblatt, Stephen. "Resonance and Wonder." In *Exhibition Cultures: The Poetics and Politics of Museum Display*, edited by Ivan Karp and Steven D. Lavine, 42–56. Washington, DC: Smithsonian Institution Press, 1991.

Grimshaw, Anna, Elspeth Owen, and Amanda Ravetz. "Making Do: The Materials of Art and Anthropology." In *Between Art and Anthropology: Contemporary Ethnographic Practice*, edited by Arnd Schneider and Christopher Wright, 147–62. Oxford: Berg, 2010.

Gross, Daniel, and Stuart Plattner. "Commentary: Anthropology as Social Work: Collaborative Models of Anthropological Research." *Anthropology News* 43, no. 8 (November 2002): 4. https://doi.org/10.1111/an.2002.43.8.4.1.

Groys, Boris. *Art Power*. Cambridge, MA: MIT Press, 2008.

Hafstein, Valdimar. "The Making of Intangible Cultural Heritage: Tradition and Authenticity, Community and Humanity." PhD diss., University of California at Berkeley, 2004.

Hale, Charles R. "Neoliberal Multiculturalism: The Remaking of Cultural Rights and Racial Dominance in Central America." *Political and Legal Anthropology Review* 28, no. 1 (2005): 10–28. https://doi.org/10.1525/pol.2005.28.1.10.

Hall, Stuart. "Notes on Deconstructing 'the Popular.'" In *People's History and Socialist Theory*, edited by Raphael Samuel, 227–40. London: Routledge and Kegan Paul, 1981.

Halpin, Marjorie. "Lévi-Straussian Structuralism on the Northwest Coast." In *Coming to Shore: Northwest Coast Ethnology, Traditions, and Visions*, edited by Marie Mauzé, Michael E. Harkin, and Sergei Kan, 91–105. Lincoln: University of Nebraska Press, 2004.

– "'Seeing' in Stone: Tsimshian Masking and the Twin Stone Masks." In *The Tsimshian: Images of the Past, Views for the Present*, edited by Margaret Seguin, 281–308. Vancouver, BC: UBC Press, 1984.

– "The Structure of Tsimshian Totemism." In *The Tsimshian and Their Neighbors of the North Pacific Coast*, edited by Jay Miller and Carol M. Eastman, 16–35. Seattle: University of Washington Press, 1984.

Hare, Jan, and Jean Barman. *Good Intentions Gone Awry: Emma Crosby and the Methodist Mission on the Northwest Coast*. Vancouver, BC: UBC Press, 2006.

Harkin, Michael. "From Totems to Derrida: Postmodernism and Northwest Coast Ethnology." *Ethnohistory* 46, no. 4 (1999): 817–30. https://www.jstor.org/stable/483020.

Harney, Elizabeth, and Ruth B. Phillips, eds. *Mapping Modernisms: Art, Indigeneity, Colonialism*. Durham, NC: Duke University Press, 2019.

Harris, Jonathan, ed. *Globalization and Contemporary Art*. Malden, MA: Wiley-Blackwell, 2011.

Hart, Sydney, and Clay Little, eds. *Weaving Histories*. Vancouver, BC: Presentation House, 2015.

Hawker, Ronald W. *Tales of Ghosts: First Nations Art in British Columbia, 1922–61*. Vancouver, BC: UBC Press, 2003.

Hawthorn, Audrey. *People of the Potlatch*. Vancouver: British Columbia Art Gallery, 1956.

Hayner, Priscilla B. *Unspeakable Truths: Transitional Justice and the Challenge of Truth Commissions*. New York: Routledge, 2011.

Hebdige, Dick. *Subculture: The Meaning of Style*. New York: Taylor and Francis, 1979.

Hedican, Edward J. *Applied Anthropology in Canada: Understanding Aboriginal Issues*. Toronto, ON: University of Toronto Press, 2008.

Henare, Amiria, Martin Holbraad, and Sari Wastell. "Introduction: Thinking Through Things." In *Thinking Through Things: Theorising Artefacts Ethnographically*, edited by Amiria Henare, Martin Holbraad, and Sari Wastell, 1–31. London: Routledge, 2007.

Henderson, Jennifer, and Pauline Wakeham. "Colonial Reckoning, National Reconciliation? Aboriginal Peoples and the Culture of Redress in Canada." *English Studies in Canada* 35, no. 1 (2009): 1–26. https://doi.org/10.1353/esc.0.0168.

Hennessy, Kate. "Repatriation, Digital Technology, and Culture in a Northern Athapaskan Community." PhD diss., University of British Columbia, 2010.

Herle, Anita, and Sandra Rouse, eds. *Cambridge and the Torres Strait: Centenary Essays on the 1898 Anthropological Expedition*. Cambridge: Cambridge University Press, 1998.

Holm, Bill. *Northwest Coast Indian Art: An Analysis of Form*. Seattle: University of Washington Press, 1965.

– "Will the Real Charles Edenshaw Please Stand Up? The Problem of Attribution in Northwest Coast Indian Art." In *The World Is as Sharp as a Knife: An Anthology in Honour of Wilson Duff*, edited by Donald N. Abbott, 175–200. Victoria: British Columbia Provincial Museum, 1981.

Holm, Bill, and William Reid. *Form and Freedom: A Dialogue on Northwest Coast Indian Art*. Houston, TX: Rice University Press, 1975.

Hopkins, Candice. "In Memoriam: Beau Dick (1955–2017)." *documenta 14*, 4 April 2017. https://www.documenta14.de/en/notes-and-works/17052/in-memoriam-beau-dick-1955-2017.

Horton, Jessica L. *Art for an Undivided Earth: The American Indian Movement Generation*. Durham, NC: Duke University Press, 2017.

Huhndorf, Shari M. *Going Native: Indians in the American Cultural Imagination*. Ithaca, NY: Cornell University Press, 2001.

Hume, Mark. "B.C. Totem Comes Home from Sweden." *The Globe and Mail*, 27 April 2006. https://www.theglobeandmail.com/news/national/bc-totem-comes-home-from-sweden/article18161058/.

Hurt, Byron, dir. *Hip-Hop: Beyond Beats and Rhymes*. Northampton, MA: Media Education Foundation, 2006. 61 min.

Hutchinson, Elizabeth. *The Indian Craze: Primitivism, Modernism, and Transculturation in American Art, 1890–1915*. Durham, NC: Duke University Press, 2009.

Igloliorte, Heather. "Inuit Artistic Expression as Cultural Resilience." In *Response, Responsibility, and Renewal: Canada's Truth and Reconciliation Journey*, edited by Gregory Younging, Jonathan Dewar, and Mike DeGagné, 123–37. Ottawa, ON: Aboriginal Healing Foundation, 2009.

Ingold, Tim. *Making: Anthropology, Art, and Architecture*. London: Routledge, 2013.

Irlbacher-Fox, Stephanie. *Finding Dahshaa: Self-Government, Social Suffering, and Aboriginal Policy in Canada*. Vancouver, BC: UBC Press, 2009.

Isaac, Gwyneira. *Mediating Knowledges: Origins of a Zuni Tribal Museum*. Tucson: University of Arizona Press, 2007.

Iverson, Margaret. "Readymade, Found Object, Photograph." *Art Journal* 63, no. 2 (2004): 44–57. https://doi.org/10.1080/00043249.2004.10791125.

Ivy, Marilyn. "Benedict's Shame: Translating the Chrysanthemum and the Sword." *Cabinet* no. 31 (Fall 2008). https://www.cabinetmagazine.org/issues/31/ivy.php.

Jacknis, Ira. "Franz Boas and Exhibits: On the Limitations of the Museum Method of Anthropology." In *Objects and Others: Essays on Museums and Material Culture*, edited by George W. Stocking, 75–111. Madison: University of Wisconsin Press, 1988.

– "'A Magic Place': The Northwest Coast Indian Hall at the American Museum of Natural History." In *Coming to Shore: Northwest Coast Ethnology, Traditions, and Visions*, edited by Marie Mauzé, Michael E. Harkin, and Sergei Kan, 221–50. Lincoln: University of Nebraska Press, 2004.

– *The Storage Box of Tradition: Kwakuitl Art, Anthropologists, and Museums, 1881–1981*. Washington, DC: Smithsonian Institution Press, 2002.

Jackson, John L., Jr. *Real Black: Adventures in Racial Sincerity*. Chicago: University of Chicago Press, 2005.

Jain, Sarah Lochlann. *Injury: The Politics of Product Design and Safety Law in the United States*. Princeton, NJ: Princeton University Press, 2006.

James, Matt. "A Carnival of Truth? Knowledge, Ignorance, and the Canadian Truth and Reconciliation Commission." *International Journal of Transitional Justice* 6, no. 2 (2012): 182–204. https://doi.org/10.1093/ijtj/ijs010.

Jasper, Adam. "No Drums or Spears." *Res: Anthropology and Aesthetics* 67–68 (2016/2017): 299–315. https://doi.org/10.1086/694229.

Jenkins, David. "Object Lessons and Ethnographic Displays: Museum Exhibitions and the Making of American Anthropology." *Comparative Studies in Society and History* 36, no. 2 (1994): 242–70. https://doi.org/10.1017/S0010417500019046.

Jessiman, Stacey R. "The Repatriation of the G'psgolox Totem Pole: A Study of Its Context, Process, and Outcome." *International Journal of Cultural Property* 18, no. 3 (2011): 365–91. https://doi .org/10.1017/S0940739111000270.

Jonaitis, Aldona. *Art of the Northwest Coast*. Seattle: University of Washington Press, 2006.

– *From the Land of the Totem Poles: The Northwest Coast Indian Art Collection at the American Museum of Natural History*. New York: American Museum of Natural History, 1988.

Jonaitis, Aldona, and Aaron Glass. *The Totem Pole: An Intercultural History*. Seattle: University of Washington Press, 2010.

Kalbfleisch, Elizabeth. "Gesture of Reconciliation: The TRC Medicine Box as Communicative Thing." In *Arts of Engagement: Taking Aesthetic Action In and Beyond the Truth and Reconciliation Commission of Canada*, edited by Dylan Robinson and Keavy Martin, 283–304. Waterloo, ON: Wilfrid Laurier University Press, 2016.

Kan, Sergei. *Symbolic Immortality: The Tlingit Potlatch of the Nineteenth Century*. 2nd ed. Seattle: University of Washington Press, 2016.

Kauanui, J. Kēhaulani. *Hawaiian Blood: Colonialism and the Politics of Sovereignty and Indigeneity*. Durham, NC: Duke University Press, 2008.

Keane, Webb. *Christian Moderns: Freedom and Fetish in the Mission Encounter*. Berkeley: University of California Press, 2007.

– "On Semiotic Ideology." *Signs and Society* 6, no. 1 (2018): 64–87. https://doi.org/10.1086/695387.

Kelm, Mary-Ellen. *Colonizing Bodies: Aboriginal Health and Healing in British Columbia, 1900–50*. Vancouver, BC: UBC Press, 1998.

Kennedy, Rosanne, Lynne Bell, and Julia Emberley, eds. "Decolonising Testimony: On the Possibilities and Limits of Witnessing." Special issue, *Humanities Research* 15, no. 3 (September 2009): 1–10. https://doi.org/10.22459/HR.XV.12.2009.01.

Kester, Grant H. *Conversation Pieces: Community and Communication in Modern Art*. Berkeley: University of California Press, 2013.

– *The One and the Many: Contemporary Collaborative Art in a Global Context*. Durham, NC: Duke University Press, 2011.

Kirshenblatt-Gimblett, Barbara. "Intangible Heritage as Metacultural Production." *Museum International* 56, nos. 1–2 (2004): 52–65. https://doi.org/10.1111/j.1350-0775.2004.00458.x.

Kisin, Eugenia. "Durable Remains: Indigenous Materialisms in Duane Linklater's *From Our Hands*." *ARTMargins Online* 7, no. 2 (2018). https://artmargins.com/durable-remains-indigenous-materialisms-in-duane-linklaters-from-our-hands-artmargins-print-7-2/.

– "Terms of Revision: Contemporary Anthropology and the Art of Collaboration." *Collaborative Anthropologies* 7, no. 2 (Spring 2015): 180–210. https://doi.org/10.1353/cla.2015.0004.

– "Unsettling the Contemporary: Critical Indigeneity and Resources in Art." *Settler Colonial Studies* 3, no. 2 (2013): 141–56. https://doi.org/10.1080/2201473X.2013.781927.

Kisin, Eugenia, and Fred R. Myers. "The Anthropology of Art, After the End of Art: Contesting the Art-Culture System." *Annual Review of Anthropology* 48 (2019): 317–34. https://doi.org/10.1146/annurev-anthro-102218-011331.

Klassen, Pamela E. *Spirits of Protestantism: Medicine, Healing, and Liberal Christianity*. Berkeley: University of California Press, 2011.

– *The Story of Radio Mind: A Missionary's Journey on Indigenous Land*. Chicago: University of Chicago Press, 2018.

Kramer, Jennifer. "Figurative Repatriation: First Nations 'Artist-Warriors' Recover, Return, and Reclaim Cultural Property through Self-Definition." *Journal of Material Culture* 9, no. 2 (2004): 161–82. https://doi.org/10.1177/1359183504044370.

– *Switchbacks: Art, Ownership, and Nuxalk National Identity*. Vancouver, BC: UBC Press, 2006.

Krmpotich, Cara. *Force of Family: Repatriation, Kinship, and Memory on Haida Gwaii*. Toronto, ON: University of Toronto Press, 2013.

Krmpotich, Cara, Heather Howard, and Emma Knight. "From Collection to Community to Collection Again: Urban Indigenous Women, Material Culture, and Belonging." *Journal of Material Culture* 21, no. 3 (2016): 343–65. https://doi.org/10.1177/1359183515610362.

Kubler, George. *The Shape of Time: Remarks on the History of Things*. New Haven, CT: Yale University Press, 1962.

Kwon, Miwon. "One Place after Another: Notes on Site Specificity." *October* 80 (1997): 85–100. https://doi.org/10.2307/778809.

Kymlicka, Will. *Finding Our Way: Rethinking Ethnocultural Relations in Canada*. Oxford: Oxford University Press, 1998.

– *Multicultural Citizenship: A Liberal Theory of Minority Rights*. Oxford: Oxford University Press, 1995.

– *Multicultural Odysseys: Negotiating the New International Politics of Diversity*. Oxford: Oxford University Press, 2007.

LaCapra, Dominick. *Writing History, Writing Trauma*. Baltimore, MD: Johns Hopkins University Press, 2013.

Lake, Marilyn, and Henry Reynolds. *Drawing the Global Colour Line: White Men's Countries and the Challenge of Racial Equality*. Cambridge: Cambridge University Press, 2008.

LaRocque, Emma. *When the Other Is Me: Native Resistance Discourse, 1850–1990*. Winnipeg: University of Manitoba Press, 2010.

Lassiter, Luke Eric. "Collaborative Ethnography and Public Anthropology." *Current Anthropology* 46, no. 1 (2005): 83–106. https://doi.org/10.1086/425658.

Latour, Bruno. *Reassembling the Social: An Introduction to Actor-Network-Theory*. Oxford: Oxford University Press, 2005.

– *We Have Never Been Modern*. Cambridge, MA: Harvard University Press, 1993.

Lau, Lucy. "Museum of Vancouver's There Is Truth Here Illustrates Humanity of Residential School Survivors." *Vancouver Magazine*, 5 April 2019. https://www.vanmag.com/museum-of -vancouvers-there-is-truth-here-illustrates-humanity-of-residential-school-survivorsefbbbf.

Lave, Jean, and Etienne Wenger. *Situated Learning: Legitimate Peripheral Participation*. Cambridge: Cambridge University Press, 1991.

Lavoie, Judith. "First Nations Chief to Perform Rare Shaming Rite on Legislature Lawn." *Times Colonist*, 9 February 2013. https://www.timescolonist.com/local-news/first-nations -chief-to-perform-rare-shaming-rite-on-legislature-lawn-4578414

Lee, Molly, and Nelson H.H. Graburn. "Diffusion and Colonial Anthropology: Theories of Change in the Context of Jesup 1." In *Constructing Cultures Then and Now: Celebrating Franz Boas and the Jesup North Pacific Expedition*, edited by Laurel Kendall and Igor Krupnik, 79–87. Washington, DC: Arctic Studies Center, National Museum of Natural History, Smithsonian Institution, 2003.

Lehrer, Erica, Cynthia E. Milton, and Monica Eileen Patterson, eds. *Curating Difficult Knowledge: Violent Pasts in Public Places*. London: Palgrave Macmillan, 2011.

Levell, Nicola. *Michael Nicoll Yahgulanaas: The Seriousness of Play*. London: Black Dog Publishing, 2016.

Lévi-Strauss, Claude. "Split Representation in the Art of Asia and America." In *Structural Anthropology*, translated by Claire Jacobson and Brooke Grundfest Schoepf, 245–68. New York: Basic Books, 1963.

– *The Way of the Masks*. Translated by Sylvia Modelski. Seattle: University of Washington Press, 1982.

Li, Tania. *Land's End: Capitalist Relations on an Indigenous Frontier*. Durham, NC: Duke University Press, 2014.

Loft, Steven. "Reflections on 20 Years of Aboriginal Art." Lecture at the University of Victoria, 8 February 2012. http://www.trudeaufoundation.ca/sites/default/files/u5/reflections_on_20_years _of_aboriginal_art_-_steven_loft.pdf.

Low, Duncan. "Content Analysis and Press Coverage: Vancouver's Cultural Olympiad." *Canadian Journal of Communication* 37, no. 3 (2012): 505–12. https://doi.org/10.22230 /cjc.2012v37n3a2581.

Lutz, John Sutton. *Makúk: A New History of Aboriginal-White Relations*. Vancouver, BC: UBC Press, 2008.

MacCracken, Krista, and Skylee-Storm Hogan. "Laughter Filled the Space: Challenging Euro-Centric Archival Spaces." *The International Journal of Information, Diversity, and Inclusion* 5, no. 1 (2021): 97–110. https://doi.org/10.33137/ijidi.v5i1.34648.

MacDonald, George F. "Cosmic Equations in Northwest Coast Indian Art." In *The World Is as Sharp as a Knife: An Anthology in Honour of Wilson Duff*, edited by Donald N. Abbott, 225–38. Victoria: British Columbia Provincial Museum, 1981.

– *Haida Monumental Art*. Vancouver, BC: UBC Press, 1983.

MacDonald, Joanne. "From Ceremonial Object to Curio: Object Transformation at Port Simpson and Metlakatla in the Nineteenth Century." *Canadian Journal of Native Studies* 10, no. 2 (1990): 193–217. https://cjns.brandonu.ca/wp-content/uploads/10-2-MacDonald.pdf.

Macdonald, Sharon. *Behind the Scenes at the Science Museum*. Oxford: Berg, 2002.

Mackey, Eva. *Unsettled Expectations: Uncertainty, Land, and Settler Decolonization*. Halifax, NS: Fernwood Publishing, 2017.

MacKinnon, Leslie. "Native Bands Challenge Omnibus Budget Bill in Court." *CBC News*, 7 January 2013. https://www.cbc.ca/news/politics/native-bands-challenge-omnibus -budget-bill-in-court-1.1371476.

Macklem, Patrick. *Indigenous Difference and the Constitution of Canada*. Toronto, ON: University of Toronto Press, 2001.

Macnair, Peter L. *The Legacy: Tradition and Innovation in Northwest Coast Indian Art*. Victoria: Royal British Columbia Museum, 1984.

Mahon, Maureen. "The Visible Evidence of Cultural Producers." *Annual Review of Anthropology* 29 (2000): 467–92. https://doi.org/10.1146/annurev.anthro.29.1.467.

Manuel, George. *The Fourth World: An Indian Reality*. Toronto, ON: Collier-McFarlane, 1974.

Marcus, George E. "Contemporary Fieldwork Aesthetics in Art and Anthropology: Experiments in Collaboration and Intervention." *Visual Anthropology* 23, no. 4 (2010): 263–77. https://doi.org /10.1080/08949468.2010.484988.

– "Ethnography in/of the World System: The Emergence of Multi-sited Ethnography." *Annual Review of Anthropology* 24 (1995): 95–117. https://doi.org/10.1146/annurev .an.24.100195.000523.

Marcus, George E., and Michael F. Fischer. *Anthropology as Cultural Critique: An Experimental Moment in the Human Sciences*. Chicago: University of Chicago Press, 1986.

Marcus, George E., and Fred R. Myers. "The Traffic in Art and Culture: An Introduction." In *The Traffic in Culture: Refiguring Art and Anthropology*, 1–51.

–, eds. *The Traffic in Culture: Refiguring Art and Anthropology*. Berkeley: University of California Press, 1995.

Martineau, Jarrett, and Eric Ritskes. "Fugitive Indigeneity: Reclaiming the Terrain of Decolonial Struggle through Indigenous Art." *Decolonization, Education & Society* 3, no. 1 (2014): i–xii. https://jps.library.utoronto.ca/index.php/des/article/view/21320/17382.

Mauss, Marcel. *The Gift: The Form and Reason for Exchange in Archaic Societies*. Translated by W.D. Halls. 1925. Reprinted, New York: W.W. Norton, 1990.

Mauzé, Marie. "A Kwakwaka'wakw Headdress in André Breton's Collection." In *The Colour of My Dreams: The Surrealist Revolution in Art*, edited by Dawn Ades, 265–7. Vancouver, BC: Vancouver Art Gallery, 2011.

– "When the Northwest Coast Haunts French Anthropology." In *Coming to Shore: Northwest Coast Ethnology, Traditions, and Visions*, edited by Marie Mauzé, Michael E. Harkin, and Sergei Kan, 63–85. Lincoln: University of Nebraska Press, 2004.

McCarty, Emily. "There Is Truth Here: The Power of Art from Residential Schools on Display." *The Tyee*, 4 April 2019. https://thetyee.ca/Culture/2019/04/04/Power-Art-Residential-Schools -Students-Tribute/.

McCormick, Kaitlin. "Frederick Alexcee's Entangled Gazes." *ab-Original* 2, no. 2 (2018): 248–64. https://doi.org/10.5325/aboriginal.2.2.0246.

McKay, Kathryn. "Recycling the Soul: Death and the Continuity of Life in Coast Salish Burial Practices." MA thesis, University of Victoria, 2002.

McLennan, Bill, and Karen Duffek. *The Transforming Image: Painted Arts of Northwest Coast First Nations*. Vancouver, BC: Museum of Anthropology, 2000.

McMaster, Gerald, and Lee-Ann Martin, eds. *Indigena: Contemporary Native Perspectives in Canadian Art*. Vancouver, BC: Douglas & McIntyre, 1992.

McNeil, Kent. *Emerging Justice? Essays on Indigenous Rights in Canada and Australia*. Saskatoon: University of Saskatchewan Native Law Centre, 2001.

Menzies, Charles R., and Caroline F. Butler. "Collaborative Service Learning and Anthropology with Gitxaała Nation." *Collaborative Anthropologies* 4 (2011): 169–242. https://doi.org/10.1353/cla.2011.0014.

Merry, Sally Engle. "Measuring the World: Indicators, Human Rights, and Global Governance." *Current Anthropology* 52, no. S3 (April 2011): S83–S95. https://doi.org/10.1086/657241.

Metcalfe, Jessica R. "Native Designers of High Fashion: Expressing Identity, Creativity, and Tradition in Contemporary Customary Clothing Design." PhD diss., University of Arizona, 2010.

– "Reclaiming the Body: Strategies of Resistance in Virgil Ortiz's Fashion Design." *Settler Colonial Studies* 3, no. 2 (2013): 172–8. https://doi.org/10.1080/2201473X.2013.781929.

Mickleburgh, Rod. "City Wins Injunction against Occupy Vancouver." *The Globe and Mail*, 18 November 2011. https://www.theglobeandmail.com/news/british-columbia/city-wins-injunction-against-occupy-vancouver/article4183905/.

Mignolo, Walter D. *The Darker Side of Western Modernity: Global Futures, Decolonial Options*. Durham, NC: Duke University Press, 2011.

Miller, Bruce G. *Invisible Indigenes: The Politics of Non-Recognition*. Lincoln: University of Nebraska Press, 2003.

Miller, Daniel. *Material Culture and Mass Consumption*. Oxford: Basil Blackwell, 1987.

Miller, James Rodger. *Shingwauk's Vision: A History of Native Residential Schools*. Toronto, ON: University of Toronto Press, 1998.

Million, Dian. *Therapeutic Nations: Healing in an Age of Indigenous Rights*. Tucson: University of Arizona Press, 2013.

Milloy, John S. *A National Crime: The Canadian Government and the Residential School System, 1879–1986*. Winnipeg: University of Manitoba Press, 1998.

Mills, Suzanne E., and Tyler McCreary. "Negotiating Neoliberal Empowerment: Aboriginal People, Educational Restructuring, and Academic Labour in the North of British Columbia, Canada." *Antipode* 45, no. 5 (2013): 1298–1317. https://doi.org/10.1111/anti.12008.

Milroy, Sarah. "The Eagle Down Dance." In *Tsimshian Treasures: The Remarkable Journey of the Dundas Collection*, edited by Donald Ellis, 22–40. Vancouver, BC: Douglas & McIntyre, 2007.

Milton, Cynthia E., and Anne-Marie Reynaud. "Archives, Museums and Sacred Storage: Dealing with the Afterlife of the Truth and Reconciliation Commission of Canada." *International Journal of Transitional Justice* 13, no. 3 (November 2019): 524–45. https://doi.org/10.1093/ijtj/ijz027.

Miner, Dylan A.T. *Creating Aztlán: Chicano Art, Indigenous Sovereignty, and Lowriding across Turtle Island*. Tucson: University of Arizona Press, 2014.

– "Mawadisidiwag miinawaa wiidanokiindiwag/They Visit and Work Together." In *Makers, Crafters, Educators: Working for Social Change*, edited by Elizabeth Garber, Lisa Hochtritt, and Manisha Sharma, 131–4. London: Routledge, 2018.

Mitchell, W.J.T., Bernard E. Harcourt, and Michael Taussig. *Occupy: Three Inquiries in Disobedience*. Chicago: University of Chicago Press, 2013.

Mithlo, Nancy Marie. *"Our Indian Princess": Subverting the Stereotype*. Santa Fe, NM: School for Advanced Research (SAR) Press, 2009.

Modest, Wayne. "Introduction: Ethnographic Museums and the Double Bind." In *Matters of Belonging: Ethnographic Museums in a Changing Europe*, edited by Wayne Modest, Nicholas Thomas, Doris Prlić, and Claudia Augustat, 9–21. Leiden: Sidestone Press, 2019.

Moray, Gerta. *Unsettling Encounters: First Nations Imagery in the Art of Emily Carr*. Vancouver, BC: UBC Press. 2006.

Moreton-Robinson, Aileen, ed. *Sovereign Subjects: Indigenous Sovereignty Matters*. Crows Nest, New South Wales, AU: Allen & Unwin, 2007.

– *Talkin' Up to the White Woman: Aboriginal Women and Feminism*. St. Lucia: University of Queensland Press, 2002.

– *The White Possessive: Property, Power, and Indigenous Sovereignty*. Minneapolis: University of Minnesota Press, 2015.

Morphy, Howard. "Art as a Mode of Action: Some Problems with Gell's Art and Agency." *Journal of Material Culture* 14, no. 1 (2009): 5–27. https://doi.org/10.1177/1359183508100006.

– *Becoming Art: Exploring Cross-Cultural Categories*. Sydney, AU: University of New South Wales Press, 2008.

Morrissette, Suzanne. "past now: Luke Parnell." Brochure published in conjunction with an exhibition entitled *past now*, curated by Suzanne Morrissette and Lisa Myers at the MacLaren Art Centre, 25 November 2010–21 February 2011. Barrie, ON: MacLaren Art Centre, 2010. https://maclarenart.com/wp-content/uploads/2018/02/past-now-brochure_5-1.pdf.

– "Stories of Place, Location, and Knowledge." MFA thesis, OCAD University, 2011.

Moten, Fred. *In the Break: The Aesthetics of the Black Radical Tradition*. Minneapolis: University of Minnesota Press, 2003.

Mullin, Molly. *Culture in the Marketplace: Gender, Art, and Value in the American Southwest*. Durham, NC: Duke University Press, 2001.

Munn, Nancy D. "Visual Categories: An Approach to the Study of Representational Systems." *American Anthropologist* 68, no. 4 (1966): 936–50. https://doi.org/10.1525/aa.1966.68.4.02a00050.

Murphy, Michelle. "Alterlife and Decolonial Chemical Relations." *Cultural Anthropology* 32, no. 4 (2017): 494–503. https://doi.org/10.14506/ca32.4.02.

Myers, Fred R. "Censorship from Below: Aboriginal Art in Australian Museums." In *No Deal! Indigenous Arts and the Politics of Possession*, edited by Tressa Berman, 174–87. Santa Fe, NM: School for Advanced Research (SAR) Press, 2012.

– "Introduction." In *The Empire of Things: Regimes of Value and Material Culture*, edited by Fred R. Myers, 3–61. Santa Fe, NM: School for Advanced Research (SAR) Press, 2001.

– "Ontologies of the Image and Economies of Exchange." *American Ethnologist* 31, no. 1 (2004): 5–20. https://doi.org/10.1525/ae.2004.31.1.5.

– *Painting Culture: The Making of an Aboriginal High Art*. Durham, NC: Duke University Press, 2002.

– "'Primitivism,' Anthropology and the Category of 'Primitive Art.'" In *The Handbook of Material Culture*, edited by Christopher Tilley, Webb Keane, Susanne Küchler, Michael Rowlands, and Patricia Spyer, 267–84. London: SAGE Publications, 2006.

– "Social Agency and the Cultural Value(s) of the Art Object." *Journal of Material Culture* 9, no. 2 (2004): 203–11. https://doi.org/10.1177/1359183504044373.

– "Unsettled Business: Acrylic Painting, Tradition, and Indigenous Being." *Visual Anthropology* 17, nos. 3–4 (2004): 247–71. https://doi.org/10.1080/08949460490468036.

Myers, Lisa. "Review of *Beat Nation: Art, Hip Hop and Aboriginal Culture*." Exhibition at the Vancouver Art Gallery, 25 February–3 June 2012. *C Magazine* no. 115 (Autumn 2012): 58–9. https://cmagazine.com/articles/beat-nation-art-hip-hop-and-aboriginal-culture.

Myers, Natasha. *Rendering Life Molecular: Models, Modelers and Excitable Matter*. Durham, NC: Duke University Press, 2015.

Nanibush, Wanda. "The Coppers Calling: Awalaskenis II: Journey of Truth and Unity." In *Lalakenis/All Directions: A Journey of Truth and Unity*, edited by Scott Watson and Lorna Brown, 67–71. Vancouver, BC: Morris and Helen Belkin Art Gallery, 2014.

Nelson, Maggie. *On Freedom: Four Songs of Care and Constraint*. Minneapolis, MN: Graywolf Press, 2021.

Newcombe, Charles F. "Notes on the Haida." 1902. Manuscript in the Charles Newcombe Notes Collection, British Columbia Archives, Victoria, BC.

Neylan, Susan. *The Heavens Are Changing: Nineteenth Century Protestant Missions and Tsimshian Christianity*. Montreal and Kingston: McGill-Queen's University Press, 2003.

Niezen, Ronald. *The Origins of Indigenism: Human Rights and the Politics of Identity*. Berkeley: University of California Press, 2003.

– *The Rediscovered Self: Indigenous Identity and Cultural Justice*. Montreal and Kingston: McGill-Queen's University Press, 2009.

– *Truth and Indignation: Canada's Truth and Reconciliation Commission on Indian Residential Schools*. Toronto, ON: University of Toronto Press, 2013.

Ochs, Elinor, and Lisa Capps. *Living Narrative: Creating Lives in Everyday Storytelling*. Cambridge, MA: Harvard University Press, 2001.

Office of the Premier, Ministry of Aboriginal Relations and Reconciliation. "Aboriginal Celebration Marks Historical Repatriation." 21 June 2006. https://archive.news.gov.bc.ca/releases/news_releases_2005-2009/2006otp0108-000836.htm.

Okeke-Agulu, Chika. *Postcolonial Modernism: Art and Decolonization in Twentieth-Century Nigeria*. Durham, NC: Duke University Press, 2015.

Ong, Aihwa. *Neoliberalism as Exception: Mutations in Citizenship and Sovereignty*. Durham, NC: Duke University Press, 2006.

Ortner, Sherry. *Anthropology and Social Theory: Culture, Power, and the Acting Subject*. Durham, NC: Duke University Press, 2006.

Ostrowitz, Judith. *Interventions: Native American Art for Far-Flung Territories*. Seattle: University of Washington Press, 2009.

– *Privileging the Past: Reconstructing History in Northwest Coast Art*. Seattle: University of Washington Press, 1999.

Parnell, Luke, with Lisa Myers. "Repeat the Chorus Three Times." In "*Contingencies of Care* virtual residency," 13 July 2020. https://www.youtube.com/playlist?list=PLB2txaKEXi6s-Vl2YvUvtQK1z704BhE0j.

Parnell, Luke J. *Art of Haida Nisga'a Woodcarving* (blog). http://haidatotempoles.blogspot.com/2010/.

– "The Convergence of Intangible and Material Wealth." MAA thesis, Emily Carr University, 2012.

Pasternak, Shiri. "The Fiscal Body of Sovereignty: To 'Make Live' in Indian Country." *Settler Colonial Studies* 16, no. 6 (2016): 317–38. https://doi.org/10.1080/2201473X.2015.1090525.

Phillips, Ruth B. *Museum Pieces: Towards an Indigenization of Canadian Museums*. Montreal and Kingston: McGill-Queen's University Press, 2011.

– *Trading Identities: The Souvenir in Native North American Art from the Northeast, 1700–1900*. Montreal and Kingston: McGill-Queen's University Press, 1998.

Phillips, Ruth B., and Christopher Steiner, eds. *Unpacking Culture: Art and Commodity in Colonial and Postcolonial Worlds*. Berkeley: University of California Press, 1999.

Povinelli, Elizabeth. "The Child in the Broom Closet: States of Killing and Letting Die." *South Atlantic Quarterly* 107, no. 3 (2008): 509–30. https://doi.org/10.1215/00382876-2008-004.

– *The Cunning of Recognition: Indigenous Alterities and the Making of Australian Multiculturalism*. Durham, NC: Duke University Press, 2002.

– *Economies of Abandonment: Social Belonging and Endurance in Late Liberalism*. Durham, NC: Duke University Press, 2011.

– *Geontologies: A Requiem to Late Liberalism*. Durham, NC: Duke University Press, 2016.

– "Geontologies: The Concept and Its Territories." *e-flux* 81 (2017). https://www.e-flux.com/journal/81/123372/geontologies-the-concept-and-its-territories/.

– "Radical Worlds: The Anthropology of Incommensurability and Inconceivability." *Annual Review of Anthropology* 30, no. 1 (2001): 319–34. https://doi.org/10.1146/annurev.anthro.30.1.319.

Pratt, Mary Louise. "Arts of the Contact Zone." *Profession* (1991): 33–40. https://www.jstor.org/stable/25595469.

– *Imperial Eyes: Travel Writing and Transculturation*. New York: Routledge, 1992.

Preziosi, Donald. *Rethinking Art History: Meditations on a Coy Science*. New Haven, CT: Yale University Press, 1991.

Price, Sally. *Primitive Art in Civilized Places*. Chicago: University of Chicago Press, 1989.

Rabinow, Paul. *Designs for an Anthropology of the Contemporary*. Durham, NC: Duke University Press, 2008.

– *Unconsolable Contemporary: Observing Gerhard Richter*. Durham, NC: Duke University Press, 2017.

Rabson, Mia. "Release All Papers on Residential Schools: Judge." *The Brandon Sun*, 31 January 2013. https://www.brandonsun.com/breaking-news/release-all-papers-on-residential-schools-judge-189157531.html.

Raheja, Michelle H. *Reservation Reelism: Redfacing, Visual Sovereignty, and Representations of Native Americans in Film*. Lincoln: University of Nebraska Press, 2011.

Raibmon, Paige. "'A New Understanding of Things Indian': George Raley's Negotiation of the Residential School Experience." *BC Studies* 110 (Summer 1996): 69–96. https://doi.org/10.14288/bcs.v0i110.1343.

Raley, George H. "Canadian Indian Art and Industries: An Economic Problem of Today." *Journal of the Royal Society of Arts* 83, no. 4320 (1935): 989–1001. https://www.jstor.org/stable/41360540.

– "Suggesting a New Industry Out of an Old Art: BC Indians Revive Their Dying Skill to Become Revenue-Producing Artisans?" *Vancouver Daily Province*, 9 May 1936.

Ramirez, Renya K. *Native Hubs: Culture, Community, and Belonging in Silicon Valley and Beyond*. Durham, NC: Duke University Press, 2007.

Rancière, Jacques. *The Politics of Aesthetics: The Distribution of the Sensible*. Translated by Gabriel Rockhill. London: Continuum, 2004.

Rata, Elizabeth. *A Political Economy of Neotribal Capitalism*. Lanham, MD: Lexington Books, 2000.

Raynauld, Vincent, Emmanuelle Richez, and Katie Boudreau Morris. "Canada Is #IdleNoMore: Exploring Dynamics of Indigenous Political and Civic Protest in the Twitterverse." *Information, Communication & Society* 21, no. 4 (2018): 626–42. https://doi.org/10.1080/1369118X.2017.1301522.

Razack, Sherene H., ed. *Race, Space, and the Law: Unmapping a White Settler Society*. Toronto, ON: Between the Lines, 2002.

Recollet, Karyn. "Aural Traditions: Indigenous Youth and the Hip-Hop Movement in Canada." PhD diss., Trent University, 2013.

"Reconciliation Is Dead. Revolution Is Alive." *Unist'ot'en* (website). https://unistoten.camp/reconciliationisdead/.

Reece, Skeena. "Purple Turtle Speaks and Breaks." Curatorial statement on *Beat Nation: Hip Hop as Indigenous Culture*. Beat Nation, 2008. https://www.beatnation.org/curatorial-statements.html.

Regan, Paulette. *Unsettling the Settler Within: Indian Residential Schools, Truth Telling, and Reconciliation in Canada*. Vancouver, BC: UBC Press, 2011.

Rickard, Jolene. "Sovereignty: A Line in the Sand." In *Strong Hearts: Native American Visions and Voices*, edited by Nancy Ackerman and Peggy Roalf, 51–61. New York: Aperture, 1995.

– "Visual Sovereignty in the Time of Biometric Sensors." *South Atlantic Quarterly* 110, no. 2 (2011): 465–86. https://doi.org/10.1215/00382876-1162543.

Rifkin, Mark. "Indigenizing Agamben: Rethinking Sovereignty in Light of the 'Peculiar' Status of Native Peoples." *Cultural Critique* 73 (2009): 88–124. https://doi.org/10.1353/cul.0.0049.

Riles, Annelise, ed. *Documents: Artifacts of Modern Knowledge*. Ann Arbor: University of Michigan Press, 2006.

Ritter, Kathleen, and Tania Willard. "Beat Nation: Art, Hip Hop, and Aboriginal Culture." In *Beat Nation: Art, Hip Hop, and Aboriginal Culture*, edited by Kathleen Ritter and Tania Willard, 9–13. Vancouver, BC: Vancouver Art Gallery and grunt gallery, 2012.

Robbins, Joel. "The Globalization of Pentecostal and Charismatic Christianity." *Annual Review of Anthropology* 33 (2004): 117–43. https://doi.org/10.1146/annurev.anthro.32.061002.093421.

Robertson, Kirsty. *Tear Gas Epiphanies: Protest, Culture, Museums*. Montreal and Kingston: McGill-Queen's University Press, 2019.

Robinson, Dylan. "Enchantment's Irreconcilable Connection: Listening to Anger, Being Idle No More." In *Performance Studies in Canada*, edited by Laura Levin and Marlis Schweitzer, 211–35. Montreal and Kingston: McGill-Queen's University Press, 2017.

Robinson, Dylan, and Keavy Martin, eds. *Arts of Engagement: Taking Aesthetic Action In and Beyond the Truth and Reconciliation Commission*. Waterloo, ON: Wilfred Laurier University Press, 2016.

Rochette, Danielle. "Indigenous Artist Carves Seven Foot Totem to Reignite His Heritage." *APTN National News*, 6 June 2016. https://www.aptnnews.ca/national-news/luke-parnell/.

Rosaldo, Renato. "Cultural Citizenship and Educational Democracy." *Cultural Anthropology* 9, no. 3 (1994): 402–11. https://doi.org/10.1525/can.1994.9.3.02a00110.

– *Ilongot Headhunting: 1883–1974: A Study in Society and History*. Stanford: CA: Stanford University Press, 1980.

Rose, Deborah. "Comment on 'Collaborative Ethnography and Public Anthropology' by Luke Eric Lassiter." *Current Anthropology* 46, no. 1 (February 2005): 100.

Rose, Nikolas. *Governing the Soul: The Shaping of the Private Self*. 2nd ed. London: Free Association, 1999.

Rose, Nikolas, and Peter Miller. *Governing the Present: Administering Economic, Social, and Political Life*. Cambridge: Polity, 2008.

Roth, Christopher. *Becoming Tsimshian: The Social Life of Names*. Seattle: University of Washington Press, 2002.

Roth, Solen. *Incorporating Culture: How Indigenous People Are Reshaping the Northwest Coast Art Industry*. Vancouver, BC: UBC Press, 2019.

"Roundtable: The Present Conditions of Art Criticism." *October* 100 (2002): 200–28. https://doi .org/10.1162/016228702320218475.

Rowse, Tim. "Indigenous Culture: The Politics of Vulnerability and Survival." In *The Sage Handbook of Cultural Analysis*, edited by Tony Bennett and John Frow, 405–26. London: SAGE Publications, 2008.

Ruddell, Bruce. *Beyond Eden*. Directed by Dennis Garnhum. Musical theatre premiered January 2010 at the Vancouver Playhouse in collaboration with the 2010 Cultural Olympiad and Theatre Calgary.

Sahlins, Marshall. "Cosmologies of Capitalism: The Trans-Pacific Sector of 'the World System.'" In *Culture/Power/History: A Reader in Contemporary Social Theory*, edited by Nicholas B. Dirks, Geoff Eley, and Sherry B. Ortner, 412–56. Princeton, NJ: Princeton University Press, 1994.

Sakahàn: International Indigenous Art. Exhibition at the National Gallery of Canada, 17 May–2 September 2013.

Sandals, Leah. "Q&A: Tania Willard on Life beyond *Beat Nation*." *Canadian Art*, 28 June 2013. https://canadianart.ca/interviews/tania-willard-beat-nation/.

Sansi, Roger, ed. *The Anthropologist as Curator*. London: Bloomsbury Academic, 2020.

– *Art, Anthropology, and the Gift*. London: Routledge, 2014.

Sansi, Roger, and Marilyn Strathern. "Art and Anthropology after Relations." *HAU* 6, no. 2 (2015): 425–39. https://doi.org/10.14318/hau6.2.023.

Saul, John Ralston. *The Comeback: How Aboriginals Are Reclaiming Power and Influence*. Toronto, ON: Penguin, 2014.

– *A Fair Country*. Toronto, ON: Penguin, 2009.

Schneider, Arnd, and Christopher Wright. "Between Art and Anthropology." In Schneider and Wright, *Between Art and Anthropology: Contemporary Ethnographic Practice*, 1–21.

–, eds. *Between Art and Anthropology: Contemporary Ethnographic Practice*. Oxford: Berg, 2010.

Schweitzer, Don. *The United Church of Canada: A History*. Waterloo, ON: Wilfred Laurier University Press, 2011.

Scott, Andrea K. "Beau Dick." *The New Yorker*, 8 April 2019. https://www.newyorker.com /goings-on-about-town/art/beau-dick.

Scott, James C. *Weapons of the Weak: Everyday Forms of Peasant Resistance*. New Haven, CT: Yale University Press, 1985.

Sedgwick, Eve Kosofsky. *Touching Feeling: Affect, Pedagogy, Performativity*. Durham, NC: Duke University Press, 2003.

Seward, Verity, Dennison Smith, and Lindsay Nixon. *Sonny Assu: A Radical Mixing*. Catalogue of an exhibition of the same name at the Canada Gallery, Canada House, Trafalgar Square, 2 June– October 2019. London: Baldwin Gallery, 2019. http://www.thebaldwingallery.com/wp-content /uploads/2018/12/Sonny_Assu_Catalogue_Digital.pdf.

Sewid-Smith, Daisy. *Prosecution or Persecution*. Cape Mudge, BC: Nu-yum-balees Society, 1979.

Siegert, Bernhard. *Cultural Techniques: Grids, Filters, Doors, and Other Articulations of the Real*. Translated by Geoffrey Winthrop-Young. New York: Fordham University Press, 2015.

Simpson, Audra. *Mohawk Interruptus: Political Life across the Borders of Settler States*. Durham, NC: Duke University Press, 2014.

– "On the Logic of Discernment." *American Quarterly* 59, no. 2 (2007): 479–91. https://doi .org/10.1353/aq.2007.0051.

– "Reconciliation and Its Discontents: Settler Governance in an Age of Sorrow." Lecture at the University of Saskatchewan, Saskatoon, 15 March 2016. https://www.youtube.com /watch?v=vGl9HkzQsGg.

– "Settlement's Secret." *Cultural Anthropology* 26, no. 2 (2011): 205–17. https://doi.org/10.1111 /j.1548-1360.2011.01095.x.

– "Under the Sign of Sovereignty: Certainty, Ambivalence, and Law in Native North America and Indigenous Australia." *Wicazo Sa Review* 25, no. 2 (2010): 107–24. https://doi.org/10.1353 /wic.2010.0000.

Singh, Julietta. *Unthinking Mastery: Dehumanism and Decolonial Entanglements*. Durham, NC: Duke University Press, 2018.

Slade, Mary Anne Barbara. *Skil Kew Wat: On the Trail of Property Woman*. PhD diss., University of British Columbia, 2002.

Sleeper-Smith, Susan, ed. *Contesting Knowledge: Museums and Indigenous Perspectives*. Lincoln: University of Nebraska Press, 2009.

Smetzer, Megan A. "Assimilation or Resistance: The Production and Consumption of Tlingit Beadwork." PhD diss., University of British Columbia, 2007.

– "Beadwork for Basketry in Nineteenth-Century Tlingit Alaska." In *Objects of Exchange: Social and Material Transformation on the Late Nineteenth-Century Northwest Coast*, edited by Aaron Glass, 71–7. New York: Bard Graduate Center, 2011.

– "Tlingit Dance Collars and Octopus Bags: Embodying Power and Resistance." *American Indian Art Magazine* 34, no. 1 (Winter 2008): 64–73.

Smith, Andrea. *Conquest: Sexual Violence and American Indian Genocide*. Cambridge, MA: South End Press, 2005.

– *Native Americans and the Christian Right: The Gendered Politics of Unlikely Alliances*. Durham, NC: Duke University Press, 2008.

Smith, Linda Tuhiwai. *Decolonizing Methodologies: Research and Indigenous Peoples*. London: Zed, 1999.

Smith, Matthew Ryan. "Aboriginal Artists Engage with Urban Youth Culture in the Urgent and Timely 'Beat Nation.'" *Blouin Art Info*, 20 December 2012.

Smith, Terry. *Art to Come*. Durham, NC: Duke University Press, 2019.

– *What Is Contemporary Art?* Chicago: University of Chicago Press, 2008.

Smith, Terry, Okwui Enwezor, and Nancy Condee, eds. *Antinomies of Art and Culture*. Durham, NC: Duke University Press, 2009.

Sözen, Gizem. "Skeena Reece's Regalia in Her Performance 'Raven: On the Colonial Fleet' (2010)." *Activating the Archives* project. Vancouver, BC: grunt gallery, 2012. https://grunt.ca/wp-content /uploads/2013/12/Regalia-of-Skeena-Reece-written-by-Gizem-Sozen.pdf.

Spady, Samantha. "Attawapiskat: The Politics of Emergency." MA thesis, Ontario Institute for Studies in Education, University of Toronto, 2013.

Spice, Anne. "Fighting Invasive Infrastructures: Indigenous Relations against Pipelines." *Environment and Society* 9, no. 1 (2018): 40–56. https://doi.org/10.3167/ares.2018.090104.

Spyer, Patricia. *The Memory of Trade: Modernity's Entanglements on an Eastern Indonesian Island*. Durham, NC: Duke University Press, 2000.

Stanton, Kim. "Canada's Truth and Reconciliation Commission: Settling the Past?" *International Indigenous Policy Journal* 2, no. 3 (2011): Article 2. https://doi.org/10.18584/iipj.2011.2.3.2.

Stark, Heidi Kiiwetinepinesiik, Aimée Craft, and Hōkūlani K. Aikau, eds. *Indigenous Resurgence in an Age of Reconciliation*. Toronto, ON: University of Toronto Press, 2023.

Starn, Orin. "Here Come the Anthros (Again): The Strange Marriage of Anthropology and Native America." *Cultural Anthropology* 26, no. 2 (2011): 179–204. https://doi.org/10.1111 /j.1548-1360.2011.01094.x.

Steiner, Christopher. *African Art in Transit*. Cambridge: Cambridge University Press, 1994.

Sterritt, Neil J., and Robert Galois. *Tribal Boundaries in the Nass Watershed*. Vancouver, BC: UBC Press, 1999.

Stimson, Adrian. "Used and Abused." *Humanities Research* 15, no. 3 (2009): 71–80. https://informit .org/doi/10.3316/informit.580372546785876.

Stoler, Ann Laura. *Along the Archival Grain: Epistemic Anxieties and Colonial Common Sense*. Princeton, NJ: Princeton University Press, 2009.

– *Duress: Imperial Durabilities in Our Times*. Durham, NC: Duke University Press, 2016.

Stoymenoff, Alexis. "Ruling Expected Friday in Occupy Vancouver Injunction Hearings." *Vancouver Observer*, 17 November 2011. https://www.vancouverobserver.com/politics/news/2011/11/17 /ruling-expected-friday-occupy-vancouver-injunction-hearings.

Strathern, Marilyn. *The Gender of the Gift: Problems with Women and Problems with Society in Melanesia*. Berkeley: University of California Press, 1988.

– "Introduction: New Accountabilities." In *Audit Cultures: Anthropological Studies in Accountability, Ethics, and the Academy*, edited by Marilyn Strathern, 1–18. London: Routledge, 2000.

– *Property, Substance, and Effect: Anthropological Essays on Persons and Things*. London: Athlone, 1999.

Sutton, Peter. *The Politics of Suffering: Indigenous Australia and the End of the Liberal Consensus*. Carleton, Victoria, AU: Melbourne University Press, 2009.

Svašek, Maruška. *Anthropology, Art and Cultural Production*. London: Pluto Press, 2007.

Taylor, Charles. *Modern Social Imaginaries*. Durham, NC: Duke University Press, 2004.

Taylor, Diana. *The Archive and the Repertoire: Performing Cultural Memory in the Americas*. Durham, NC: Duke University Press, 2004.

Tennant, Paul. *Aboriginal Peoples and Politics: The Indian Land Question in British Columbia, 1849–1989*. Vancouver, BC: UBC Press, 1990.

"Terabytes of Testimony: Digital Database of Residential School Stories Opens to the Public." CBC Radio, 30 October 2016. https://www.cbc.ca/radio/unreserved/opportunities-for-reconciliation

-pop-up-in-unexpected-places-1.3294030/terabytes-of-testimony-digital-database-of-residential
-school-stories-opens-to-the-public-1.3296657.

Thom, Ian. *Challenging Traditions: Contemporary First Nations Art of the Northwest Coast.*
Seattle: University of Washington Press, 2009.

Thomas, Deborah. *Political Life in the Wake of the Plantation: Sovereignty, Witnessing, Repair.*
Durham NC: Duke University Press, 2019.

Thomas, Nicholas. "Cold Fusion." *American Anthropologist* 98, no. 1 (1996): 9–16. https://doi.org
/10.1525/aa.1996.98.1.02a00020.

– *Entangled Objects: Exchange, Material Culture, and Colonialism in the Pacific.* Cambridge, MA:
Harvard University Press, 1991.

– *Possessions: Indigenous Art/Colonial Culture.* London: Thames and Hudson, 1999.

Todd, Loretta. "Notes on Appropriation." *Parallelogramme* 16, no. 1 (1990): 24–33. https://
philarchive.org/archive/TODNOA-2.

– "What More Do They Want?" In *Indigena: Contemporary Native Perspectives in Canadian Art*,
edited by Gerald McMaster and Lee-Ann Martin, 71–9. Toronto, ON: Douglas & McIntyre, 1992.

Todd, Roy, and Martin Thornton, eds. *Aboriginal People and Other Canadians: Shaping New
Relationships.* Ottawa, ON: University of Ottawa Press, 2001.

Todd, Zoe. "Fish Pluralities: Human-Animal Relations and Sites of Engagement in Paulatuuq, Arctic
Canada." *Études Inuit Studies* 38, nos. 1–2 (2014): 217–38. https://doi.org/10.7202/1028861ar.

– "An Indigenous Feminist's Take on the Ontological Turn: Why 'Ontology' Is Just Another Word
for Colonialism." *Journal of Historical Sociology* 29, no. 1 (March 2016): 4–22. https://doi.org
/10.1111/johs.12124.

– "Relationships." Theorizing the Contemporary. *Fieldsights*, 21 January 2016. https://culanth.org
/fieldsights/relationships.

Townsend-Gault, Charlotte. "Art, Argument, and Anger on the Northwest Coast." In *Contesting
Art: Art, Politics, and Identity in the Modern World*, edited by Jeremy MacClancy, 131–53.
Oxford: Berg, 1997.

– "Art Claims in the Age of *Delgamuukw*." In *Native Art of the Northwest Coast: A History of
Changing Ideas*, edited by Charlotte Townsend-Gault, Jennifer Kramer, and Ḳi-ḳe-in, 684–935.
Vancouver, BC: UBC Press, 2013.

– "Circulating Aboriginality." *Journal of Material Culture* 9, no. 2 (2004): 183–202. https://doi.org
/10.1177/1359183504044372.

– "Failed Social Relations and the Volatility of Cultural Techniques in British Columbia." Lecture at
the Bard Graduate Center, New York, 17 April 2019. https://www.bgc.bard.edu/research-forum
/articles/424/failed-social-relations-and-the.

– "Lalakenis: Mode and Situation." In *Lalakenis/All Directions: A Journey of Truth and Unity*,
edited by Scott Watson and Lorna Brown, 74–80. Vancouver, BC: Morris and Helen Belkin Art
Gallery, 2014.

– "Struggles with Aboriginality/Modernity." In *Bill Reid and Beyond: Expanding on Modern Native
Art*, edited by Karen Duffek and Charlotte Townsend-Gault, 225–44. Vancouver, BC: Douglas &
McIntyre, 2004.

– "When the (Oven) Gloves Are Off: The Queen's Baton – Doing What to Whom?" In *Beyond
Aesthetics: Art and the Technologies of Enchantment*, edited by Christopher Pinney and Nicholas
Thomas, 235–58. Oxford: Berg, 2001.

Townsend-Gault, Charlotte, Jennifer Kramer, and Ḳi-ḳe-in, eds. *Native Art of the Northwest Coast:
A History of Changing Ideas.* Vancouver, BC: UBC Press, 2013.

Trouillot, Michel-Rolph. "Anthropology and the Savage Slot: The Poetics and Politics of Otherness."
In *Recapturing Anthropology: Working in the Present*, edited by Richard Gabriel Fox, 17–44.
Santa Fe, NM: School for Advanced Research (SAR) Press, 1991.

"Truth and Reconciliation." Association of Canadian Archivists/Association canadienne des archivistes (website). https://archivists.ca/Truth-and-Reconciliation.

Truth and Reconciliation Commission of Canada. *Honouring the Truth, Reconciling for the Future: Summary of the Final Report of the Truth and Reconciliation Commission of Canada.* Ottawa, ON: Truth and Reconciliation Commission of Canada, 2015. https://ehprnh2mwo3.exactdn.com/wp-content/uploads/2021/01/Executive_Summary_English_Web.pdf.

– "Open Call for Artistic Submissions." 2010. https://www.artstno.com/sites/nwtarts/files/TRC_Art_Submissions_en_p6.pdf.

Tsing, Anna. "On Collaboration." In section "A New Form of Collaboration in Cultural Anthropology: Matsutake Worlds," by the Matsutake Worlds Research Group. *American Ethnologist* 36, no. 2 (May 2009): 380–4. https://doi.org/10.1111/j.1548-1425.2009.01141.x.

Tsing, Anna Lowenhaupt. *Friction: An Ethnography of Global Connection.* Princeton, NJ: Princeton University Press, 2005.

– *The Mushroom at the End of the World: On the Possibility of Life in Capitalist Ruins.* Chicago: University of Chicago Press, 2015.

Tuck, Eve. "Suspending Damage: A Letter to Communities." *Harvard Educational Review* 79, no. 3 (Fall 2009): 409–27. https://doi.org/10.17763/haer.79.3.n0016675661t3n15.

Tuck, Eve, and K. Wayne Yang. "Decolonization Is Not a Metaphor." *Decolonization: Indigeneity, Education & Society* 1, no. 1 (2012): 1–40. https://jps.library.utoronto.ca/index.php/des/article/view/18630.

Turner, Dale. *This Is Not a Peace Pipe: Towards a Critical Indigenous Philosophy.* Toronto, ON: University of Toronto Press. 2006.

Vastokas, Joan M. "Cognitive Aspects of Northwest Coast Art." In *Art in Society: Studies in Style, Culture and Aesthetics*, edited by Michael Greenhalgh and Vincent Megaw, 243–59. London: Duckworth, 1978.

Verdery, Katherine, and Caroline Humphrey, eds. *Property in Question: Value Transformations in the Global Economy.* Oxford: Berg, 2004.

Vizenor, Gerald. *Survivance: Narrative of Native Presence.* Lincoln: University of Nebraska Press, 2008.

Vowel, Chelsea. *Indigenous Writes: A Guide to First Nations, Métis, and Inuit Issues in Canada.* Winnipeg, MB: Highwater Press, 2016.

Waldram, James B., ed. *Aboriginal Healing in Canada: Studies in Therapeutic Meaning and Practice.* Ottawa, ON: Aboriginal Healing Foundation, 2008.

Walsh, Andrea. "Repatriation, Reconciliation, and Refiguring Relationships: A Case Study of the Return of Children's Artwork from the Alberni Indian Residential School to Survivors and Their Families." In *Indigenous Collections Symposium: Promising Practices, Challenging Issues, and Changing the System*, 87–103. Proceedings of the Ontario Museum Association Indigenous Collections Symposium, 23–24 March 2017. https://members.museumsontario.ca/sites/default/files/2018_04_OMASymposiumProceedings_Eng.pdf.

Walters, Mark D. "The Jurisprudence of Reconciliation in Canada." In *The Politics of Reconciliation in Multicultural Societies*, edited by Will Kymlicka and Bashir Bashir, 165–91. Oxford: Oxford University Press, 2008.

Watson, Scott. "Art/Craft in the Early Twentieth Century." In *Native Art of the Northwest Coast: A History of Changing Ideas*, edited by Charlotte Townsend-Gault, Jennifer Kramer, and Ḵi-ḵe-in, 348–78. Vancouver, BC: UBC Press, 2013.

Watson, Scott, and Lorna Brown, eds. *Lalakenis/All Directions: A Journey of Truth and Unity.* Vancouver, BC: Morris and Helen Belkin Art Gallery, 2014.

Watson, Scott, Keith Wallace, and Jana Tyner, eds. *Witnesses: Art and Canada's Indian Residential Schools.* Vancouver, BC: Belkin Gallery, 2014.

Weiner, Annette. *Inalienable Possessions: The Paradox of Keeping-While-Giving*. Berkeley: University of California Press, 1992.

Williams, Raymond. *Marxism and Literature*. Oxford: Oxford University Press, 1977.

Willis, Paul. *Learning to Labor: How Working-Class Kids Get Working-Class Jobs*. New York: Columbia University Press, 1977.

Wilson, Jordan. "'Belongings' in 'Ċəsnaʔəm: The City before the City.'" *Intellectual Property Issues in Cultural Heritage (IPinCH*; blog), 27 January 2016. https://www.sfu.ca/ipinch/outputs/blog/citybeforecitybelongings/.

Wilson, Lyle. *Haislakala: Spoken from the Heart*. Exhibition at Coastal Peoples Gallery, Vancouver, BC, 5 November–18 December 2016.

Wilson, Michael. "Planning a Homecoming for Indians' Remains." *New York Times*, 16 September 2002. https://www.nytimes.com/2002/09/16/nyregion/planning-a-homecoming-for-indians-remains.html.

Winter, Robert W. "The Arts and Crafts as a Social Movement." *Record of the Princeton University Art Museum* 34, no. 2 (1975): 34–40. https://doi.org/10.2307/3774439.

Wolfe, Patrick. "Settler Colonialism and the Elimination of the Native." *Journal of Genocide Research* 8, no. 4 (2006): 387–409. https://doi.org/10.1080/14623520601056240.

Young, Iris Marion. *Inclusion and Democracy*. Oxford: Oxford University Press, 2002.

– *Justice and the Politics of Difference*. Princeton, NJ: Princeton University Press, 1990.

Yúdice, George. *The Expediency of Culture: Uses of Culture in the Global Era*. Durham, NC: Duke University Press, 2003.

Zeitlyn, David. "Anthropology in and of the Archives: Possible Futures and Contingent Pasts." *Annual Review of Anthropology* 41 (2012): 461–80. https://doi.org/10.1146/annurev-anthro-092611-145721.

Zhang, Qiaoyun. "Disaster Response and Recovery: Aid and Social Change." *Annals of Anthropological Practice* 40, no. 1 (2016): 86–97. https://doi.org/10.1111/napa.12090.

Index

Page numbers in italics indicate images.

Aboriginal Healing Foundation, 155
Activating the Archives (grunt gallery), 74, 79
activism, 16, 17; art in, 54, 129, 132, 141; collaboration and, 51, 57, 62; environmental, 135; Indigenous issues and, 88, 93, 126. *See also* Idle No More; protest
actor-network theory, 61
Adams, KC, 72
aesthetics: of care, 6, 165–6; of contemporary art, 9–10, 12–13, 48, 49, 92; dialogic, 51–3; engaged, 151–2; and ethics, 55, 60, 63–4, 165; Indigenous, 12–14, 63, 74, 178n54; and Northwest Coast art, 10, 31, 44, 98, 105–6; and politics, 65–6, 86, 87, 136, 141, 146; reparative, 15; of resistance, 77, 92, 157. *See also* relational aesthetics; repair
affect, 54, 127, 129, 144–5, 155; and art, 157
Afrofuturism, 92
Alaska, 28, 29–30
Alberni Indian Residential School, 157–8, 166
Alcheringa Gallery, 121
Alert Bay, British Columbia, 126–7, 139, 169
Alexcee, Frederick, 24–6, 35, 39, 179n18
Allaire, Christian, 86–7, 89
Alteen, Glenn, 77
American Indian Movement, 12, 128
American Museum of Natural History, 9, 27–9, 47, 121, 180n32

Amos, Gerald, 21
Anglican Church of Canada, 23, 166, 182n67, 183n96. *See also* Duncan, William
Angus, Trevor, 69, 89
Anishnaabensag Biimskowebshkigewag/Native Kids Ride Bikes (Miner), 69–70
anthropology, 8–11, 17, 107–8; Americanist tradition in, 27–8, 64; and art, 59, 65, 127; collaboration in, 49–51, 54–7, 60, 62–3, 67–8; cultural, 12–13; as extractive, 96; and materiality, 131–2; and the Northwest Coast, 27, 31–2, 47–8; of shame, 144. *See also* ethnography; fieldwork; salvage paradigm
anthropology of art, 23, 38, 53, 84, 165; collaboration in, 90
Aotearoa/New Zealand, 98
appropriation, 38, 57, 64, 91–2
archives: access to, 81–2; art as, 147, 150, 151, 155–6; and art practice, 47, 51–2, 140; care of, 165; as colonial, 181n41; extension of, 78–9; of performance art, 126; and repair, 169; of residential schools, 153–4; and witnessing, 163
"art claims" (Townsend-Gault), 10, 136, 137
art criticism, 9, 15, 16; anxieties of, 63, 89–90; formalist, 109; and Indigenous art, 84, 85, 151; participatory art in, 59–60; perspective of, 127

art history, 12–14; and craft, 38, 182n70; of the Northwest Coast, 27, 52, 55; participatory art in, 59–60; structures of, 84, 151; teaching of, 97, 100

Artifact Piece, The (Luna), 90

artist-run centres, 70, 74, 77–81, 83, 89. *See also* grunt gallery

art market, 16, 17, 96–7; breaking into, 113–14; for Northwest Coast art, 99, 103–4, 106; refusal of, 112. *See also* Northwest Coast art

art-resource nexus, 96, 129. *See also* extractive industries; resource economies

Arts and Crafts movement, 37–8, 182n70

arts funding, 79–80, 83, 122

Arts of the North (Freda Diesing School), 100

Arts of the Raven (1967), 67, 107, 179n17

artwork, 14, 178n64; agency of, 16, 19, 23, 53–4, 59–60; as anthropological resource, 50, 63; care for, 166–7; criticism of, 84–5, 108–9; effectiveness of, 71, 73, 94; as testimony, 150–9, 166, 167. *See also* contemporary art; Indigenous artists; Indigenous contemporary art

art worlds: and anthropology, 10, 12–13, 51, 54–5, 59; dangers of, 116, 151; global, 98, 168; Indigenous, 6, 89–90, 128; labour in, 104; materiality in, 131; value in, 4, 126

Assembly of First Nations (AFN), 95

Assu, Billy, 76

Assu, Sonny, 76, 83

Atleo, Shawn, 95, 145

Attawapiskat, 86, 88

Audain Foundation, 79, 83

Australia, 131, 144

Awalaskenis I, 127, 129–31

Awalaskenis II: Journey of Truth and Unity, 126, 127, 129, 132, 135; exhibitionary life of, 139–40; as performance art, 141, 194n28; and shame, 145. *See also* Dick, Beau

Baptiste, Ernest, 168

Barbeau, Marius, 105

Beam, Carl, 147

Beat Nation: Art, Hip Hop, and Aboriginal Culture, 17, 70, 130, 137; internationalism of, 187n12; interpretations of, 84, 92–4; origins of, 77–9, 81; political context of, 88–9; reception of, 85–6, 89–92; remix of,

74–7; touring version of, 81–3; walk through of, 71–3

beings and belongings, 14, 21, 125, 131–2; agency of, 53–4; care for, 165–6; in museums, 134–5, 151–2, 167–8. *See also* objects; re-enchantment

Belkin Gallery (UBC), 126, 131, 134, 140, 147–8

Belmore, Rebecca, 79

Bennett, Jordan, 72–3

bentwood box, 161, 163, 166

Berthiaume, Rocque, 99, 115

Bevan, Stan, 95–6, 99, 103, 123–4, *124*

Beyond Eden (musical), 7–8

Biddle, Jennifer, 10, 12, 96

"bilateralism" (Parnell), 16, 66, 67. *See also* formalism

Black Arts Movement, 129–30

Black Power, 129–30

Blackwater v. Plint, 157

Boas, Franz, 10, 27–9, 180n38; collaborators of, 52, 64; collecting of, 180n32, 181n41

Bob, Dempsey, 31, 99, 102, 109, 110; as a teacher, 112–15, 121

Boisjoly, Raymond, 72, *73*, *91*, 91–2

Breton, André, 29–30

Brief History of Northwest Coast Design, A (Parnell), 55–7

British Columbia, 10, 14, 18; arts funding in, 79; environmentalism in, 189n45; Indigenous artists of, 13; research context of, 53–4; resource industries in, 135–6; settler state of, 8, 32–4. *See also* settler states

British Columbia Arts Council, 79

Bulpitt, Corey, 93

Busby, Cathy, 125, 131, 142–4, *142*, *143*, 159

button blankets, 74, 84, 101, 118, 130

Canada, settler state of, 5, 6; apologies to Indigenous peoples by, 142; arts funding of, 79, 80; and collecting, 28; and extraction industries, 11, 13; and gender, 106; Indigenous policy of, 54, 76, 86, 87–8; and land claims, 40; liability of, 157, 158; protest action against, 70; shaming of, 145–6. *See also* settler states

Canada Council for the Arts, 79. *See also* arts funding

Canadian Association of Petroleum Producers (CAPP), 125

Canadian Museum of History, 125–6
Canadian West Coast Art: Native and Modern (National Gallery of Canada), 32–3
capitalism, 11, 30–1, 130, 132; in arts exchange, 39; and arts production, 43; limiting of, 69. *See also* liberalism; neoliberalism; resource economies
Cardinal, Gil, 19–20
Cardinal-Schubert, Joane, 148, 159
care, 4, 8, 14, 151, 194n28; aesthetics of, 6, 47–8, 166; collaborative approach to, 52; for the environment, 129; in fieldwork, 16; liberal approach to, 50. *See also* repair
Carr, Emily, 32–3
Cavagnaro, Angelo, 117–18, *118*
ceremonialism, 23, 25, 31, 43. *See also* ritual
Challenging Traditions (2009), 101, 104
Charles, Roxane, 167
China, 11, 95–6, 98
China Friendship Pole, 95–6, 111
Christianity, 24, 182n67; Indigenous, 25, 26; and property, 42; at residential schools, 35–6, 168, 200n13; and the settler state, 155–6. *See also* Anglican Church of Canada; Protestantism; religion; United Church of Canada
citizenship, 106, 111, 120. *See also* settler states
Clarkes, Lincoln, 188n17
Claxton, Dana, 72, 187n6
Cliff Painting (Nicolson), 72
climate change, 11, 179n9
Coastal GasLink pipeline, 8, 176n14. *See also* pipelines
Coast Mountain College, 99, 104, 110–11, 191n17
Coast Salish, 162
co-conspirator, 50, 68
collaboration, 16, 178n64; and anthropology, 49–52, 55–7, 59, 67–8; anxieties about, 62–4; and art exhibitions, 71, 150–1; in art research, 52–4; and care, 169; foundations of, 65; politics of, 90; process of, 61–2; values of, 60
colonialism, 11, 113; and archives, 181n41; and governance, 80; and museums, 76; recognition as, 98; resistance of, 26, 30–1; violence of, 157. *See also* settler colonialism; settler states
Colour of My Dreams, The (VAG), 30

Common Experience Payments, 155
community art, 98–9, 111
"conciliation" (Garneau), 145, 155, 156. *See also* reconciliation
connoisseurship, 10, 15, 47–8, 106, 108. *See also* art criticism; formalism
contemporaneity, 8, 35, 52, 57; anthropological approaches to, 183n9; of Indigenous art, 60, 70–1, 89, 107; of Indigenous peoples, 86; sites of, 97. *See also* Indigenous contemporary art
contemporary art, 6, 8, 10–11, 15; as anti-institutional, 78; and authorship, 66; and colonialism, 51, 76; exhibitions of, 76; and Indigenous cultures, 85–6, 97, 150–1; process orientation of, 61–2; and resilience, 44; spectacle of, 82–3. *See also* art worlds; Indigenous contemporary art
contredon, 54
coppers, 125–9, 131, 137–9, 195n34; cutting of, 130, 133, 141, 145–6; material of, 133–5, 195n31
Coppers from the Hood (Yahgulanaas), 137–9, *138*
Coqualeetza Residential School, 35, 36, 42
cosmopolitanism, 9, 12, 14, 165, 168. *See also* art worlds
craft, 38, 39–40, 43
Cranmer, Dan, 29
Crewdson, Gregory, 85–6
Crosby, Marcia, 53, 55, 76–7, 83, 106
Crosby, Thomas, 24–5
cultural genocide, 154. *See also* genocide
cultural heritage, 80, 138, 155. *See also* cultural property
Cultural Olympiad 2010, 7, 81–2
cultural policy, 24, 42, 65, 67, 152; in settler states, 31, 55, 64, 80, 108
cultural property, 11, 53, 122, 129; politics of, 113, 117; return of, 19–20, 42, 93, 132. *See also* cultural heritage; repatriation
curatorial practice, 5, 32, 59, 186n75; "authority" of, 81, 151; Indigenous, 17; unsettling of, 51, 52, 60–1, 65

Davidson, Robert, 103, 119
decolonization, 8–9, 14, 112, 152; of art institutions, 147, 165, 166, 199n10; of education, 99; of research, 17, 49–52, 57;

decolonization (*continued*)
 through collaboration, 55, 61. *See also*
 refusal; resistance
Department of Heritage, 79
Department of Indian Affairs, 23, 34, 35, 39, 161
Devine, Bonnie, 93
Devoured by Consumerism, 140
Dick, Beau, 17, 125–9, 159, 169; as an art
 world figure, 130–1, 139–41, 146. See also
 Awalaskenis I; *Awalaskenis II*; *Taaw*
Diesing, Freda, 58, *102*, 102–3, 105–8, 192n38,
 192n42; influences on, 109; as a teacher, 114.
 See also Freda Diesing School of Northwest
 Coast Art
documenta 14, 126, 130, 131, 140
Duff, Wilson, 6–7, 105
Duffek, Karen, 110
Duncan, William, 24–5, 179n19

Edenshaw, Charles, 107
education, 58–9, 87, 114; in art, 35, 36, 39,
 182n70; for the extraction industry, 118,
 191n17; Indigenization of, 97, 99, 103, 111,
 123; through art, 147. *See also* Freda Diesing
 School of Northwest Coast Art; Gitanmaax
 School of Northwest Coast Art; labour;
 pedagogy
Edzerza, Alano, 39
Ellipsis (Assu), 76
Emily Carr University of Art and Design, 32,
 57–60
Emmons, George T., 180n32
Epistemological Conundrum (Parnell),
 58–9
Ernst, Max, 29
ethnography, 6, 9–10, 34, 148; in art, 63;
 collaboration in, 51–3; of the Northwest
 Coast, 49, 104, 115; refusal of, 56, 157. *See
 also* anthropology; fieldwork
ethnohistory, 27, 133
ethnologie, 27, 29
exhibitions, 16, 71; belongings in, 151–2, 166;
 and connectivity, 93–4; contexts of, 150; of
 difficult knowledge, 167; of performances,
 73, 126–7; process of, 81; shifting meanings
 of, 89. *See also* curatorial practice;
 museology; museums and galleries
Expo 67, 179n17
Expo 86, 112, 116

extractive industries, 11, 32–4, 96–7, 136; and
 collecting, 31; and cultural resources, 123–4;
 opposition to, 70, 125–6, 128, 135, 189n45.
 See also resource economies

fieldwork, 16, 50, 96, 148; collaborative, 60,
 64, 90; as process, 61, 63, 65, 93
First Story Toronto, 183n96
Flappes (Yahgulanaas), 139
forestry industry, 26, 136
formalism, 4, 6, 8, 14; and the art market,
 85–7, 89; of Northwest Coast art, 10,
 16, 56, 109; and social art practice, 51,
 66–7, 165. *See also* aesthetics; art criticism;
 connoisseurship
Fortney, Sharon, 166–9
Fort Simpson. *See* Port Simpson
Freda Diesing School of Northwest Coast
 Art, 9, 16, 17, 50; audit of, 122–3; context
 of, 99–100, 108–10; and neoliberal
 Indigenization, 110–11; networks of, 95–7;
 pedagogy of, 101–4, 112–16; students of, 44,
 117–22; work of, 98–9, 108, 123–4. *See also*
 education

Galanin, Nicholas, 71, 72
Garfield, Viola, 76
Garneau, David, 43, 145, 155–6
Gell, Alfred, 15, 23, 162
gender, 74–5, 77, 92, 106, 190n71. *See also*
 masculinity
genocide, 5, 59. *See also* cultural genocide
"geontology" (Povinelli), 11
Ginsburg, Faye, 100, 178n54
Gitanmaax School of Northwest Coast Art,
 98, 102, 104, 108–9, 192n38. *See also* Freda
 Diesing School of Northwest Coast Art
Gitanyow, 105–6
Gitmidiik Wildman (Cavagnaro), *118*
Gitxsan, 31, 105, 109–10
Glass, Aaron, 28, 49, 52, 64, 115, 126–7
global art, 13, 76, 82, 131. *See also* art worlds;
 contemporary art
globalization, 12, 84–5
Going to Town (Kruger), 167
Gong, Louis, 39
Gordon, Russell, 140
governmentality, 54, 88, 111, 123. *See also*
 settler states

G'psgolox pole, 16, 19–23, 41, 44–5
Green, Henry, 58
Grey, Donald (Chief), 31
grunt gallery, 70, 74, 77–9, 81. *See also* artist-run centres
Gurl 23, 93
Guujaaw, Gidansda, 125, 135

Haida Gwaii, 30, 47, 105, 127
Haida Nation, 3, 7, 105, 125; art of, 60, 72, 107, 109; belongings of, 22, 137; cosmology of, 134; territories of, 29–30; trade routes of, 132, 133, 135
Haisla Nation, 19–20, 22, 41, 44–5, 179n9. *See also* G'psgolox pole
Halluci Nation, The. *See* Tribe Called Red, A
Hamat'sa dance society, 130
Hansson, Olaf, 19
Harper, Stephen, 86, 125–6, 131, 141–2, 145
Hart, James, 161
"Heroines" (Clarkes), 188n17
Heron, Dean, 99, 120–2
Heye, George Gustav, 29–30
Hill, Gabrielle, 69, 89
hip hop, 71, 77, 87, 190n71; Indigenization of, 83–4, 92–4, 129–30
Holm, Bill, 10, 106, 109, 110
Hopkins, Candice, 126, 130
Horton, Jessica L., 12, 128
Hudson's Bay Company, 7, 24
human rights, 41, 144, 152, 156, 166
Hunt, Corinne, 52
Hunt, George, 52, 64–5
Hupfield, Maria, 54, 71, 72, 86
hybridity, 35, 42, 52, 87; in artworks, 72, 85, 90–2, 109–10. *See also* syncretism

Idle No More, 17, 70, 82, 86, 87; aims of, 94; contexts of, 88–9, 141; impact of, 148; and social media, 129–30
Igloliorte, Mark, 72
Image Recovery Project, 55–6
Indian Act, 76, 87–8
INDIANacts (grunt gallery), 79
Indian Arts and Crafts Board, 35, 38
Indian New Deal, 34
Indian residential schools, 5, 17, 28, 35–6; archives of, 153–5; and art as testimony, 147–8, 150–2; arts in, 38–9, 101, 166, 167;

claims settlements for, 157–8; and cultural loss, 32, 44; federal apology for, 125–6, 131, 141–4; teaching about, 161; violence of, 37, 59. *See also* survivors of residential schools; testimony; trauma; Truth and Reconciliation Commission
Indigeneity, 12–14, 76, 113; and contemporary art, 13, 59, 62, 70, 83; and modernity, 42, 94; and museums, 64, 90; pathologizing of, 157
Indigenization: of education, 99, 104; of hip hop, 92; of labour, 110–11, 114, 123
Indigenous art, 6, 10–14, 24, 178n54; anti-colonialism of, 29; displays of, 69, 73, 85; neoliberal narratives of, 108; in residential schools, 35–6; social relations of, 63; as testimony, 150–2; writing about, 89–90. *See also* Indigenous contemporary art; Northwest Coast art
Indigenous artists, 6, 10, 12–13; and anthropologists, 51, 55–6, 64; as liberal subjects, 117; positioning of, 60, 113; state funding of, 80; testimony of, 149–50; training of, 97–8, 103–4, 114, 120
Indigenous contemporary art, 12–13, 17, 71, 78; internationalism of, 187n12; remix of, 74, 76; and the settler nation, 83. *See also* contemporaneity; contemporary art; Indigenous art
Indigenous governance, 40, 94, 136, 194n28; and "art," 133; obstacles to, 87–8. *See also* Indigenous sovereignty; self-determination
Indigenous peoples: activism of, 5, 126; and anthropological fieldwork, 49–50, 65, 180n38; appropriations from, 132; and colonialism, 11, 30–2, 59, 87–8; incarceration of, 114; labour of, 32–4; and reconciliation, 145, 148, 175n7; territories of, 123–4; and trauma, 129, 144, 157, 167; urban, 70, 71, 75, 77, 78, 85; visibility of, 83–4; youth, 69, 72, 88, 93
Indigenous research methods, 50–1, 69
Indigenous sovereignty, 6, 50, 69, 79; denial of, 87; enacting of, 105, 145, 155; and refusal, 157; relationships of, 98; and resource development, 136–7; and state-based arts funding, 80–1; through refusal, 112. *See also* Indigenous governance; refusal; self-determination

Inkameep Day School, 166, 168
installation art, 90–1, 138, 147, 148

Japanese anime, 48
Jesup North Pacific Expedition, 27
Jungen, Brian, 72

Kanesatake (Mohawk) resistance. *See* Oka crisis
Keystone XL pipeline, 136
Kitimat, BC, 19, 21, 34–5, 44, 99
Kitwancool, 105
Kramer, Jennifer, 41, 113
Kruger, Edith, 167
'Ksan. *See* Gitanmaax School of Northwest Coast Art
'Ksan style, 109–10
Kwakwaka'wakw, 64, 115–16, 132, 166; collecting from, 29, 166, 180n32; cosmology of, 133–4; fieldwork with, 49, 52, 76, 195n34

labour: in art, 6, 34, 35, 38–9, 70; art as, 104; Christian morality of, 35; colonial regimes of, 32, 33, 110–11, 120, 132–3; at the Freda Diesing School, 98–9, 114, 123; reparative work of, 96–7, 152; shared, 66. *See also* Protestantism; resource economies
Laing, Gina, 147, 149–51, 159, 166, 169
Lalakenis/All Directions (Belkin Gallery), 126, 134, 140
Laliberte, Amanda, 169
land claims, 10, 76, 83, 123, 136
Large, R.W., 26
Lax Kw'alaams, 24–6, 34. *See also* Port Simpson
Legacy Art Gallery, 166
Lesson, The (Cardinal-Schubert), 148, 159
Lévi-Strauss, Claude, 27, 29
liberalism, 11, 108; in education, 110–11, 191n17; recognition politics of, 50, 98, 106, 134. *See also* capitalism; neoliberalism; reconciliation; settler states
liberation theology, 40
like a boss (Reece), 77
Linklater, Duane, 71, 92
Luna, James, 79, 90–2

Mackay Indian Residential School, 166
Margaret A. Cargill Foundation, 123

maritime fur trade, 28
Marston, Luke, *161*, 161–2, 199n55
Martin, Mungo, 115–16
masculinity, 38, 63, 107. *See also* gender
materialism, 70, 131–2; Indigenous, 133; new, 11, 15, 131–2. *See also* "transcultural materialism" (Horton)
materiality, 23, 41, 85, 131; and archives, 153–5; and care, 165; and witnessing, 160–1, 163
Mauss, Marcel, 27, 31, 54, 195n34
McLennan, Bill, 99, 110
McNeil, Ken, 99
Meddling in the Museum (MOA), 138
media, 19–20, 85, 87–8, 189n45; and *Awalaskenis*, 126, 129, 130, 143; news-based, 96, 148, 150. *See also* social media
Medicine Box, The (Marston), *161*, 161–2, 199n55
Mesa-Bains, Amalia, 90
Methodism, 24, 26
"methodological philistinism" (Gell), 15, 23
Migrations (Linklater), 92
Miner, Dylan, 69, 89, 93–4. *See also* "visiting" methodology
missionaries, 21, 23, 34–6; as collaborators, 64; collecting practices of, 25–8, 31, 41, 183n96. *See also* Christianity
modernisms, 13, 29, 31, 38, 55; art and, 60, 86; Indigenous arts and, 33, 98, 107, 110, 182n70; postcolonial, 12
modernity, 13, 14, 26, 31; syncretism with, 42, 60, 65
Mohawk Nation, 78–9
Monds, Elaine, 121
Monkman, Kent, 72
Morin, Peter, 147, 159
Morris, Eric (Chief), 95
Morrisseau, Norval, 159
multiculturalism, 6. *See also* liberalism
museology, 5, 19, 28; critical, 20, 76, 139, 181n41. *See also* museums and galleries
Museum Age, 27–30
Museum of Anthropology, UBC, 24, 26, 110, 138; collaborations of, 55; collection of, 35–6, 179n18
Museum of Ethnography (Stockholm, Sweden), 19–21
Museum of Vancouver, 166–7, 188n17, 199n10

museums and galleries, 4–5, 9; anxieties about, 64, 80; as collaborators, 55; collecting by, 27–8, 32, 105, 165; collections of, 18, 25–6, 168; as colonial, 82; as connective spaces, 93–4, 131; critique of, 139; Indigenous programming in, 73, 76; and pedagogy, 159; and repatriation, 20–3, 41–2, 53, 138, 166. *See also* artist-run centres; curatorial practice; museology

Musqueam Nation, 161, 167

Myers, Fred, 15, 55, 151

Myers, Lisa, 70, 85, 89–90

Myre, Nadia, 79

'Namgis First Nation, 132, 133

Napoleon, Julian, 69, 89

National Centre for Truth and Reconciliation (NCTR), 153, 156, 163

National Gallery of Canada, 32–3, 187n12

nationalism, 28, 79, 105

Native Brotherhood of British Columbia, 25, 179n19

Native Renaissance, 107, 109, 110

natural resources. *See* extractive industries

Navigable Waters Act, 88, 141

Neel, Ellen, 106, 107

Nelson, Maggie, 6, 14, 165

neoliberalism, 40, 60, 97, 108; and heritage, 123–4; and Indigenization, 104, 110–11. *See also* liberalism

Nicolson, Marianne, 72, 117, 136, *137*

Nisga'a, 3, 40, 60, 109; museum of, 116, *118*

Nisga'a Treaty, 40–1, 182n87

Njootli, Jeneen Frei, 69, 89

Northern Exposure (Spirit Wrestler Gallery, 2012), 103, 119

Northern Gateway pipeline, 10, 136

Northwest Coast, 28, 32, 35, 132; and anthropology, 47; "Dark Age" of, 16, 34, 44–5; newcomers to, 105; and resource extraction, 135, 136

Northwest Coast art, 4, 6–11, 24, 27; appropriation of, 31–2, 38; category of, 55, 63, 66, 132, 183n96; collecting of, 27–8, 34, 36; commodification of, 39–40; and community, 104; criticism of, 84; exhibition of, 67, 179n17; and gender, 106; history of, 101; market for, 16–17, 23, 29–30, 32–4,

177n31; meaning of, 12, 47–8; protocols of, 156; renaissance of, 106–9; as resistance, 43–4; training in, 99–100, 108–9, 115

Northwest Community College. *See* Coast Mountain College

Nuxalk Nation, 113

objects, 12, 14, 134; agency of, 15–16, 19, 29, 132–3, 181n41; in anthropology, 28; and identity, 39–40; instability of, 61; repair of, 18; as resistance, 43–4; return of, 41–2; transformations of, 21–6, 67. *See also* beings and belongings; re-enchantment

Objects of Exchange (Glass), 126

Occupy movement, 70, 82, 148, 189n45

Occupy Museums, 83

Oilspill: The Inevitability of Enbridge (Nicolson), 136–7, *137*

Oka crisis, 78–9

Olympics, Vancouver 2010, 7, 10, 81, 148. *See also* Cultural Olympiad 2010

One Line Creates Two Spaces (Parnell), 3

oolichan, 16, 21–2, 45, 134, 179n9

Ostwelve, 92–3

other cosmos, an (Boisjoly), 72, *73*, *91*

"outsider" art, 159. *See also* "primitive art"

Paalen, Wolfgang, 30

Pacific National Exhibition, 168

Parnell, Luke, 3–4, 6–7, 9, 10, 79–80; aesthetics of, 47–8; collaboration with, 50–2, 57–9, 100–1; pedagogy of, 103–4; work of, 16, 55–6, 60, 66–7, 163

participatory action research, 51

Pechawis, Archer, 79

pedagogy, 16, 98, 104, 105–6; and exhibitions, 158; and labour, 111; and the TRC, 154. *See also* education; Freda Diesing School of Northwest Coast Art

People of the Potlatch (VAG), 108

performance art, 3, 16, 17, 50; archives of, 139–40; documents of, 73, 74, 79, 84, 126; embodied, 85, 93, 148; objects in, 132–3; participants in, 154, 157; and pedagogy, 158–9; process of, 61, 64, 141; sites of, 72, 77; work of, 127–9

Phantom Limbs (Parnell), 47–8, 50, 67

Picasso, Pablo, 112, 114–15

pipelines, 17, 99, 135–7; protests against, 5, 8–10, 14, 17, 70, 189n45. *See also* extractive industries; resource economies
Playing at School (Kruger), 167
Port Simpson, 24, 25, 34, 179n19
postcolonialism, 6, 12, 13, 78
"postcolonial modernism" (Okeke-Agulu), 12
post-humanism, 22, 132. *See also* beings and belongings
postmodernism, 8, 66, 78, 85
potlatch, 11, 17, 29, 126, 133–5; anthropology of, 27, 195n34; and art, 53, 140, 144; changes in, 28–9; as commodity exchange, 39; obligations of, 160; protocols of, 146. *See also* potlatch ban
potlatch ban, 31, 43, 67, 101, 133–4; paradox of, 105
Povinelli, Elizabeth, 11, 134
Power Plant Gallery, 87, 89
"primitive art," 10, 29, 112, 130
primitivism, 13, 31, 84–6, 132; and contemporary art, 83, 145–6
protest, 7, 10, 11, 14, 128; environmental, 189n45; impact of, 148; sites of, 74, 82. *See also* Idle No More; Occupy movement; pipelines
Protestantism, 38–9, 41; work doctrine of, 11, 24, 35, 117, 177n31. *See also* Christianity
protocols, 54, 136; and archives, 153, 166; of display, 156, 162; and museums, 64; as productive, 61, 151
PuSH International Performing Arts Festival, 77

Qiang Indigenous people, 95

race, 90, 190n71
racism, 87, 120
Raley, George, 16, 24, 26, 33–4; and Indigenous arts, 34–6, 39–40; as a social reformer, 37–8, 42
Raley Collection, 41, 43
Raven Fin Whale (Bulpitt, Gurl 23), 93
Raven: On the Colonial Fleet (Reece), 74–5, 75, 84–5
recognition, politics of, 6, 50, 76, 81, 98; as colonialism, 98, 134; and gender, 106; legal forms of, 157; trap of, 145. *See also* reconciliation

reconciliation, 5, 10, 37, 175n7; and art, 22, 154–5, 158–60, 198n33; failure of, 8, 126, 149–52; and research, 23; and shame, 144–6; state processes of, 13–15, 62, 129, 142, 156–7
Reece, Skeena, 72, 74–7, 75, 83–5, 92–4, *160*
re-enchantment, 11, 16, 24, 31, 48; of objects, 23, 42
refusal, 56, 97, 112, 151, 156–7. *See also* Indigenous sovereignty; resistance
regalia, 28, 71, 74–5, 75, 128, 131; collecting of, 180n32; in galleries, 72, 84–5; seizure of, 133. *See also* button blankets
Reid, Bill, 3–4, 6–7, 106, 107
relational aesthetics, 13, 60, 63, 91, 98. *See also* social and participatory art
religion, 11, 23, 26, 31, 177n31. *See also* Christianity; Protestantism; syncretism
remediation, 4–5, 8, 22, 170
Remediation (Parnell), 3–4, 7, 66, 163
"remote avant-garde" (Biddle), 12–13
repair, 5–8, 11, 14–16, 18, 27; aesthetics of, 160, 165, 170; and art, 53, 96–7, 147–8, 151–2, 169; and legal settlements, 155; state approaches to, 62, 126; and stories, 21–4, 45; through return, 49–50; through teaching, 108, 123
reparations, 6, 15; financial, 21, 145, 150, 154
repatriation, 11, 19–23, 132; artistic responses to, 47–8; material support for, 80, 179n6; and museums, 53, 138, 166; and ownership, 92–3; protocols of, 41–2, 44–5; routes of, 30
residential schools. *See* Indian residential schools
resistance, 23, 27, 31; in academia, 50–1; aesthetic of, 77, 86; history of, 88, 105–6, 141; through art, 154; through refusal, 156; through syncretism, 43–4. *See also* Indigenous sovereignty; refusal
resource economies, 7, 17, 95–7, 128; of culture, 132; vocational training for, 110–11, 118, 123–4, 191n17. *See also* art-resource nexus; extractive industries; labour
resource frontier, 45, 111, 132, 135, 136
Ritter, Kathleen, 70, 73, 81
ritual, 17, 66, 72, 163; efficacy of, 169; objects and, 11, 84, 133, 162; of shaming, 126, 130, 134, 143, 145. *See also* ceremonialism
Robertson, Henry, 19

Robes of Power (1986), 101
Robinson, Dylan, 15, 127, 132, 151–2
Robinson, Sam, 116
Rouch, Jean, 54
Royal British Columbia Museum, 120–1
Royal Ontario Museum, 26
Rudd, Kevin, 131, 142

Sakahàn: International Indigenous Art, 187n12
salvage paradigm, 5–7, 28–9, 35, 64, 163; paradox of, 36, 105; and the Surrealists, 30–1
SAW Gallery, 77
Scott, Duncan Campbell, 34
Scott-Heron, Gil, 129
secularism, 11, 38, 39, 42
Sedgwick, Eve Kosofsky, 13–14
self-determination, 40, 80. *See also* Indigenous governance
self-governance. *See* Indigenous governance
Seligmann, Kurt, 29–31
Semchuk, Sandra, 159–60
settler colonialism, 14, 15; anxieties of, 40, 86, 140; appropriations of, 132; and arts funding, 79; expansion of, 28, 105, 136; narratives of, 23, 87–8, 149, 154; recognition as, 98, 144; unsettling of, 61–2, 82; violence of, 77, 126. *See also* Canada, settler state of; colonialism
settlers, 70, 145, 148, 159–60
settler states, 4, 8, 11, 25; decolonization of, 52–3, 69, 165; governance by, 80, 97, 122, 126, 156; Indigenous peoples in, 54, 83, 134; and museums, 64. *See also* British Columbia; Canada, settler state of; citizenship
Shingwauk Residential Schools Centre, 153
Sichuan earthquake 2008, 95–6
Sick and Tired (Stimson), 148–9, 155
Skil Kew Wat. See Diesing, Freda
Slade, Mary Anne Barbara, 106–7
smallpox, 7, 19, 31, 47, 179n19
Smith, Terry, 13, 82
Smithsonian Museum, 121
social and participatory art, 51, 60, 66, 67, 91–2; beyond the gallery, 71, 94, 98; efficacy of, 141, 158; ephemerality of, 63–4; exhibitions of, 167; process in, 61. *See also* relational aesthetics

social media, 88, 126–7, 129–31. *See also* media
Sort, Loretta Quock, 118
Space Gallery, A, 72–3
Space, Time, Interface (Hupfield), 86
Speck, Henry, 147, 159
Spence, Teresa (Chief), 86, 89
Spirit Wrestler Gallery, 103, 109, 118–19, 193n62
St. Andrew's Mission School, 168, 200n13
Sterritt, Art, 109
Sterritt, John, 109
Stimson, Adrian, 148, 155
St. Michael's Indian Day and Residential School, 166, 167, 169
Stolen But Recovered (Yahgulanaas), 137–8, *138*
Surrealism, 29–32, 49, 112
Survival and Other Acts of Defiance (Hupfield), 71
survivors of residential schools, 123, 162; art by, 42, 167–8; federal apology to, 125, 131, 141–2; financial compensation for, 155, 157; testimony of, 145, 150–4, 156, 158. *See also* Indian residential schools; testimony; trauma; Truth and Reconciliation Commission (TRC)
syncretism, 39, 168; and objects, 35, 41, 43; and religion, 24, 26. *See also* hybridity

Taaw, 17, 125, 134, 135, 139; activation of, 141, 143–4; display of, 140. See also *Awalaskenis I*; *Awalaskenis II*; coppers
tar sands, 136–7. *See also* extractive industries
Task Force on Museums and First Peoples, 80
Terrace, BC, 9, 96–100
Terse Cell (Yahgulanaas), 137
Testify: A Project of the Indigenous Laws + the Arts Collective, 50, 184n17
testimony: archiving of, 153–5, 163; art as, 150–2, 157, 166, 167; in exhibitions, 158–60, 169; expectations for, 156. *See also* survivors of residential schools
There Is Truth Here (Museum of Vancouver), 152, 166–70
This is not a simple movement (Morin), 147, 159
Tlingit, 28–9, 109, 120–1
totem poles, 3–4, 6–7, 31, 40–1; carving of, 57–8, 63–4, 66; doing things with, 95–6, 160–1;

totem poles (*continued*)
national styles of, 109; reading of, 59, 120; and tourism, 105. *See also* G'psgolox pole
Totem: The Return of the G'psgolox Pole (Cardinal), 19–20, *20*
Touch Me (Reece), 160, *160*
tourism, 39, 42–3; cultural, 63, 82; and cultural production, 101, 105
traditionalism, 12, 17, 89
"transcultural materialism" (Horton), 128–9
Transforming Image (MOA), 110
Transforming Image Project, 67
Trans Mountain pipeline, 137
trauma, 14; archiving of, 154, 156, 158; art and, 147, 149–50; healing from, 103, 116, 123, 142, 162–3; narratives of, 59, 129, 148, 157–8, 167; theory of, 49, 144. *See also* survivors of residential schools
treaties, 10, 14, 40, 88, 136. *See also* Nisga'a Treaty
Tribe Called Red, A, 72
Trudeau, Justin, 137
Truth and Reconciliation Commission (TRC), 5, 14, 17, 141–2, 197n82; and academic research, 50; archive of, 153–5; and art, 18, 43, 150–2, 161, 169; critiques of, 155–8, 198n33; final report of, 145, 147; and shame, 144–5. *See also* survivors of residential schools; testimony
Tsimshian, 24–6, 29, 109, 116
Tuck, Eve, 8, 14, 166
Turning Tables (Bennett), 72–3
Twilight (Crewdson), 85
2Bears, Jackson, 72
Txaldzap'am nagyeda laxa, 24–6, 35, 39
Txalp, Jagam, 40–1

U'Mista Cultural Centre, 127, 199n10
U'Mista Cultural Society, 30
United Church of Canada, 21, 35, 182n67; repatriation of objects by, 40–2, 179n6; and residential schools, 157
United Nations Declaration on the Rights of Indigenous Peoples, 166

University of British Columbia, 126, 159, 160–1, 181n54. *See also* Museum of Anthropology, UBC
University of Manitoba, 153
University of Victoria, 105
Urban Shaman Gallery, 72

Vancouver, BC, 6, 7, 9, 17; art world of, 55, 97; Downtown Eastside of, 188n17; Indigenous context of, 78; reconciliation work of, 148
Vancouver Art Gallery, 30, 32; *Beat Nation* at, 70–1, 73, 74, 76, 81–3; Indigenous art exhibitions at, 108
Vancouver School of Decorative and Applied Arts, 32
Vancouver School of Theology, 181n54
Vickers, Roy Henry, 109, 116
violence, 59; colonial, 79, 126, 157; exhibitions of, 167; gendered, 74, 77, 144
"visiting" methodology (Miner), 17, 69–71, 88, 93
visual anthropology, 54
visual culture, 12, 44, 78, 129
Vowel, Chelsea, 87–8, 190n62

Walsh, Andrea, 150–1, 166
WE ARE SORRY 2013 (Busby), 125, 131, 142–4, *142*, *143*, 159, 195n52
Wet'suwet'en, 8
Willard, Tania, 70, 74, 77–8, 81
Wilson, Fred, 90
Wilson, Jordan, 14
Wilson, Lyle, 22, 103
Wilson, Nathan, 103, 104
Witness, Bear, 72
Witnesses: Art and Canada's Indian Residential Schools (Belkin Gallery), 142, 147–52, 158–60, 198n44
witnessing. *See* testimony
Woodlands art, 159
Wyatt, Gary, 193n62

Yahgulanaas, Michael Nicoll, 48, 83, 137–9
Yuxweluptun, Lawrence Paul, 72, 159

Printed and bound by CPI Group (UK) Ltd, Croydon, CR0 4YY

31/08/2025

14727222-0002